NO TIME TO DIE: The Making of the Film

ISBN: 9781789093599

Published by
Titan Books
A division of Titan Publishing Group Ltd
144 Southwark St
London
SE1 0UP

www.titanbooks.com

First edition: April 2020
10 9 8 7 6 5 4 3 2 1

Main Unit Photographer Nicola Dove.

2nd and Splinter Unit Photographers Jasin Boland, Christopher Raphael, Ed Miller, Nick Dimbleby.
Specials Photographer Greg Williams pages 4, 6, 8, 99, 156.

Did you enjoy this book? We love to hear from our readers. Please e-mail us at: readerfeedback@titanemail.com or write to Reader Feedback at the above address.

To receive advance information, news, competitions, and exclusive offers online, please sign up for the Titan newsletter on our website: www.titanbooks.com

ALBERT R. BROCCOLI'S EON PRODUCTIONS PRESENTS DANIEL CRAIG AS IAN FLEMING'S JAMES BOND 007 IN "NO TIME TO DIE"
RAMI MALEK LÉA SEYDOUX LASHANA LYNCH BEN WHISHAW NAOMIE HARRIS WITH JEFFREY WRIGHT WITH CHRISTOPH WALTZ AND RALPH FIENNES AS "M"
CO-PRODUCERS DANIEL CRAIG ANDREW NOAKES DAVID POPE MUSIC BY HANS ZIMMER COSTUME DESIGNER SUTTIRAT ANNE LARLARB
EDITED BY ELLIOT GRAHAM, ACE TOM CROSS, ACE PRODUCTION DESIGNER MARK TILDESLEY
DIRECTOR OF PHOTOGRAPHY LINUS SANDGREN, FSF EXECUTIVE PRODUCER CHRIS BRIGHAM
STORY BY NEAL PURVIS & ROBERT WADE AND CARY JOJI FUKUNAGA
SCREENPLAY BY NEAL PURVIS & ROBERT WADE AND CARY JOJI FUKUNAGA AND PHOEBE WALLER-BRIDGE
PRODUCED BY MICHAEL G. WILSON, p.g.a. AND BARBARA BROCCOLI, p.g.a. DIRECTED BY CARY JOJI FUKUNAGA
FEATURING "NO TIME TO DIE" PERFORMED BY BILLIE EILISH

 SCORE ALBUM ON DECCA RECORDS #NoTimeToDie 007.com MGM

NO TIME TO DIE

THE MAKING OF THE FILM

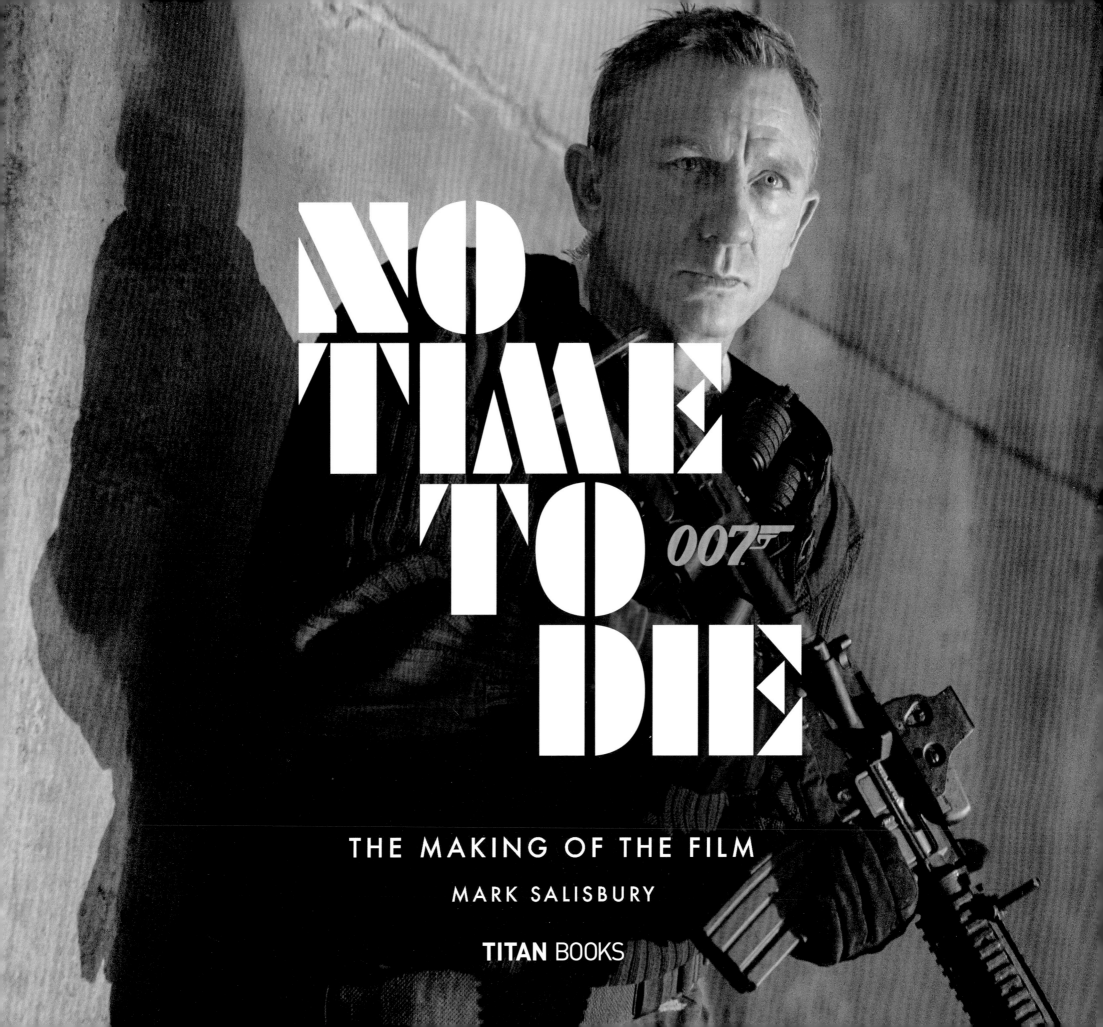

NO TIME TO DIE

007

THE MAKING OF THE FILM

MARK SALISBURY

TITAN BOOKS

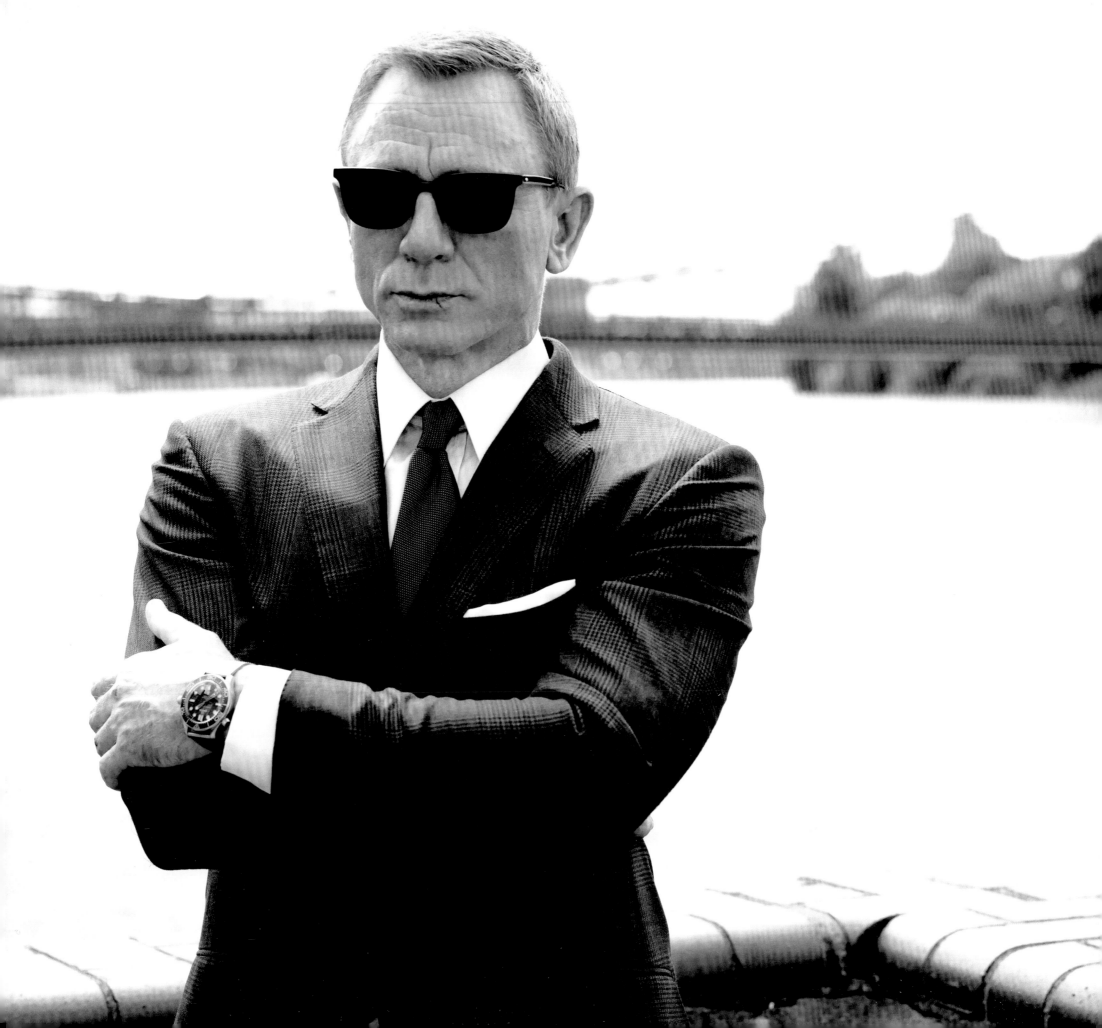

CONTENTS

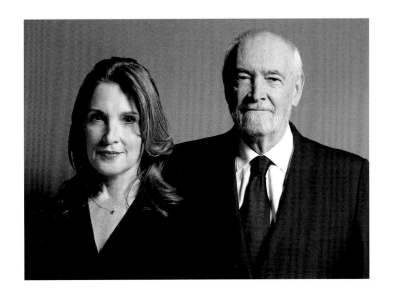

Jamaica is rooted in the history of James Bond, so it was incredibly momentous that we launched the 25th Bond film, *No Time To Die*, in April 2019 at Ian Fleming's home, GoldenEye, where he created the iconic character James Bond.

No Time To Die is the fifth and final outing for Daniel Craig. It is an epic and emotional love story in which Bond says goodbye to MI6 and in retirement tries to live a normal life. After a visit from his friend, CIA agent Felix Leiter, he is drawn into a complex web of intrigue, spun by forces from his past.

In his portrayal of Bond, Daniel has created a complex and multi-layered character whose emotional life has evolved through the films, culminating in the final climax of *No Time To Die*. His contribution to the Bond legacy is historic.

As with the making of any film, we faced challenges along the way, but we think the end result is a magnificently compelling achievement from all involved.

We would like to thank the wonderful cast and all the amazing crew led by Cary Joji Fukunaga. We are also honoured to have worked with the hugely talented Hans Zimmer on the score and, of course, Billie Eilish and FINNEAS on the powerful title song.

We hope you enjoyed the film as well as this '*Making of*' book.

Michael G. Wilson and Barbara Broccoli

"WELCOME BACK, MR BOND"

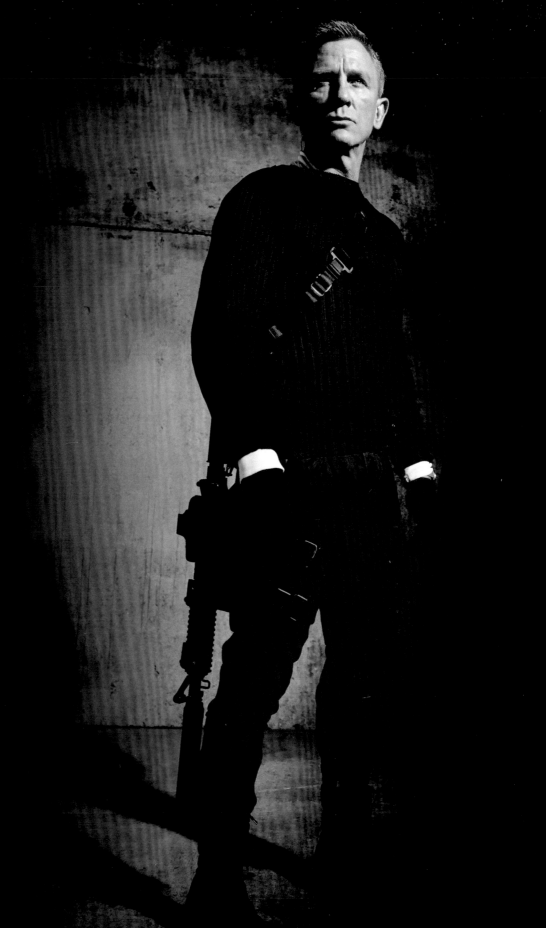

Since his first big-screen appearance in 1962's *Dr. No*, James Bond has remained cinema's most celebrated spy, a globetrotting agent who makes the world a safer place on behalf of Her Majesty's secret service.

With 2006's *Casino Royale*, Daniel Craig, the sixth actor to officially carry Bond's licence to kill, brought grit, realism and a marked physicality to the role. His back-to-basics Bond was less a reinvention than a realignment, hewing closer to creator Ian Fleming's original vision of a steely, serious, cynical killing machine, shorn of the comic quips and arch one-liners that characterised previous incarnations. Craig's Bond was blunt and unrelenting, and didn't give a damn whether his vodka martini was shaken or stirred. But he was also very human. He had flaws. He bled. He made mistakes. He fell in love – with Eva Green's Treasury agent Vesper Lynd – was betrayed – Vesper again – and had his heart broken. Audiences lapped it up. *Casino Royale* was a smash hit, earning the franchise unparalleled levels of critical and commercial success. Craig followed it two years later with *Quantum Of Solace* (2008), before his third outing, 2012's *Skyfall*, the movie that celebrated the 50th anniversary of the franchise and was released in the same year as the London Olympics. It became the first Bond to top $1 billion at the global box-office.

"He'd thrown his gun, his Walther, into the water, and there was some finality to it."

Daniel Craig

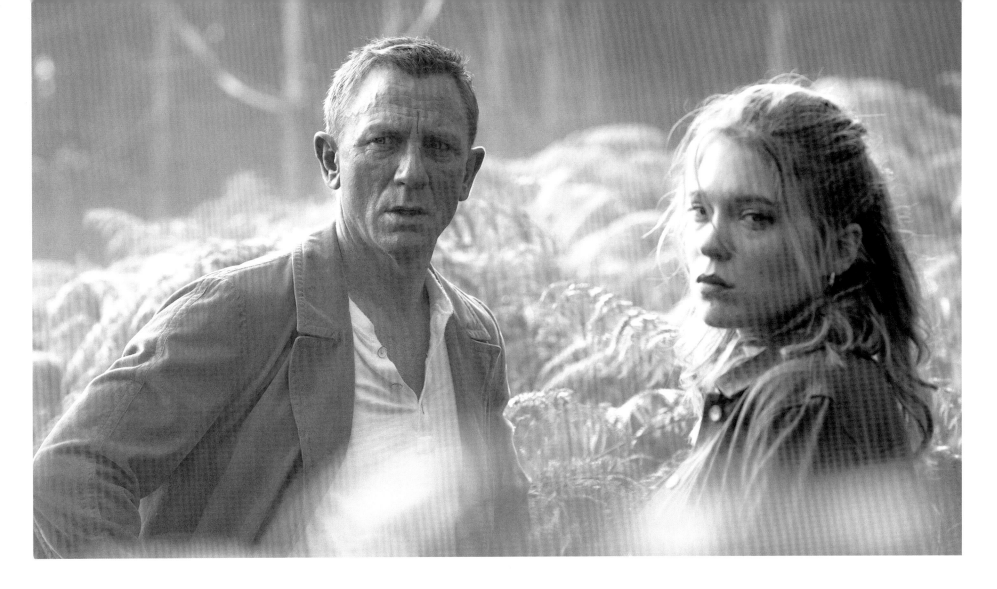

LEFT: Craig on the Poison Island set.

ABOVE: Bond and Madeleine Swann (Léa Seydoux) try to avoid capture in a forest.

Following the release of *Spectre* in 2015, it seemed time had run out on Craig's tenure, the film ending with Bond driving his iconic Aston Martin DB5 off into the metaphorical sunset, with Léa Seydoux's icy blonde psychiatrist Dr. Madeleine Swann beside him. Contractually, too, it marked the end of the actor's four-film contract. "I think I felt, after *Spectre*, that was enough," says Craig. "He'd thrown his gun, his Walther, into the water, and there was some finality to it."

However, Bond producers Michael G. Wilson and Barbara Broccoli, who had steered the franchise since the passing of their father, Cubby Broccoli, in 1996, were determined that Craig return for one final outing. Broccoli recalls "He said he really felt *Spectre* should be his last and, of course, we didn't want it to be. He took some time and, at one point, I said – and I didn't realise it meant anything to him until many, many months later – 'The story is not finished with you.' I really meant that. It wasn't just wanting to get him back. I didn't feel he'd completed his cycle."

"Enough time passed to get some distance," Craig admits.

"Barbara and I didn't stop talking. There was a constant dialogue going on. I said, 'If we do it, then we need to do something that really puts a button on the whole thing, so it's really worth it. That we somehow finish the story, finish my tenure, and for me it would be satisfying and hopefully satisfying for audiences, as well.'"

So, in August 2017, on *The Late Show with Stephen Colbert*, Craig announced that he would be returning to the role that had made him a global superstar, for what would be the twenty-fifth official James Bond movie.

Danny Boyle, Oscar-winning director of *Slumdog Millionaire*, *Trainspotting* and *28 Days Later*, took on the mantle of director. The Bury-born Boyle had a previous connection with 007, having presided over the opening ceremony of the 2012 London Olympics, a celebration of the best of British, which featured Craig's 007 escorting Her Majesty The Queen by helicopter from Buckingham Palace to the Olympic Stadium, where the pair appeared to skydive into the crowd, paying homage to the opening of *The Spy Who Loved Me* (1977) with their Union Jack

parachutes and accompanied by Monty Norman's Bond theme.

Even before Boyle's appointment was announced, screenwriters Neal Purvis and Robert Wade, who have had a hand in every Bond since 1999's *The World Is Not Enough*, had been hired to work on the script, which had the working title *Bond 25*. Once Boyle signed on, he brought on John Hodge, who had written his explosive debut, *Shallow Grave*, as well as *Trainspotting*, *A Life Less Ordinary* and *The Beach*. Boyle also drafted in two more regular collaborators: production designer Mark Tildesley and costume designer Suttirat Anne Larlarb. Like Boyle, Tildesley had started in the theatre before moving into television then film, working with him on *28 Days Later*, *Millions*, *Sunshine*, *Trance* and *T2: Trainspotting*. In addition, Tildesley designed the opening ceremony of the 2012 Olympics, as well as Boyle's National Theatre production of *Frankenstein*, which co-starred Craig's Moneypenny, Naomie Harris. Larlarb, too, had a theatre background, as an assistant in the art department on *The Beach*, before becoming Boyle's costume designer from 2006's *Sunshine* onwards. Larlarb is also a Production Designer and worked with Boyle on *127 Hours*.

With Boyle's key team in place, pre-production began. Locations were scouted, actors auditioned, stunts planned, costumes and sets conceived and designed, but three months in to the process Boyle exited the production citing "creative differences".

"We all spent a lot of time developing a storyline, and got to a point where we looked at what we had and jointly decided that the film [Danny] wanted to make and the film we wanted to make were not the same," explains Wilson. "And he agreed. Sometimes it happens. Better we all decided early on than going through a long, painful process. It was a very amicable parting that was the best for everybody, because, had we gone on to make a film, it would have been a very difficult situation for him – and for us. You couldn't ask for anything better, really, given the situation," said Broccoli.

Boyle's departure came as a shock for many on the crew, who were kept on while a new director was found. "I'm left with this team of people, building things, then the question is, how do we proceed?" reflects Tildesley. "Are we proceeding with the nuts and bolts of the original script? Are we going to reconvene? Should we keep the team together? Should we part and return on another date? I made the decision to remove all the imagery from the walls, because I thought whoever's coming in is not going to want to see it. I couldn't be sure if we were going to take off from where we were or start again."

Enter American-born writer-director Cary Joji Fukunaga, an alumni of the film programme at New York University who left before graduating to shoot his Spanish-language debut, *Sin Nombre*. The film established him as a bold, dynamic, visually inventive filmmaker and won him the Best Director Award (Dramatic) at the 2009 Sundance Film Festival. He followed it with an atmospheric adaptation of Charlotte Brontë's *Jane Eyre* and the ferociously compelling child soldier story *Beasts of No Nation*, which he wrote, directed and photographed. But it was Fukunaga's stellar work on the first season of the groundbreaking HBO show *True Detective* that made everyone take note.

"The great thing about Cary is he has an artist's aesthetic, but he's also a great storyteller," says Broccoli. "This film has a very complex story, it's multi-layered, so we needed someone who wouldn't be afraid of taking that on. The fact he's a writer-director was also very appealing, because we felt he would really get into the story and the characters and tell a story on a big scale, but also be really specific about the aesthetic and make things look beautiful. And he's great with performances. He is a really exceptional director."

He was also a Bond fan, dating back to 1985's *A View To A Kill*, which had been partly filmed in his home town of San Francisco. "That was exciting. That was my introduction to this heroic character, saving my city from flooding," Fukunaga recalls. "And it had Duran Duran doing the song. They were my older brother's favourite band, so they were my favourite band."

Not long after the release of *Spectre*, Fukunaga had invited Broccoli out to discuss what was happening with the franchise. "I took Barbara for a drink and asked what their plans were, if she and Michael knew who they wanted for the next Bond, and talked about possibilities."

"He said, 'I'd be interested in doing a Bond,'" recalls Broccoli. "We were flattered, but we didn't know if it was ever going to happen."

"Then, when Danny fell out of the project, again I raised my hand," notes Fukunaga. "I was like, 'Hey, what's going on?'"

"The timing worked out perfectly," Broccoli continues. "He turned out to be available and interested, and we've never looked back. We like to find directors who have their own vision. Then it's about trying to get their vision to fit within certain parameters, and he's been incredibly collaborative. He's brought a new, unique point of view to telling a James Bond story. We couldn't be more thrilled."

On September 20th, 2018, less than six weeks after Boyle's departure, Fukunaga was announced as the new director of *Bond 25*, making him the first American to helm a film in the franchise. (*Never Say Never Again*'s Irvin Kershner doesn't count as the film is not an official EON Productions movie.) With the clock ticking and the Bond juggernaut already under way, Fukunaga immediately set about overhauling the script. "We decided that script was

RIGHT: Bond caught in the spotlight at a SPECTRE party in Cuba.

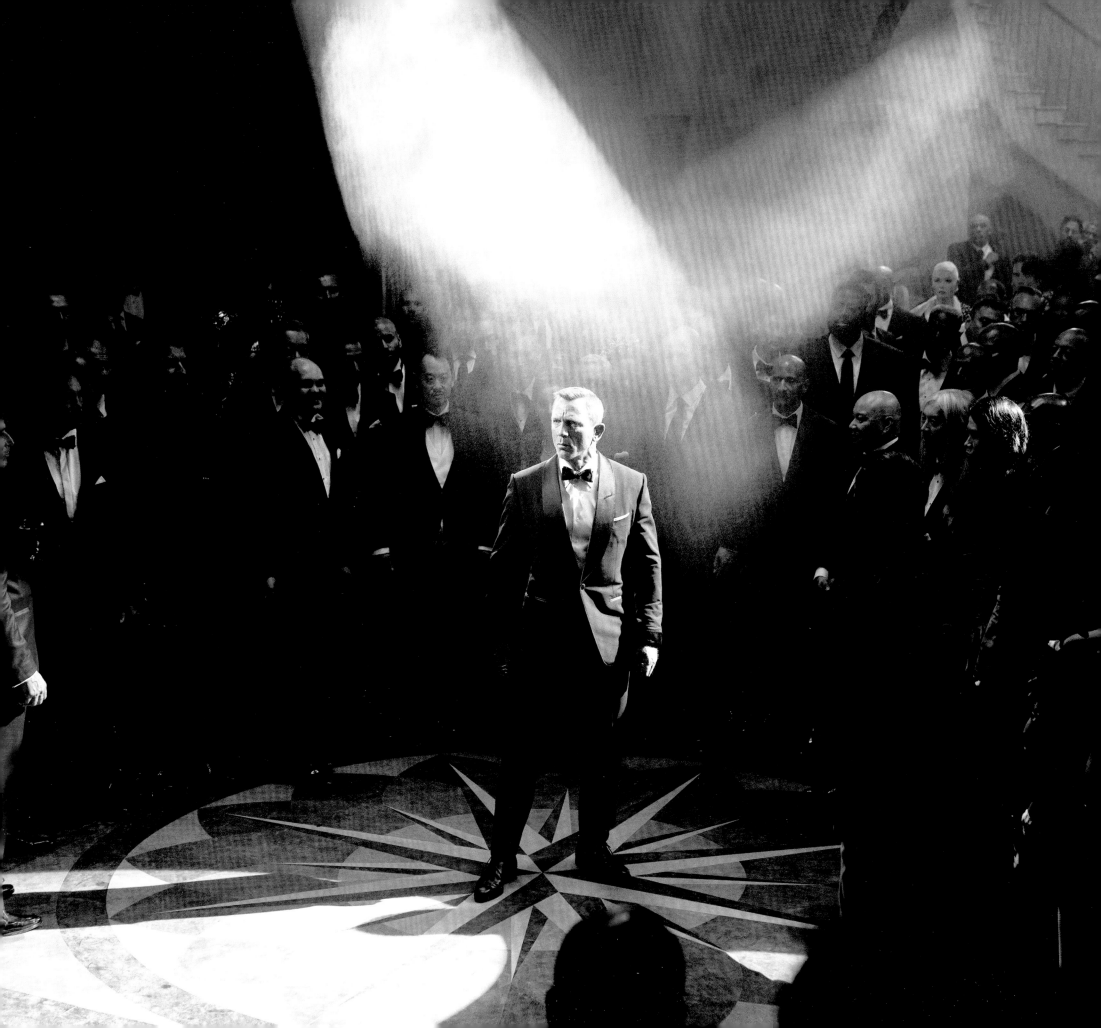

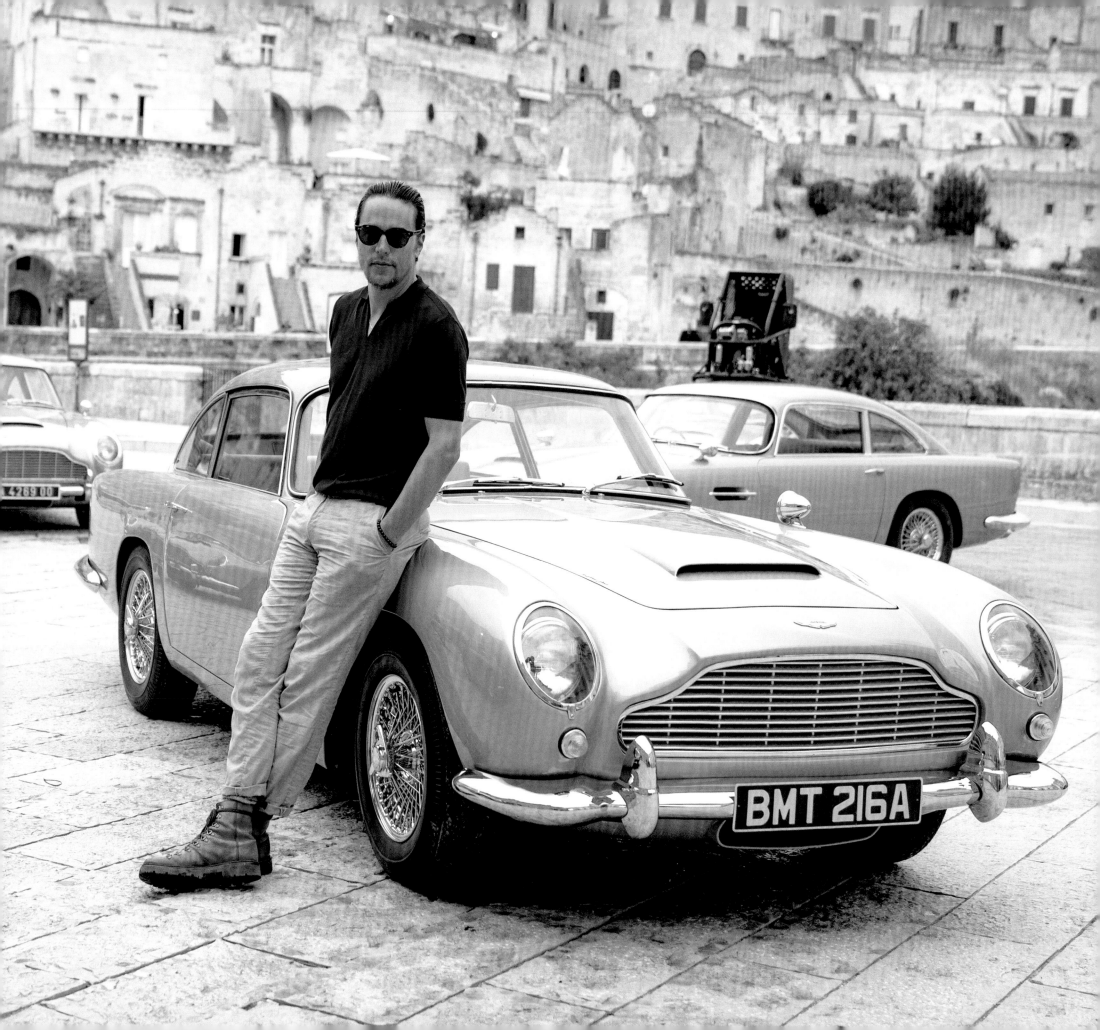

not reflective of where we wanted to go with the twenty-fifth chapter," says Wilson, "so we had Cary work on the script with Rob and Neal, and then he took over." Elements from Purvis and Wade's pre-Boyle draft were brought back in and developed. "It was wanting to make this feel like a classic Bond, but with a contemporary edge," says Broccoli, "and that's where Cary's really hit the sweet spot."

No Time To Die, as *Bond 25* would eventually be titled, picks up from *Spectre* and centres on Bond's relationship with Seydoux's Madeleine Swann. "My first job was to figure out how to flesh out Madeleine," reveals Fukunaga. "We know Mr. White, her father, has been a presence in all the Daniel films, and you have this incident she describes on the train, that happened when she was a kid and a man came to kill her. There was a gun under the sink and she shot this man. To me, you take the films as canon, then try and figure out a narrative around that. So, I have

a little bit of an inkling about her backstory, and I said, 'Okay, how about we figure out what's haunting her?' This was the seed of what became the Safin character."

For Wilson and Broccoli, completing the cycle meant crafting an emotionally satisfying conclusion to Bond's personal journey that had begun with *Casino Royale*. "In that first [Craig] film, he's very military-like, very single-minded, almost like a machine," Broccoli says. "And after being betrayed by Vesper, he deliberately cuts off any possibility of an emotional life. I think over the course of the films his character has morphed and he's become more humane. He's become a more caring person and realises the precious aspects of life."

"When Daniel came in he brought a realism and brutality and emotional raw nerve elements to the character, and it changed the nature of what was possible," concurs Fukunaga. "He became vulnerable. That then changes the stakes in a good way, because

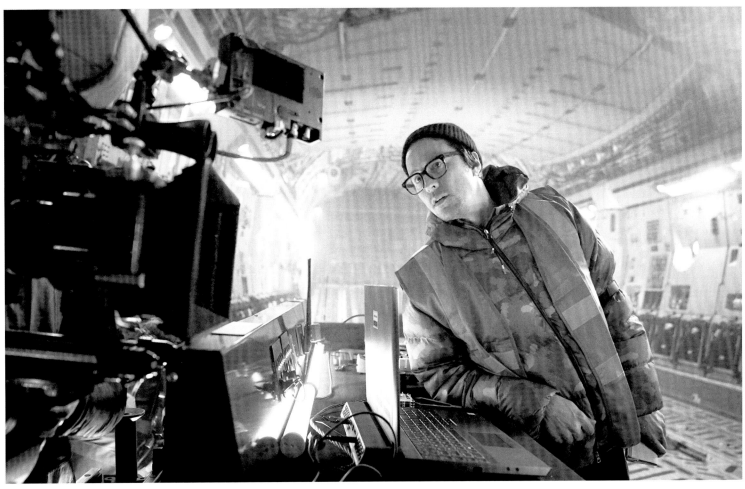

LEFT: Director Cary Joji Fukunaga with Aston Martin DB5s on location in Matera.　**ABOVE:** Fukunaga on Q's mobile laboratory set in a C17 Globemaster aircraft.

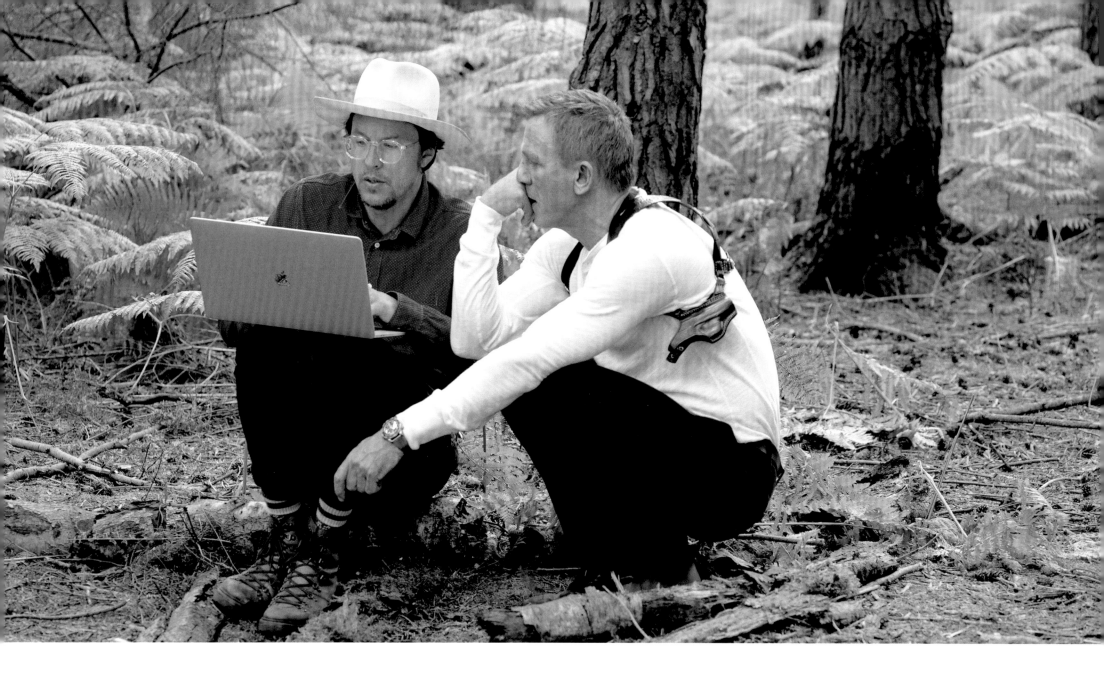

'his heart can be broken... his flesh can be cut... he could die.' That potential makes the thrilling aspects of the story that much more exciting."

"No Time To Die is a culmination of the five films in which Daniel has been playing the character of Bond. It is about the evolution of his character, starting with Casino Royale, ending in No Time To Die. What Daniel has managed to do with the character over the five films is a pretty extraordinary achievement," notes Wilson.

So, at the start of No Time To Die, we're presented with a Bond on the cusp of shedding his emotional armour and allowing himself to love again, only to find that happiness comes at a cost.

"It's going to be a very different Bond," notes Naomie Harris, "because we've never seen a Bond movie centred so deeply

around a relationship and wanting to protect that relationship. We've never seen Bond in a committed relationship before, so that's going to be huge for people. It's going to be a Bond that really surprises people, deeply touches them and provides a fitting goodbye to Daniel."

"We will see a real relationship between a man and a woman, and that's going to be very unusual for a James Bond film," concurs Léa Seydoux. "He's attached. He has feelings and emotions for her. There's a real intimacy between the two of them and, of course, at the same time you have all the beautiful locations and the amazing stunts and explosions, but you will also have this love story. It's very emotional and beautiful."

"It's a more vulnerable Bond, and a much more personalised

ABOVE: Fukunaga and Craig between takes of the Norway chase sequence.

OPPOSITE: Bond in the aftermath of the explosion at Vesper Lynd's tomb in Matera.

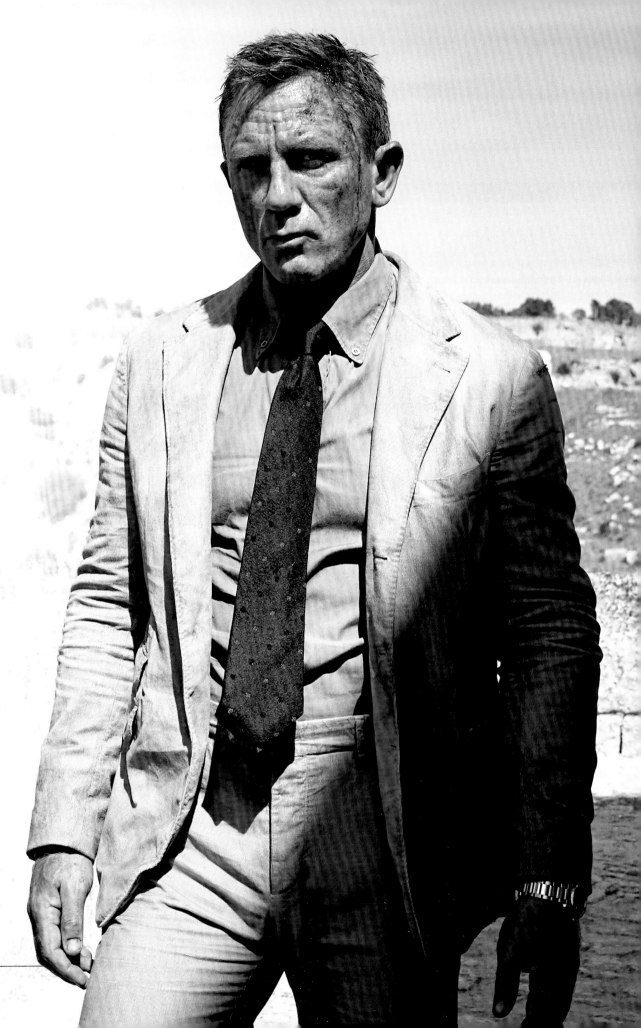

> **"Over the course of the films his character has morphed and he's become more humane. He's become a more caring person and realises the precious aspects of life."**
>
> *Barbara Broccoli, producer*

experience," continues Fukunaga.

"He's in love and is at that place where he was in *Casino Royale* when he was with Vesper in Venice. This is it. This is the moment," says Craig. "But he's Bond. Unfortunately, he's full of terrible faults, not least of which is he doesn't trust anybody, and when he kind of gets the proof – or the tenuous proof – he's been betrayed once more, it's like, 'There you go. See. The only person you can trust is yourself.' That felt very Fleming to me. We have to try and bring Fleming back into it in some way, and that felt like original James Bond."

Fleming also directly influenced *No Time To Die*'s story. "There are a few things from *You Only Live Twice* that are echoed in here," says Fukunaga, referencing Fleming's twelfth Bond novel, previously filmed in 1967.

"It's one of the Fleming elements we've always wanted to explore and this felt like the perfect film to do it," says Broccoli of the poison garden, which would become part of Safin's island lair, "because it is the showdown with the arch enemy. Although in this particular case it's not Blofeld." Nevertheless, Blofeld would also make an appearance in *No Time To Die*, having been reintroduced in *Spectre*.

Fukunaga developed the new draft with Purvis and Wade. Scott Z. Burns then came on for several weeks, before *Fleabag* and *Killing Eve* creator Phoebe Waller-Bridge contributed to the script for several months, adding her signature wit and magic to the story and characters. Waller-Bridge was an early suggestion from Craig. "Watching *Killing Eve*, and what she did with that... It's a thriller, but also very, very funny, and neither suffered," says Craig, who was keen to get back the wittiness of the Sean Connery era. "When I saw *Killing Eve* I was like, 'There's our writer. There she is. That's the person who knows how to do it, and who does it without thinking,' because it's in every scene; wit, thrills, all of that."

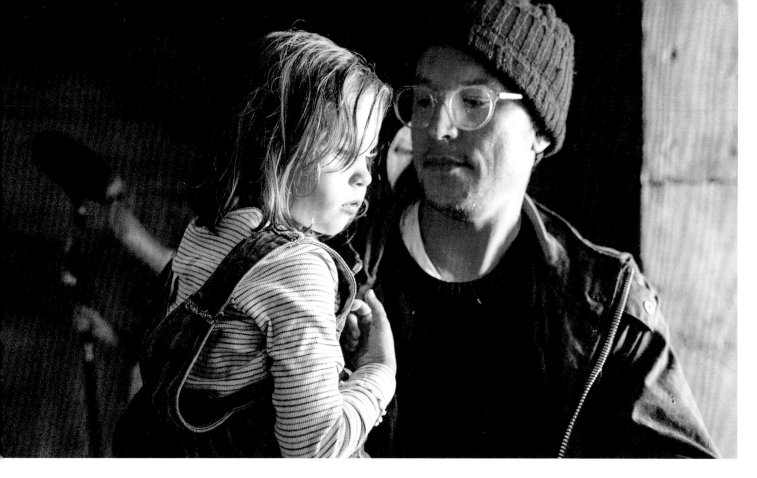

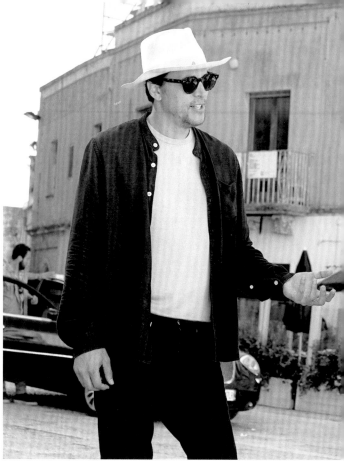

ABOVE LEFT: Lisa-Dorah Sonnet with Fukunaga on the Poison Island set.
ABOVE: Fukunaga with Dali Benssalah on location in Matera.

"Obviously hyper-intelligent, whip smart, and really good at character," says Fukunaga. "Phoebe really brought a lot to Madeleine's character, and to Bond, getting what his essential need for the story was."

"This chapter of Bond movies has become Daniel's, and so, inevitably, he wants to go out with a bang and do something wonderful," observes production designer Mark Tildesley. "He's been revved up for a last fling. It's a really strong script, really powerful."

Given their close ties to Boyle, both Tildesley and Larlarb were sanguine about their continued involvement once Fukunaga took over. "I was very aware that directors of a certain ilk come with their team, and I wasn't going to presume Cary wouldn't want to bring his on," says Larlarb, "but I was okay with it. It would have been a great thing to do a Bond film – when you're a designer starting out, you fantasise about doing a Bond film – but I was very zen about it."

"I reached out to Danny, who had always been really supportive of my previous films," says Fukunaga. "I just felt, coming in as his replacement, it would be remiss not to touch base with him, sort of get his blessing. He was really sweet about it and he also said, 'If you get a chance to work with Mark and Suttirat, you won't regret it.' I met with Suttirat, I met with Mark, and the producers also had high praises for them, and I really liked all their previous work. There's a morale booster that comes with continuity, especially when there's big changes, like the change of a director."

"At that point I wasn't going to do the second film," says Tildesley. "I was ready to do a handover. Then our handover became a, 'Great, when do we get started?'"

With Tildesley and Larlarb remaining on board, Fukunaga began assembling his other key crew, bringing in first assistant director Jon Mallard, who'd worked with him on *True Detective*, *Beasts of No Nation* and his dystopian Netflix show *Maniac*; editors Tom Cross (*First Man*) and Elliot Graham (*Captain Marvel*); and Swedish-born cinematographer Linus Sandgren, who won the Oscar and BAFTA for Damien Chazelle's *La La Land*, which starred Emma Stone, who also appeared in *Maniac*.

"Emma used to rave about him, and I was, 'Who *is* this Linus? Why are you always talking about Linus?'" Fukunaga recalls. "I'd seen Damien's films, but when I saw *First Man* I was really impressed with the camerawork and the mixing of 16mm, 35mm and IMAX. He's a Swede, my family's Swedish, and there were a lot of things we saw eye-to-eye on. It's turned into a really great relationship. I will absolutely continue working with him. He's a kind

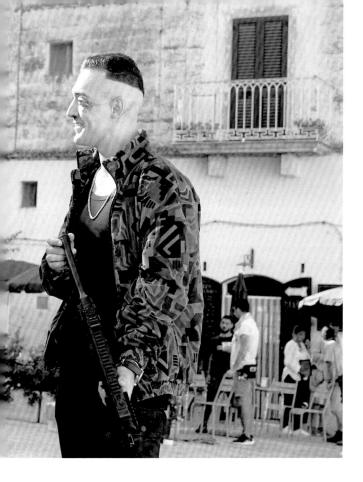

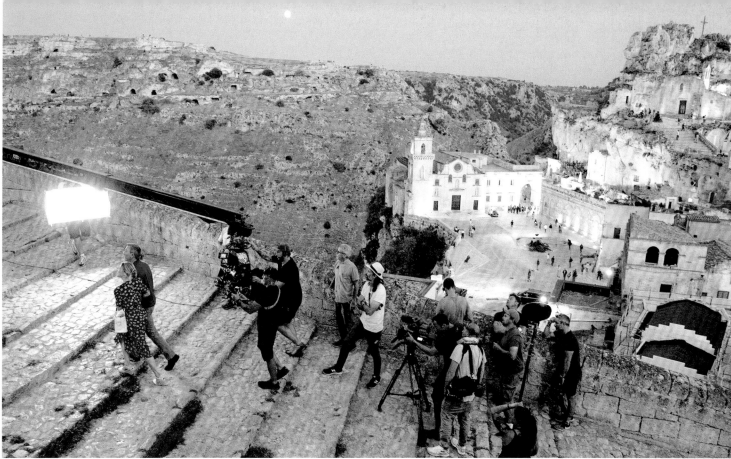

ABOVE RIGHT: Behind the scenes of a romantic Bond and Madeleine moment in Matera.

and gentle man with character and conviction. He fights harder than I fight for the creative things I want. Because on a lot of my projects I'm a producer too, I have to think pragmatically and cost effectively, but Linus gets to be the one that says, 'We can do it the wrong way, or we can do it the right way.'"

While *Skyfall* had been shot digitally by Roger Deakins, Hoyte van Hoytema had used film for *Spectre*, and Fukunaga and Sandgren were determined to continue the celluloid tradition with *No Time To Die*. "I love shooting on film, and the reality is, it's gorgeous," says Fukunaga. "Digital makes things sharper, more precise, more seamless, but film, just on a sensory level, *feels* better. Maybe that's subjective. Most people don't really care, but for the people who do, it makes a big difference."

"Bond, for me, is film," says Sandgren, who starred in his own 007 movies on Super-8 as a boy in Stockholm. "I always think of a movie as an impression, rather than a photograph, of the reality. The imagery should be a reflection of the emotions on the screen, and celluloid film really helps us to make the colours and contrast of the light more expressive and I think that the audience can feel that the film looks more emotional and alive. To me, the Bond world is about escapism. It's enchanting and absolutely romantic. So, I really thought it was important we shot on film".

However, Fukunaga didn't just want to shoot film. Initially, he toyed with filming the entire movie using large format 65mm 5-perf and 70mm 5-perf IMAX cameras. "Seeing what Chris Nolan has done with IMAX on his *Batman* films and his personal projects, I thought if we could shoot on that scale, it would be amazing," says Fukunaga. "Bond is a larger-than-life character, so why be limited to 35mm?"

"In an IMAX theatre you're surrounded by the world," offers Sandgren, who used IMAX for the lunar scenes on *First Man*. "You feel everything. It's immersive. It's obviously very sharp and detailed, as well. I didn't feel we needed to shoot the whole film in IMAX, rather save it for certain sequences where we wanted audiences to feel even more engulfed."

Ultimately, Sandgren and Fukunaga opted to shoot *No Time To Die*'s two pre-credit sequences – filmed in Norway and Italy – as well as a Cuban-set action sequence in IMAX, using the Panavision's 65mm 5-perf camera for any dialogue scenes, because it's quieter. The rest of the film would be shot in 35mm.

"Linus and Cary thought it would bring a sort of large scope to the film if they could do certain sequences in IMAX. Linus is a tremendously talented director of photography and he really did bring a special element to it with the lighting not only on location

but also in the studio. We had a lot of tricky situations in the studio that had to be lit and he did it flawlessly," says Wilson.

As principal photography loomed, the script was still being worked on, with Tildesley designing sets "preceding story, because story was slow to catch up," says Fukunaga, "and some of these worlds [Mark] was presenting were also inspiring story elements. Visually we spoke the same language." In the end, Tildesley and his forty-strong team of designers, concept artists, draftsmen and model makers – including supervising art director Chris Lowe, senior art director Mark Harris and art directors Andrew Bennett, Neal Callow, Dean Clegg and Sandra Phillips, all Bond veterans – oversaw the construction of around sixty sets, across nine Pinewood soundstages and a large expanse of the back lot, as well as on location in Norway, Jamaica, Italy and the UK. "We didn't have a lot of time to think about things, which in a design sense is quite nice, because it catapults you into making decisions quickly," says Tildesley. "Rather than doing that thing of making a decision, going full circle around eight other ideas, then coming back to the original, you go straight in and do it."

When it came to costume design, "Bond falls somewhere between a really highly stylised contemporary film and a little bit of science fiction," says Larlarb. "It's almost its own genre and people expect a level of style from it that is aspirational, in a way. At the same time, in an initial conversation with Cary, we talked about making sure things felt grounded. 'Grounded cool' is the phrase I remember him giving me when we were waiting to see how the script would unfold. You always presume there's going to be somewhere hot, somewhere cold, so we started doing a lot of research, real, grounded documentarian-style research."

While Tildesley, Larlarb and Sandgren were new to Bond, many of the other heads of department are experienced campaigners. Among them, Oscar-winning special effects and action vehicles supervisor Chris Corbould, whose association with the franchise began with 1977's *The Spy Who Loved Me*; second unit director Alexander Witt, a veteran of *Casino Royale*, *Skyfall* and *Spectre*; Olivier Schneider, fight arranger on *Spectre*, here promoted to supervising stunt coordinator; and stunt coordinator Lee Morrison, who doubled for Craig on *Casino Royale* and has worked on all of his films since. "Bond films are challenging," says Corbould. "They're a massive machine, like a rollercoaster. Once you're on it, you're off."

"It's a beast," agrees Tildesley. "Second unit on Bond is bigger than all the films I've ever worked on. Just the second unit. It's massive."

"There's always pressure," admits Fukunaga. "But I'd feel the same amount of pressure on a $5 million film. You can't climb a mountain looking down the whole time. You've got to have your eyes on the goal. The fact there were so many people involved meant there were more people to explain things to. After that, the next hardest thing is to get people to understand what's inside your head, which is why you end up drawing things and finding photo reference. By the same token, there would be days where I'd be, 'We need a prop to do this! Guys, what can you do?' And four hours later they've built a machine. I'm like, 'How the hell do you do this?'"

Rejoining Craig and Seydoux in front of the camera are Ben Whishaw (Q), Ralph Fiennes (M), Naomie Harris (Moneypenny), Rory Kinnear (Tanner) and Jeffrey Wright (Felix Leiter). "We always see Ralph, Ben, Naomie and Rory as Bond's family," says Broccoli, "and Naomie's Moneypenny is the heart, because she loves him the most. She's come to terms with the fact they're not going to run off together, but she still cares about him. She's tough with him, too. She doesn't just swoon over him, she tells him the truth. She's a very honourable character, and Naomie plays that so beautifully. M, in this, has secrets and a very complicated relationship with Bond, which is really wonderful, because when those two are in a room together, at each other's throats, it's fireworks. We also see a different side to Q in this. Then there's Rory as Tanner, who always has his own particular take on the situation and a wonderful wry sense of humour. We also have Felix Leiter coming back, with Jeffrey, who is wonderful, and he has a sidekick this time, a very shady character called Logan Ash, played by Billy Magnussen."

Other new cast include *Bohemian Rhapsody* Oscar-winner Rami Malek as the film's villain, Safin; Lashana Lynch as MI6 agent Nomi; Ana de Armas as Cuban agent Paloma; David Dencik as Russian scientist Valdo Obruchev; and Dali Benssalah as one-eyed henchman Primo, initially working for Christoph Waltz's returning Ernst Stavro Blofeld.

The cameras rolled on March 25th, 2019, as Fukunaga oversaw a pre-shoot in Norway with a reduced crew, before the main unit flew to Jamaica for the official start of principal photography on April 28th, returning to the island that featured in Bond's very first cinematic adventure, *Dr. No*, and where author Ian Fleming wrote all of the Bond novels. There, on the penultimate day of filming in Jamaica, Craig injured his left ankle while filming with David Dencik on the waterfront at Banana Wharf. "Ridiculously, I slipped," Craig explains. "I wasn't particularly running fast, [but] I was in dress shoes – which was part of the problem, they're hardly built for sprinting – and I slipped. I went down. I know my body, and I know when tendons snap, and I snapped a couple of tendons."

Filming was extended to late October and the release date was pushed back to April 2020. Craig continued to work and

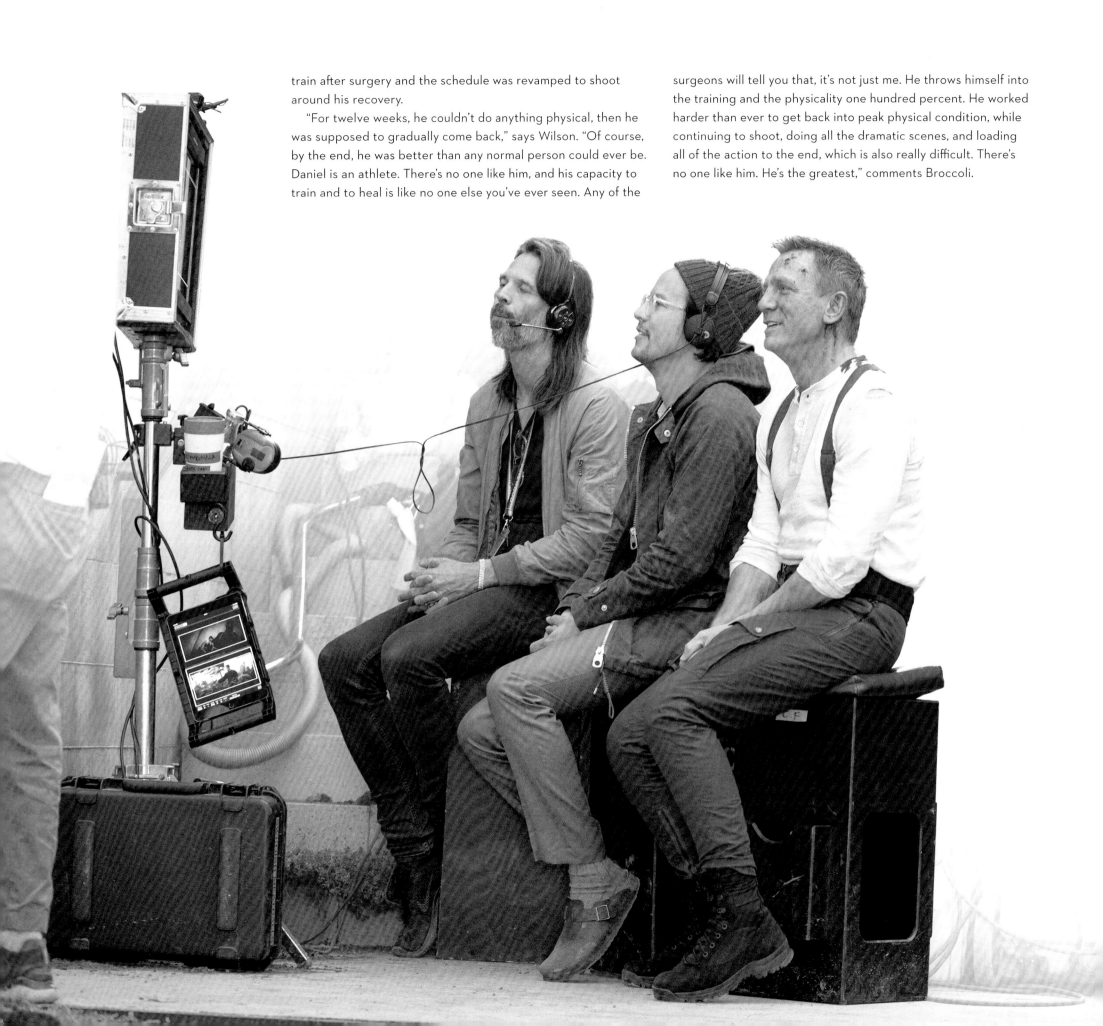

train after surgery and the schedule was revamped to shoot around his recovery.

"For twelve weeks, he couldn't do anything physical, then he was supposed to gradually come back," says Wilson. "Of course, by the end, he was better than any normal person could ever be. Daniel is an athlete. There's no one like him, and his capacity to train and to heal is like no one else you've ever seen. Any of the surgeons will tell you that, it's not just me. He throws himself into the training and the physicality one hundred percent. He worked harder than ever to get back into peak physical condition, while continuing to shoot, doing all the dramatic scenes, and loading all of the action to the end, which is also really difficult. There's no one like him. He's the greatest," comments Broccoli.

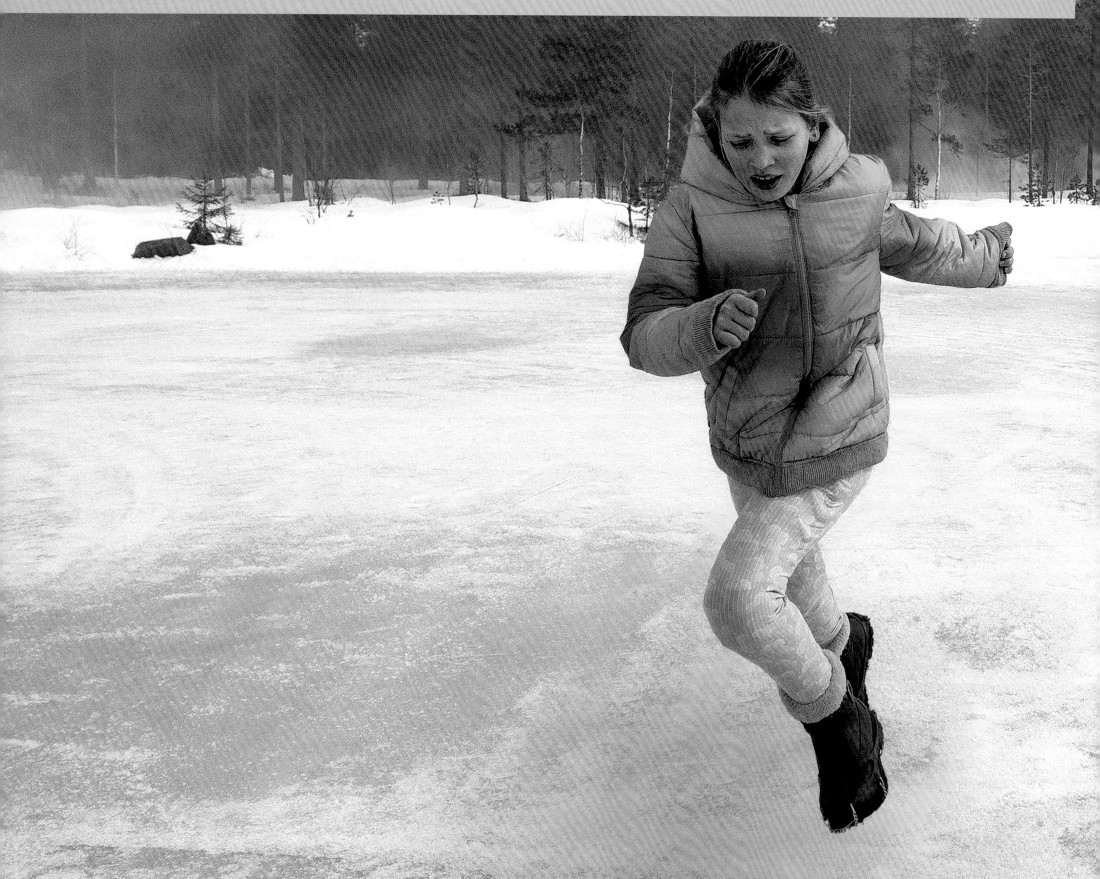

A COLD AND LONELY PLACE

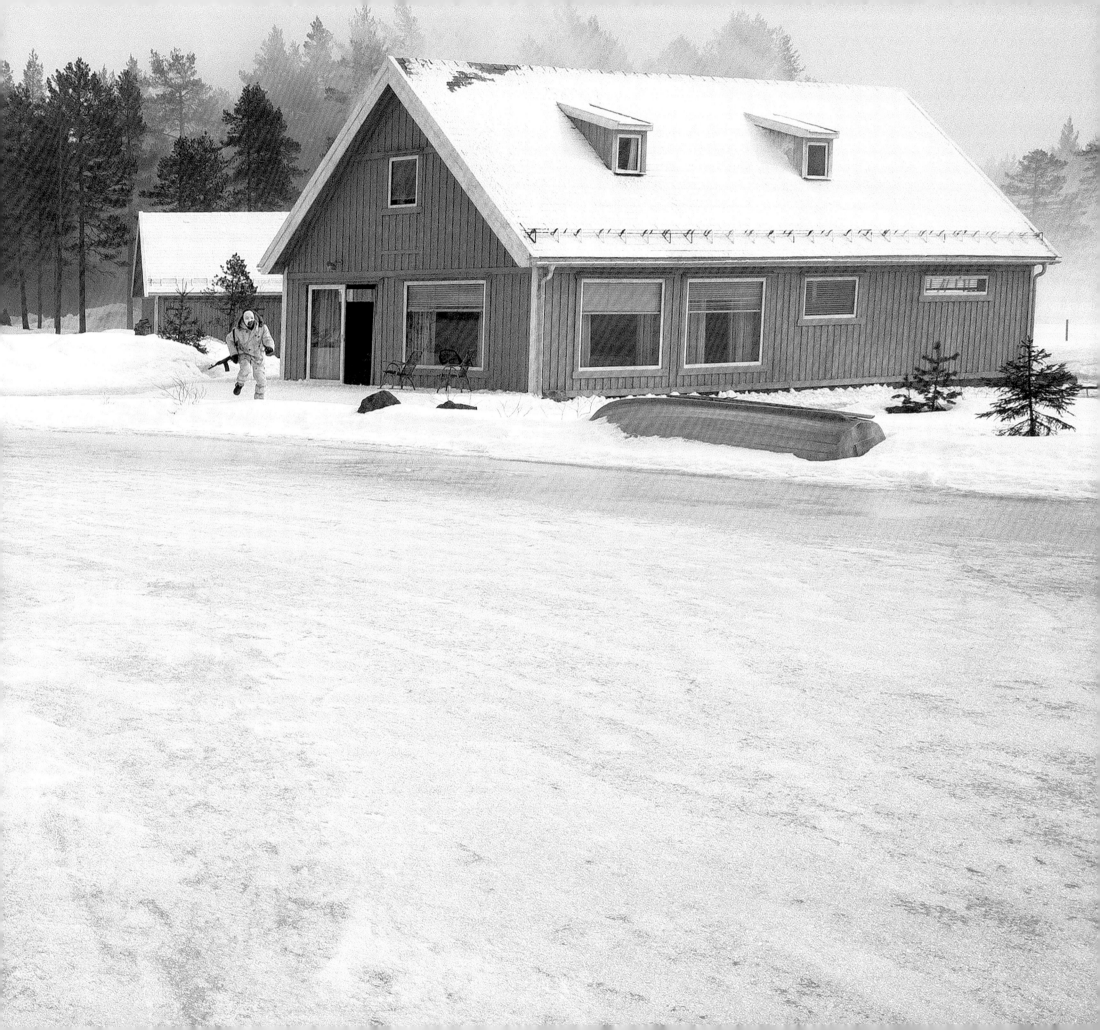

A COLD AND LONELY PLACE

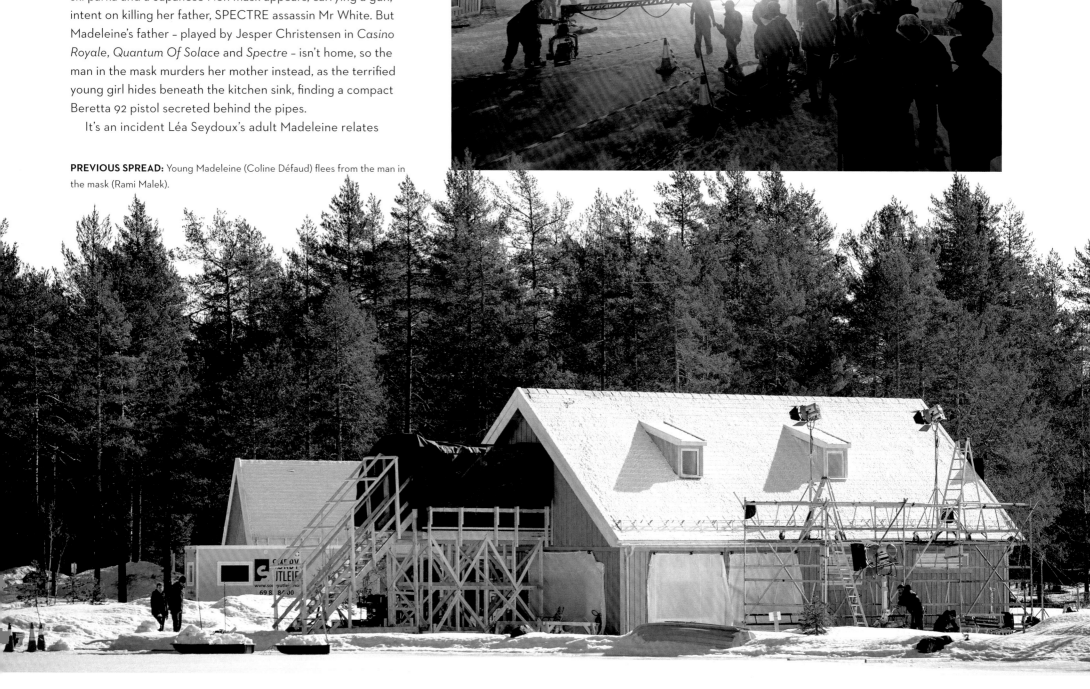

No *Time To Die* opens, uniquely for a Bond film, with a 007-free flashback. Twelve-year-old Madeleine Swann (Coline Défaud) is with her troubled mother (Mathilde Bourbin) in their Norwegian lake house when a mysterious man in a white ski parka and a Japanese Noh mask appears, carrying a gun, intent on killing her father, SPECTRE assassin Mr White. But Madeleine's father – played by Jesper Christensen in *Casino Royale*, *Quantum Of Solace* and *Spectre* – isn't home, so the man in the mask murders her mother instead, as the terrified young girl hides beneath the kitchen sink, finding a compact Beretta 92 pistol secreted behind the pipes.

It's an incident Léa Seydoux's adult Madeleine relates

PREVIOUS SPREAD: Young Madeleine (Coline Défaud) flees from the man in the mask (Rami Malek).

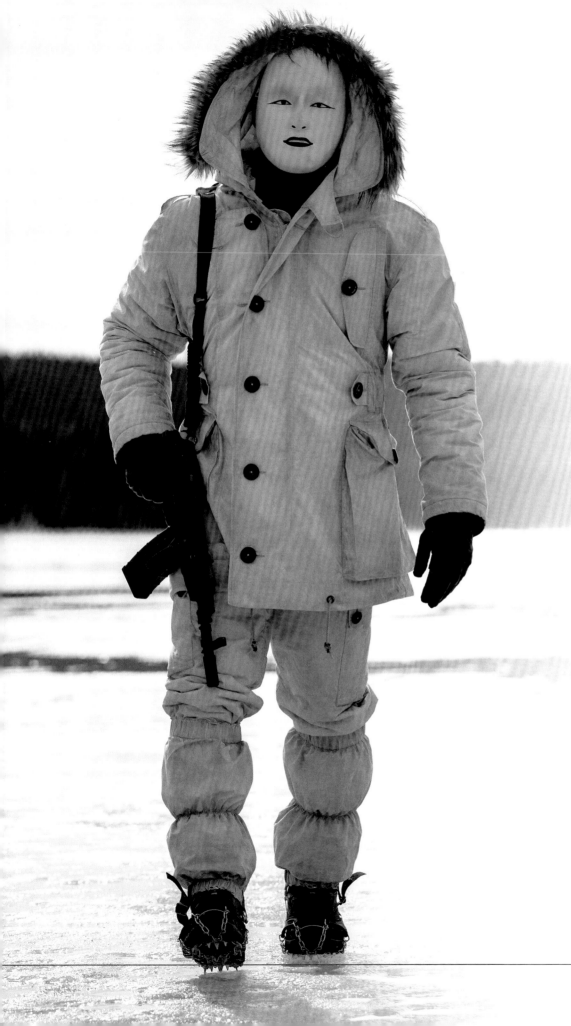

to Bond in *Spectre*. "She's only just met this guy Bond, at that point," observes Fukunaga. Here we witness exactly what happened next, as young Madeleine shoots the intruder in the face, shattering his mask, before fleeing across the frozen lake, heading for the treeline opposite, with her mother's killer in slow pursuit.

"It was Cary's idea to start the film with this sequence," says Broccoli. "You see this little girl and have no idea what it has to do with the story until later on. We loved that approach for getting into a Bond movie – something totally surprising and new. It's brilliant and really intriguing."

The key word for Norway was isolation, both literal – in terms of the positioning of the lake house – and thematic. "I'd been to Norway the summer before and fell in love with the ruggedness of the countryside and the isolation," Fukunaga reveals. "People are very respectful of privacy in Norway, and the idea that an international assassin like Mr White could disappear there made perfect sense to me. Similar to where you find Mr White in *Spectre*. In that case, it was a little chalet in the Austrian Alps. Also, Norway feels very safe. If you're going to go off and do things for SPECTRE, where's safer for your family than a place like that?"

Not that everything is rosy at Chez White. "Papa is a killer," Madeleine's mother, half asleep on red wine and painkillers, tells her daughter.

"Madeleine never mentions her mother in *Spectre*," Fukunaga continues, "so I tried to imagine who the woman who would marry Mr White is. What kind of mother was she to Madeleine? For Madeleine not to talk about her, how bad a mother was she? What was their relationship like, and how would that affect who Madeleine would be as an adult?"

"Each sequence has a different look," says director of photography Linus Sandgren. "You want to give the audience a rich film, with a lot of different flavours. The essence of the mood in the Norway sequence was all about accentuating their solitude. Madeleine and her mother are very lonely out there in this big cabin by a lake. Enhancing reality a little bit, we aimed to make the scenery graphic and moody, stark, almost black and white. The celluloid still picked up blues and pink hues in the white snow, making it slightly colourful."

OPPOSITE TOP: The crew shooting on the frozen lake.

OPPOSITE BOTTOM: Assembling the house set on location in Norway.

LEFT: The man in the Noh mask.

The lake house was a traditional Scandinavian timber-frame model. "It's a classic 1960s Norwegian chalet with two stories, a big open-plan area and a spiral staircase rising to the roof, which is where Madeleine's bedroom is," explains Mark Tildesley, who designed it. "Cary's input was to change what was, initially, a 1970s staircase into a spiral one, which gave it a little bit more openness and visibility in the main room."

Sandgren prepares for each film by pulling together photographs and images that "have to do with the mood and the lighting, and are not related to exact locations." His Norwegian mood board included a photograph of a woman standing behind striped glass, face distorted. "Cary really loved that image and wanted to bring it into the house. Mark designed some sliding

doors with it in, so our evil masked man could walk up behind the glass in the same way."

When it came to Madeleine's bedroom, set decorator Véronique Melery imagined "her growing up in this strange and depressing place, far away from everything, with one parent a criminal, the other completely depressed, so you understand life is very sad and very dangerous." As a result, Melery suggested Madeleine only played with things that "she's found in nature, in the forest, along the lake. She's used little bits of wood, stones, to create very scary and strange puppets, dolls and toys, giving body to her fears and nightmares".

The house was assembled on the 007 Stage at Pinewood Studios and once finished, "we flatpacked it, IKEA-style, placed it

BELOW: Fukunaga with one of the two IMAX cameras used by the production.

RIGHT: The man in the mask kills Madeleine's mother.

BOTTOM RIGHT: The man in the mask distorted by striped glass.

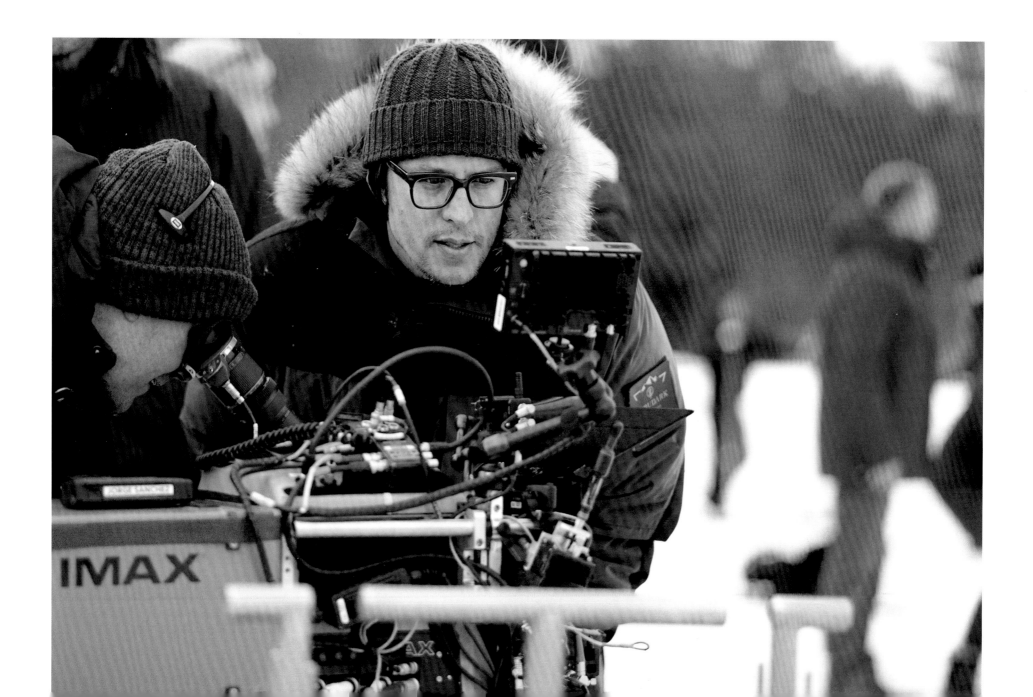

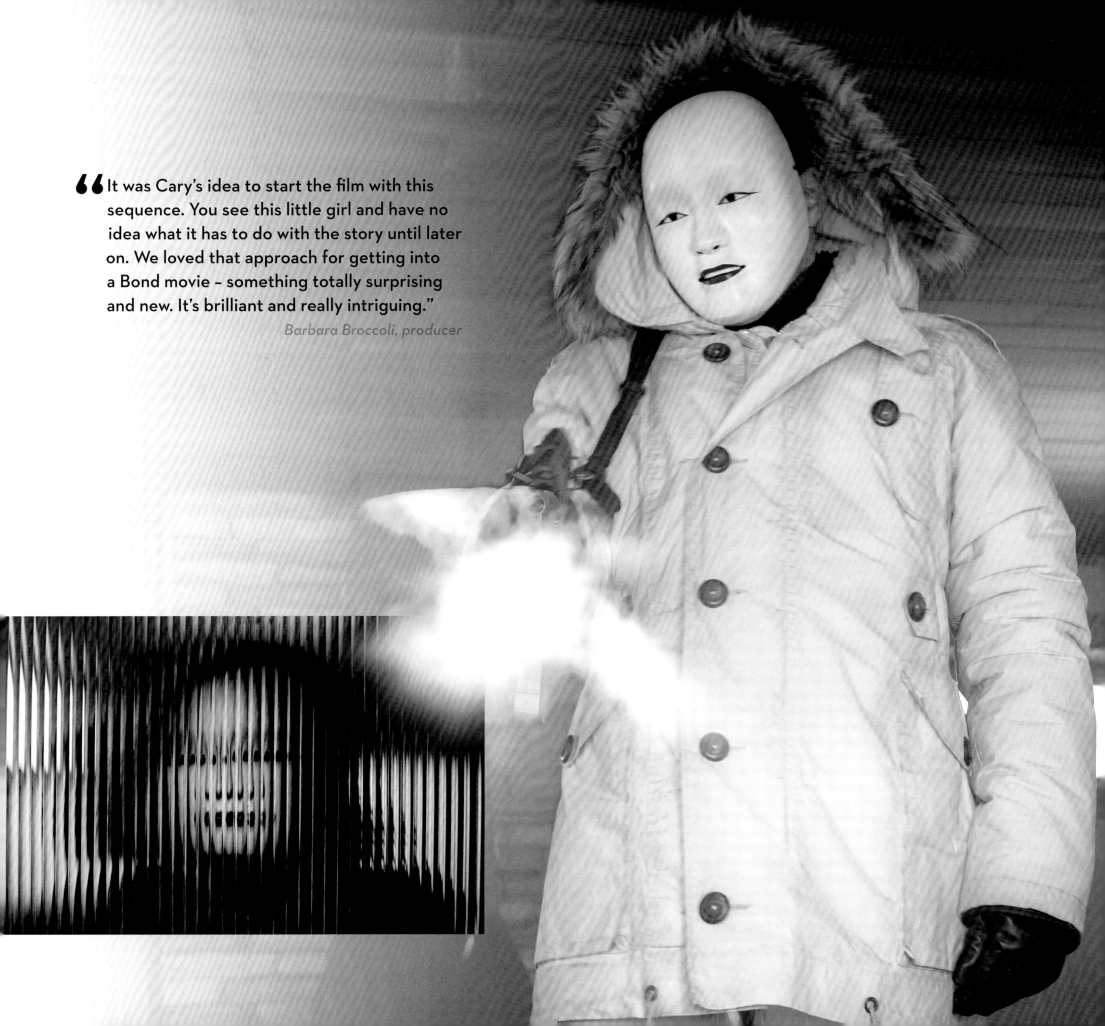

"It was Cary's idea to start the film with this sequence. You see this little girl and have no idea what it has to do with the story until later on. We loved that approach for getting into a Bond movie – something totally surprising and new. It's brilliant and really intriguing."

Barbara Broccoli, producer

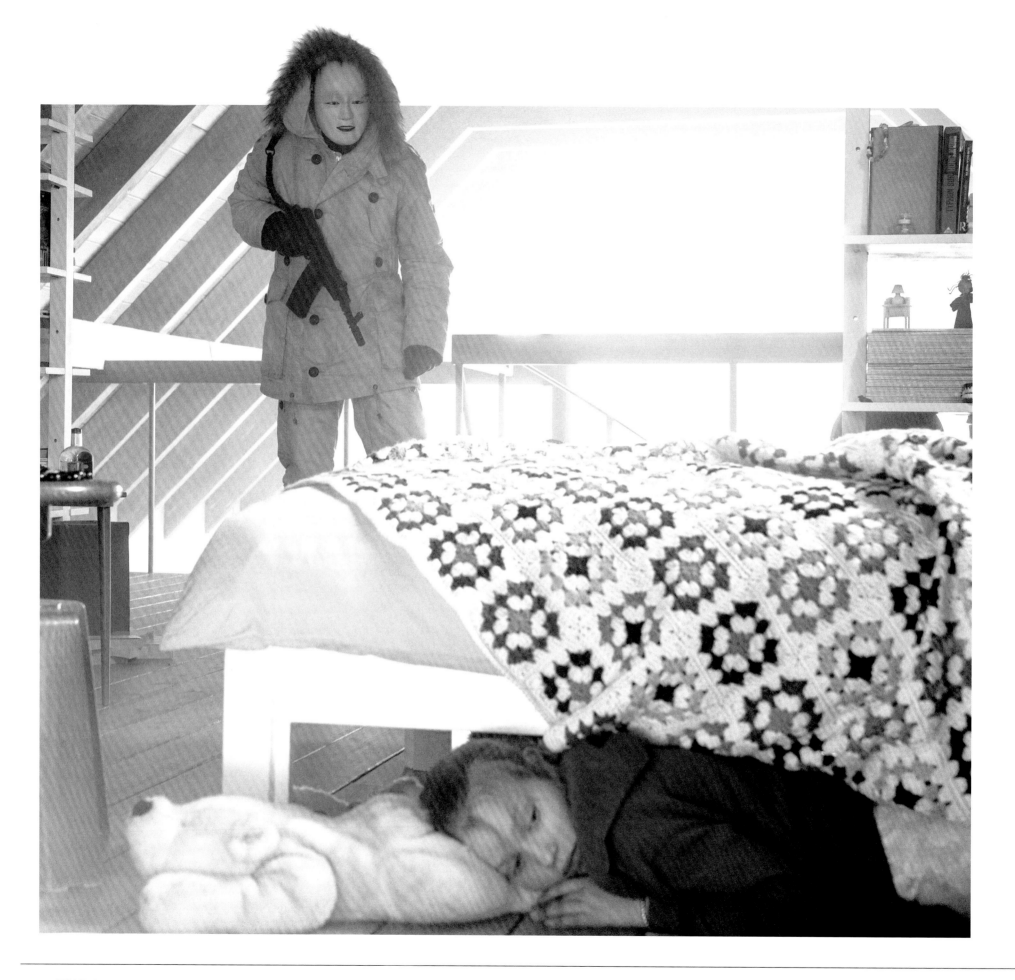

in a container and shipped it out to Norway," says Tildesley, who was expecting to reassemble it on the shore of Langvann Lake, a picturesque setting near the village of Hakadal, half an hour north of Oslo. Fukunaga had other ideas. "We got to the edge of the lake – it wasn't frozen at the time – and I could see Cary's eyes looking at the middle of the water. He said, 'I think the house should be out here,'" Tildesley recalls.

"I had a vision of what I wanted the place to look like," explains Fukunaga. "When I start writing, things become a real place in my mind and I'm pretty certain they exist somewhere if you scout hard enough. I love scouting, and typically I scout a lot more than I did on this film, because it's almost like water divining. I know if I just go over this hill, the place I'm looking for will be there. When we

found that lake I said, 'This works, but it only works if we put the house here,' which was on the lake."

"The view around the house looked better when it was on the ice," says Sandgren. "Obviously, it was much more complicated for construction to put the house out there – especially given its size."

During the initial scout, the weather on the lake was overcast and very foggy. "Cary took a liking to that," remembers special effects supervisor Chris Corbould. "The lake was twenty times the size of a football pitch, so we had to send out some heavy duty smoke and wind machines, and numerous crew, because you have to cater for the wind changing all the time. That was quite challenging, to keep that level of smoke consistent."

"We fell in love with the low fog on the ice that we saw on the

LEFT: Young Madeleine hides from the man in the mask.

BELOW: Madeleine's homemade toys.

BELOW RIGHT: Young Madeleine.

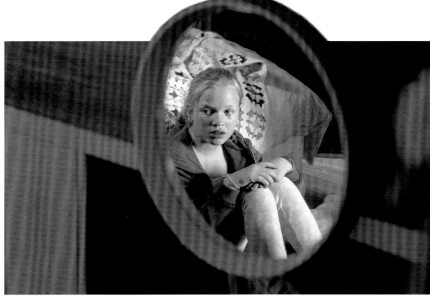

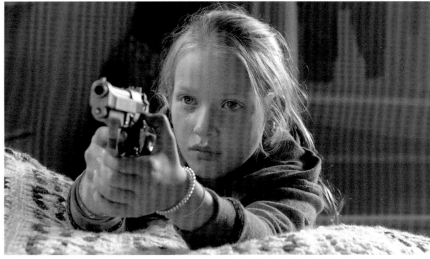

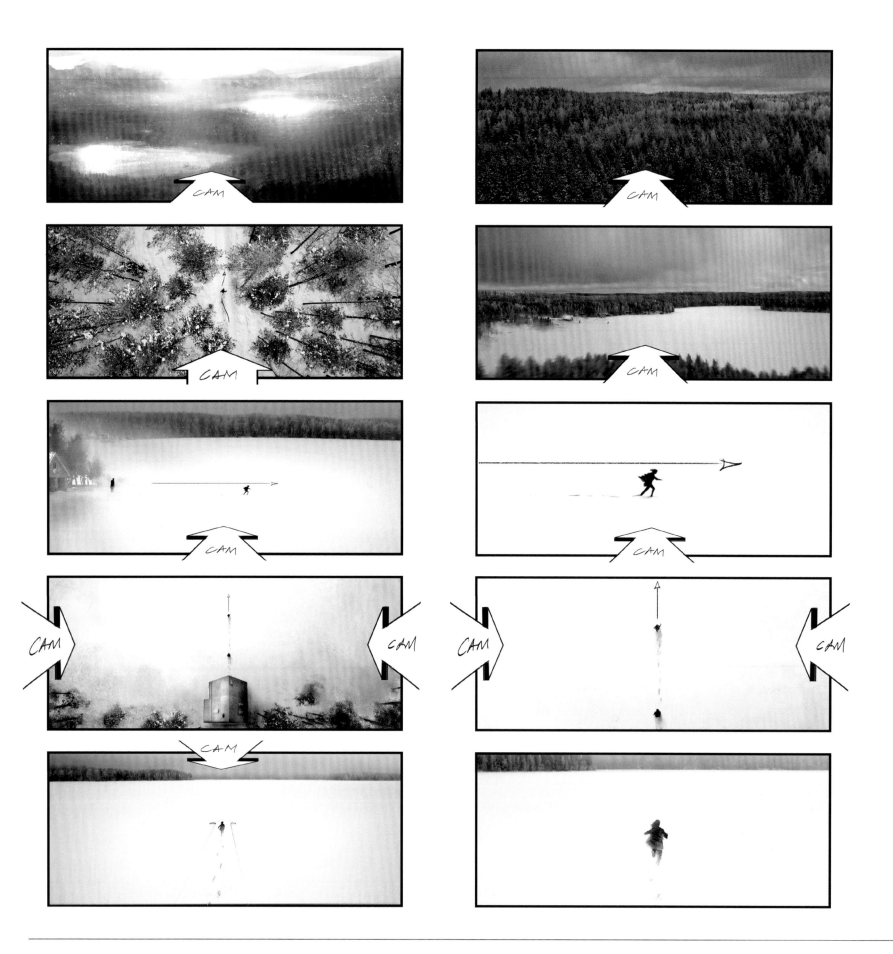

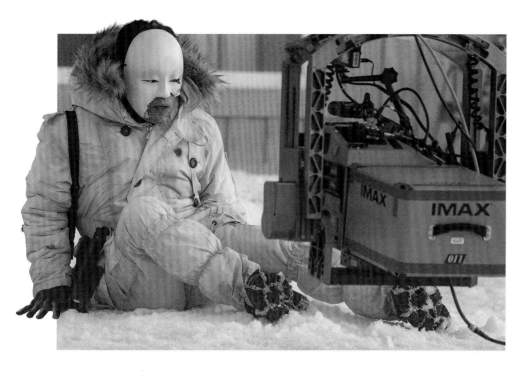

location scout," adds Sandgren, "and the trees were all white, with frost rather than snow, so it looked really perfect. But when we came back to shoot a few months later, it was mostly sunny, a bit warmer and windy. Nature was against us. Chris Corbould's team did an amazing job to add fog across the ice to hide the sun and make it look more like our location scout."

In order to film the Norwegian scenes before the ice completely melted, Fukunaga shot for five days in late March 2019. "Working on ice is always challenging," notes Corbould. "I've done three or four films on ice lakes and it's traditionally unpredictable. You can bet your bottom dollar it'll be the first time it's melted before it's supposed to – which was exactly what we were faced with. It was all right in the morning, but by lunchtime, it was getting slushy. It was safe to work on, but they had to plan shots where they needed to see hard ice in the morning, and other shots, where it wasn't as important, for the afternoon. Or go inside."

The limitations of the ice also impacted Sandgren's crew, who shot the entire sequence using large-format IMAX cameras. "We couldn't put too much weight on the ice or be too close to certain areas, because the temperature was too warm and they were afraid the ice would crack," he recalls. "We were also limited to how large

LEFT: Storyboards for the chase on the frozen lake by David Allcock.

ABOVE: Filming the man in the mask with an IMAX camera.

BELOW: Filming the chase on the lake.

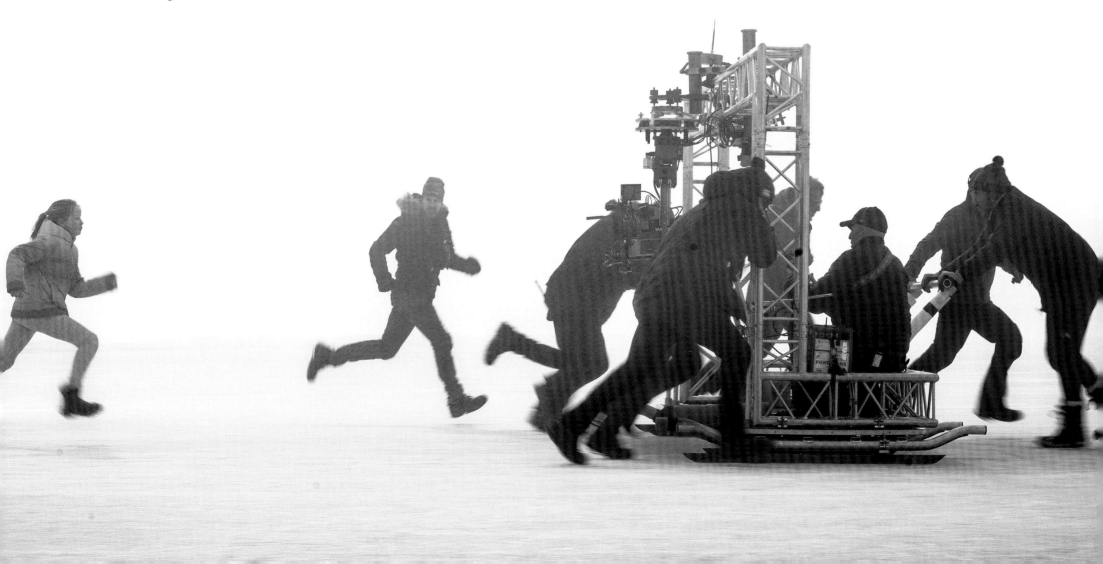

the cranes were we could use."

The biggest challenge was filming *inside* the house. "On days when it was overcast, or we managed to control the sunlight with fog, we shot with the windows clear so that we could see the exterior and it looked beautiful," Sandgren says. "As soon as the sun came out, it completely destroyed the feeling and the mood, so we were forced to cover the windows with white silks and then add the exteriors in post. In retrospect, we could have filmed the exteriors in Norway and the rest on stage, but it was nice to get what we could get for real in camera and also the shots looking out through the attic window, where we see the man approaching, had to be shot on location."

While Fukunaga worked with the actors, second unit director Alexander Witt spent four days shooting stunts, among them the pivotal moment when young Madeleine falls through cracked ice into the freezing water. Filmed at nearby Lutvann Lake, the sequence required Corbould's team to sink a steel trapdoor into the frozen lake through which a small stuntwoman would drop. Each night, the steel-frame rig was positioned the required two inches below the surface. By the following day, however, the sun would have warmed the metal to such a degree it melted the surrounding ice and the trapdoor dropped several inches.

"It was a constant battle," says Corbould, whose crew also made an underwater camera rig, using cables and pulleys, so Witt could film young Madeleine running along the surface of the lake from below. "Anything to do with snow and ice, you're fighting it every step of the way." When filming the drop sequence, Witt had safety divers and camera operators positioned beneath the

BELOW: Concept art of Madeleine fleeing from the masked man across the lake by Charlie Cobb.

RIGHT: Fukunaga and Malek between takes.

ice, all wearing breathable tanks, so they didn't create air bubbles in the water and therefore be visible on camera. "It's a challenge in the cold, especially for the stuntwomen, Christina Petrou and Chelsea Mather," says Witt. "After ten, fifteen seconds, they had to come out."

Close-ups of the man in the mask shooting at the ice, as well as young Défaud falling into the lake were filmed, several weeks later, back at Pinewood, where conditions were controlled and the water not so cold. In order to recreate a large enough section of frozen lake in the underwater tank on U Stage, the art department required around twenty massive slabs of ice for Corbould to mount in steel frames, which they floated on top of the water. But Fukunaga didn't just want any old ice. He wanted Norwegian ice.

THIS IMAGE: Young Madeleine under the ice.
BELOW: Défaud and Malek filming at Pinewood.
OPPOSITE: The man in the mask shooting at the ice in Norway.

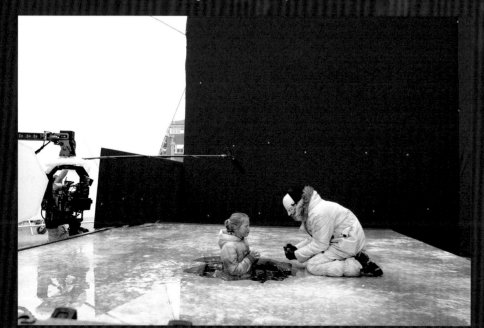

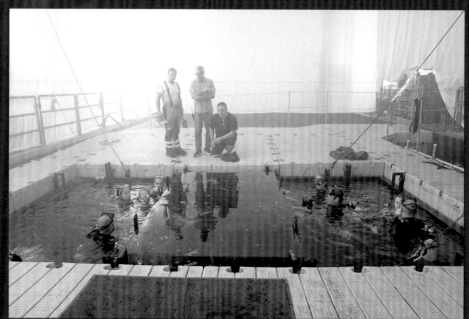

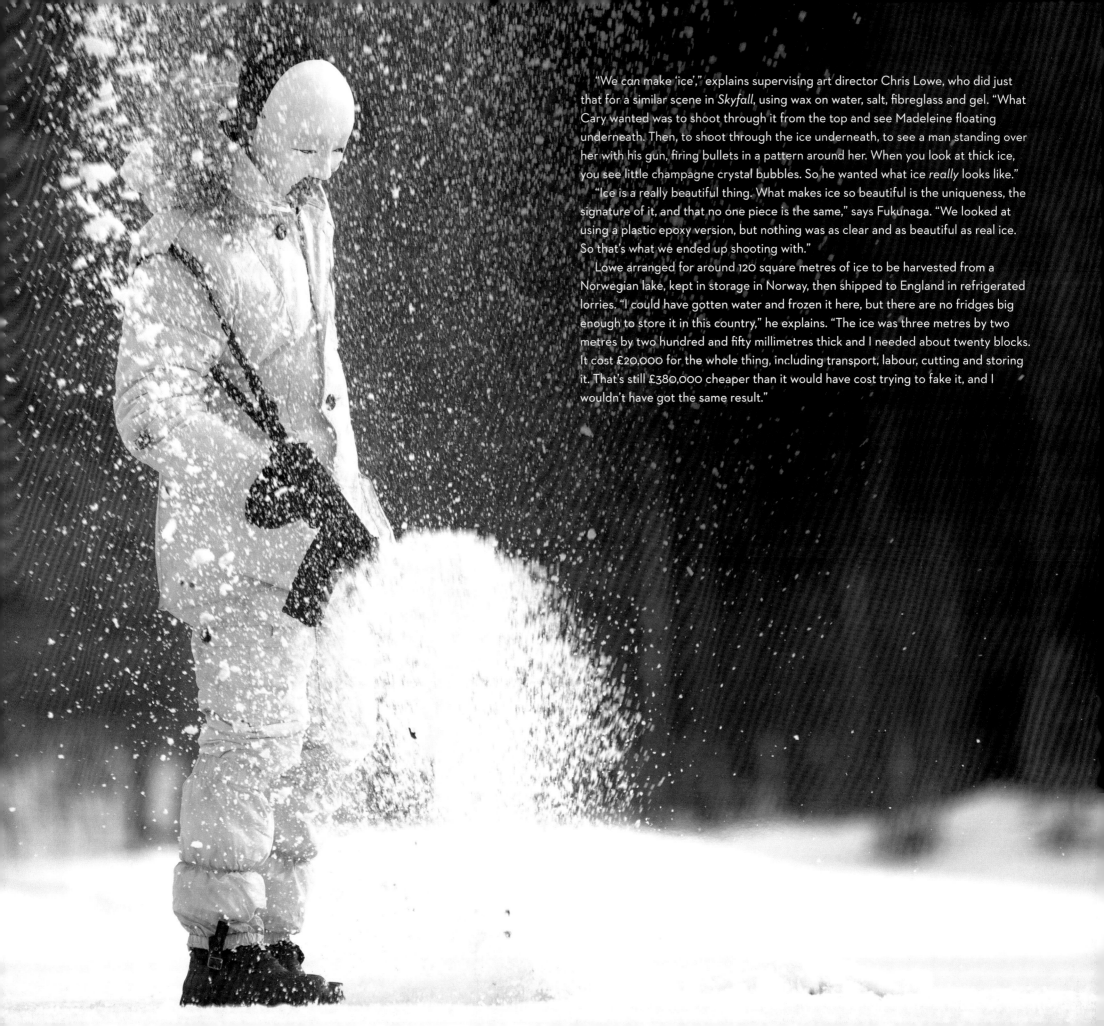

"We *can* make 'ice'," explains supervising art director Chris Lowe, who did just that for a similar scene in *Skyfall*, using wax on water, salt, fibreglass and gel. "What Cary wanted was to shoot through it from the top and see Madeleine floating underneath. Then, to shoot through the ice underneath, to see a man standing over her with his gun, firing bullets in a pattern around her. When you look at thick ice, you see little champagne crystal bubbles. So he wanted what ice *really* looks like."

"Ice is a really beautiful thing. What makes ice so beautiful is the uniqueness, the signature of it, and that no one piece is the same," says Fukunaga. "We looked at using a plastic epoxy version, but nothing was as clear and as beautiful as real ice. So that's what we ended up shooting with."

Lowe arranged for around 120 square metres of ice to be harvested from a Norwegian lake, kept in storage in Norway, then shipped to England in refrigerated lorries. "I could have gotten water and frozen it here, but there are no fridges big enough to store it in this country," he explains. "The ice was three metres by two metres by two hundred and fifty millimetres thick and I needed about twenty blocks. It cost £20,000 for the whole thing, including transport, labour, cutting and storing it. That's still £380,000 cheaper than it would have cost trying to fake it, and I wouldn't have got the same result."

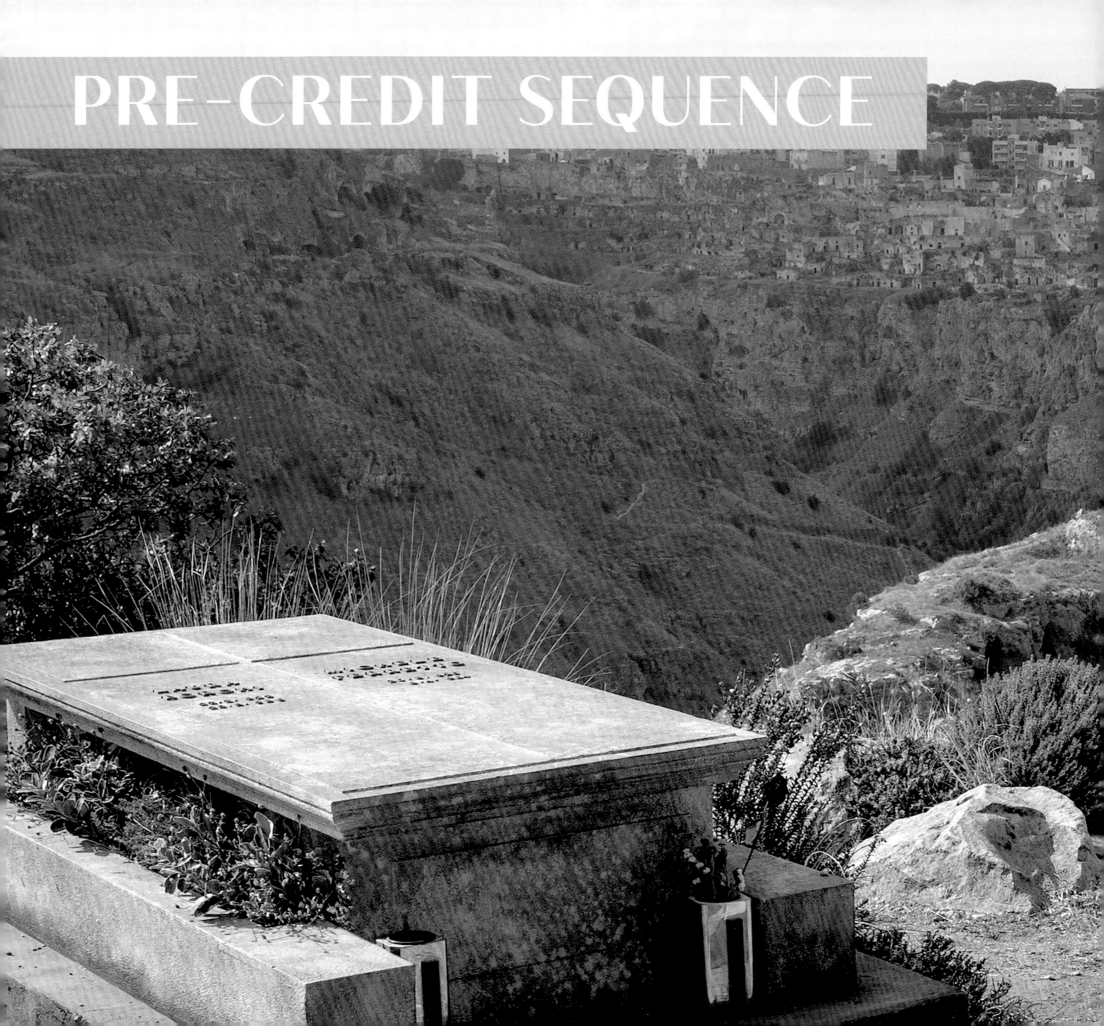

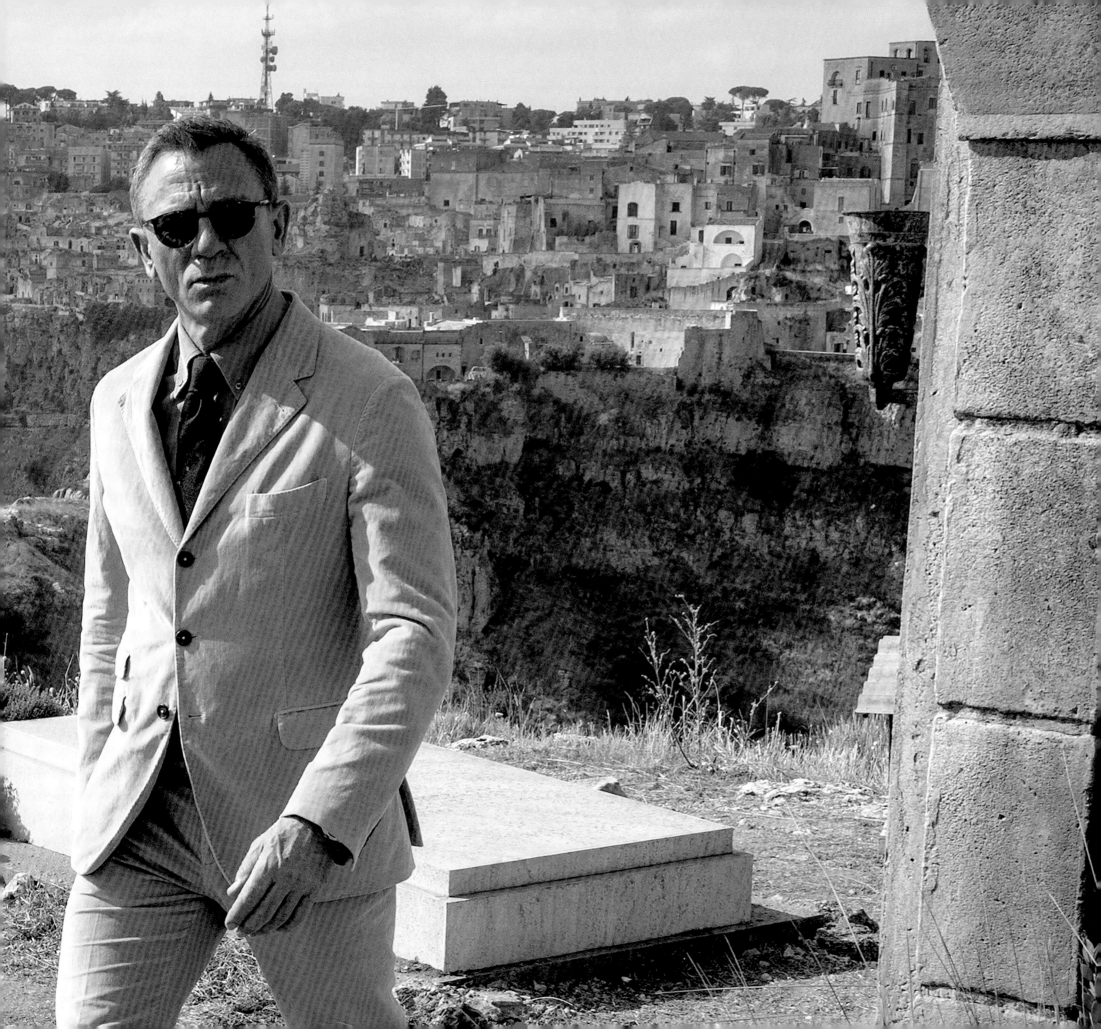

PRE-CREDIT SEQUENCE

Bond's grand tour of Italy, which, in recent years, has taken in Venice (*Casino Royale*), Siena (*Quantum Of Solace*) and Rome (*Spectre*), continues in *No Time To Die*'s second pre-credit sequence, as the story fast-forwards twenty years from the events of Norway to find Bond and Madeleine in love and on holiday, post-*Spectre*. "As much as you want Bond to go to new places, Italy seems a place we just keep going back to," says Fukunaga. "From the north to the south, it's incredible, so much history."

"We wanted to continue from where *Spectre* ended and Bond was driving off into the sunset with the love of his life. When Bond meets Madeline, they obviously have some things in common that come from their family backgrounds. Maybe this is the only person who could ever understand him and really love him. In *No Time To Die* this is developed further and has more significant elements. More is at stake," says Wilson.

We see the happy couple first at the beach, as Bond watches Madeleine emerge from the shimmering blue waters of the Mediterranean into a blaze of white light, "almost like

an angel," says Linus Sandgren. From there, they travel in Bond's Aston Martin DB5 to the stunning, ancient hilltop town of Matera.

"We were looking at places for them to have an adventure," reveals Mark Tildesley. "I saw a picture of Matera on the front of a magazine and thought, *Wow, that looks pretty exotic*. It has a very ancient look. It feels timeless." Thought to be the third-oldest city in the world (after Jericho and Aleppo), dating back 10,000 years, Matera evolved out of troglodyte caves and has been used as a location for a number of films and TV shows, including *Jesus of Nazareth* and *The Passion of the Christ*. "It's a really difficult city to shoot in," notes Tildesley, "because it's built on a hill and is basically a maze of alleyways. But Cary and I came, had a look round, and walked for miles up and down, then went for it."

Matera, we discover, is where Vesper Lynd has been laid to rest in the family tomb following her death in *Casino Royale*, and it's

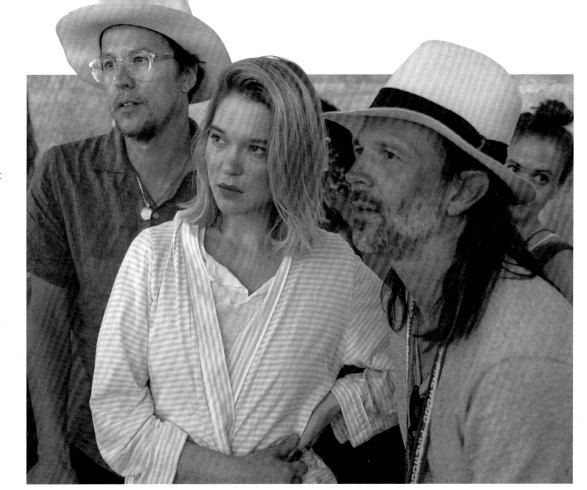

PREVIOUS SPREAD: Bond visits Vesper Lynd's tomb in the Matera cemetery.

LEFT: Bond and Madeleine in love.

RIGHT: Fukunaga, Seydoux and Sandgren between filming on the hotel room set.

BELOW: Concept art of the Matera festival by Qingling Zhang.

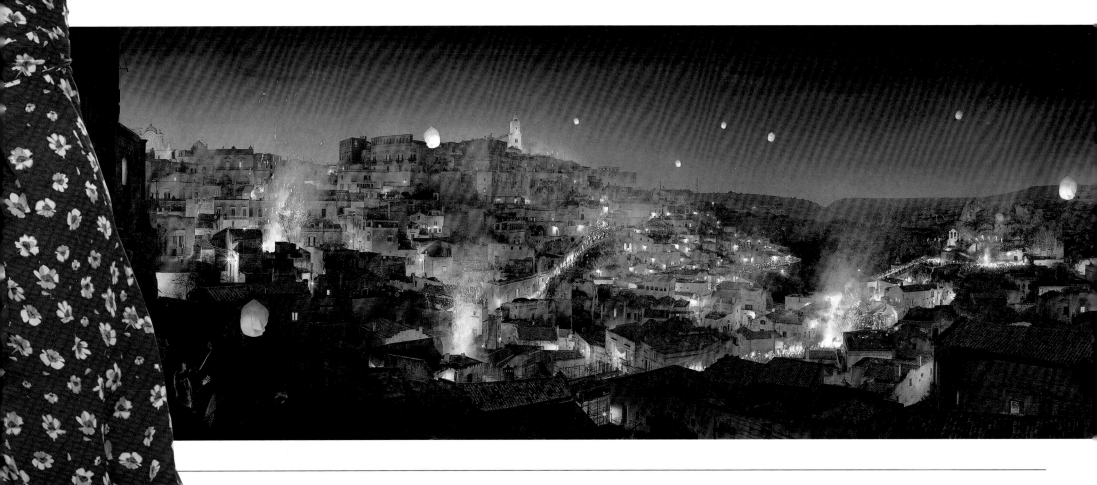

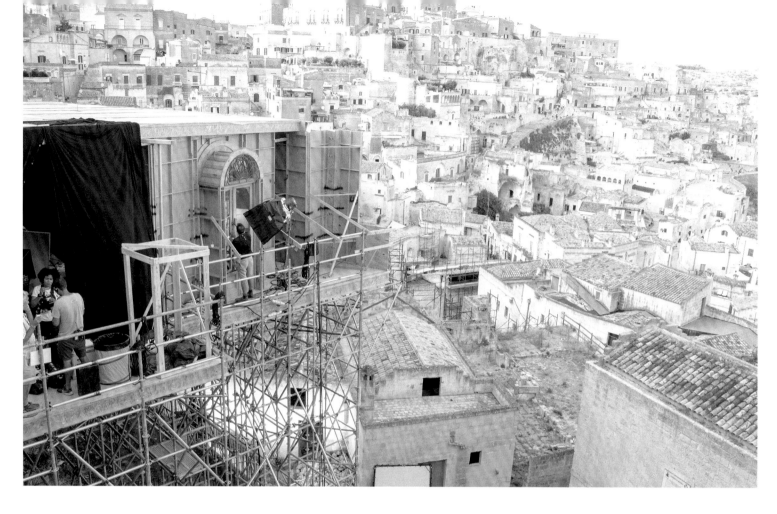

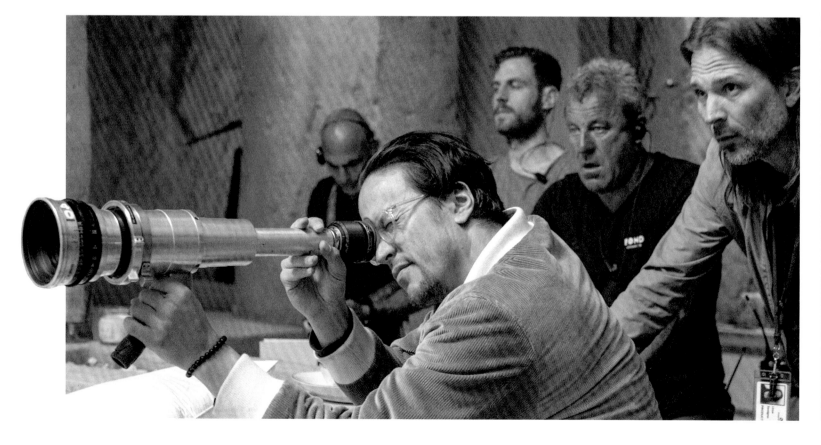

LEFT: The hotel room balcony exterior set under construction in Matera.

BELOW LEFT: Fukunaga and Sandgren setting up a shot on the hotel room interior set.

BELOW & RIGHT: Concept art of the Matera cemetery by Kim Frederiksen.

where Madeleine has brought Bond in the hope he can forgive Vesper for betraying him and move on with his life. And theirs. "We started off thinking, *Where would Vesper be buried?*" explains Broccoli. "She had a very mysterious background and we liked the idea of this walled city being where she came from. It's the most beautiful spot to bring back Vesper's spirit. It's Bond saying goodbye to the past – and his relationship with Vesper – and starting a new chapter in his life with Madeleine. And, of course, it goes horribly wrong."

"There's a haunted quality to Matera that, to me, mimicked the haunting of Vesper Lynd, the haunting of his relationship," says Fukunaga.

When the handsome couple arrive in the ancient hilltop town, they drive through a specially built tunnel – constructed by the production to provide the best angle of the city – and take a hotel room in Via San Postiti. There's a festival taking place, with burning bonfires and candlelit processions, all providing a richly symbolic

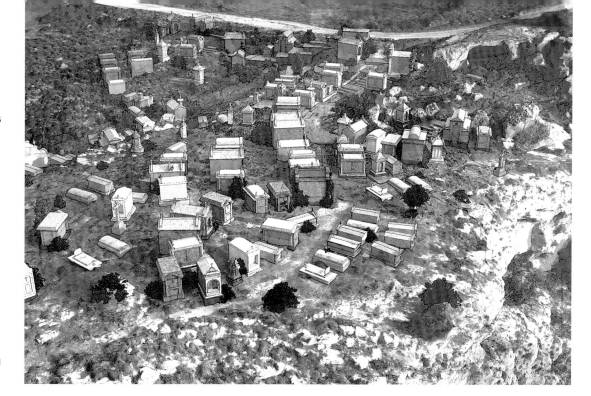

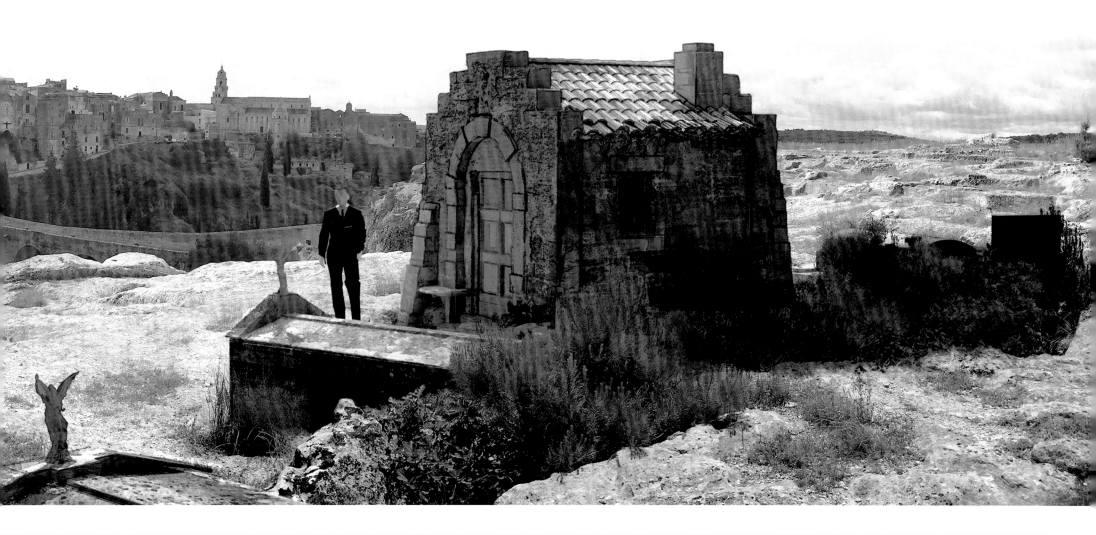

as well as dramatic backdrop to their tryst, with locals setting light to pieces of paper on which they have scribbled down their memories, before letting them float up into the night sky. "We wanted to establish Bond and Madeleine's relationship as being very romantic and beautiful and that they're very much in love," continues Sandgren. "They're in this very picturesque old town, and we wanted it to feel magical."

While the interior of their hotel suite was built on L Stage at Pinewood, Tildesley's art department reconstructed half of it, along with an exterior balcony, at one of Matera's prime tourist spots, so Fukunaga could film the couple at magic hour.

The view was crucial, too, for the placement of the Lynd family tomb, part of a cemetery set created on the other side of the ravine, among the prehistoric caves, and designed to be a mini Matera. "The same roughness of stone. The same higgledy-piggledy design," says art director Dean Clegg. Unlike most formal Italian cemeteries, this one wasn't walled, because that, too, would interrupt the picturesque panorama. "Originally, we

built a bunch of three-foot high mausoleums right at the edge of the gorge, and Cary asked if we could make some more that were lower, because the view was super important, for obvious reasons – it's sensational."

The graveyard featured ninety "sandstone" mausoleums, based on twenty-three different designs, crafted out of foam, wood and plaster, making them lightweight and easy to transport, essential given that there was no direct vehicular access to the location. Of the ninety, the Lynd tomb was the most eye-catching. Appearing to be clad in river stones with two skeletons holding up a banner written in Latin: *Quod Tu Es, Ego Fui, Quod Ego Sum, Tu Eris* (what you are, I once was, and what I am, you will become), its design was based on church doors Fukunaga had seen in Matera and nearby Gravina. "Cary picks up ideas as he runs around," says Tildesley. "He's super specific about details, so he's fully involved in everything."

"You barely see it in the film, but it has to do with mortality and the idea that all of us are on this world for such a short period of

ABOVE: Bond at the Lynd family tomb.

RIGHT: Fukunaga and Craig between takes after the explosion.

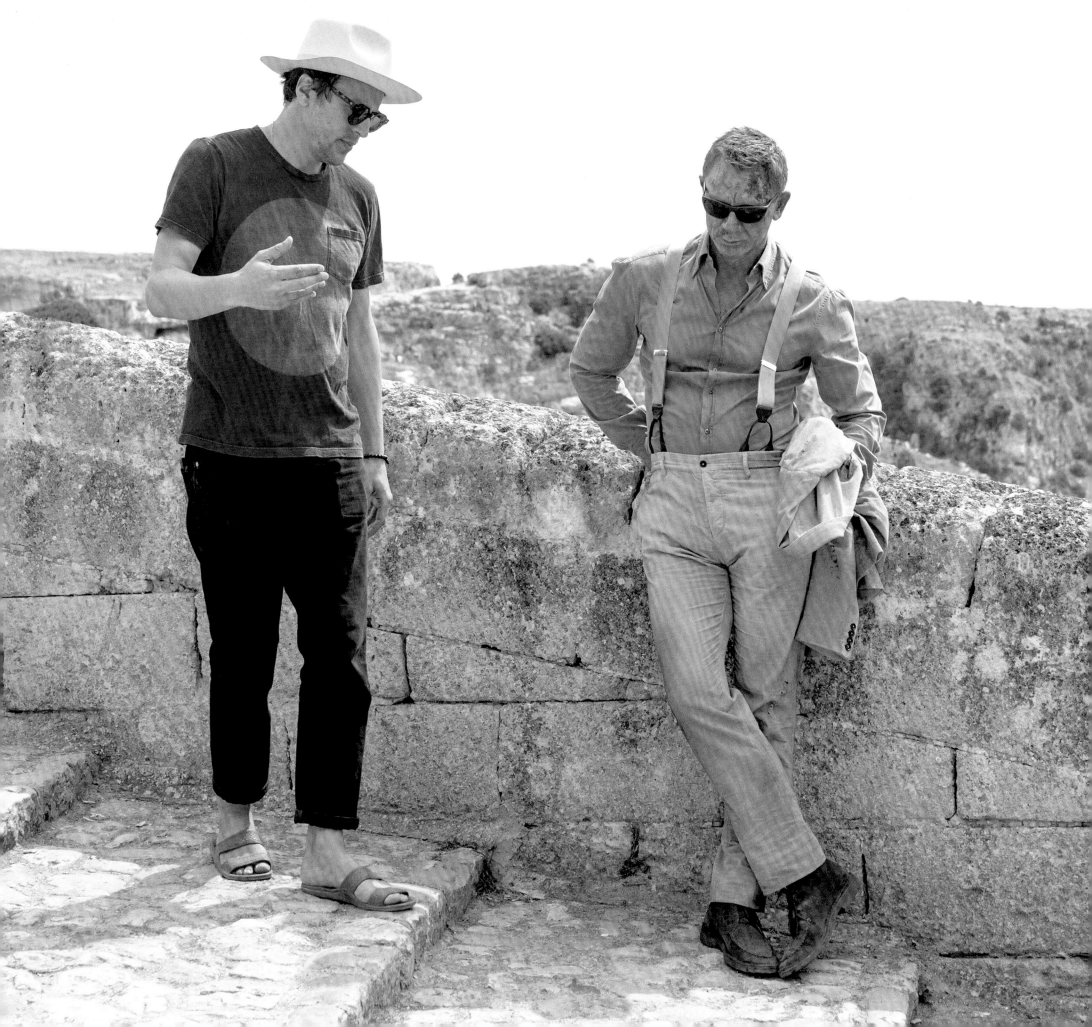

time," states Fukunaga. "It's a way to remember that people, while gone, were once flesh and blood."

Visiting Vesper's tomb, Bond spots a bunch of fresh flowers that have been left by the grave alongside a card with the SPECTRE symbol. "Very dark Baccarat roses, dyed to look almost black," says set decorator Véronique Melery, whose tasks in Matera included stripping away anything touristy. "Signage, umbrellas, horrible plastic chairs, souvenir shops. To empty the place to create a beautiful, romantic world." As Bond reaches down to examine the roses, the crypt explodes, courtesy of Chris Corbould and his special effects team. While the scene had been rehearsed months before in the UK, when it came time to shoot, Craig "wanted it to be really, really believable, that the explosion would take him off of his feet," says Corbould. "He had quite severe makeup damage to his face for subsequent scenes, and wanted to make sure that what we did warranted the damage."

Together with supervising stunt coordinator Olivier Schneider, stunt coordinator Lee Morrison, Craig and Corbould came up with a solution: attaching a cable to Bond, so when the explosion goes off, he's jerked off his feet. "It wasn't an over-the-top jerk," says Corbould, "but was really hard-hitting. You really felt he'd been part of the blast – not enough to kill him, but enough to do a bit of damage to his hearing and knock the wind out of him."

Bloodied and concussed, Bond staggers out of the graveyard, and across a gorge-spanning bridge – in reality, the incredible

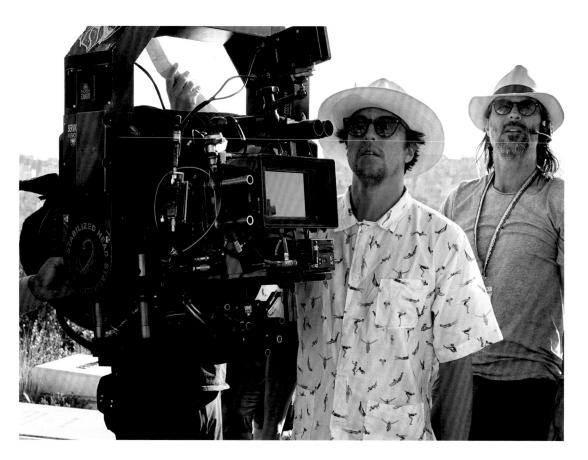

> 66 [Craig] wanted it to be really, really believable, that the explosion would take him off of his feet. He had quite severe makeup damage to his face for subsequent scenes, and wanted to make sure that what we did warranted the damage."
>
> *Chris Corbould, special effects supervisor*

TOP RIGHT: Fukunaga and Sandgren.

RIGHT: Craig filming the aftermath of the explosion in the cemetery.

OPPOSITE: The Lynd family crypt explodes.

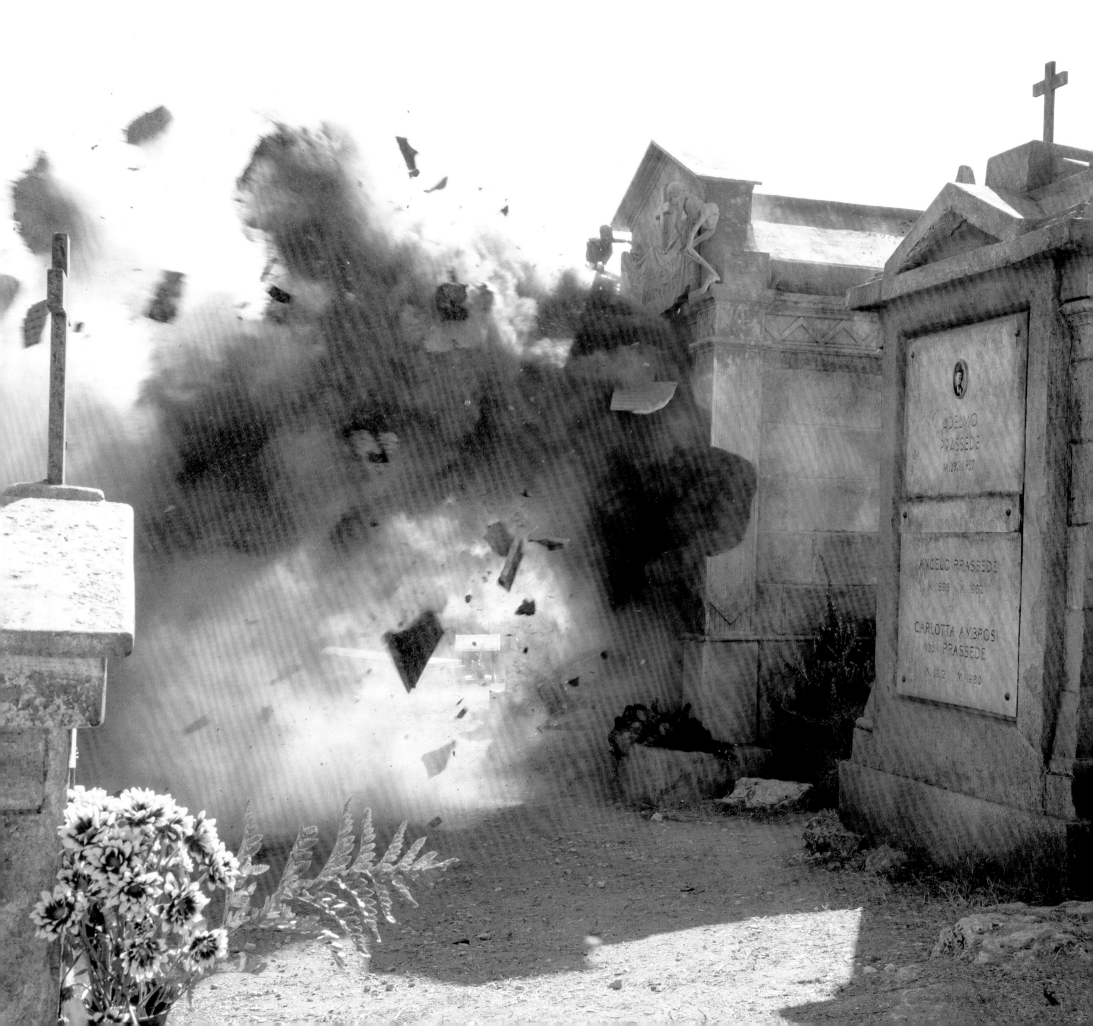

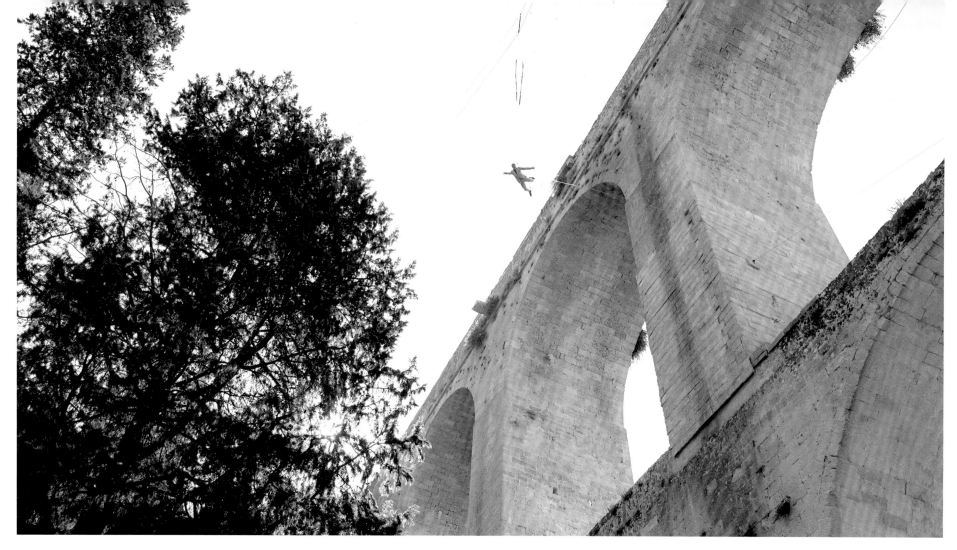

THIS PAGE & OPPOSITE BOTTOM: Filming the bridge stunt on location in Gravina.

OPPOSITE TOP: The overall schematic for the bridge stunt by Dean Clegg.

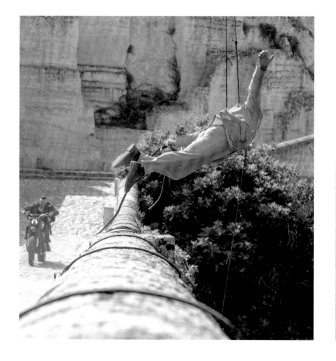

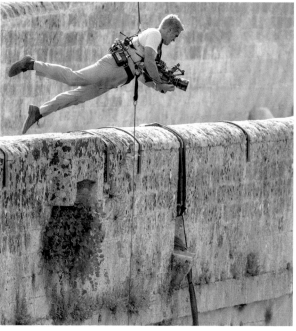

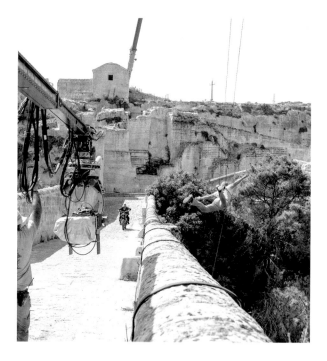

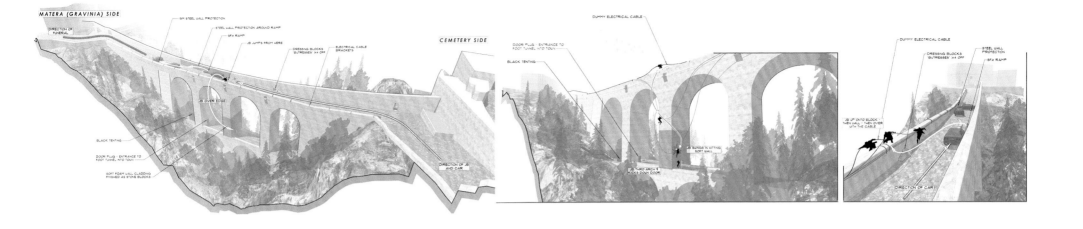

Ponte Viadotto-Acquedotto Madonna della Stella in neighbouring Gravina, since Matera doesn't have one – desperate to make his way back to his hotel.

Coming under serious fire from Dali Benssalah's Primo, a baddie with a robotic eye and rather severe haircut, and his men, Bond dives over the side, grabs hold of an electrical cable and swings onto a lower level. From there, he makes his way through Matera's back streets, running into Primo.

The two men fight, a brutal scrap choreographed by supervising stunt coordinator Olivier Schneider, during which Primo tells Bond, "Blofeld sends his regards," telling him that Madeleine is the daughter of SPECTRE. Furious, Bond smashes Primo's head into a concrete pillar, dislodging his robotic eye, grabs his motorbike and races back to Madeleine, who he's now convinced has betrayed him, just like Vesper.

In keeping with Bond's edgy, distrustful state of mind, Sandgren

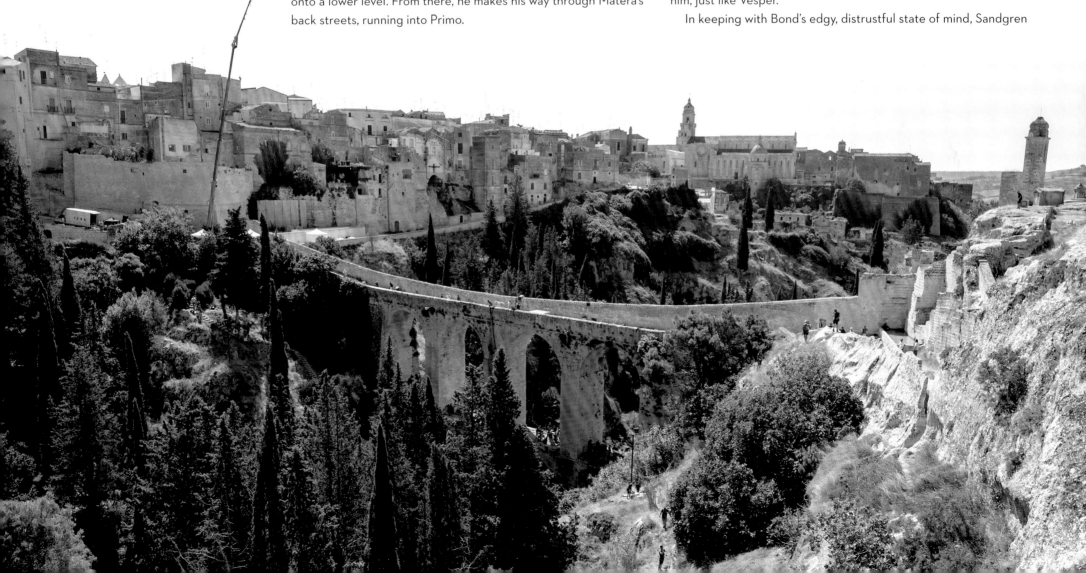

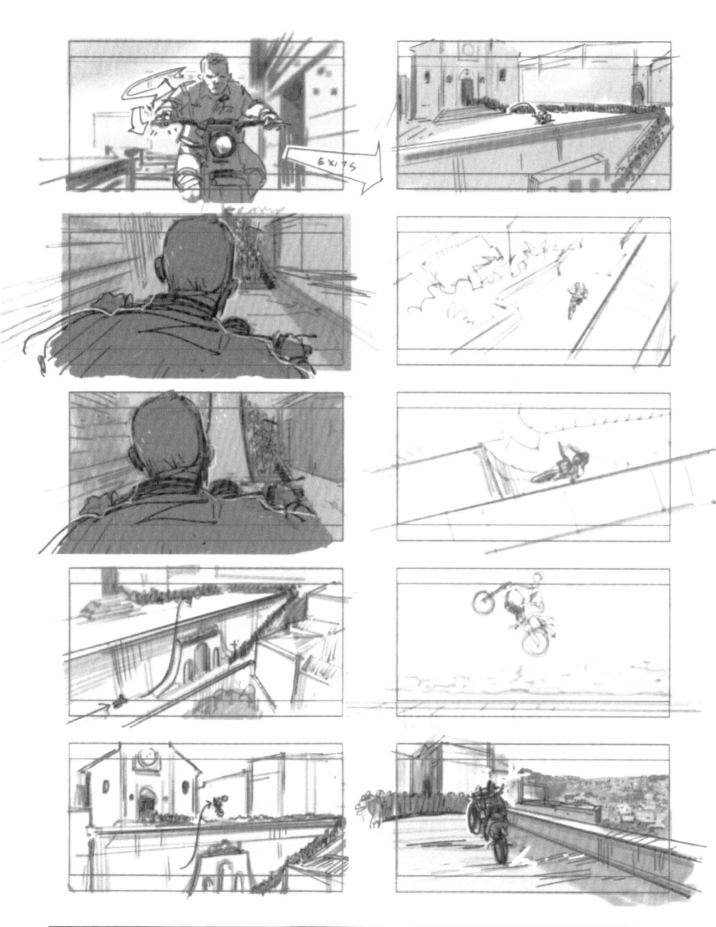

tweaked the visuals for this section, eschewing the magic hour romanticism of the previous day for a style closer to Italian neorealism. "When Bond goes to the graveyard and the explosion happens, everything changes, which is the end of their relationship," says Sandgren. "The town looked really beautiful in sunlight, but especially dramatic in the low morning sunlight." Replicating such conditions over the course of a three-week shoot, as well as the three weeks Alexander Witt's second unit were in Matera, was, Sandgren admits, "kind of impossible," so they had to chase the sunlight. First assistant director Jon Mallard helped to schedule wider, more open locations for "late morning or early afternoon, which was a good mix, because you could cheat it and shoot scenes under the bridge or inside tunnels and between big, tight buildings, in the middle of the day. That whole sequence was supposed to look like a classic Italian film."

Having made it back to his hotel, Bond finds Madeleine's bags packed, which only compounds his sense of betrayal. Madeleine pleads her innocence – "James, why would I betray you?" – but Bond isn't convinced and drags her to his DB5, with the stage set for a high-speed pursuit

LEFT: Storyboards for the Bond motorbike stunt sequence by Steven Forrest-Smith.

OPPOSITE TOP LEFT & OPPOSITE: Filming the motorbike jump and chase.

OPPOSITE TOP RIGHT: Fukunaga, stunt cordinator Lee Morrison and first assistant director Jon Mallard.

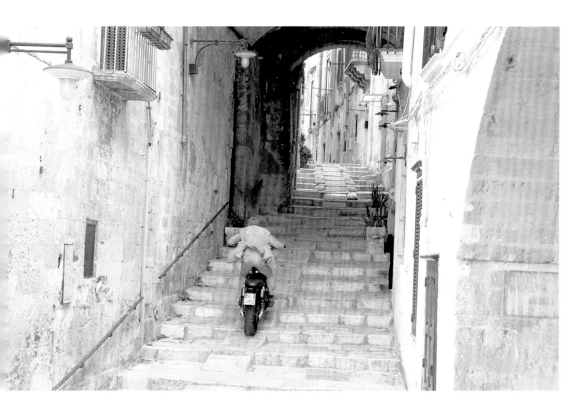

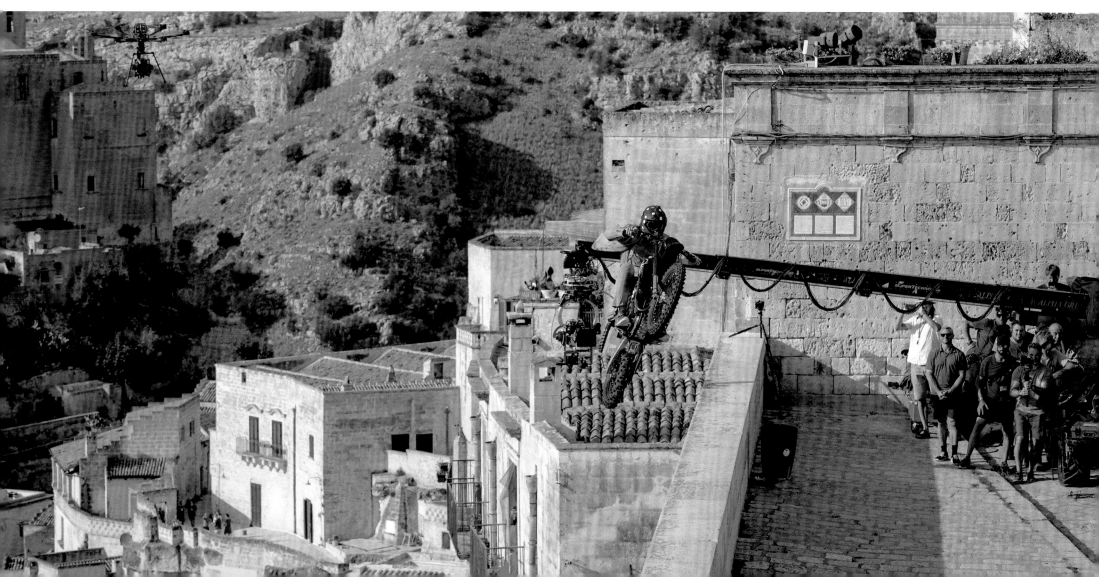

through Matera's narrow, twisty cobbled streets, as Primo and his men give chase in cars and on motorbikes.

As with Norway, the action-packed Matera sequence was shot in IMAX, which gave rise to its own unique set of challenges. Firstly, the magazine on a 240-pound IMAX camera can only hold around two and a half minutes of film stock, compared to roughly ten minutes on a 35mm camera. "It is a bit tricky," says Sandgren. "It means many more reloads, and reloads take time." Then there was the availability of the cameras. "We were limited, because Christopher Nolan was shooting his new film in IMAX at the same time. We had two. Nolan had five, because he shot his entire film in IMAX, and we only shot a few sequences."

Initially, the most challenging thing was simply the size and weight of the IMAX cameras. "In Norway, where we started, they felt very heavy and I think some of the crew felt it was a bit daunting," continues Sandgren. "But over time, as everyone got used to the cameras, it got faster and faster, and towards the end of the shoot, it worked like a dance. No one was afraid of it. Having worked with IMAX cameras a little bit on *First Man*, I felt we were going to be limited in how we could shoot, and we planned a lot of dolly and crane shots, because we didn't think handheld was even possible. But after a while the operators were very comfortable even with handheld in action sequences and it became a much easier tool to use than you would think."

BELOW: Bond and Primo (Dali Benssalah) fight.

RIGHT: Behind the scenes of Bond and Madeleine in the hotel room.

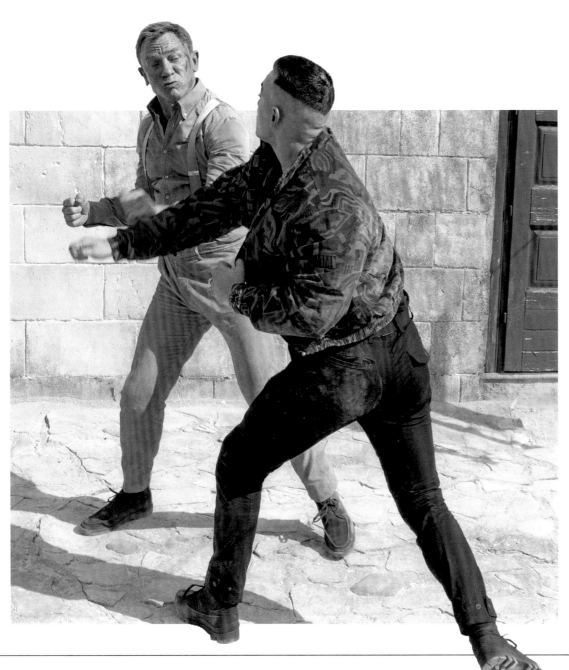

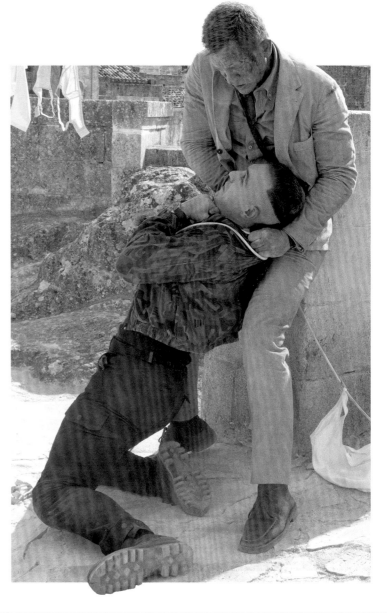

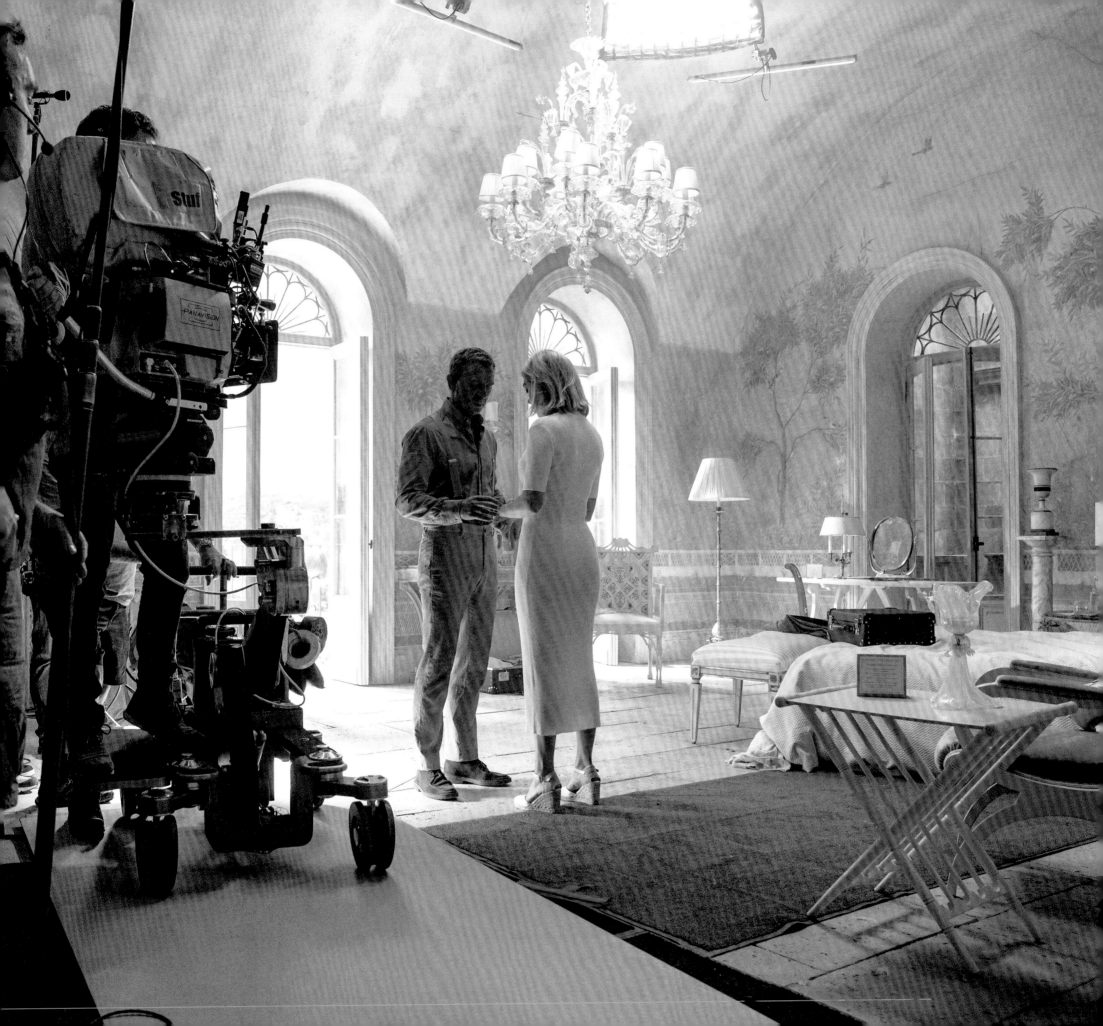

ITALY CHASE

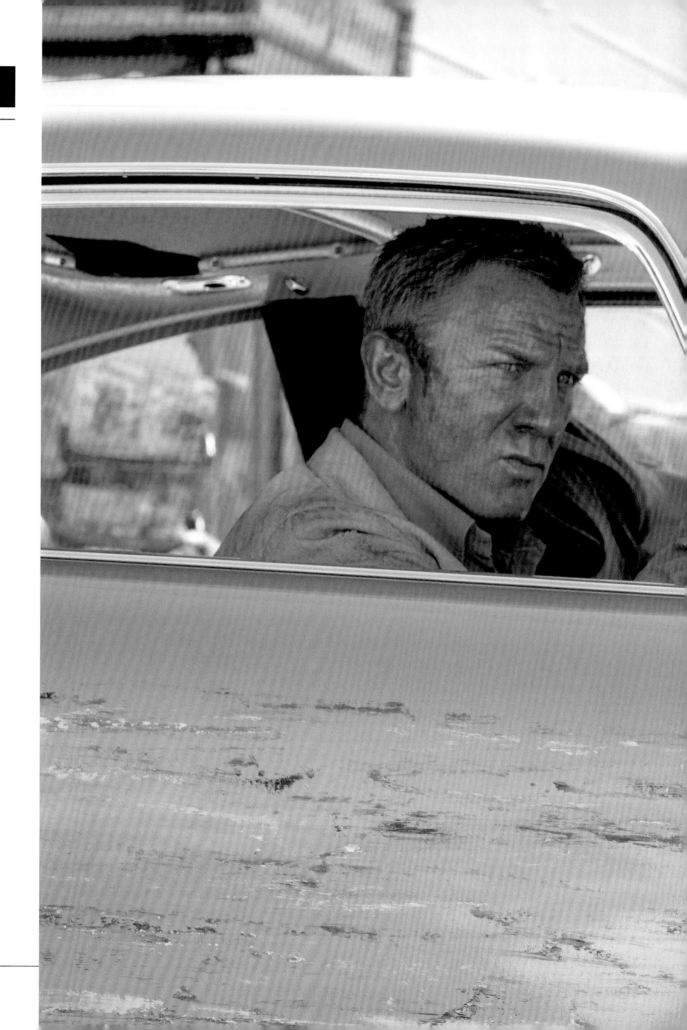

The car most closely associated with James Bond in the films is the iconic 1964 Aston Martin DB5 that Sean Connery drove in *Goldfinger*.

To shoot the Matera chase required ten DB5s in total: two 1964 models – known as the hero cars – and eight stunt vehicles, two of which have driving pods on the roof. Of the two fifty-six-year-old silver birch hero cars, only one retains the original, and now beautifully weathered, Connolly leather interior, and is the property of EON Productions. Having previously appeared in *GoldenEye* (1995), *Tomorrow Never Dies* (1997), *Skyfall* (2012) and *Spectre* (2015), it continues to take centre stage in *No Time To Die*.

"Everything that is linked with the DB5, the gadgets and everything, are monumental and a very proud moment for everyone involved," says action vehicles supervisor Neil Layton. "The cars themselves were spaceframe vehicles and built up as a seven-part clamshell. They were made of carbon fibre and all of the sections were interchangable, so that helped us out enormously to deliver a very fast, quick turnaround on repairs during the shoot. We worked very closely with Aston Martin on the replica DB5 stunt cars that were built solely for this film. We were able to incorporate all of our requirements in the cars whilst the build was taking place – they had standard roll cages, hydraulic handbrakes, brake pedal boxes and three-way adjustable dampers. The cars were very heavily modified and each car is set up specifically for each individual stunt, although their DNA is the same."

Ben Strong, senior programme manager – Q Advanced Operations at Aston Martin, explained, "The requirements for the film are somewhat different to the requirements of what an original DB5 was built and engineered for. Once we'd gone through the volume of cars needed and what the cars needed to do, we quickly established we would need a replica that not only honoured the visual appearance of an original DB5, but also met the more rigorous demands of the film."

RIGHT: Bond evades the bad guys in his DB5, with Madeleine in the passenger seat.

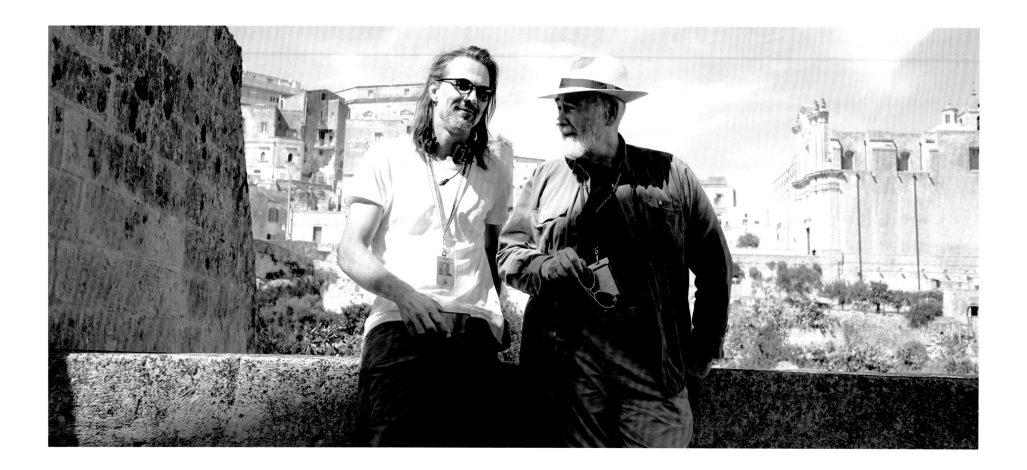

Identical on the outside to the vintage DB5s, the eight stunt replicas have carbon fibre rather than steel bodies and other modifications to aid the rigours of filming. This allowed the production to mount up to two IMAX cameras on the body via special rigging attached to the chassis. "The underneath was very sturdy, so we could hang one on each side, creating quite a good balance," says Sandgren. "We were limited only by the fact we drove through very narrow streets and the width of the car with cameras attached became massive."

Just as it did with Connery at the wheel all those years ago, the DB5 was able to show its true colours in Matera. "Once we knew we were using the DB5, then the question was, 'What does it do?'" grins Corbould, who supervised the design and implementation of the various gadgets, which include the reappearance of the headlight machine guns, exhaust smoke and revolving number plate. Although the latter has been replaced by an LED screen, which changes from the original registration – BMT 216A – to an Italian one – A 4269 00 – at the flick of a switch. There are also a number of new gadgets, added after it was destroyed in Skyfall.

"Q put a few little extra pieces in there, for fun," reveals Broccoli. "The whole sequence is very reminiscent of Goldfinger."

"Originally, Bond had little Browning guns that came out of the headlamps," says Corbould. "We've taken that a step further. We've now got thousand-round-a-minute mini guns that decimate anything in its range and mini-ball grenades that scatter from the boot, unleashing carnage on any vehicle following. Bond presses a button and you see these things drop between the back wheels and sprinkle across the ground. We've got rubber ones that drop onto the road, and nicely made ones for close-ups."

The Matera chase took months of planning, and the combined talents of Witt, Schneider, Morrison, Corbould, Clegg and Fukunaga. "Originally, it was Madeleine driving, then the storyline changed," says Morrison. "It's a very dark chase for Bond. He feels as if another love of his life has double-crossed him, so we were playing all of those very intimate moments whilst driving at high speed, with vehicles crashing and at the same time using weapons to get himself and Madeleine out of Matera. We needed spectacular action, but it's more about the emotion inside the car.

ABOVE: Sandgren and producer Michael G. Wilson in Matera.

RIGHT: Bond navigates the narrow, winding streets of Matera in his DB5.

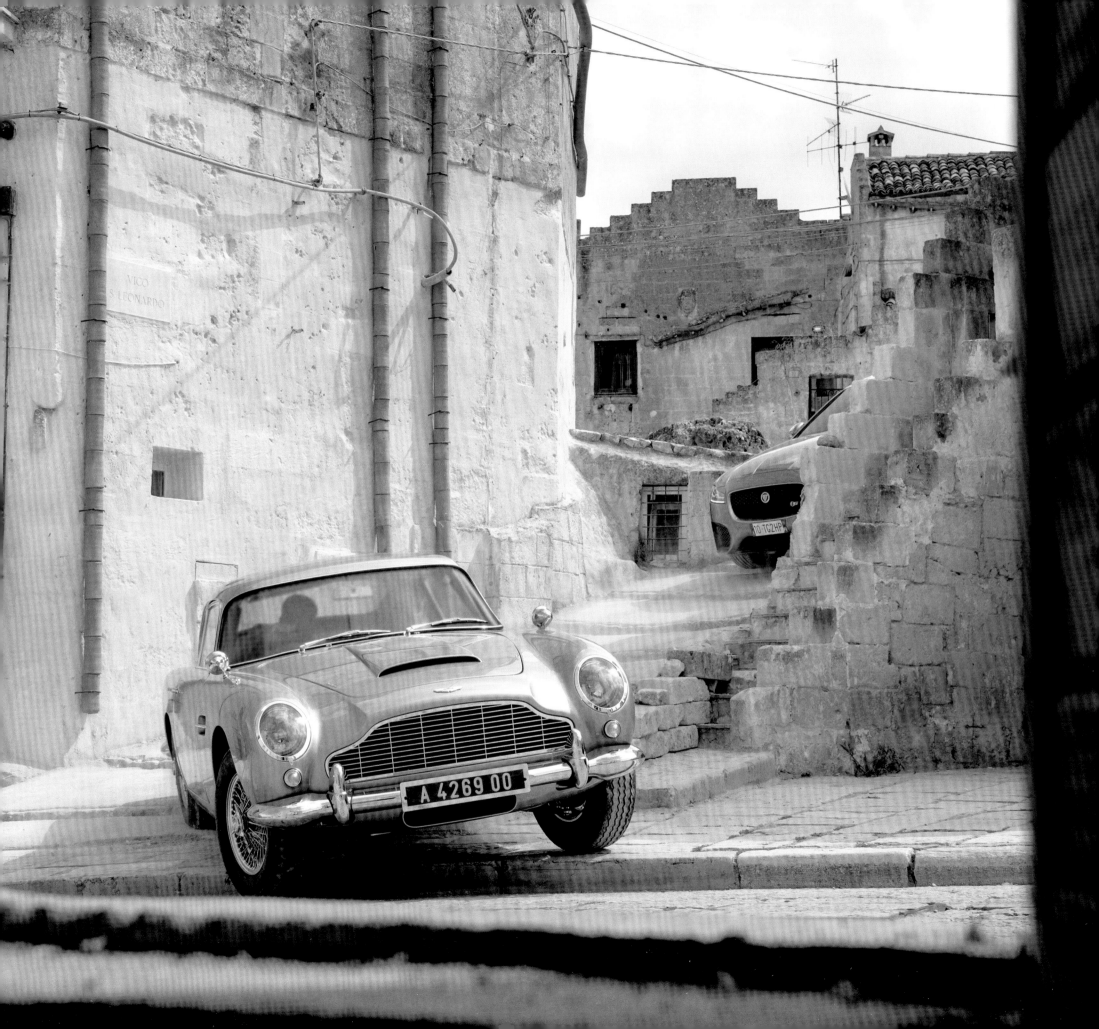

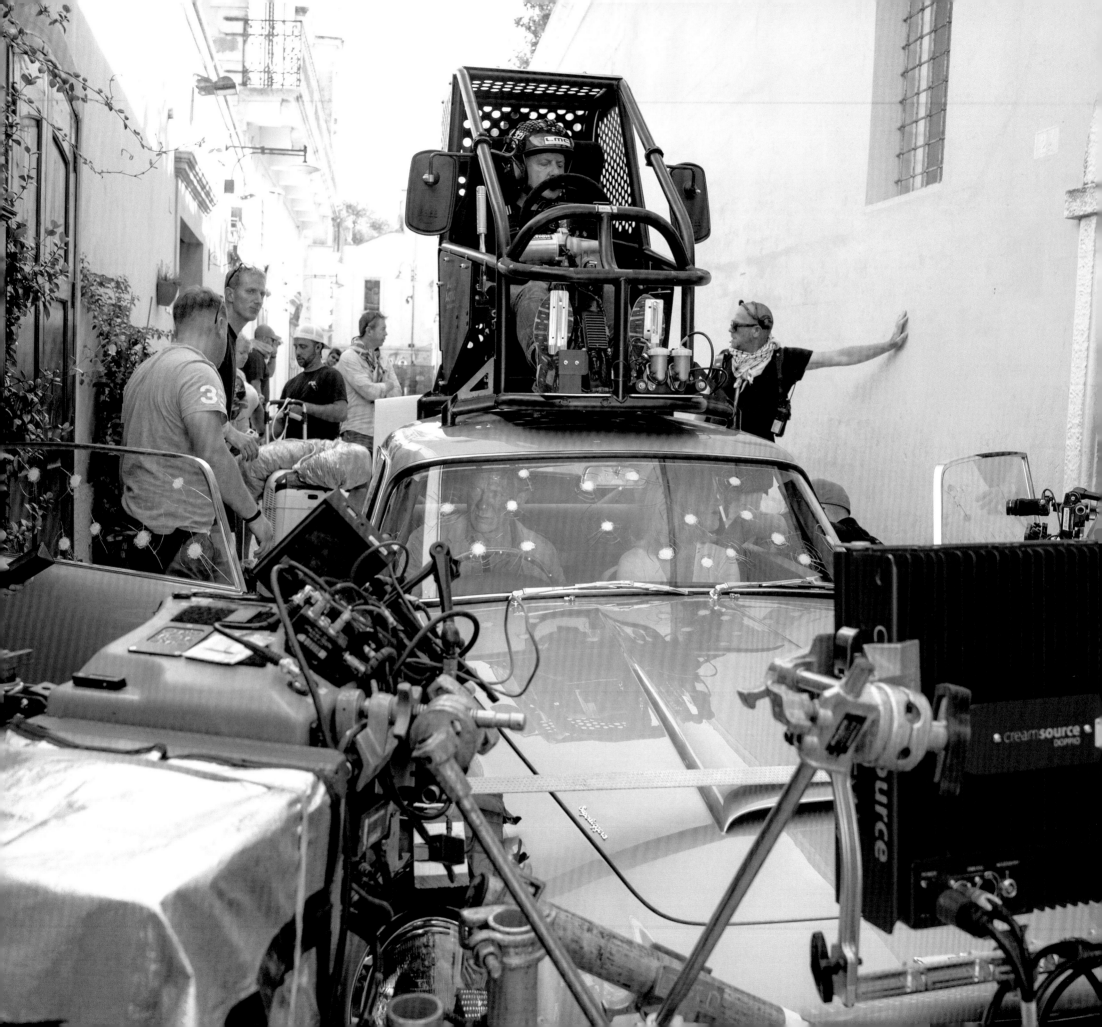

It's scary for Madeleine. She's seeing James turn back into 007. When he comes back from the bridge, he's feeling a bit paranoid. There's a change in his eyes. Getting that across while he's driving was what we needed to do."

"I came to Matera with Lee months before shooting and we started thinking, *What could we do?*" recalls Schneider, who pre-visualized the sequence, first with toy cars and 3D computer models, before moving on to rehearsing with cars and motorbikes. "We know he's going to have the DB5. We know he's going to be chased. Our job is to make that special and different and fit with a Bond film. We always try to do as much as we can on Bond for real, in terms of crashes, fights. We try to not use too much visual effects, because we are not a superhero film. We are Bond."

Which means putting Craig behind the wheel as often as possible. "We want to see Daniel as much as we can, so we need to find a way to make that possible," says Schneider. "We

did extensive tests with Daniel driving and he was thrilled with it," adds Corbould. "He feels really part of it, and you get a completely different kind of performance than if you filmed the sequence against a process screen." Stunt driver and three-time British rally champion Mark Higgins took over with the pod car when Daniel needed to fully focus on the acting.

"Daniel himself is very involved in the sequences. He works, rehearses them and adds elements to them. He discusses it with the director and the stunt team. He has a very good handle on what he can do and how those action sequences can be made better," says Wilson.

Working in the ancient streets of Matera proved a major logistical and safety challenge for both stunts and special effects. "The roads are very narrow and, of course, we can't damage anything, because it's a historical city," says Witt, who spent three weeks in Matera, filming the graveyard explosion, bridge attack

LEFT: Craig and Seydoux in the DB5, with stunt driver Pascal Lavanchy in the driving pod on the roof.

RIGHT: Shooting in "donut square".

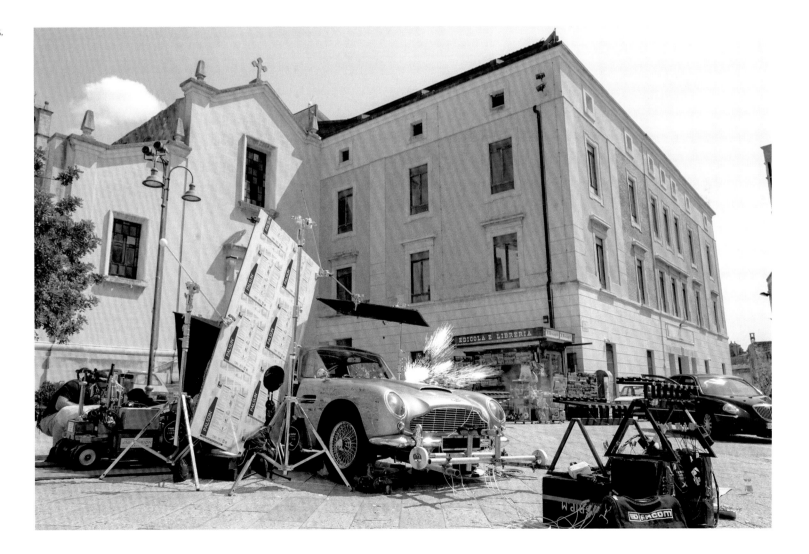

and chase sequence in IMAX and 35mm, with cameras mounted to cars, motorcycles, even drones. "Also, the roads are made of stone and are very slippery," adds Witt. To aid the latter, Morrison had litres of Coca-Cola sprayed over every surface, the carbonated drink providing an additional adhesive layer when dry, thereby helping tyre rubber stick.

As he did with the car chase through the streets of Rome in *Spectre*, Clegg was required to shield walls and buildings in Matera with a layer of six-millimetre-thick steel over which three-quarter-inch foam sheeting – indistinguishable from real stone and

> **"** I was very keen to have a big end moment, so we came up with the idea of the car donuting around, spraying bullets 360 degrees, shredding walls and buildings. Bond hits the smokescreen and it completely fills the square in seconds, which gives him the opportunity to get away."
>
> *Chris Corbould, special effects supervisor*

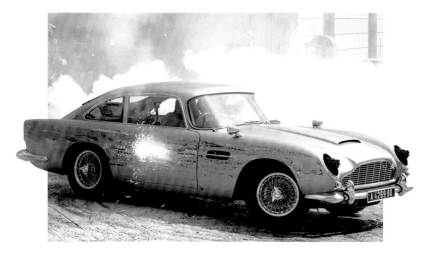

ABOVE: The DB5 with the headlight machine guns activated.

RIGHT: An aerial shot of the DB5 "donuting".

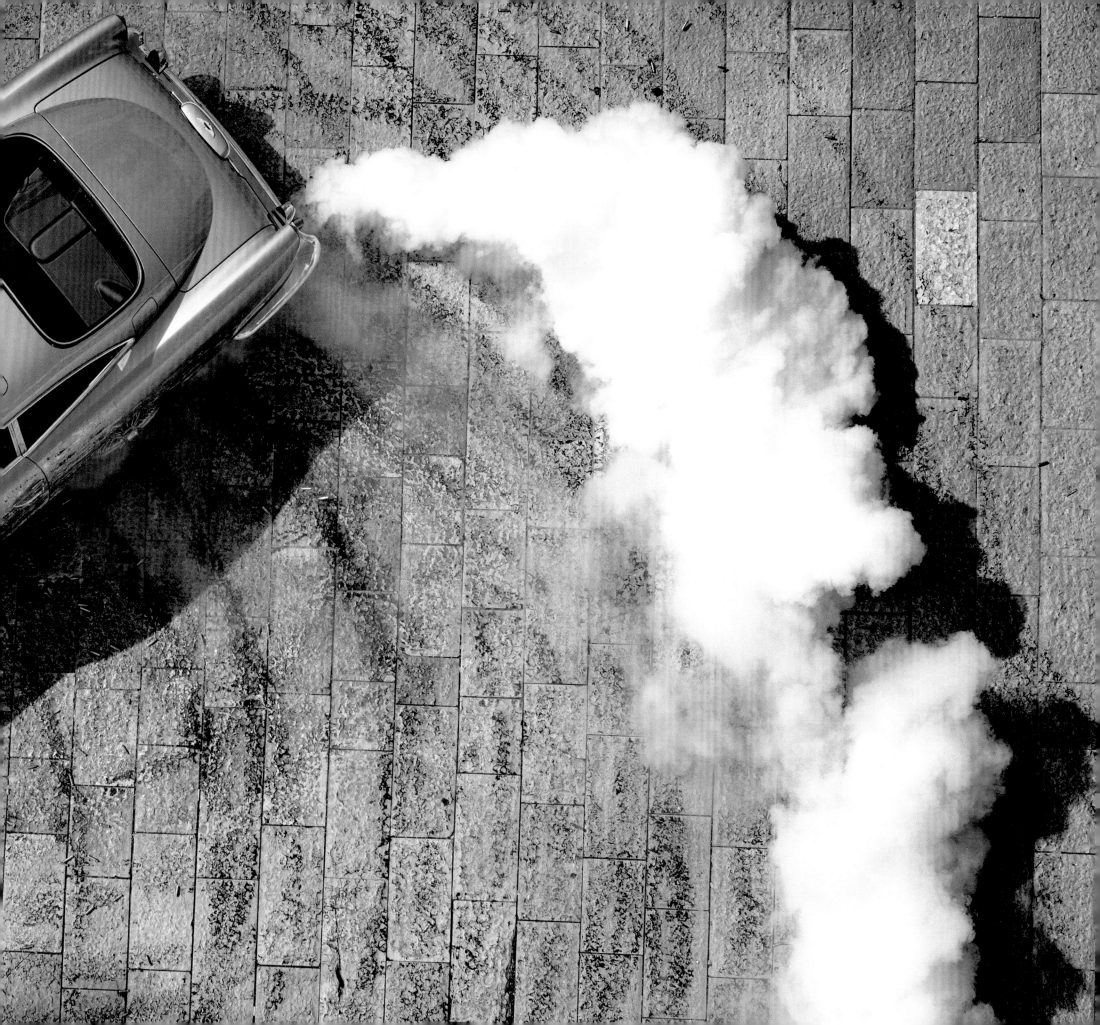

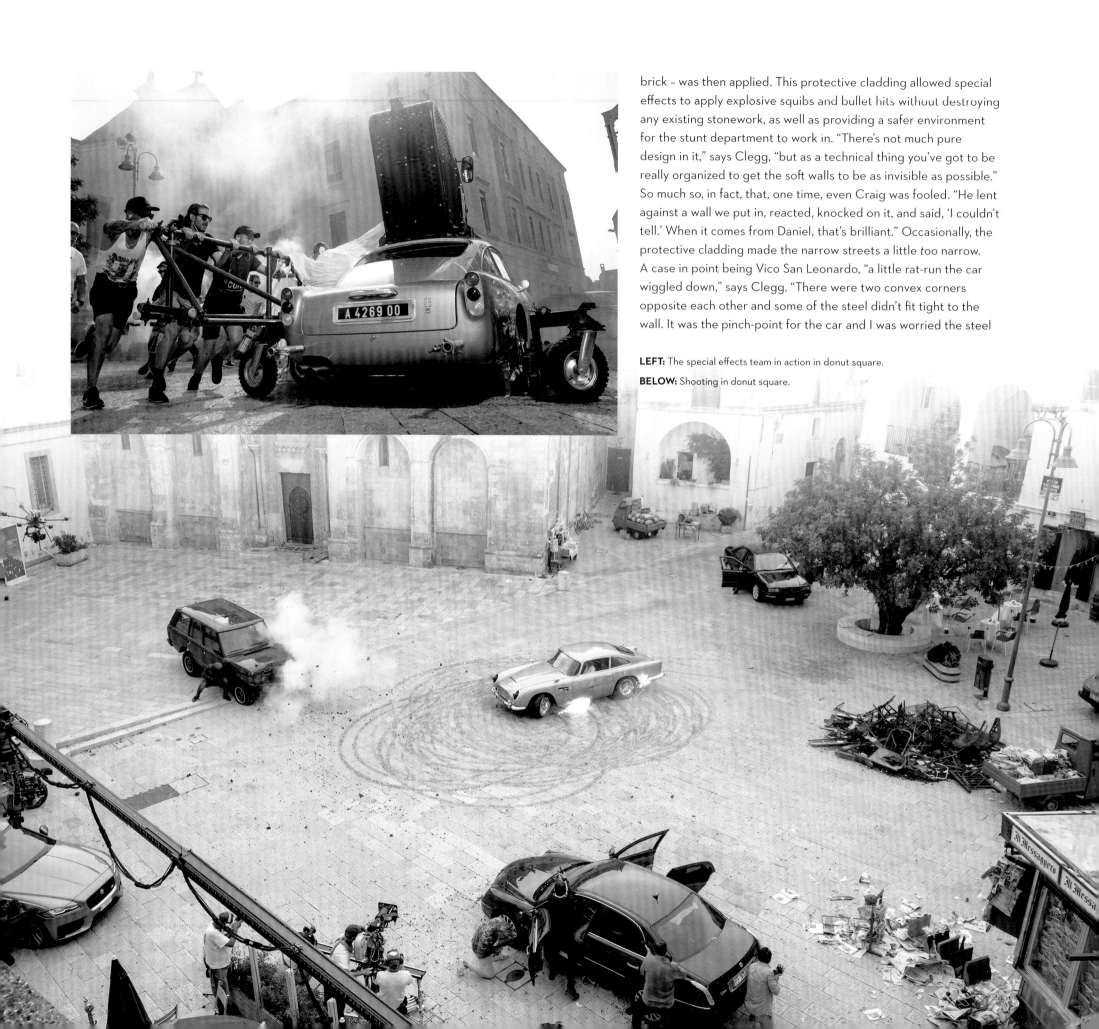

brick – was then applied. This protective cladding allowed special effects to apply explosive squibs and bullet hits without destroying any existing stonework, as well as providing a safer environment for the stunt department to work in. "There's not much pure design in it," says Clegg, "but as a technical thing you've got to be really organized to get the soft walls to be as invisible as possible." So much so, in fact, that, one time, even Craig was fooled. "He lent against a wall we put in, reacted, knocked on it, and said, 'I couldn't tell.' When it comes from Daniel, that's brilliant." Occasionally, the protective cladding made the narrow streets a little *too* narrow. A case in point being Vico San Leonardo, "a little rat-run the car wiggled down," says Clegg. "There were two convex corners opposite each other and some of the steel didn't fit tight to the wall. It was the pinch-point for the car and I was worried the steel

LEFT: The special effects team in action in donut square.

BELOW: Shooting in donut square.

PRIMO

"Primo is an action guy, a kind of war dog," says Dali Benssalah, "and in the end, a mercenary looking for a reason to fight. He was born and raised on the dark side. So he is a baddie by loyalty."

Bond first runs into Primo in Matera when he's working for Blofeld and the pair wrestle in the street, before Primo rams his Range Rover into Bond's Aston Martin DB5 and unloads his machine gun into the car. "Matera was an incredible experience," Benssalah enthuses, "from the fight with Daniel to shooting the DB5. I remember Jon Mallard, the first AD, shouting 'Cut!' and I was pretending not to hear him just so I could empty my mag!"

The French-born actor was spotted by Fukunaga's assistant, India Flint, in a music video for 'Territory' by The Blaze. "She saw it on YouTube and showed it to Cary. I had an audition in Paris, then was invited to Pinewood. During the casting, I had to fight ten guys and play poker with Cary. Then I got the role." In keeping with Bond henchmen of the past, Primo has a very distinctive look. "The haircut. The robotic eye. Amazing costumes. Really cool. The first time we meet him he looks like a gangster. He's enigmatic. We will remember Primo, I think."

Bond later runs into Primo at the SPECTRE party in Cuba, where his robotic eye is used as a video link by Blofeld to communicate with his men from jail. After SPECTRE is wiped out, Primo is suddenly unemployed. "That's when Primo, son of SPECTRE, becomes an orphan and a mercenary looking for a fight." Which means joining Safin's crusade and once again facing off against Bond. Going mano-a-mano with Craig, once in Matera and again on Poison Island, was, says Benssalah, also "an experience, because he is always two hundred percent. It was a chance for me to work with [supervising stunt coordinator] Olivier Schneider. I did so many stunts, I'm a bit like a stunt guy now. What helped me was the fact that I do Thai boxing. I have experience in fighting. It gives you the attitude."

ABOVE: Primo on his motorbike in Matera.

RIGHT: Second unit director Alexander Witt.

FAR RIGHT: (Left to right) Key grip David Appleby, Fukunaga, stunt coordinator Lee Morrison and Sandgren.

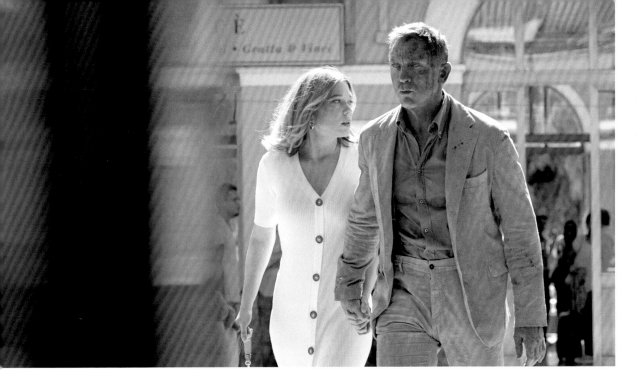

had stolen a bit too much room, but it was fine in the end. Much to my relief."

The chase climaxes in Piazza San Giovanni Battista, where the DB5 is T-boned by Primo's Range Rover, bringing it to an abrupt stop. As Primo and his men surround the car and open fire with automatic weapons, bullets pinging off the shatterproof glass and scuffed paintwork – cosmetic damage faked using stickers attached to the windows and bodywork – Madeleine is panicking. Bond remains calm, engaging the headlight mini guns and putting the Aston into a tyre-screeching spin. "I was very keen to have a big end moment," reveals Corbould, "so we came up with the idea of the car donuting around, spraying bullets 360 degrees, shredding walls and buildings. Bond hits the smokescreen and it completely fills the square in seconds, which gives him the opportunity to get away. We injected the smoke straight into the exhaust gases. A bit extravagant, probably, but it worked really well."

Dubbed "donut square," the sequence was shot initially by the second unit. According to Fukunaga, "They really struggled with weather. I wanted the film to be an experience. On an emotional, visceral level, the beginning of the film is very much about Madeleine and what Madeleine means to Bond. The armour of the car is like his armour. So when he's in that square and the car's being shot up, it's like his heart is being attacked, and she's in there, trying to wake him up. Then, on a physical, visceral level, I wanted the audience to be inside the car as it's being pelted by thousands of pounds of lead, to feel what that must feel like."

In addition to IMAX cameras bolted to the car and positioned around the square, Fukunaga also had the art department build a fake bell tower on one of the surrounding rooftops to provide him with yet another vantage point. "Cary was really keen on getting that foreground view of the car being hit through these swinging church bells, with the camera pulling back," explains Clegg, who also covered the exterior of the St. John the Baptist Church that gives the square its name with false walls to hide numerous squibs, as well as protect the stonework. "We even added a hedge, so Bond couldn't see the car that T-bones him until the last minute."

To provide extra visual interest, as well as more places to conceal Corbould's bullet hits, Véronique Melery's thirteen-strong team dressed the square with a newsstand, plantings, a café and restaurant, a glass screen and market stalls selling Virgin Mary statues and watermelons; all of which required cleaning and redressing after every take, a time consuming but necessary process.

Once filming in Matera was complete, a specialist cleaning company was brought in to remove all the tyre marks that had been laid down by the production throughout the city, and return the streets and pavements to their sparkling best. "The council was fantastic. The town opened up its arms and let us do what we had to do there," muses Corbould, whose fleet of ten Aston Martins were given police escorts wherever they went, and became something of a tourist attraction in their own right during the weeks the production was based there. "Every time the DB5 did something spectacular you got a round of applause," he chuckles. "It was quite special."

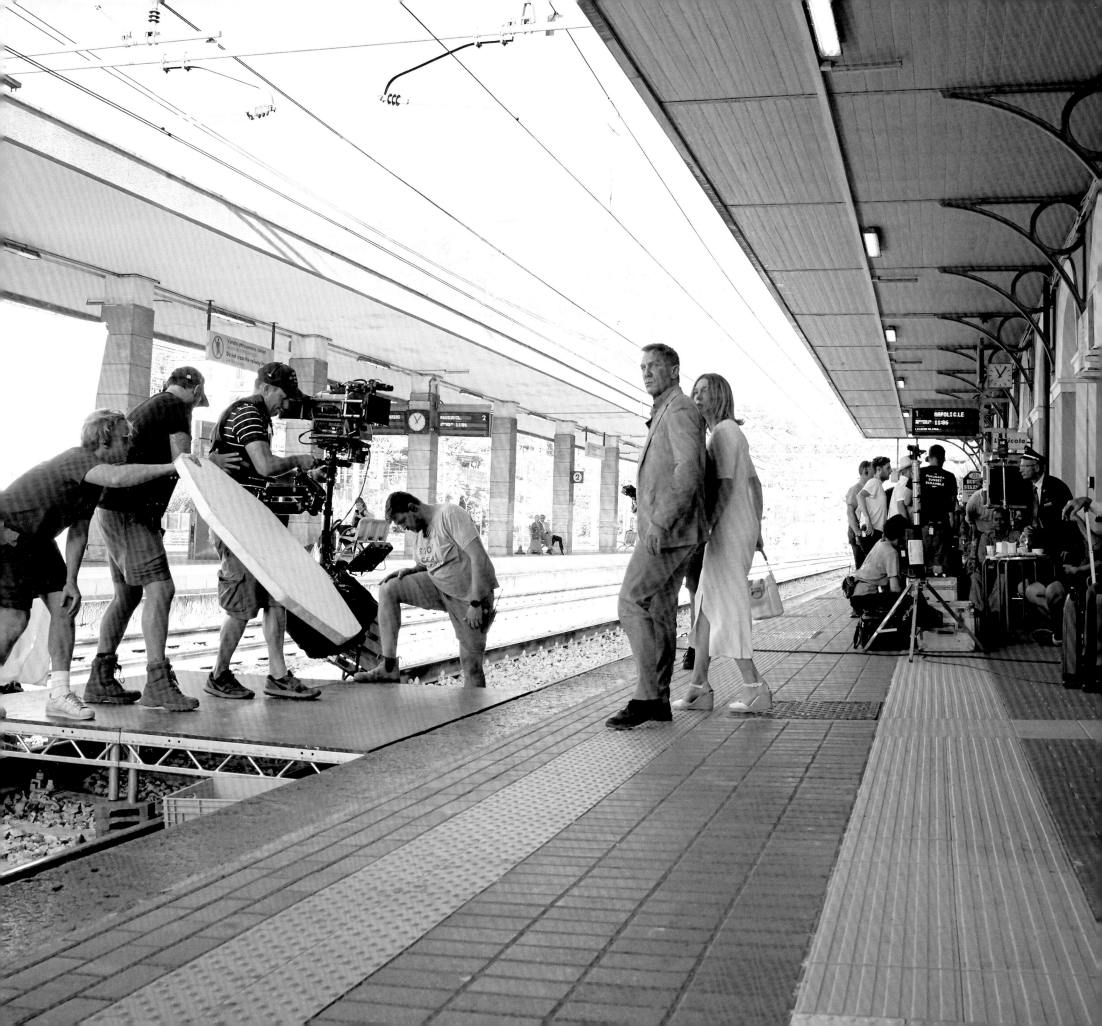

HERACLES HIJACK

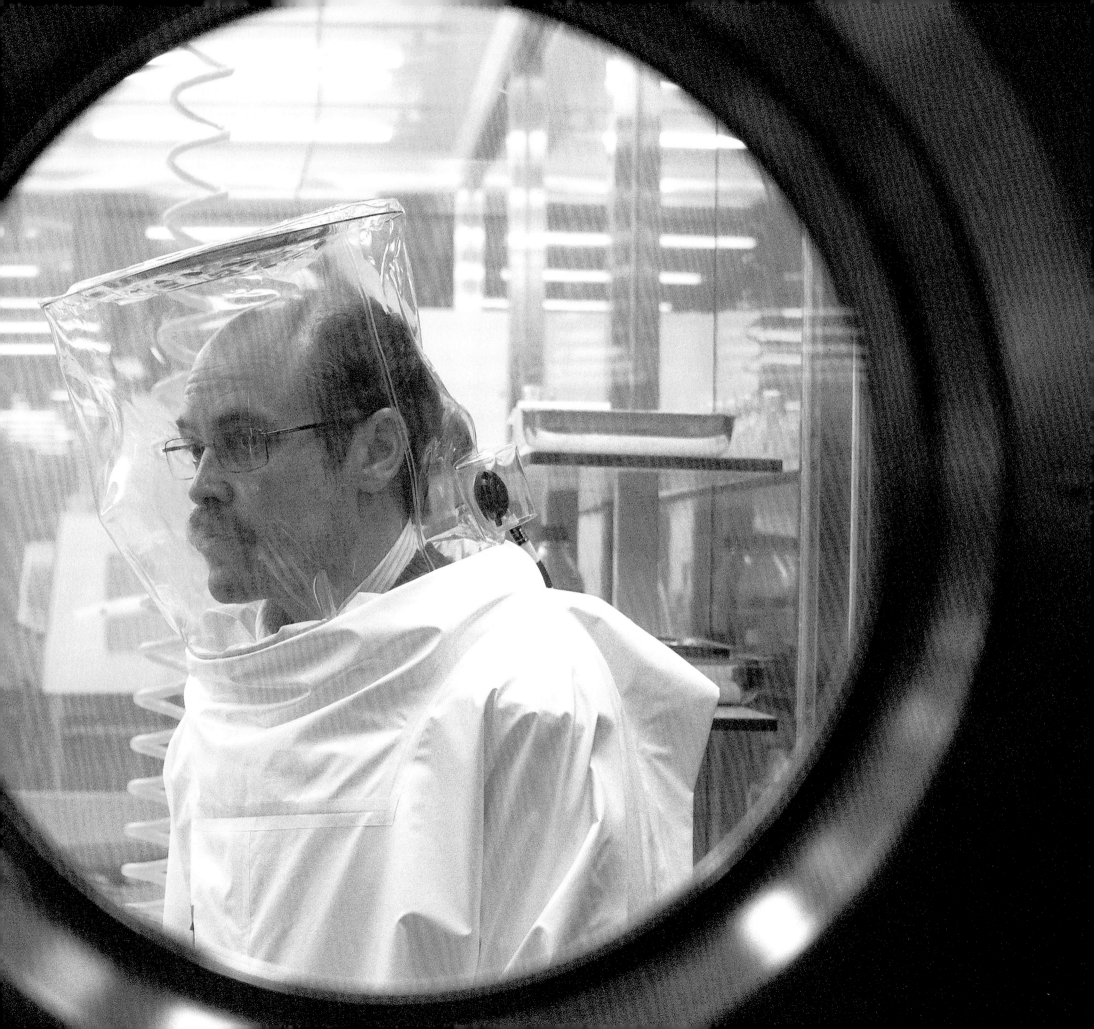

HERACLES HIJACK

Bond villains have always been at the cutting-edge of new technology – be it lasers, space travel or state-of-the-art weaponry – and *No Time To Die* baddie Safin is no exception. His weapon of choice is a DNA-targeted toxin, delivered by nanobots, modified and now capable of killing millions of people in one go. Codenamed Heracles, the toxin is procured during a daring raid on a top-secret British government facility, when seven armed men, led by Primo, rappel down the side of a London skyscraper at dusk, cut through the glass and enter a high-tech research laboratory. Once inside, they steal the toxin, kidnap its creator, Russian scientist Valdo Obruchev (David Dencik), then blow the laboratory to kingdom come.

PREVIOUS SPREAD: Valdo (David Dencik) in the research laboratory.

BELOW: A 3D plan of the laboratory set layout by Sandra Phillips.

RIGHT: A section of the laboratory set.

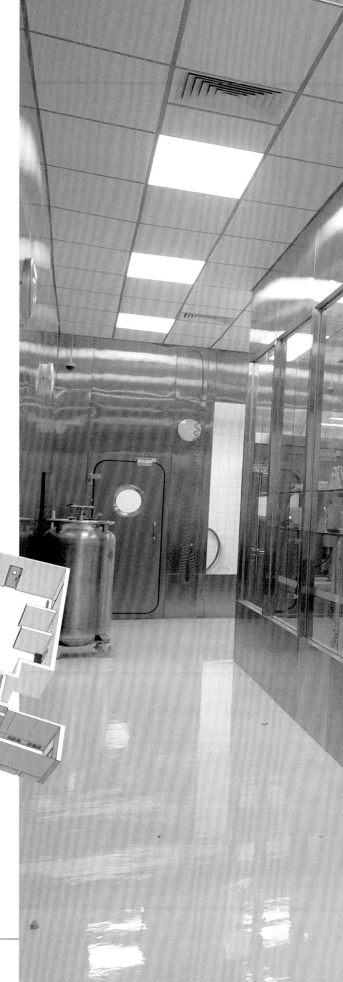

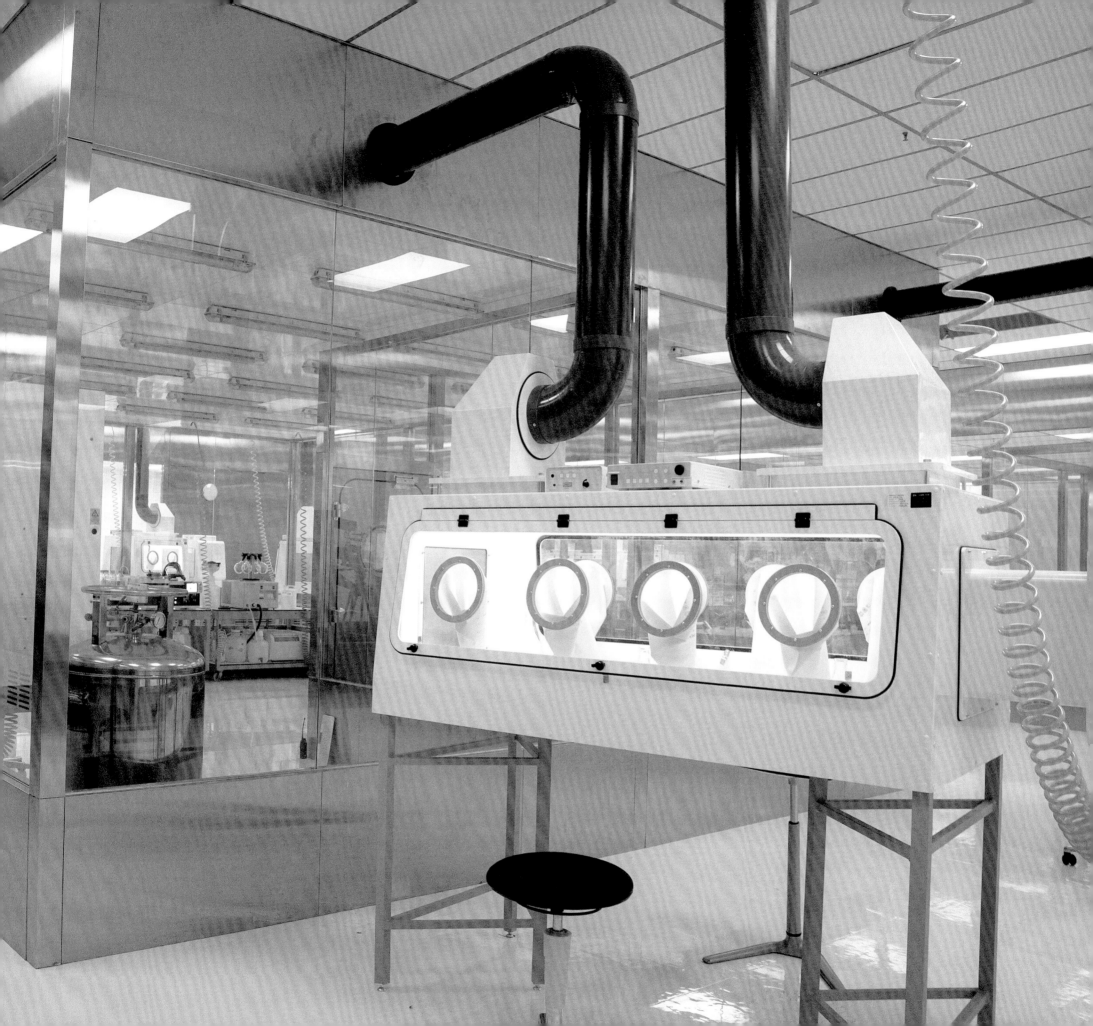

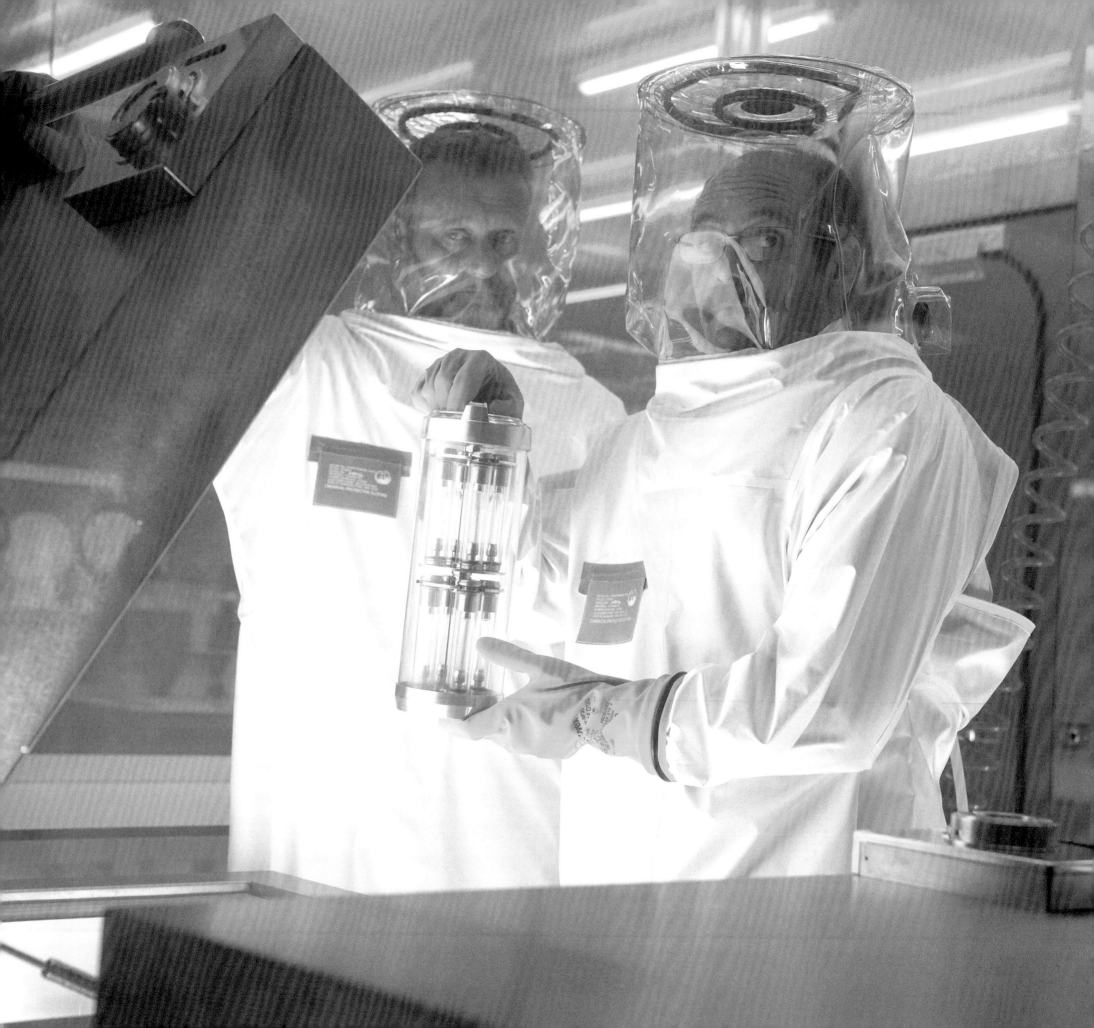

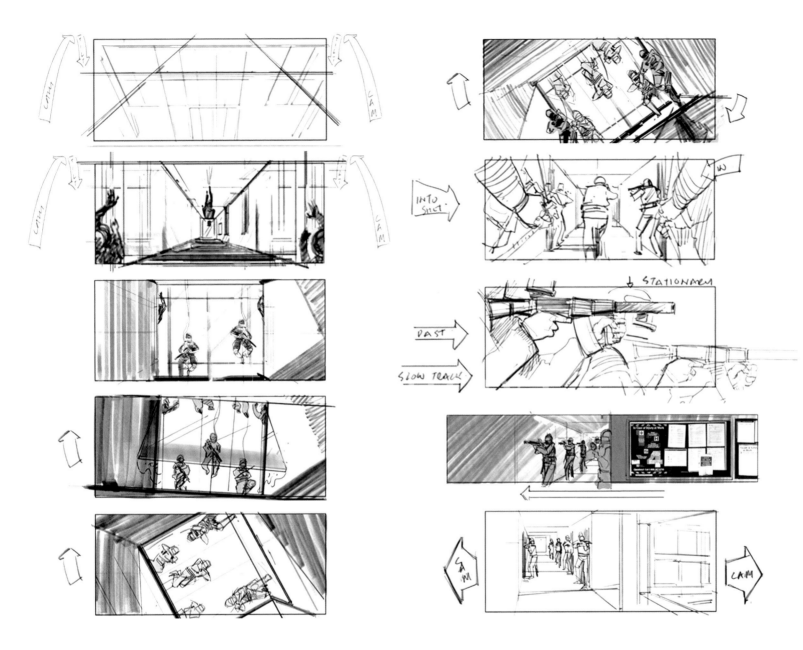

OPPOSITE: Valdo and a fellow scientist (Hugh Dennis) with the Heracles virus.

LEFT: Storyboards for the beginning of the heist sequence by Forrest-Smith.

Tasked with designing such a laboratory – airlocks, wash rooms, et al – that looked great on camera was art director Sandra Phillips. Phillips worked up a 3D computer model to allow Fukunaga and Sandgren to "walk through the set digitally," before marking it out on the floor of 007 Stage, "so people could feel the volume." Measuring 150 feet by 80 feet, the laboratory came together in five weeks, "because there was very little paint or plaster involved. Everything was stainless steel and glass, with white walls and floors, very reflective. We were trying to get layers

of reflection, so it was almost like a Pandora's box or a Babushka doll. Everything was very symmetrical and lined up, so you just saw light, reflections and white."

Once the laboratory was built, Véronique Melery and her set decoration team moved in, adding futuristic microscopes, containment vials, storage, along with air-supplied full-body suits. "Mark and Cary supplied very strong [reference] images of very bizarre, space-age equipment, and we tried to give the space the same futuristic feel. So when you enter, you really don't

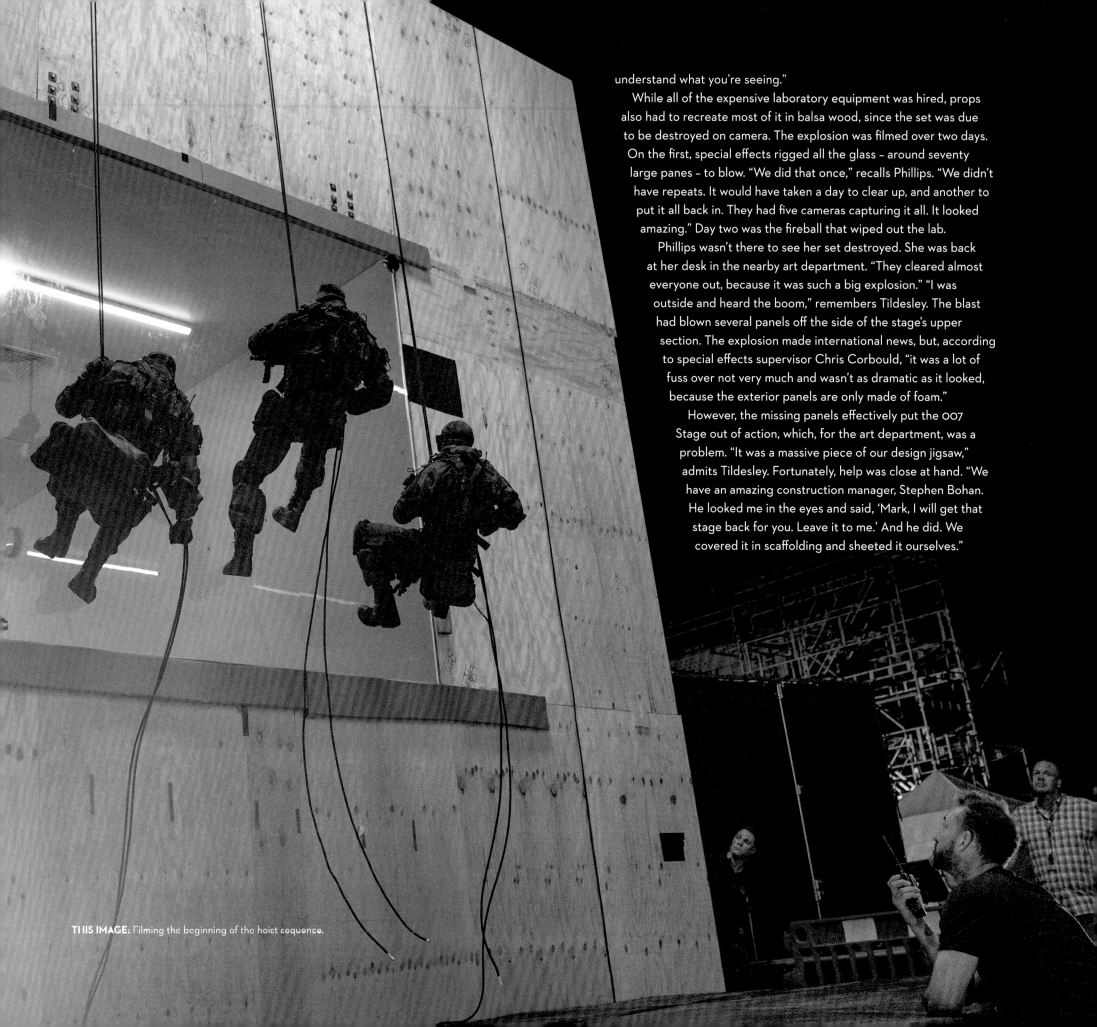

understand what you're seeing."

While all of the expensive laboratory equipment was hired, props also had to recreate most of it in balsa wood, since the set was due to be destroyed on camera. The explosion was filmed over two days. On the first, special effects rigged all the glass – around seventy large panes – to blow. "We did that once," recalls Phillips. "We didn't have repeats. It would have taken a day to clear up, and another to put it all back in. They had five cameras capturing it all. It looked amazing." Day two was the fireball that wiped out the lab.

Phillips wasn't there to see her set destroyed. She was back at her desk in the nearby art department. "They cleared almost everyone out, because it was such a big explosion." "I was outside and heard the boom," remembers Tildesley. The blast had blown several panels off the side of the stage's upper section. The explosion made international news, but, according to special effects supervisor Chris Corbould, "it was a lot of fuss over not very much and wasn't as dramatic as it looked, because the exterior panels are only made of foam."

However, the missing panels effectively put the 007 Stage out of action, which, for the art department, was a problem. "It was a massive piece of our design jigsaw," admits Tildesley. Fortunately, help was close at hand. "We have an amazing construction manager, Stephen Bohan. He looked me in the eyes and said, 'Mark, I will get that stage back for you. Leave it to me.' And he did. We covered it in scaffolding and sheeted it ourselves."

THIS IMAGE: Filming the beginning of the hoist sequence.

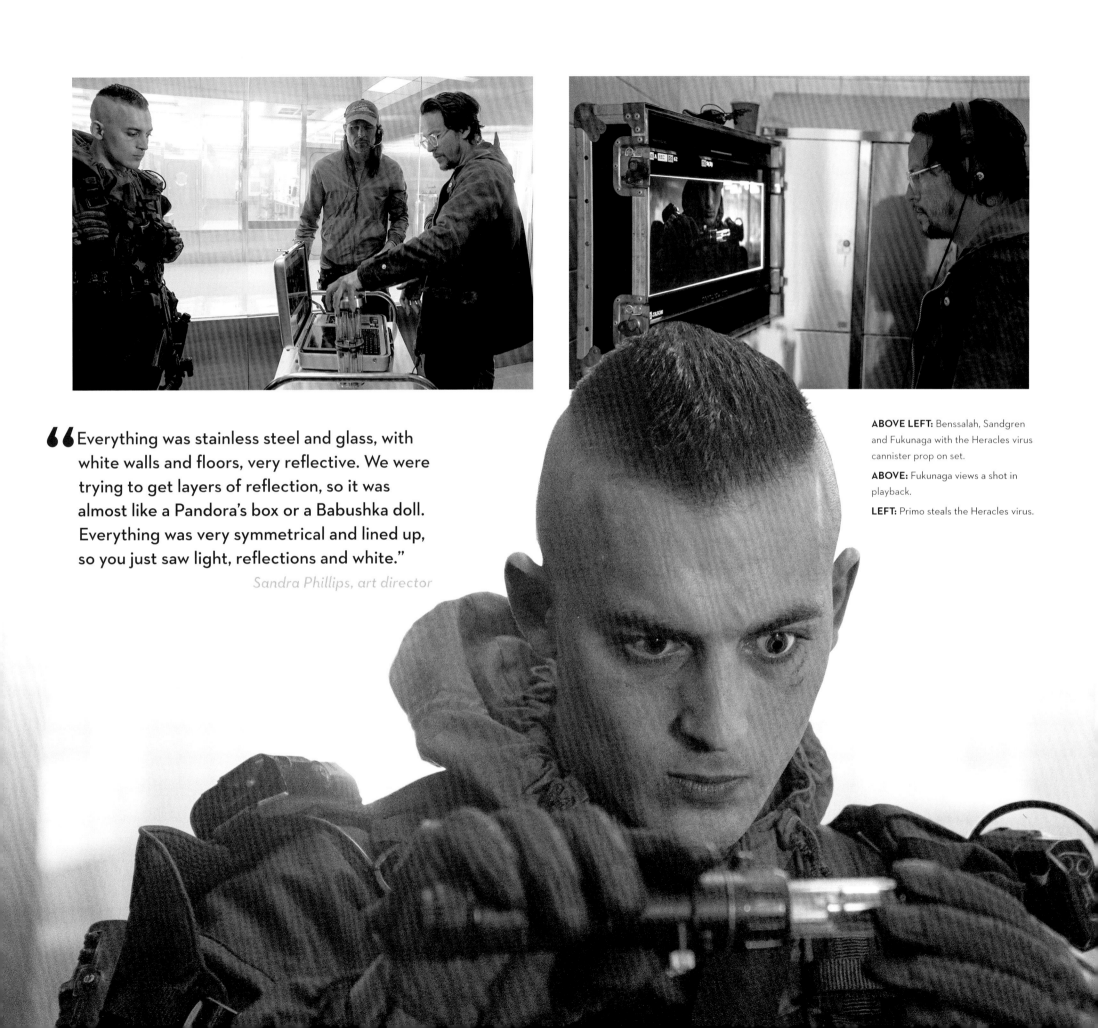

"Everything was stainless steel and glass, with white walls and floors, very reflective. We were trying to get layers of reflection, so it was almost like a Pandora's box or a Babushka doll. Everything was very symmetrical and lined up, so you just saw light, reflections and white."

Sandra Phillips, art director

ABOVE LEFT: Benssalah, Sandgren and Fukunaga with the Heracles virus cannister prop on set.

ABOVE: Fukunaga views a shot in playback.

LEFT: Primo steals the Heracles virus.

On screen, once the fireball destroys the laboratory, it will be seen racing down a series of corridors, before blowing out of the top of a London skyscraper.

For Primo and his men, and Valdo, their escape route involves leaping fifty stories down an empty elevator shaft to ground level, slowing their descent via a series of magnets attached to the inside of the shaft and connected via sensors on their clothing. The concept was pitched by supervising stunt coordinator Olivier Schneider. "We had many other ideas, such as using small parachutes, but [the magnets] were cool, because no one has ever seen it," says second unit director Alexander Witt, who filmed the stunt.

" Not much acting was involved in that [stunt], because there was a real drop and I did it seven or eight times. It was uncomfortable each and every time."

David Dencik, Valdo

RIGHT: Dencik shooting the elevator shaft drop sequence against a greenscreen.

OPPOSITE: Benssalah shooting in the laboratory set

VALDO

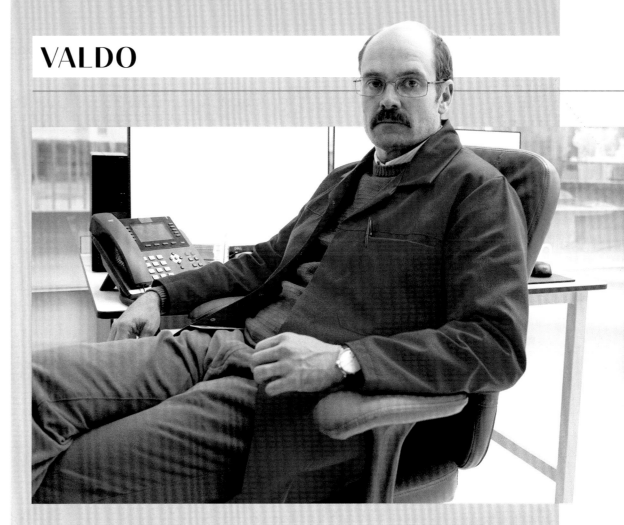

David Dencik came close to playing a Bond baddie once before. "I auditioned for *Skyfall*, I think. I met with Debbie McWilliams, the casting director of this and many other James Bonds. I didn't get the part." Still, all good things come to those who wait, and, two Bonds later, the Scandinavian actor is finally getting to show his villainous worth as Russian scientist Valdo Obruchev in *No Time To Die*. Although, initially, McWilliams asked if he could do a Cuban accent. "I said yes. I can be a woman. I can be a bear. I'm an actor. I can do anything."

Apparently in the employ of MI6, Valdo reveals his true colours when Primo and his team burst into the top-secret London laboratory where he works, kidnapping him and stealing the deadly Heracles toxin he's been developing. That said, Valdo is very much the film's comic relief. "My character gets hijacked, kidnapped, shot at, thrown down an elevator shaft, flown up through a roof... Things are always happening to him, and you can tell something about a character through the way they react to these circumstances."

A case in point was the scene, filmed on Banana Wharf in Jamaica, subbing for Cuba in the film, where Valdo and Bond are running away from the authorities. "The first take was me running, from one point to another, with Bond, being shot at," recalls Dencik. "Afterwards, Cary said to me, 'I like the crab run,' and that was pretty much where the character of Valdo emerged, running sideways. It was very intuitive. I didn't know Cary well at that point, but I saw him approving, so my entire character was built from that. From then on, we just explored how far we could take this Valdo guy in all his weirdness, his nerdiness, and his cowardice."

LEFT & ABOVE: The stunt team and Benssalah shooting the elevator shaft drop scene. The bomb-shaped object releases the magnets that slow their descent.

RIGHT: Dencik between takes on the laboratory set.

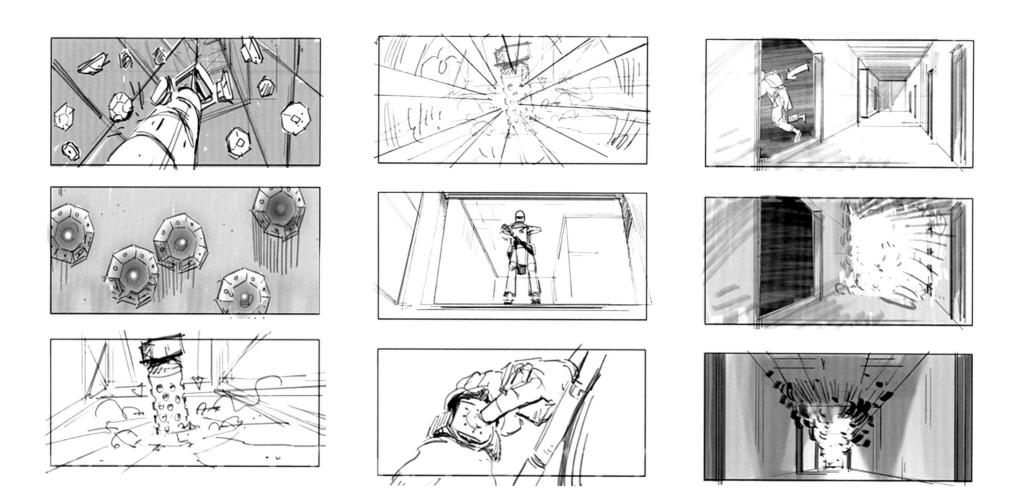

To simulate the drop, Phillips created a fifty-foot section of elevator shaft on the Richard Attenborough Stage so Schneider's stuntmen, and Dencik, could be filmed jumping for real. "Not much acting was involved in that," says Dencik, "because there was a real drop and I did it seven or eight times. It was uncomfortable each and every time." Phillips also built another section covered in LED screens onto which the shaft interior was projected, so the actor could be filmed, held in place by wires, with a moving background playing to simulate the actor falling.

Finally, Phillips designed a ground-level set for when Primo's team blow out the floor and escape into an underground tunnel. "It was quite complicated in terms of stunts and special effects and visual effects linking together," she notes, "but it was fun."

ABOVE: Storyboards for the elevator shaft escape and laboratory explosion sequence by Forrest-Smith.

RIGHT: Primo jumps down the elevator shaft.

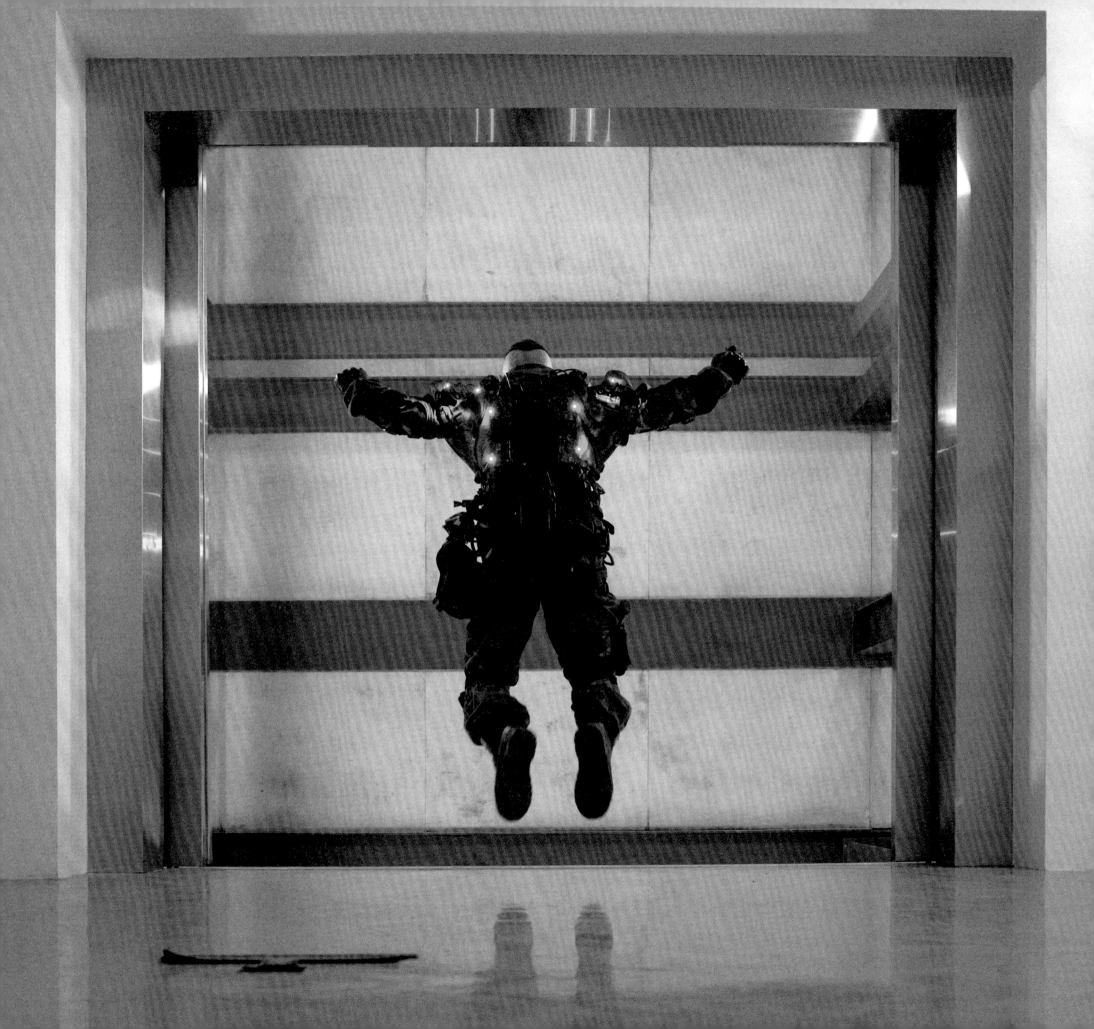

SPIRITUAL HOME

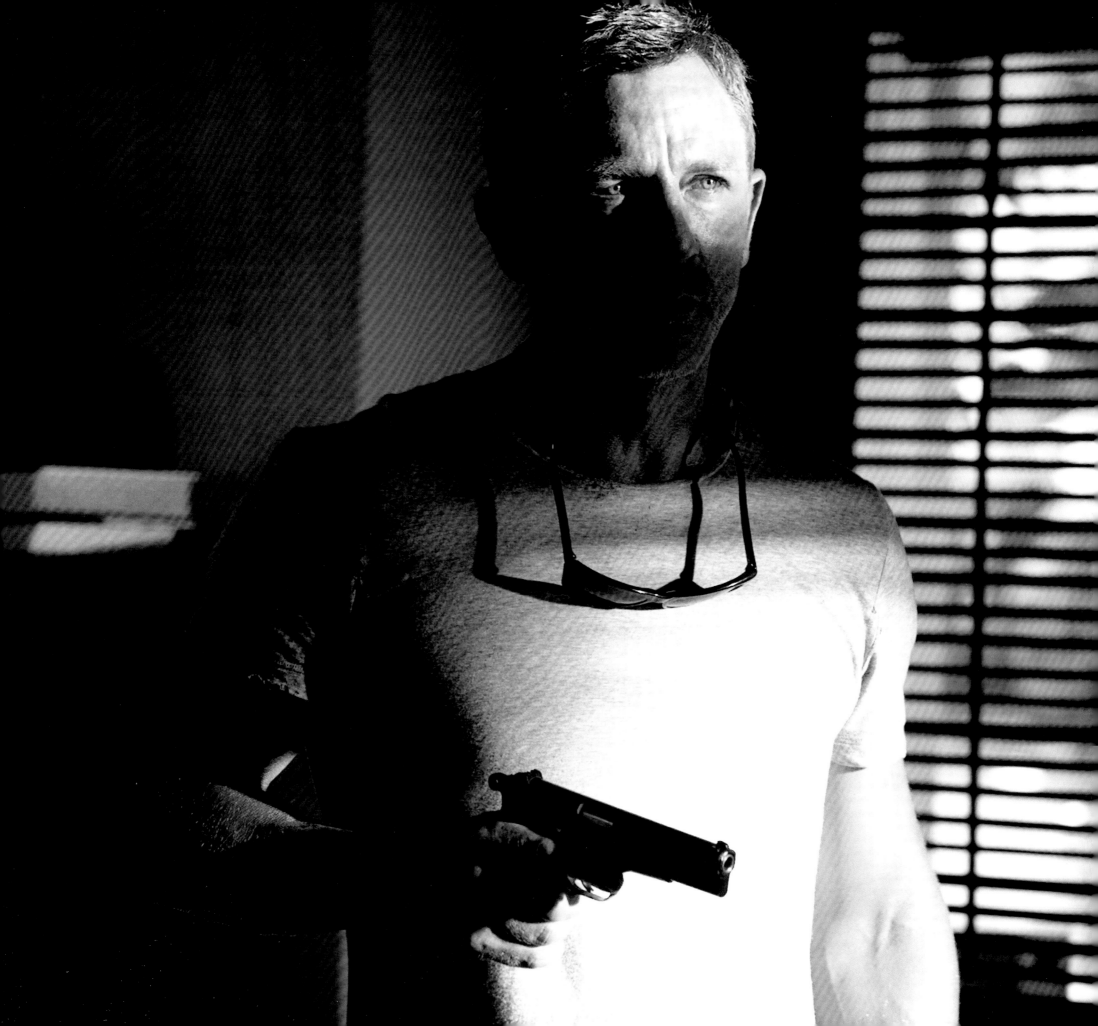

SPIRITUAL HOME

"Where would James Bond go to retire?" asks Wilson. "Where did Fleming retire to and write the books?" The answer, of course, is Jamaica, that tropical island paradise where former naval intelligence officer and *Sunday Times* journalist Ian Fleming gave birth to his most famous literary creation in 1952, and which has become Bond's spiritual home-away-from-home ever since.

Jamaica played a starring role in *Dr. No* (1962), a film notable for many things, not least the now-iconic moment in which Ursula Andress stepped from the sparkling turquoise waters of the Caribbean and into cinematic history, a scene paid homage to by Halle Berry in *Die Another Day* (2002) and Daniel Craig in *Casino Royale* (2006). Jamaica also featured heavily in *Live And Let Die* (1973), while Fleming's former home on the island's north shore provided the title

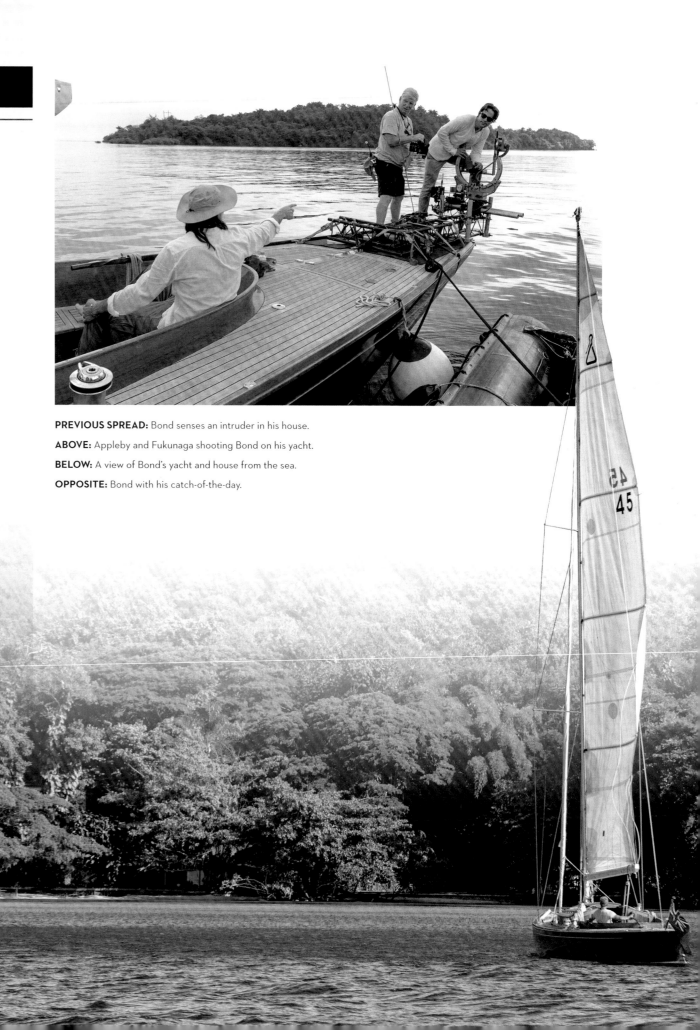

PREVIOUS SPREAD: Bond senses an intruder in his house.

ABOVE: Appleby and Fukunaga shooting Bond on his yacht.

BELOW: A view of Bond's yacht and house from the sea.

OPPOSITE: Bond with his catch-of-the-day.

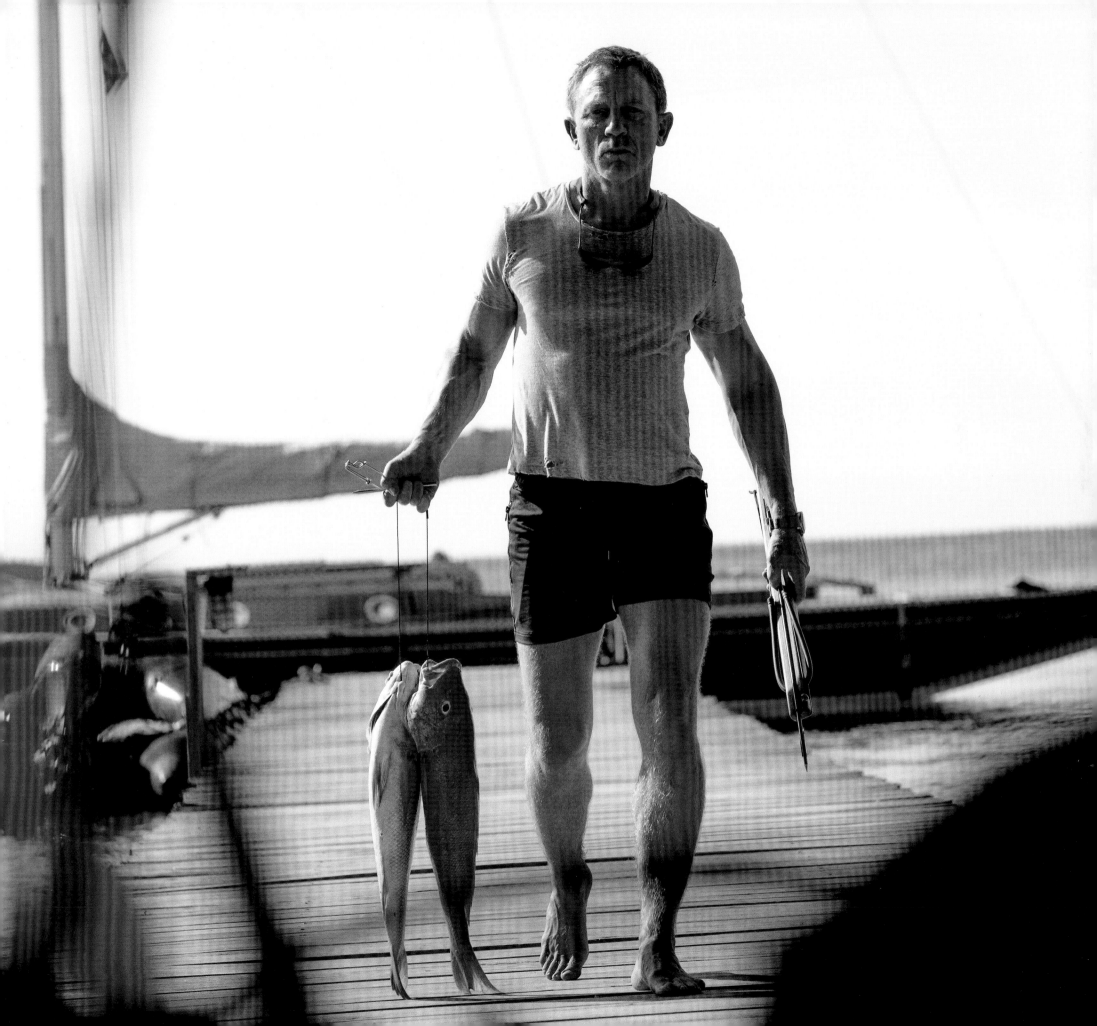

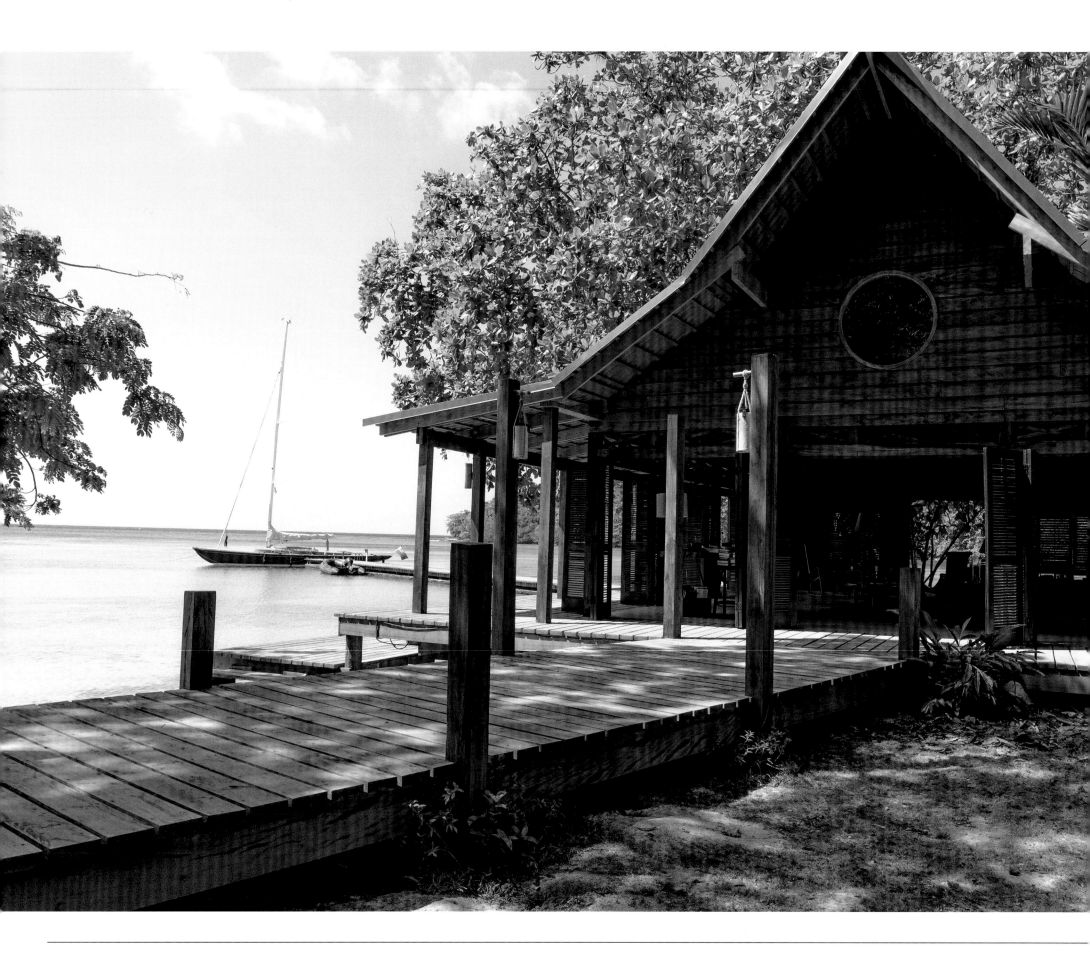

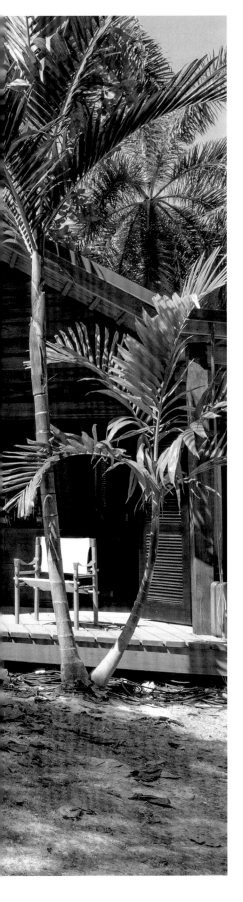

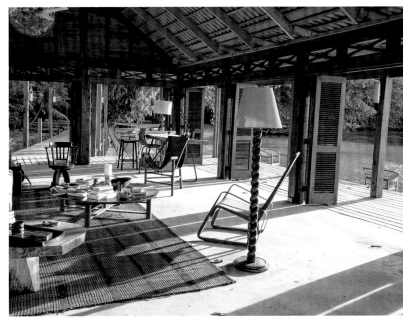

for Pierce Brosnan's Bond debut, *GoldenEye*. Now a luxury resort, GoldenEye was the venue for the official launch of *No Time To Die*, when Fukunaga, Wilson, Broccoli, Daniel Craig, Léa Seydoux, Naomie Harris, Lashana Lynch and Ana de Armas greeted the world's media on April 25th, 2019.

"It was really interesting being at Fleming's house, knowing he wrote all the Bond books there," recalls Broccoli. "Looking at the view from his window, it's so evident that what he was seeing outside – the natural world with all its beauty, the lush greenery, the birds, the coral reefs – is the world Bond was saving. It really hit me, that's why he was so obsessed with Bond's mission to save the natural world. And we need him now more than ever."

So, five years after bidding goodbye to Madeleine in the ancient hilltop town, having hung up his Walther PPK, handed in his licence to kill and turned his back on active service, it's Jamaica where Bond has retired to in *No Time To Die*. We see him first sailing his forty-five-foot yacht, the *Happenstance*, a Fleming refererence, in stormy seas, before heading inland with the fish he's caught for his supper, tying up his boat on his private wooden jetty, beside his beachside home. He is, according to the script, "visibly relaxed, walking at island pace, a Bond we've never seen before."

"He's retired and is living a simple life, the perfect life," says Linus Sandgren. "He's fishing, doing his own thing. He has a very simple house, but it's obviously very luxurious and exclusive, right on the water. It was all set up to feel lush and wet and romantic. It should also feel like a quiet, manly world he lives in, with his tools and his cool house and his sailboat and his old truck – which is a Land Rover – and the fishing and the spear gun. Ultra-sexy Bond."

Mark Tildesley scouted Jamaica with supervising location manager Ben Piltz looking for either an existing property to be Bond's retirement home or somewhere they could build their own. Eventually he found a secluded spot near Port Antonio, an hour and a half east of GoldenEye, surrounded on three sides by lush greenery. "It was relatively near to where Fleming wrote the books, but not right on its doorstep," says art director Neal Callow. "The surrounding area had everything we wanted: an absolutely fantastic town, a harbour we could use for our Cuban sequences

LEFT: The exterior and interior of the house, with (top left) a sketch of the layout by Mark Tildesley.

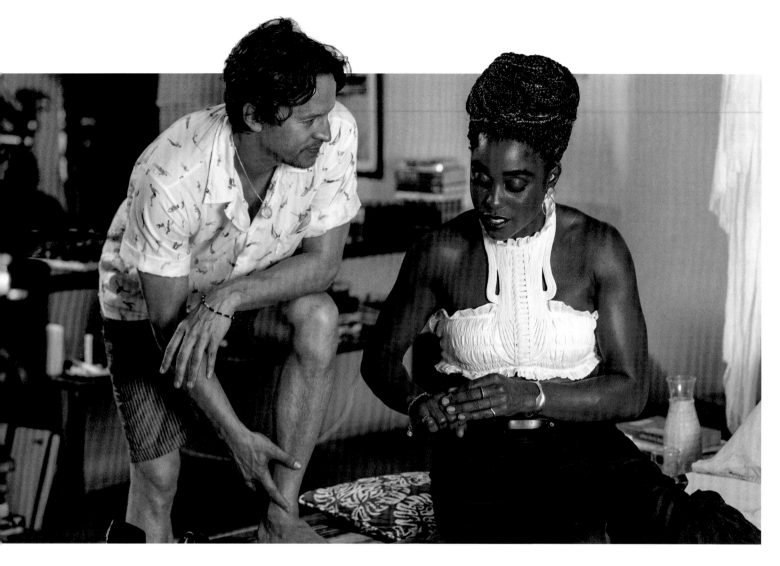

and a beautiful beach where we built our house."

"The owner lived eighty feet up the hill from the beach," recalls Chris Lowe. "He said we could build a house as long as we took it down after and left the ground as we found it. That was perfect for us. Geographically, it was very private, so we didn't get too hounded by paparazzi. We got to have full creative control whilst remaining in a relatively exclusive environment. And it felt right for Bond."

Bond's house went through multiple design iterations – from beach hut/shabby chic to Colonial to tree house to modernist – even before the location was decided upon. "We wanted it to have that Jamaican vibe, but with a twist. Something that makes it intriguing," says Tildesley. The twist turned out to be Japanese. "Cary is very drawn to Japanese things. He's very proud of his heritage. I don't know if people will think it's got a Japanese feel, but we followed that with our roof lines and put some circular windows in to give it a more Japanese look. It has a Japanese

lodge feel."

Tildesley originally conceived the house over two stories, before, at the last minute, splitting it in two, a living block and a separate bedroom joined by a walkway, to make better use of the location. "There was this natural pond between the two sides of the beach that was filling itself from a spring that came down from the mountain," explains Callow. "Cary and Mark wanted to use that as the centrepiece of the layout."

"The houses in Jamaica and Norway were influenced by dream homes that Mark and I would want to live in," admits Fukunaga. "Initially, Mark and I had a very different vision, I think, for Bond's home, but once we picked that little bay, I told him to take the roof off – which was the bedroom – and move it over and connect it with a little boardwalk, because why not use this whole space."

"Cary added a shower in the trees, a homemade shower, so when Bond turns it on, the water falls thirty feet, and spreads all over his body," says Sandgren. "It was a way of feeling the jungle

ABOVE LEFT: Fukunaga and Lashana Lynch between takes in Bond's house set.

ABOVE: Nomi (Lynch) gives Bond a lift home.

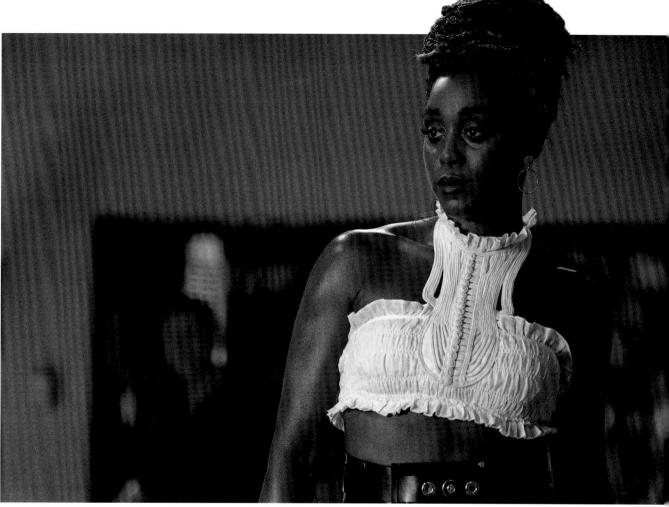

ABOVE RIGHT: Nomi at Bond's house.

and the ocean, together, at the same time. That's probably the ultimate escapism we get in the movie, that location."

At the cinematographer's request, Tildesley incorporated wooden slats into his design. "There's no glass in the windows, just wood, so I thought slats would create interesting shafts of sunlight coming through," says Sandgren, "and we could see Bond, in silhouette, outside, as he approached and notices some cigar ash on the ground and knows someone's been there. We can go from a romantic setting into a suspense setting instantly, thanks to those slats."

Short of plumbing, the house was built for real out of Jamaican mahogany (chakte kok), "which sounds really expensive and unsustainable," admits Callow, "but it is actually a green alternative to hard woods and grows in abundance in the local forests, so it felt right in that particular environment". Construction manager Stephen Bohan used mostly local craftsmen and local timber. "We don't take a huge UK crew out,"

says Lowe. "We send a supervisor, painter and plasterer, then hire lots of locals. One, because it's great enviromentally and economically, and two, they know the place, know where to find the timber, know all the people we need. Then, at the end, we take the house down and the timber gets given to people who need it."

When it came to decorating the house's interior, it was important that Bond "feel he's slightly a fish out of water," says Tildesley. "We started to think about giving him lots of hobbies, boats to rebuild, but Daniel said, 'He's getting too involved in this place. My heart's elsewhere, my mind's elsewhere, all I know is how to kill people.' So he's always trying to test himself with a sailing trip, a climbing trip, or a diving trip, but he's not sitting around tinkering with a speedboat or a bike. He has a yacht and spends a lot of time at sea."

To reflect Bond's interest in sailing, as well as his years in the Navy, set decorator Véronique Melery gave him a selection of nautical maps and maritime paraphernalia. "Bond, now, is all about

enjoying a peaceful, intellectual life, so he reads a lot: history, political history; he has a lot of books about his travels, sailing, and marine exploration." As for furniture, Melery had the props department make several pieces inspired by French industrial designer Jean Prouvé, "who designed fantastic pieces that you need to look at closely to realise the delicacy of the architecture. Bond is someone who has very precise, very good taste, and chose every object following the Japanese idea of 'wabi-sabi,' that everything has to have meaning, everything has to have inner beauty, even if it's not obvious. Nothing is there by accident."

Once the set was dressed, Craig was invited on for his input. "He asked for more books and wanted the place to be a bit messier," says Melery. "We also had quite a lot of sailing artefacts and he asked for a little less."

"Mostly it was story beats," adds Tildesley. "What would Bond have in terms of passports and guns, and where would he keep them? But Daniel was genuinely blown away. He loved the house."

Bond's retirement ends when his old friend Felix Leiter washes up in Jamaica with US State Department official Logan Ash in tow, asking for a favour. They want Bond to return to work, on behalf of the CIA, sail to Santiago de Cuba and extract Valdo, who's been kidnapped. Felix mentions that his intel suggests SPECTRE agents will be gathering *en masse*. That gets Bond's attention, and he agrees to go.

The three men meet in a noisy, crowded, thumping nightclub the art department built on the site of an open-sided bar that had previously featured in the film *Cocktail*. "We needed a fairly large space and there was nowhere available in central Port Antonio, so

LEFT: Behind the scenes: Bond drives to meet Felix Leiter.

BELOW: Behind the scenes: Felix (Jeffrey Wright) and Bond in Jamaica.

ABOVE: Fukunaga, Craig, Wright and Billy Magnussen discuss a scene between takes on the nightclub set.

BELOW: Fukunaga with costume designer Suttirat Anne Larlarb.

BELOW: Fukunaga and Sandgren view a shot in playback.

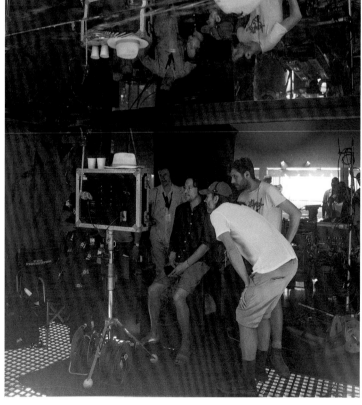

we ended up in this resort right on the beach," says Callow. "We stripped out their bar, built a new one, blacked the place out and put crazy lighting in. We had an LED dance floor from Miami made up of a hundred square LED tiles you could run graphics through. Then we built a mirror box around that for people to dance on. It felt like an intense nightclub." Although, because of a scheduling issue, the production had to shoot there during the day. "It was pretty bizarre. You'd walk out of this thumping nightclub and be on this absolutely pristine beach with the sea lapping on the shore ten yards away."

"It was an opportunity to show the vibe of another side of Jamaica – sweaty, sexy and gritty," says Sandgren. "At the same time, because in the story we go to Cuba next, we wanted to separate the two places in style. I've been to Cuba a couple of times and they have less of things. Whereas Jamaica has more stuff, more lights, so we wanted Jamaica to be more colourful, with laser lighting in that disco. Then Cuba could be more sparse and simple."

> 66 **It was pretty bizarre. You'd walk out of this thumping nightclub and be on this absolutely pristine beach with the sea lapping on the shore ten yards away."**
>
> *Linus Sandgren, director of photography*

LOGAN ASH

ABOVE: Logan Ash (Magnussen) meeting with Bond in the Jamaican nightclub.

Billy Magnussen was on holiday in Vietnam when he got a text from Fukunaga that said: What are you doing next summer? "I knew instantly what he was talking about and my quick, unashamed response was, 'If it's about Bond, I'm free,'" recalls Magnussen, who starred in Fukunaga's Netflix show *Maniac* and was cast in *No Time To Die* as Logan Ash, working with Jeffrey Wright's Felix Leiter, who Bond meets in Jamaica and takes an immediate dislike to. "He's a combination of a Mormon mixed with an insufferable preppy college grad," says Magnussen. "Very straight-laced, doesn't drink alcohol, always follows the book, always chipper."

None of which stops Ash from straying to the dark side, pledging his allegiance to Safin's new world order, getting to shoot and fight Bond, before his demise. "Logan drinks the Kool-Aid and becomes part of Safin's cult," continues Magnussen. "He follows Safin's vision and wants to fulfil it. Logan doesn't think he's a bad guy, which makes him even more dangerous."

Magnussen recalls being very nervous filming his first scene with Craig and Wright. "I look up to Jeffrey so much, and to Daniel – what Daniel has done over the past few films is truly remarkable." Magnussen laughs out loud. "I am pretty sure I was so nervous while shooting that scene that every time I spoke my lines, it had to sound as though English was my seventh language. Honestly, it was one of those 'pinch me' moments."

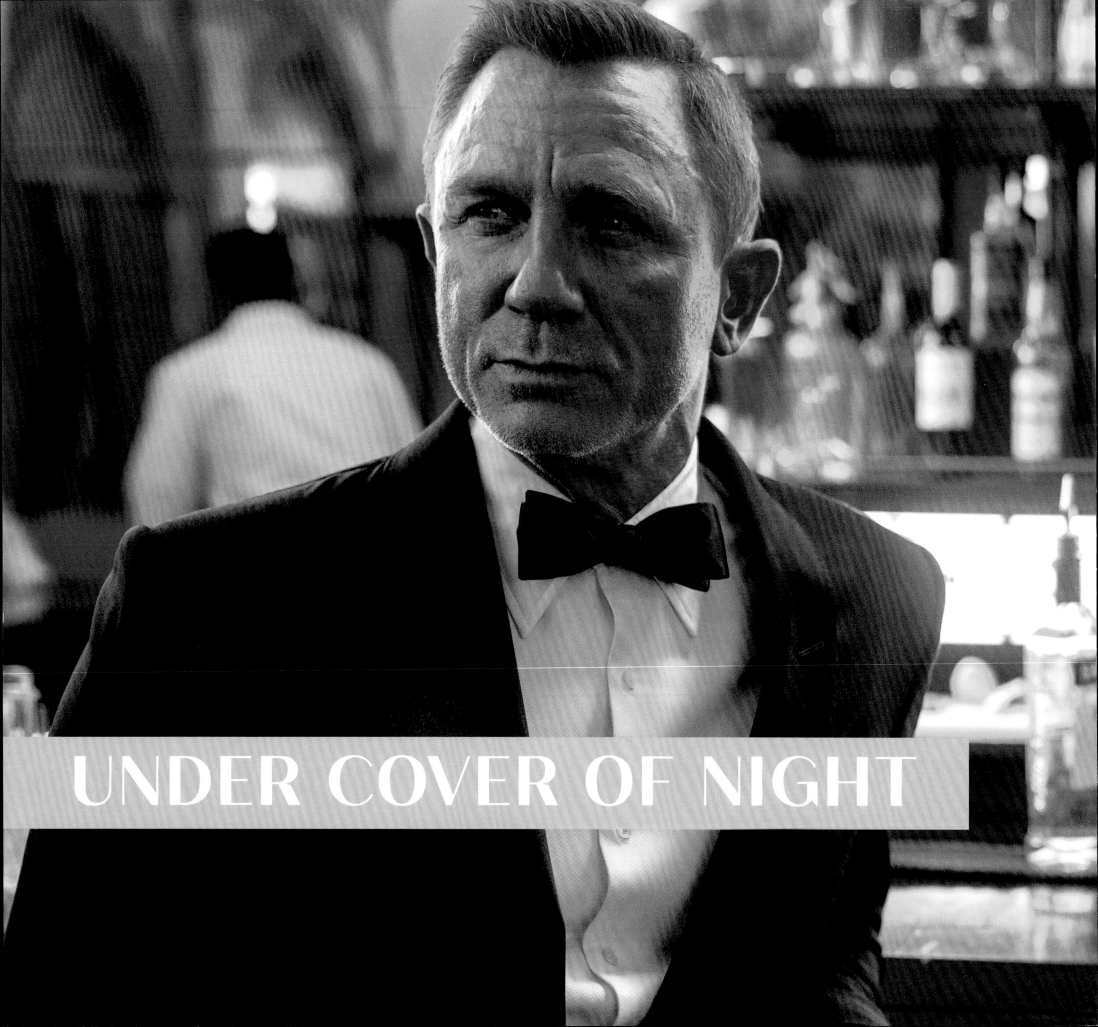

UNDER COVER OF NIGHT

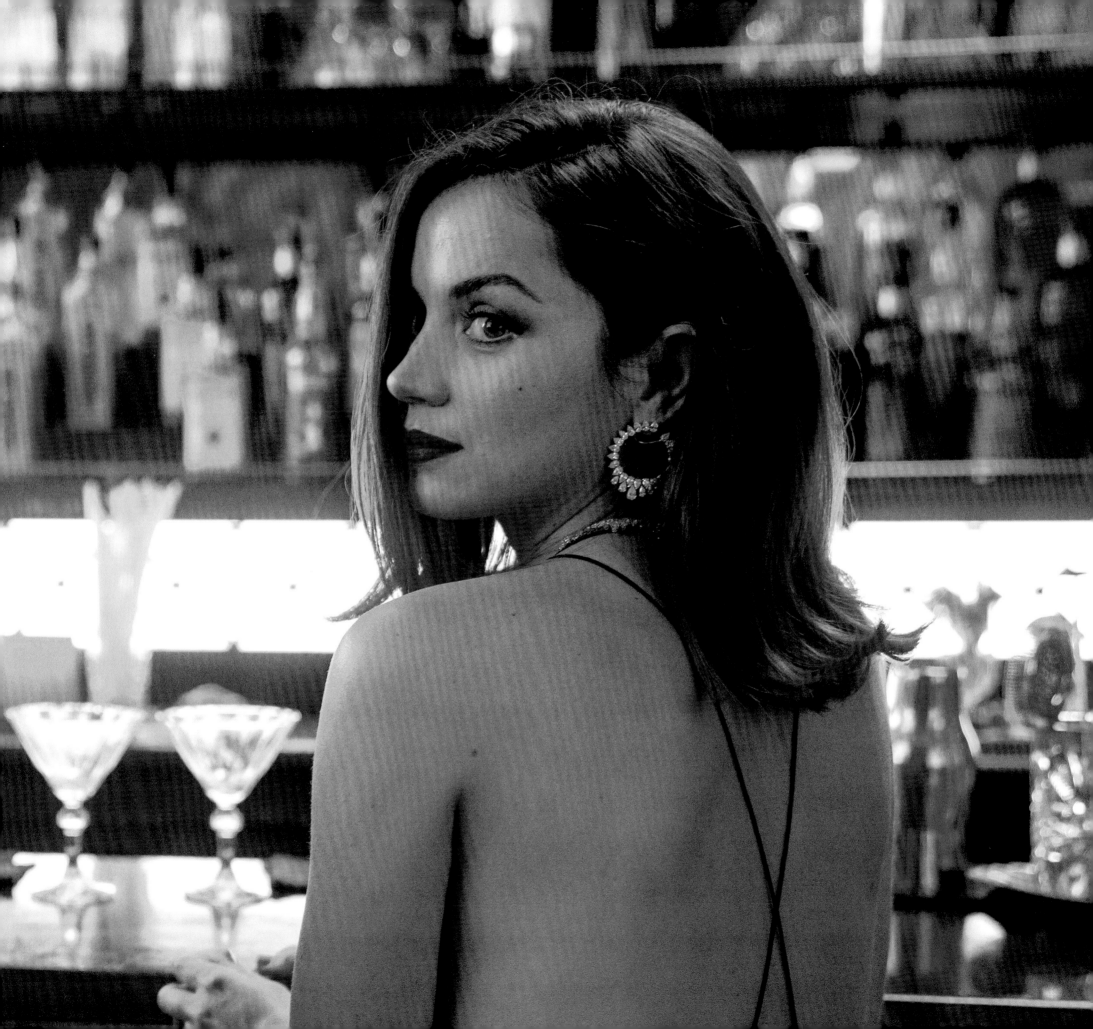

UNDER COVER OF NIGHT

ond arrives in Santiago de Cuba at dusk, rendezvousing with local agent Paloma (Ana de Armas) in a brightly lit corner bar. After changing into his trademark Tom Ford tuxedo, the pair head across the street to the ornate Hotel Olympia for a glamourous black-tie SPECTRE party that's taking place in an old dance hall, a party that their target is due to attend. Once inside, Bond finds himself in a literal spotlight, surrounded by SPECTRE agents still doing the bidding of their incarcerated leader, Ernst Blofeld. But neither Bond nor Blofeld are aware of another, even more sinister plan in motion, one that will result in the death of every SPECTRE agent present. Meanwhile, Nomi has tailed Bond to Cuba, determined to retrieve Valdo for MI6.

For Fukunaga, the SPECTRE party was a way "to bring some of the old-school Bond glamour to an otherwise gritty story, and the one opportunity to put Bond in a tuxedo. I wanted to do something that felt bizarre and kind of out there. We've had a lot of film up to this point, but this is the first time Bond is really being Bond again. We've been waiting for it and so I wanted to create something fabulous. And if it's going to be the end of SPECTRE, it might as well be a spectacular end."

The idea of Bond travelling to Cuba was present in Purvis and Wade's original script. "It's a place that's difficult for the British to operate in, so it's a place villains could get up to stuff," notes Wilson.

PREVIOUS SPREAD: Bond and Paloma (Ana de Armas) at the "Hopper Bar".

BELOW: Associate producer Gregg Wilson, Fukunaga and Craig.

BELOW: Producer Michael G. Wilson in costume for the SPECTRE party scene.

RIGHT: Shooting Bond at the SPECTRE party.

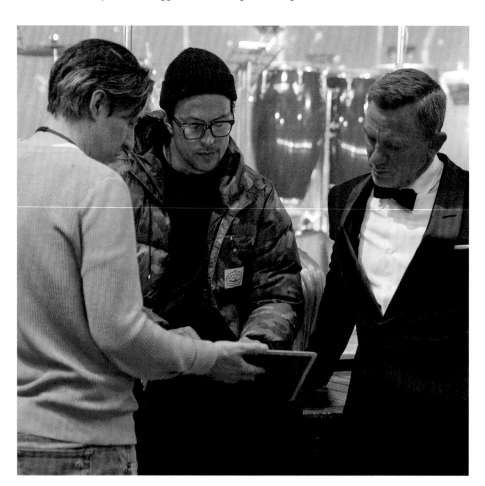

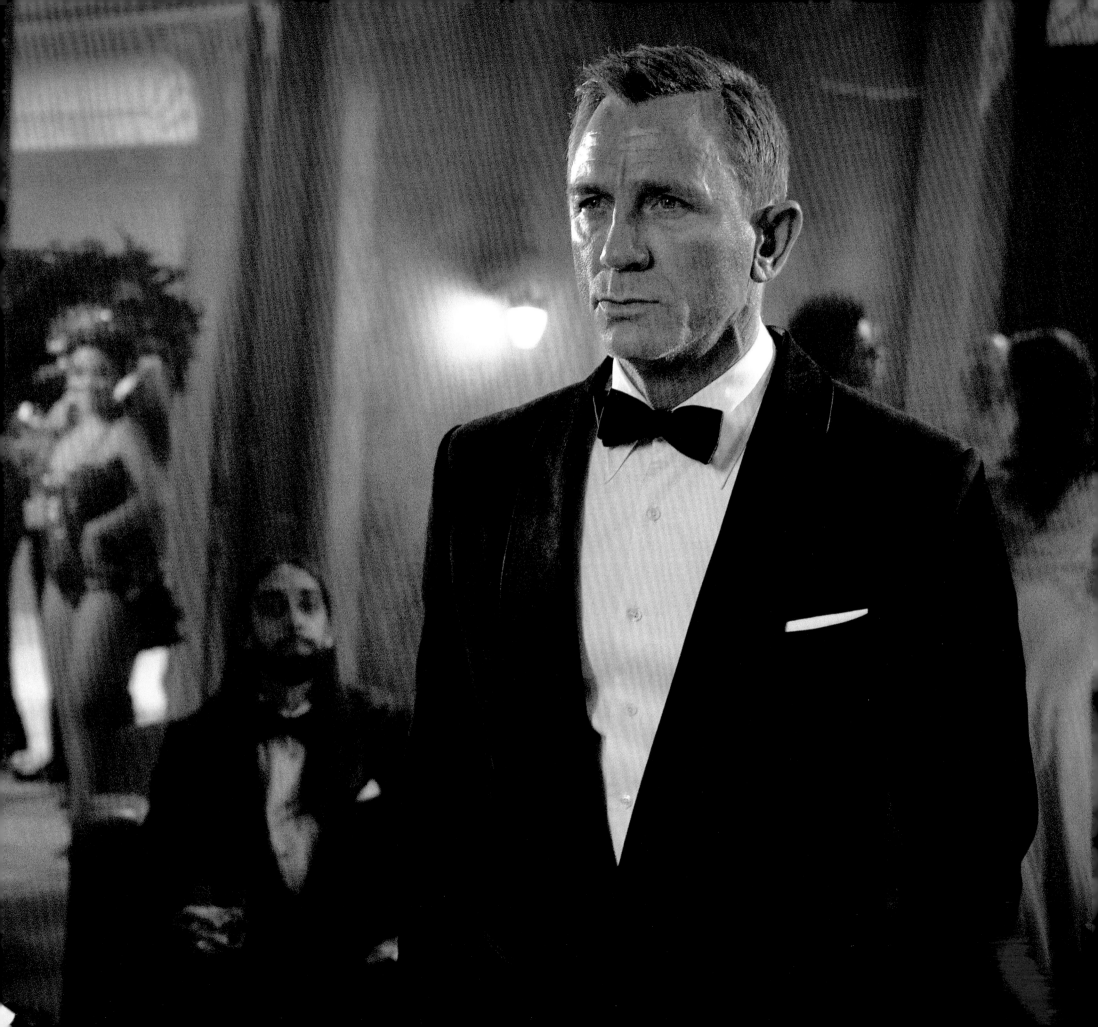

Also, while Bond previously visited Havana in *Die Another Day*, Pierce Brosnan didn't actually set foot in the Communist-governed country, with Cádiz, Spain subbing for the Cuban capital. So, for *No Time To Die*, Mark Tildesley was keen to shoot Cuba as Cuba and scouted the island with location manager Ben Piltz. "Mark did the tour, photo referenced it and found the bits he liked," says Chris Lowe. "Obviously, there are amazing textures, architecture, people, landscapes, light, dilapidation, vehicles – all the things you'd expect in a country that's been held back economically."

However, as the sequence continued to develop, it became clear that the level of action required by the script – gunfights, explosions, car crashes, destruction of property – would make shooting on location in Cuba impossible. "As these things gain 'stunt legs,' you realise you're going to have to close streets down and evacuate the people who live there for seven, eight, nine nights," explains Lowe. "When your unit becomes so big it's taking over the city, eventually there comes a tipping point."

Filming in Jamaica was briefly considered, before a more practical solution was found. "We thought, *How else can we do this?*" says Barbara Broccoli. "*Do we go to Spain, as we have in the past, and call it Cuba?* But seeing as it was such an extensive action sequence, we thought we might be better to build it, like we did with St. Petersburg for the tank chase in *GoldenEye*. We set Mark a pretty hard task of recreating Cuban streets on the north lot."

Measuring 250 feet long by 250 feet wide by 36 feet high, the Cuba set was built on Pinewood's north lot in a remarkable ten weeks and featured eleven buildings in total – four of which were composites, with full interiors – arranged along two intersecting streets, one with a colonnade running almost its entire length.

" I wanted to do something that felt bizarre and kind of out there... this is the first time Bond is really being Bond again. We've been waiting for it and so I wanted to create something fabulous. And if it's going to be the end of SPECTRE, it might as well be a spectacular end."

Cary Fukunaga, director

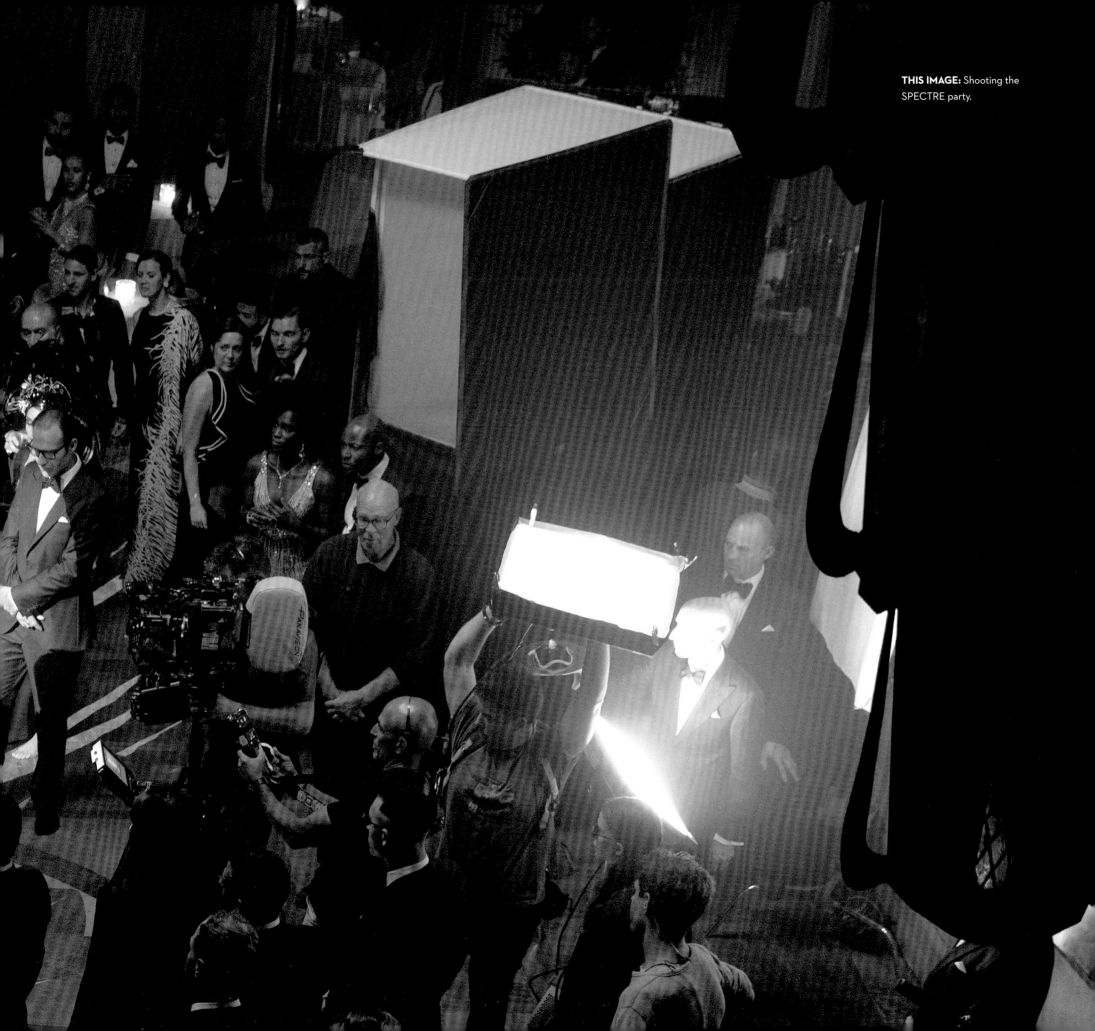

PALOMA

Bond's guide through the night-time streets of Santiago de Cuba is a feisty, if excitable, Cuban agent played by Ana de Armas. "Paloma's a fun character," says de Armas, who previously worked with Craig on *Knives Out*. "When the time comes to perform, she's really a badass, but she is also not afraid of saying how nervous she is and how this is her biggest job."

Fukunaga had first met with de Armas a few years ago about another project that subsequently fell through. "I really liked our meeting, and when this film came up I said to Ana, 'Do you want to do a cameo, just for fun?' and I wrote the character around her. Bond didn't really need a fixer," he admits.

Paloma required de Armas to spend two weeks training with Olivier Schneider's stunt team, learning to fire a gun as well as hand-to-hand combat. "That's probably the hardest thing I've ever done," she reveals. "I wasn't prepared, mentally or physically, for all the action. I thought I was going to mainly shoot people. But I was equally thrilled and excited as I was tired and insecure, because you can't fake being strong, you are or you're not. I never thought I was going to look good enough to play a spy who's trained for years. It's been [physically] painful."

"She knows how to use a weapon, but is not super technical. She's more of a street fighter, using her legs," says Schneider of Paloma. "She's very explosive and has an energy you don't expect, because she's tiny. That's why we had her do a special flying kick, then roll when she lands. It was pretty amazing, and very hard to do, because she was wearing high heels and a dress. Definitely not the ideal costume for a fight."

"A black-tie event means couture, and the dress we ended up with – navy blue, low cut, almost backless – is super lightweight silk,"

explains costume designer Suttirat Anne Larlarb. "If you stepped on it, it would shred, but because she runs a lot, it flows in a really lovely way when she is doing her badass work."

One of several strong female characters in *No Time To Die*, Paloma is most definitely not the typical Bond Girl. "As a young actress, I looked at Bond Girls like a myth and never thought I could be one, because it was hard to relate to perfection," de Armas insists. "I was really flattered that Cary, Daniel and the producers thought of me. When I read the script, I was surprised, too, because Paloma has flaws, she's not perfect, she's messy and scared and tipsy and makes mistakes. On the other hand, she's nothing close to the damsel in distress. She's actually the opposite. She's there to help James Bond get through the night alive. It's her territory, and so, at least for the night, she's in charge. That felt very powerful and very exciting. All the women in this [film] are really independent and strong and pretty equal to Bond. They're more like partners. That is much more fun and interesting, not only to play, but for an audience to see."

OPPOSITE & RIGHT: Paloma.

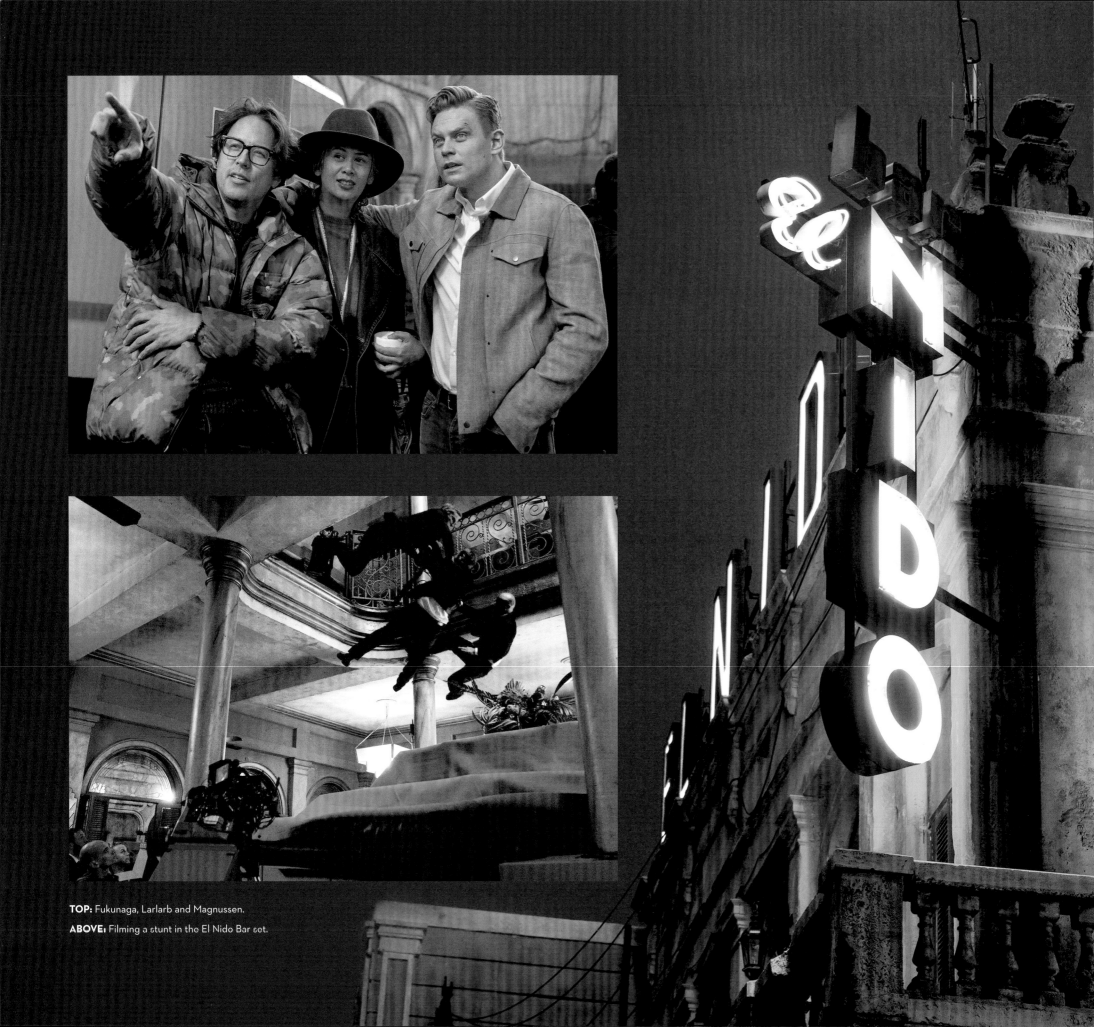

TOP: Fukunaga, Larlarb and Magnussen.

ABOVE: Filming a stunt in the El Nido Bar set.

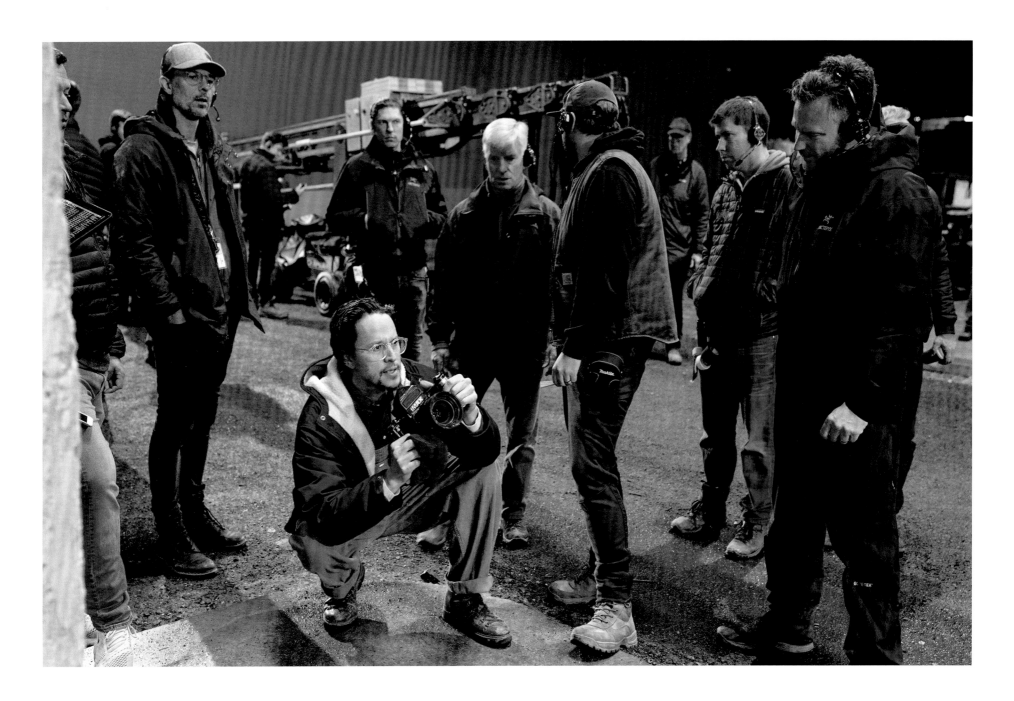

LEFT: The exterior of the El Nido Bar set.

ABOVE: Fukunaga and crew on set.

"The wonderful thing about Cuba is anything goes," explains art director Andrew Bennett. "I tried to create a juxtaposition of styles, placing modern buildings next to more period structures."

The majority were designed using a pick 'n' mix approach to architecture, with Bennett taking existing elements – a balcony, doorway, detail, or an entire floor – to create a series of unique buildings. Only two were based on real structures: the modernist El Paraiso Cinema at one end of Main Street was inspired by a 1950s Cuban nightclub, while its immediate neighbour, a pink period building – referred to as "Number 6" on the art department

plans – was based on one in Havana that had collapsed. "I wanted to give it its life back, so I resurrected it," reveals Bennett, who initially couldn't believe the size of the buildings as he drew up plans and blueprints and began modelling both in the computer and with card. "I did have to question it a few times, thinking, *Have I got the correct scale?* The doors are ten to twelve feet high, the arches and colonnades are very, very tall. Because Cuba is a hot and humid environment, everything is larger and more elongated." Even so, every building was designed to be extended vertically by visual effects in post-production.

"It was an expensive piece, because we needed a certain amount of scale to enact the sequence," admits Tildesley. The art department used repeated patterns throughout. "We had a set of seven arches and ten pillars and cut them up and put different arches with different pillars. There was a lot of trickery going on. It was a case of needs must. We managed to action-pack all Cuba's greatest bits into one set. We stole the best buildings and combined them into a Cuban mash. I would have loved to have filmed in Cuba, but it would have been a lot more naturalistic. What Bond requires is a slight heightening. It's a fantasy Cuban world. Andrew Bennett did a brilliant job pulling all those pieces together."

Bennett began by designing the stark fluorescent-lit bar where Bond meets Paloma, and which sits at the base of a brutalist apartment building on one corner of Main and South Streets. "It's a monster piece. I imagined somebody had bought a bit of land, didn't give a monkey's about the wonderful church next door, and built this horrible thing on the corner." Dubbed the "Hopper Bar," after Edward Hopper's celebrated 1942 painting *Nighthawks* – a copy of which cinematographer Linus Sandgren gave the art department, initially as a lighting reference – it influenced the look and feel of the entire set. "It's the heart of our Santiago de Cuba, that corner bar," Sandgren explains, "but unlike the one in the Edward Hopper image, where you have warm light spilling out into the night, in Cuba they often light spaces with crude fluorescent lights. It's like garage lighting. Some consider these lights to be quite horrific, but I love them. It's quite wonderful to create a romantic image with harsh fluorescent lights. It's an aesthetic thing that does represent Cuba. Although these lights alone can be too cold, so we mixed it with warm practicals, to give the sets a great depth and stay in an enchanting world".

Across Main Street from the Hopper Bar sits the canary yellow Hotel Olympia and adjacent chalky

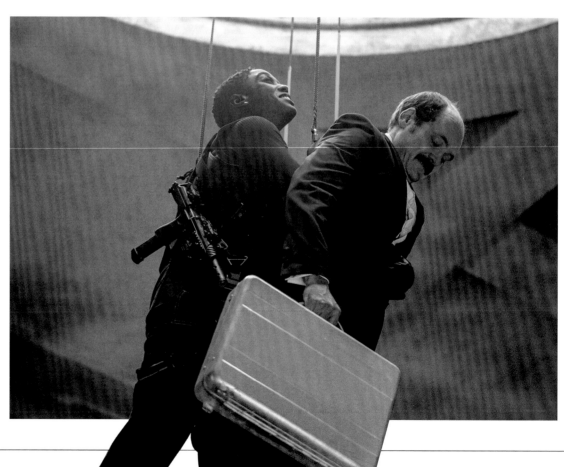

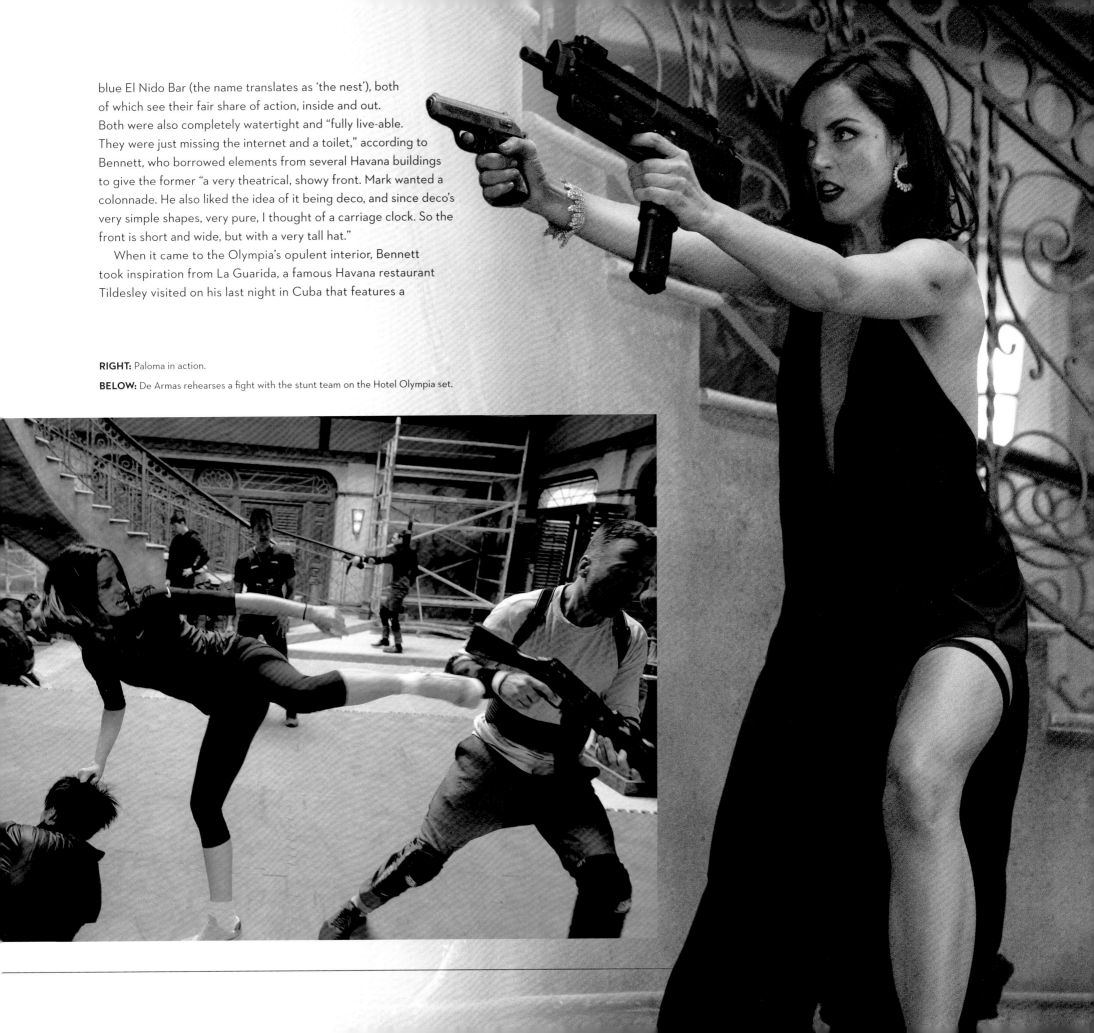

blue El Nido Bar (the name translates as 'the nest'), both of which see their fair share of action, inside and out. Both were also completely watertight and "fully live-able. They were just missing the internet and a toilet," according to Bennett, who borrowed elements from several Havana buildings to give the former "a very theatrical, showy front. Mark wanted a colonnade. He also liked the idea of it being deco, and since deco's very simple shapes, very pure, I thought of a carriage clock. So the front is short and wide, but with a very tall hat."

When it came to the Olympia's opulent interior, Bennett took inspiration from La Guarida, a famous Havana restaurant Tildesley visited on his last night in Cuba that features a

RIGHT: Paloma in action.

BELOW: De Armas rehearses a fight with the stunt team on the Hotel Olympia set.

staircase crossing over a road that runs *inside* of the building. "I was looking at the interior thinking, *That is stunning*, and was mildly determined to have it in the set somehow." For Bennett, the ornate iron and stone staircase presented a fantastic opportunity to show "all the grandeur and wealth Havana had." The staircase was so large, in fact, it required three columns to hold it up. "I was very specific about where it started, how the first step was extremely wide and tapered to a narrow section, then folded round in a moon shape and came back up," he notes. "Initially, Bond needed to be led up the stairs by Nomi to the mezzanine, but the action changed slightly, so now Bond runs up the staircase and jumps over the railing."

Both the mezzanine and foyer featured a series of colourful Cuba murals that were the idea of set decorator Véronique Melery, who commissioned Rohan Harris to create them, unaware that Fukunaga was a massive fan.

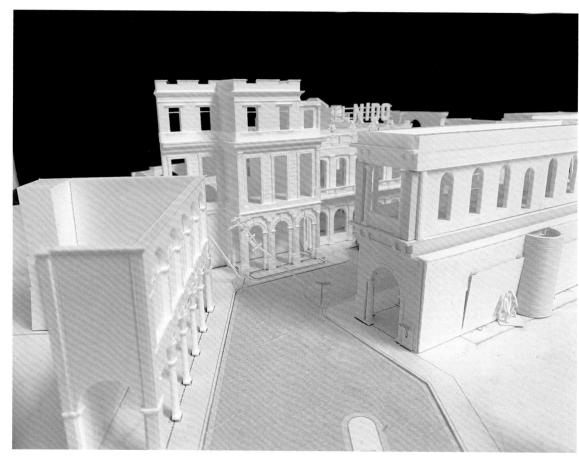

RIGHT: A model of the Cuba set by Rob Jose, Jack Cave and Jonpatrick Prendergast.

BELOW: An elevation colour study of the El Nido Bar section of the Cuba set by Frederiksen.

OPPOSITE: The Cuba set under construction on the north lot at Pinewood Studios.

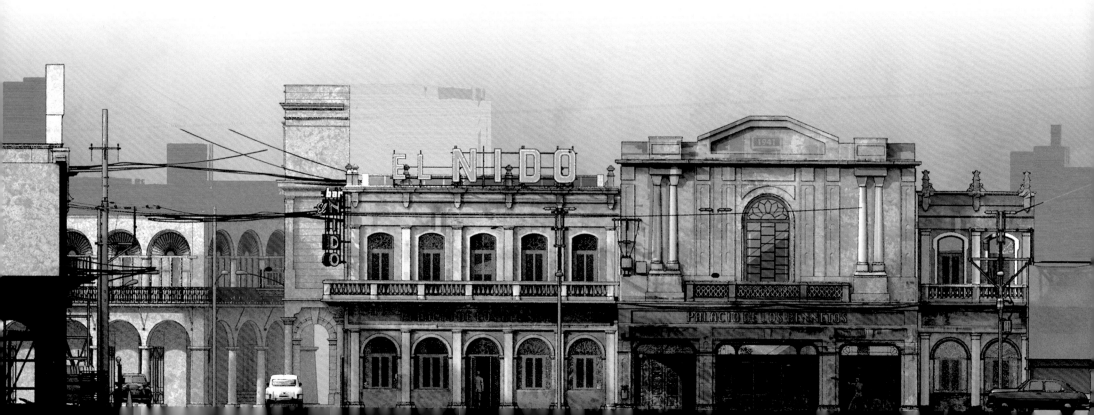

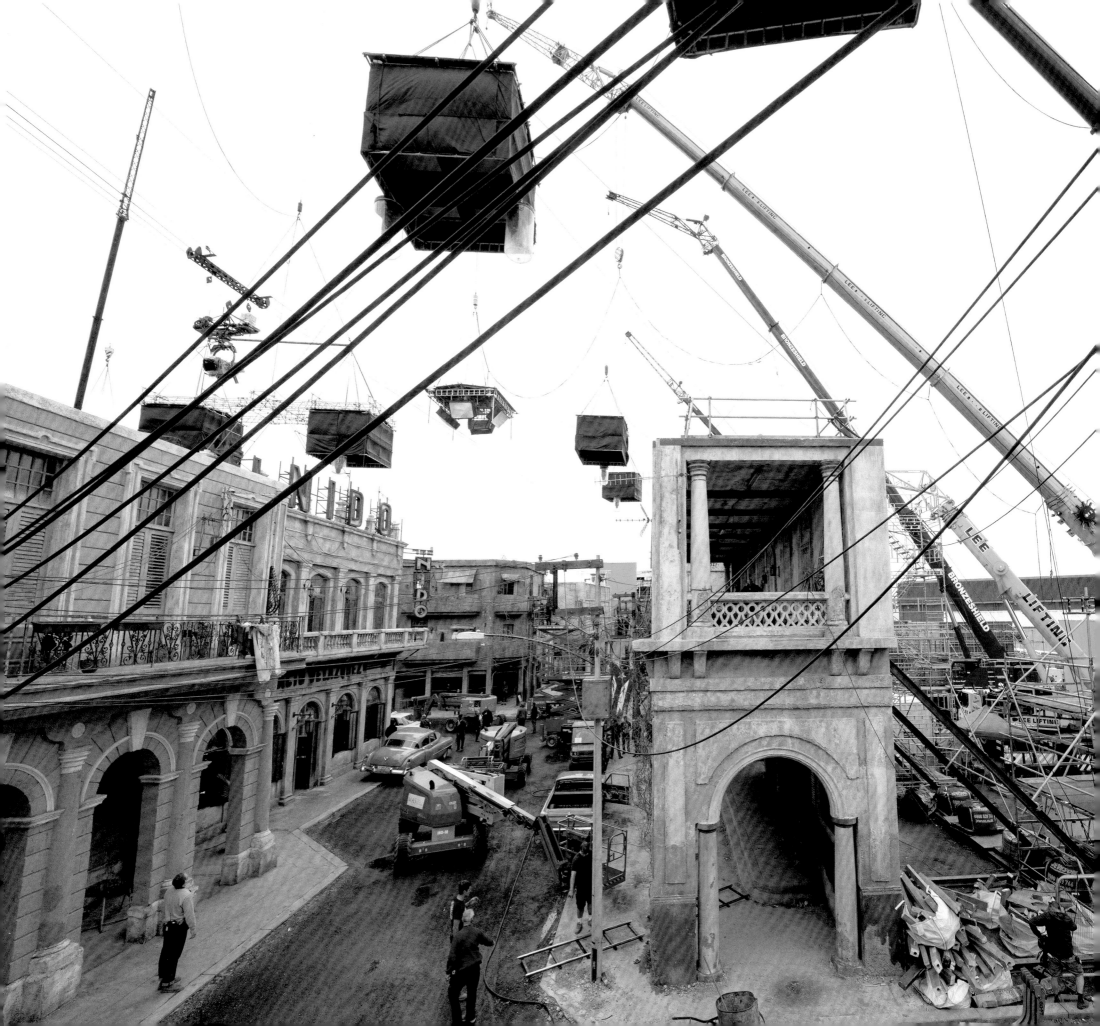

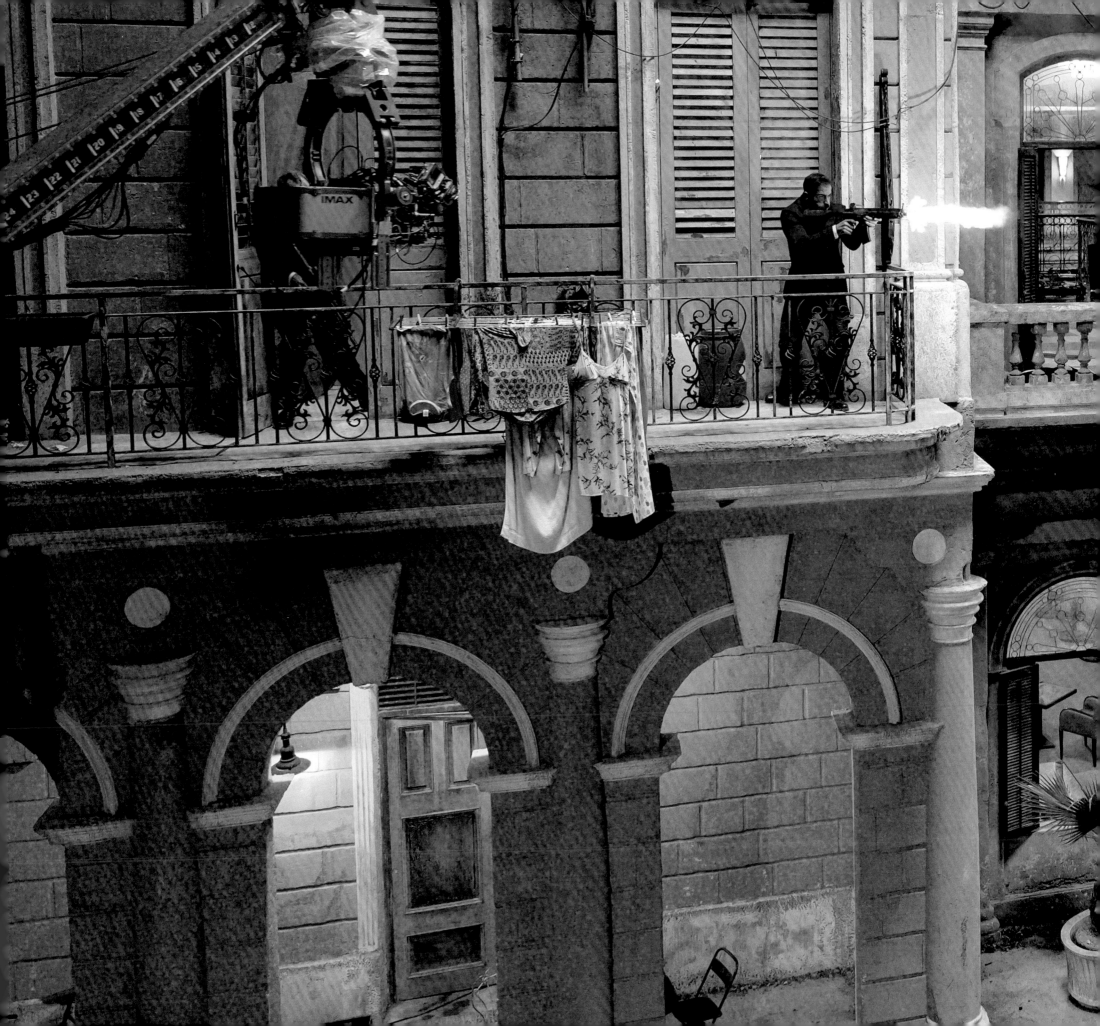

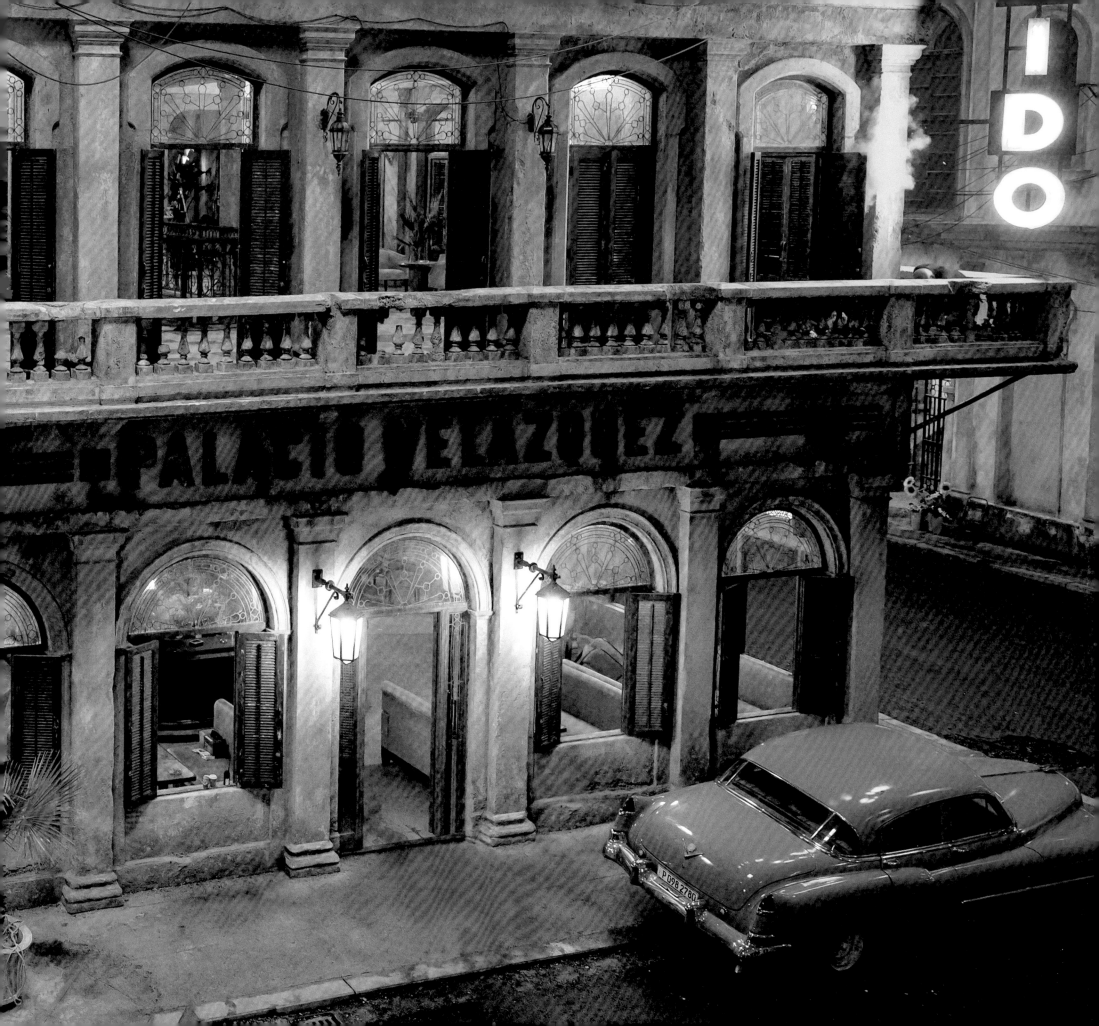

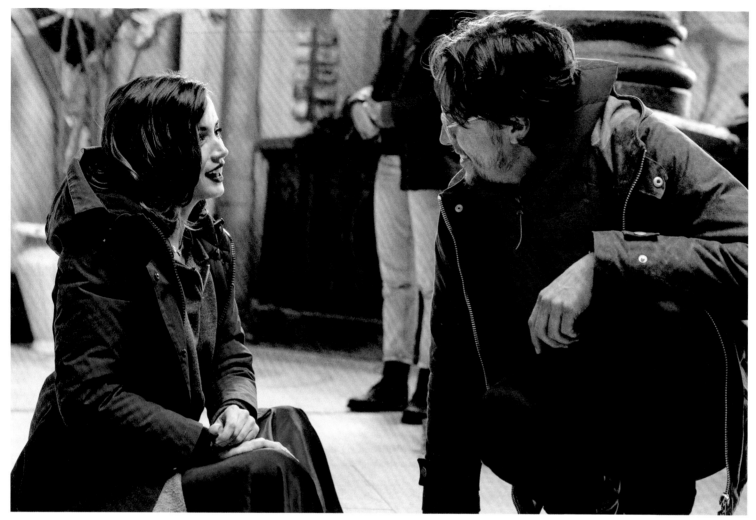

PREVIOUS SPREAD: Shooting a gunfight on the Cuba set.

ABOVE: De Armas and Fukunaga between takes on the Cuba set.

RIGHT: Lynch and Dencik behind the scenes on the Cuba set.

"I wanted to bring something from Cuba, having been there years ago," Melery notes. "I remembered all these walls were painted and thought it would be nice to recreate this sort of exuberance in a place that was otherwise quite formal. One day Cary came by and said, 'I love that,' so I tried, with Mark, to add more into our sets."

"I love murals," reveals Fukunaga. "Frescos, murals, mosaics, anything that's figurative on a wall I think is really interesting. I even put them in my own house, I like them so much. They did some beautiful ones in the SPECTRE party scene and around the hotel, although you can hardly see them." Look hard enough, however, and you will see the familiar figure of Che Guevara on the side of one building. "I was looking down the aperture at the end of the balcony one day and thought,

This needs something," recalls Fukunaga. "Then I thought Che playing chess was an interesting image." The mural was then painted by Marcus Williams.

The centrepiece of El Nido was a pill-shaped mahogany bar, with a column embedded into the countertop at each arched end, that Bond crashes into from the mezzanine above. "Cary did a sketch for me, showing how Bond and Paloma work their way into the bar, into the top level, and work their way around, so the building has a dome, a skylight, a staircase and a bar," reveals Bennett. "It's a fantastic space. And my third bar on a Bond."

The fourth and final composite set was a charming barber's shop through which Bond flees with Valdo and Paloma. "It's a very Cuban thing," Bennett continues. "Very tall. The ceiling is fifteen or sixteen feet high. There are fans. It was a sparse, wonderful

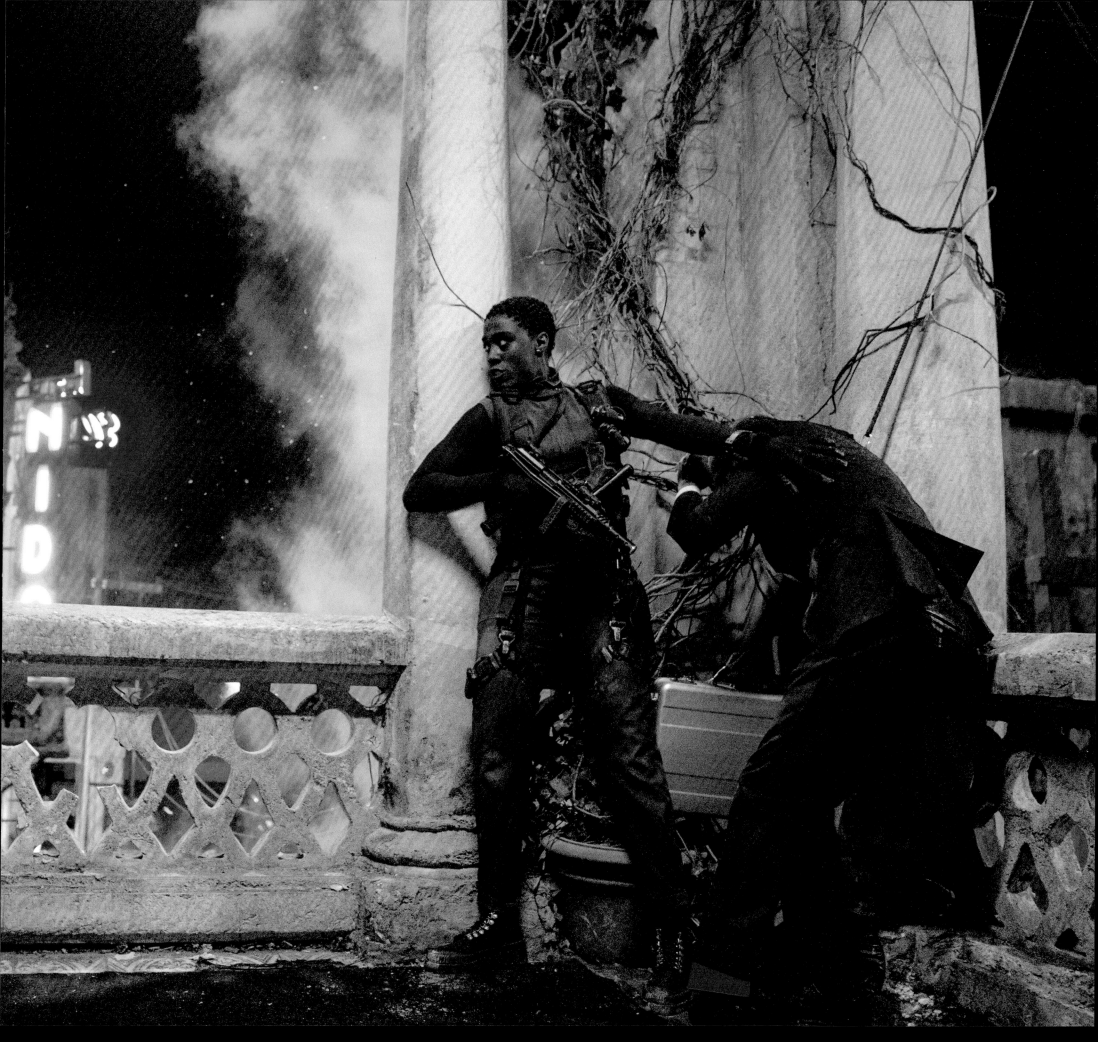

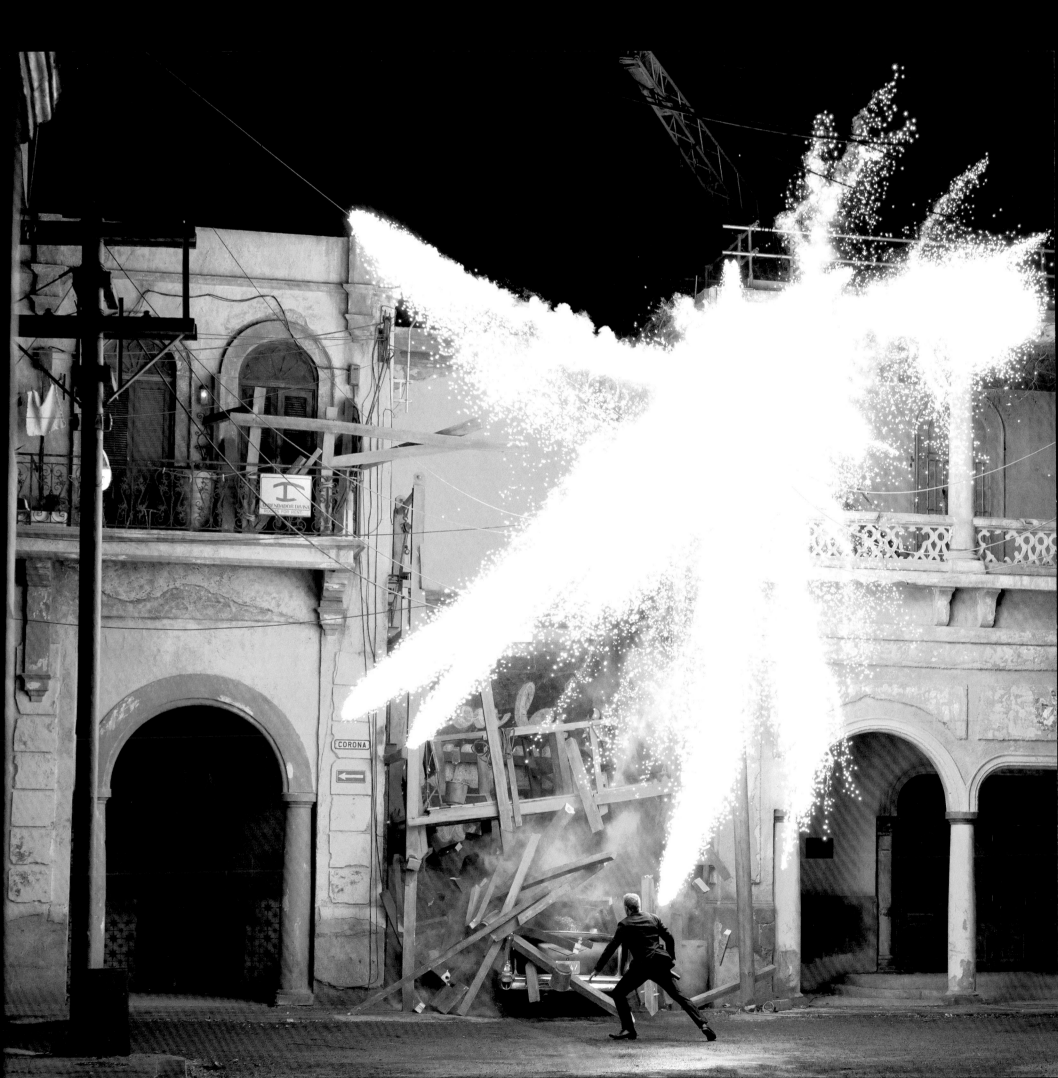

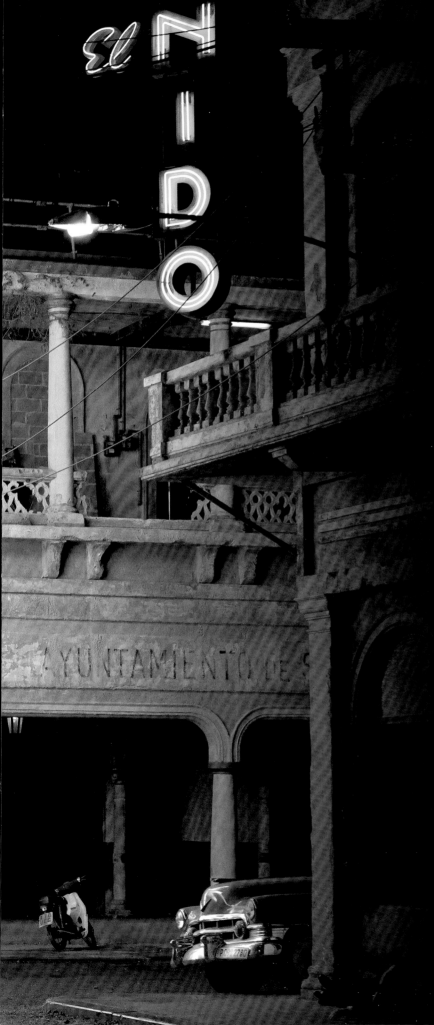

space. Pure Mark Tildesley."

Given that the Cuban sequence takes place almost entirely at night, light – mostly fluorescents and large crude neon signage – was paramount, and Bennett worked closely with Sandgren to "create light in a very graphic way." Every window opened and every louvre worked, so the cinematographer could put his lights anywhere. "I love working on a stage. It's more practical and you can control everything and design all the lights," says Sandgren, who had ten construction cranes positioned around the vast back lot, with a massive light box hanging from each. "If we had been in Santiago de Cuba, lighting the way we lit the set would have been impossible. With this film, we wanted to design *everything*: the world, the production design, the costume design, the lighting."

Colour, too, was crucial. "Cuba's very colourful, but I punched it up a little bit more than I normally would," continues Bennett. "We've got very strong blues and pinks and greens, so when it came to the night, the colour still had presence. If you're too timid with it, it goes flat."

Distressed paintwork, haphazard metalwork, flickering neon, crumbling brickwork and balconies with hanging washing all helped the set's verisimilitude, with Tildesley keen to replicate Cuba's "faded glory, because one of the things that's wonderful about Havana is it has these lovely buildings but it's crumbling."

"Cuba is not a daily maintained environment. Some buildings are slightly more painted, some aren't, some are almost on the point of falling down," says Bennett. "When we were dressing the set, I said, 'Don't hide the wires, don't be nice about it. *Ruin* it.' I wanted the planting to be caught up in the buildings, to show a sense of age and how some have been left to fall apart."

"The set was amazing," enthuses Fukunaga, "and there were moments where you felt completely

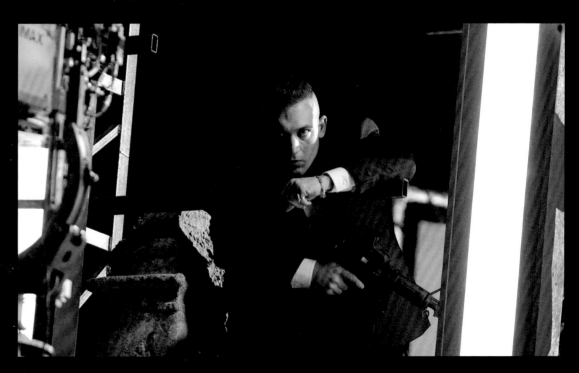

LEFT: Behind the scenes of Paloma drives a car into telegraph poles.
ABOVE: Primo pursues Bond and Paloma.

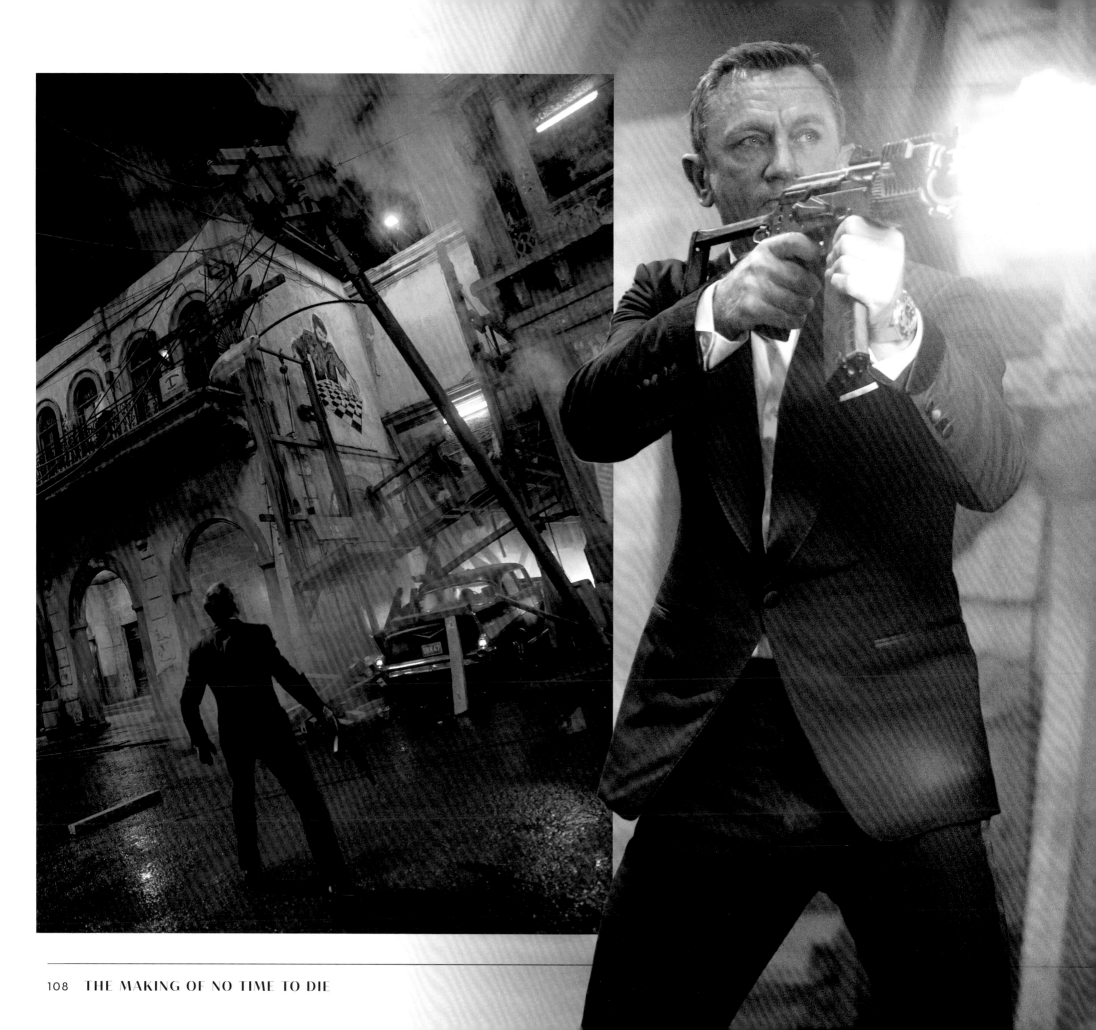

FAR LEFT: The car crash.

LEFT: Bond in action.

BELOW RIGHT: Paloma.

transported. Whenever people visited, I would take them on it, because it was so impressive. Mark's sets are so beautiful you sometimes feel you want to shoot the set more than the scene. What I think is most impressive about all the sets we built is you do really travel the world from Pinewood."

"It was really stunning," agrees Cuban-born Ana de Armas. "I was shocked at the size and scale of the whole thing. It was pretty accurate: the colours, the textures, just the feeling of it. The only thing that didn't match was the weather, but I guess you can't tell that on camera. I wish we could have done it in Cuba, with the people and the vibe and the energy. I would have loved that, having my people working on a movie like this, but it can't get better than this amazing set as a second option. Everyone really did their research. It looked beautiful, and it made me feel a little closer to home."

As the Cuba set would play host to an enormous amount of intense action, Bennett worked with both the stunts and special effects departments to incorporate breakaway elements, bullet hits, rubber telegraph poles and collapsible scaffolding into

his various designs. A glass dome was integrated into the roof of the Olympia's foyer so Nomi could come crashing through, before later rocketing back up again with Valdo. The pair then hightail it across the El Nido roof and zipwire across the street to the rundown civil building opposite using Nomi's Q-designed harpoon gun. "That is a nifty little gadget she has there," says Lynch of Nomi's weapon, which was designed and built by the special effects department. "It's on her person all the time and she uses it here, there and everywhere, almost like a mysterious ninja in the sky."

For another scene, scaffolding was rigged to collapse when Paloma drives a car into one of three (rubberized) telegraph poles. All three were built on pivots, so they would safely fold down on top of each other, showering sparks into the street and bringing the scaffolding down on top of the vehicle.

"Cuba was a huge sequence to design and rehearse," says Olivier Schneider. "We had jumps, fights, gun fights. It was a long process to tell the journey of so many characters at the same time, but still tell Bond's story."

> **Cuba was a huge sequence to design and rehearse. We had jumps, fights, gun fights. It was a long process to tell the journey of so many characters at the same time, but still tell Bond's story."**
>
> *Olivier Schneider, supervising stunt coordinator*

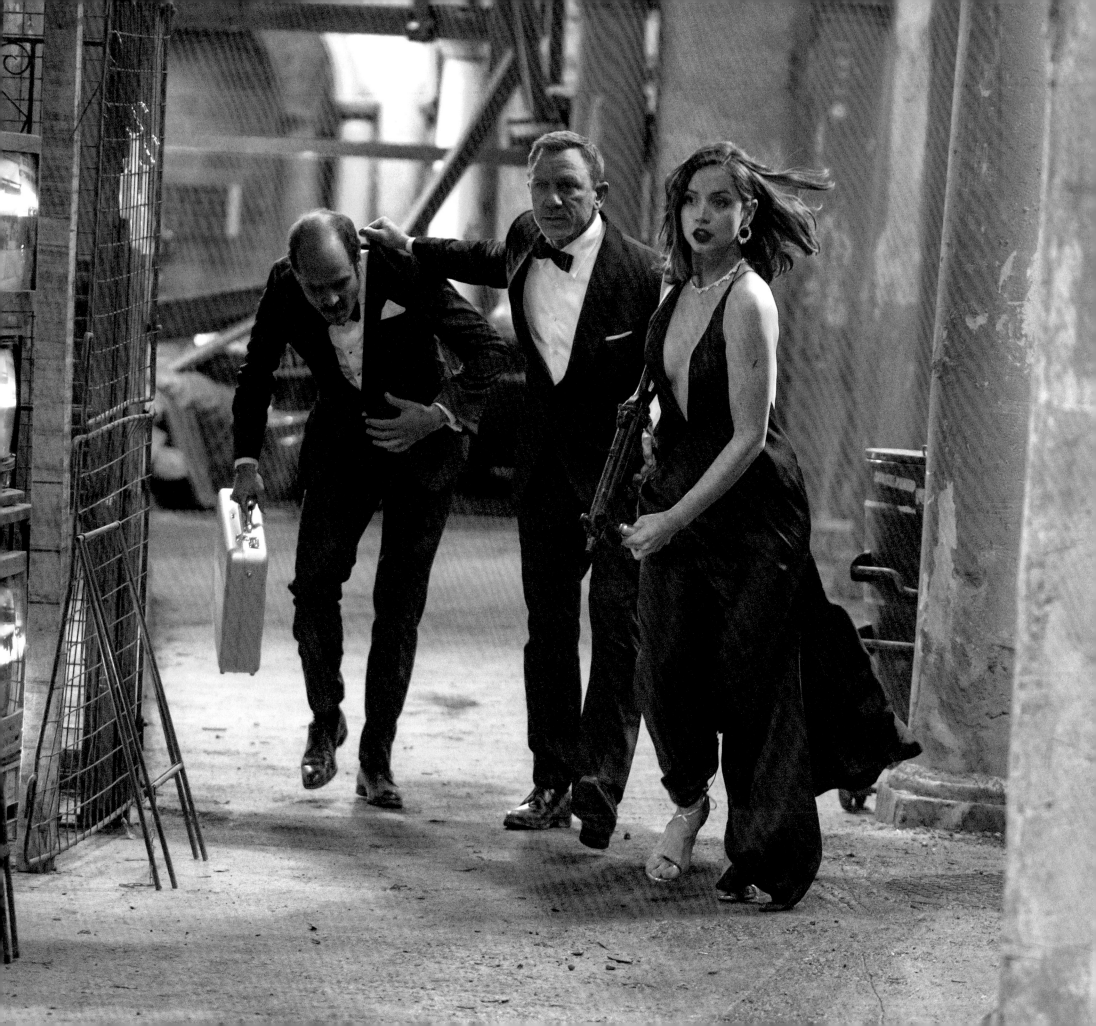

THE TUXEDO

"We knew there would be an event in Cuba that would require everybody to be in black tie," says costume designer Suttirat Anne Larlarb, "so I looked at all of Daniel's suitings, all of his tuxedos, all his formal wear from the previous films, looking at the details of what's come before; the proportions of the collar, the shirting underneath, all of those things are considered and tweaked and updated. I wanted to make sure we were able to move things forward and not just repeat something. We needed to find a way to have Bond take ownership of this particular tuxedo." As in *Skyfall* and *Spectre*, Bond again wears a Tom Ford tuxedo, an adjusted version of the Atticus model custom-tailored for Craig. "We had multiple fittings in New York and London just to get all the details right," says Larlarb. "In addition, there are aesthetic differences, like how low the collar sits, how wide the lapels are, does it have a longer torso, does it have a shorter body rise, are the shoulders close to the person's body, are they a bit more structured."

It's not just a case of what looks good. Bond's tuxedo has to stand up to the rigors of action, too. "The costume department has access to the storyboards, any pre-visualisation, lots of discussions with the stunt department, and we also need to factor in all the what-ifs," continues Larlarb. "We vaguely knew we were going to be in the tropics, so I wanted to make sure it was a tropical-weight wool. We could have used a lighter-weight fabric, but it wouldn't have looked as sharp or as sculptural as I needed it to, and because of the physicality expected, we were looking for fabrics that would have a little bit of give."

Ultimately, whatever the fabric, whatever the cut, Craig looks sharp. "He has a fine physique for wearing anything, truly anything," concludes Larlarb. "It could be a pair of shorts, a T-shirt, a pair of jeans. It's a pleasure to dress him, because there's not a whole lot he doesn't look good in."

LEFT: Bond and Paloma make their escape with Valdo.

RIGHT: Bond in his Tom Ford tuxedo.

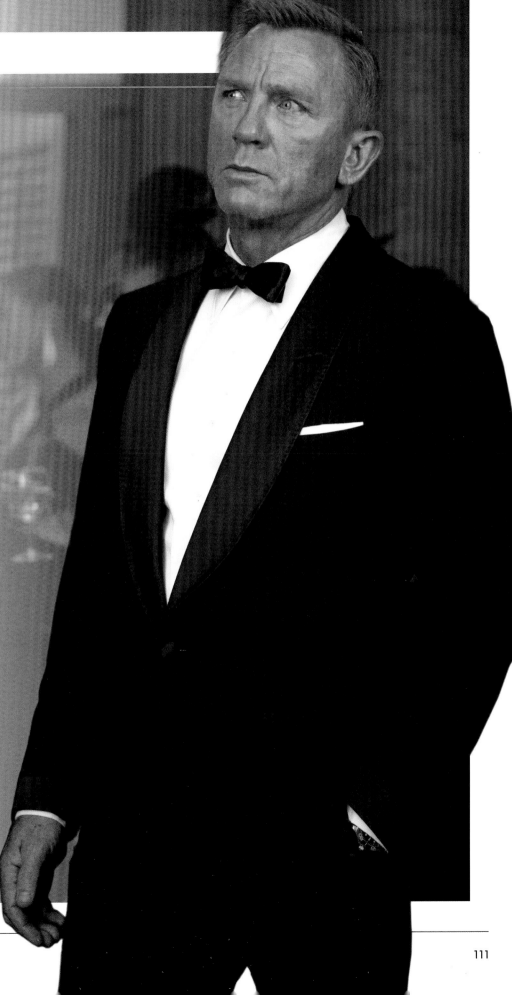

The Cuba set was designed to last for a couple of months. However, following Craig's injury in early May 2019, all the heavy action involving Bond was pushed to the tail end of the shoot, with main and second unit filming around the actor on the Cuba set in June, before Fukunaga's unit returned with Craig, de Armas, Dencik and Lynch for the final week of principal photography in late October. Meaning the set remained standing for five months, a credit to the craftsmanship of the construction crew, painters, plasterers and set decoration team involved. "We were originally meant to be shooting in June, which was going to be warm," notes Fukunaga, "and ended up shooting in October, with thick woolly sweaters."

One unexpected side effect was the way the set weathered over time. "I think it improved on a month by month basis," says Tildesley, "as the colours faded and it started to get a little bit shabby. There were even plants growing out of the buildings. It began to take on a life of its own, which was quite fun." Ultimately, the only downside was that the north lot couldn't be used for anything else until Cuba was struck. "The creative side of it was definitely worth it," insists Lowe, "and it solved an injury problem. It meant we could go back as and when we wanted, to change the action or scenery. It was a very good justification for why we should build these things in the first place."

"I'm so glad we built it," says Fukunaga, "the amount of hours we spent there, trying to do that sequence. We would never have got that on a public street. It would have been impossible to shoot."

LEFT & BELOW: Valdo and Bond escape in a sea-plane. Filmed on location at Kingston Container Terminal in Jamaica.

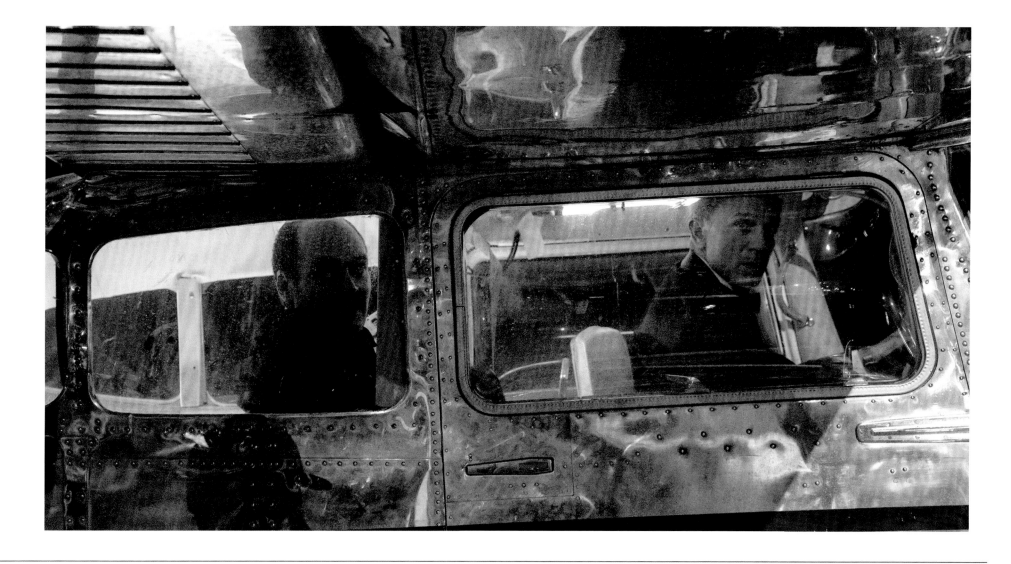

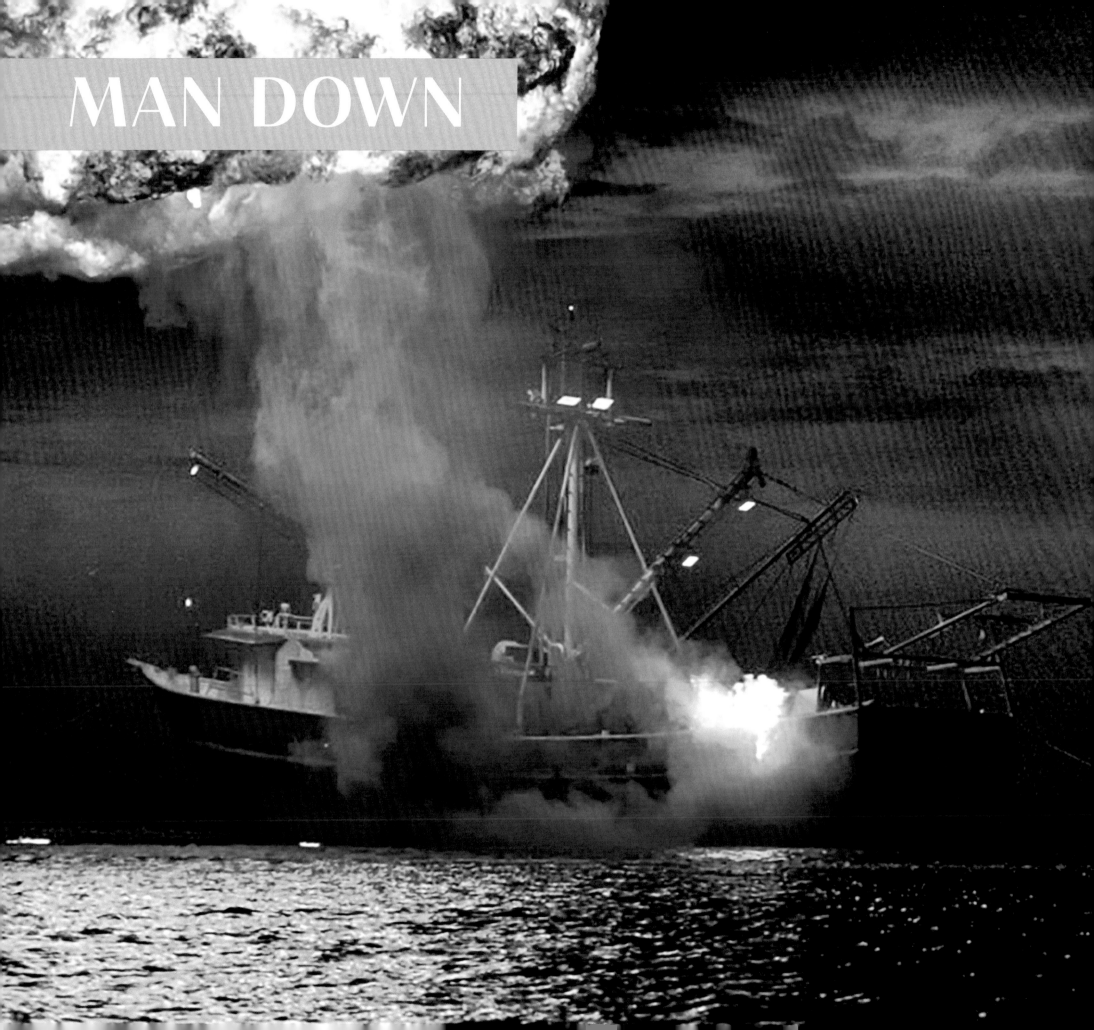

MAN DOWN

MAN DOWN

After flying Valdo into international waters to meet with Felix and Ash on a fishing trawler, Bond discovers that Ash is one of the bad guys. He shoots Felix, locks Bond and Felix in the engine room, then blows a hole in the trawler, with the two friends trapped inside the sinking vessel.

The boat, a disused shrimper, belonged to a Jamaican fisherman named Norman from whom the production rented it. "It was fantastic, a wonderful little boat," reveals Mark Tildesley. Nevertheless, the art department spent a week

"painting it to look like a rusty old hulk," before special effects mounted an explosive device to its hull, then piloted it off the coast of Jamaica, where second unit director Alexander Witt shot the explosion at dusk with Ash's plane taking off, silhouetted in front. "We had to do it twice, because the first time the plane was too far away from the explosion, and we wanted to have both in the same shot, so we did it again the next night," says Witt. "We could have done it with the help of CGI, but we'd rather do it for real and it worked perfectly. We always look for the real thing on Bond."

PREVIOUS SPREAD: The fishing trawler explodes with Bond and Felix trapped inside.

BELOW: Concept art of the trawler and Bond's sea-plane.

RIGHT: Bond and Valdo with the Heracles virus vials on board the trawler.

For interior scenes, the art department built a sixty-foot replica of the trawler's front hold and engine room at Pinewood, casting the entire set – engine, pipes, floor, walls, ceiling – in rubber, so Daniel Craig, Jeffrey Wright and Billy Magnussen wouldn't hurt themselves while filming the fight. "When I was looking for reference I found an image of a Japanese captain, on the ocean, with a dark blue night sky behind him and his face all red," says Linus Sandgren, who bathed the trawler, inside and out, with red light. "Then I remembered, in my dad's sail boat we had a special lamp for reading sea charts that you could make red. Having just come from Cuba, Cary and I felt it was mysterious and quite beautiful, the combination of the dark, dark blue sky and the red light."

As the engine room of the trawler set would need to be submerged on Pinewood's Underwater Stage, its shell was built of mesh and steel to minimize buoyancy, "so it's not fighting when it goes down," says Tildesley. To simulate the boat sinking, Chris Corbould mounted both ends to a hydraulic system, which not only allowed it to move up and down, but rotate 360 degrees like a large spit roast. "Weirdly enough, it didn't look so good upside down, because staircases still look like staircases," explains

> **"I remembered, in my dad's sail boat we had a special lamp for reading sea charts that you could make red. Having just come from Cuba, Cary and I felt it was mysterious and quite beautiful, the combination of the dark, dark blue sky and the red light."**
>
> Linus Sandgren, *director of photography*

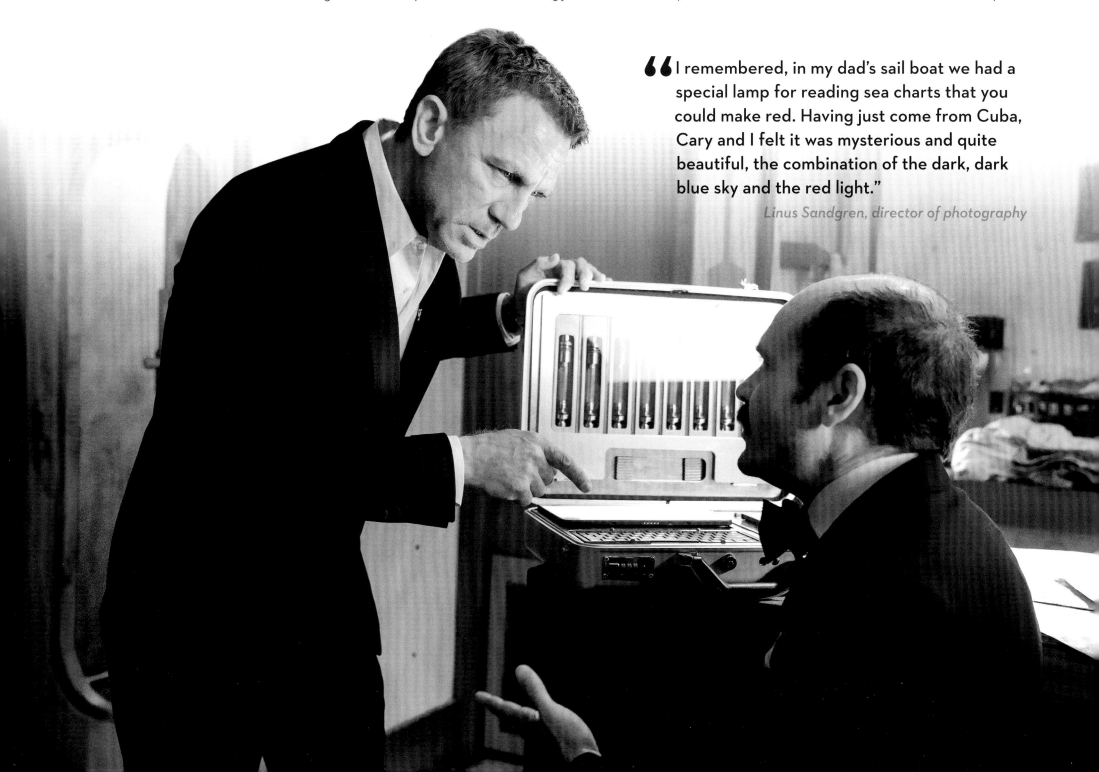

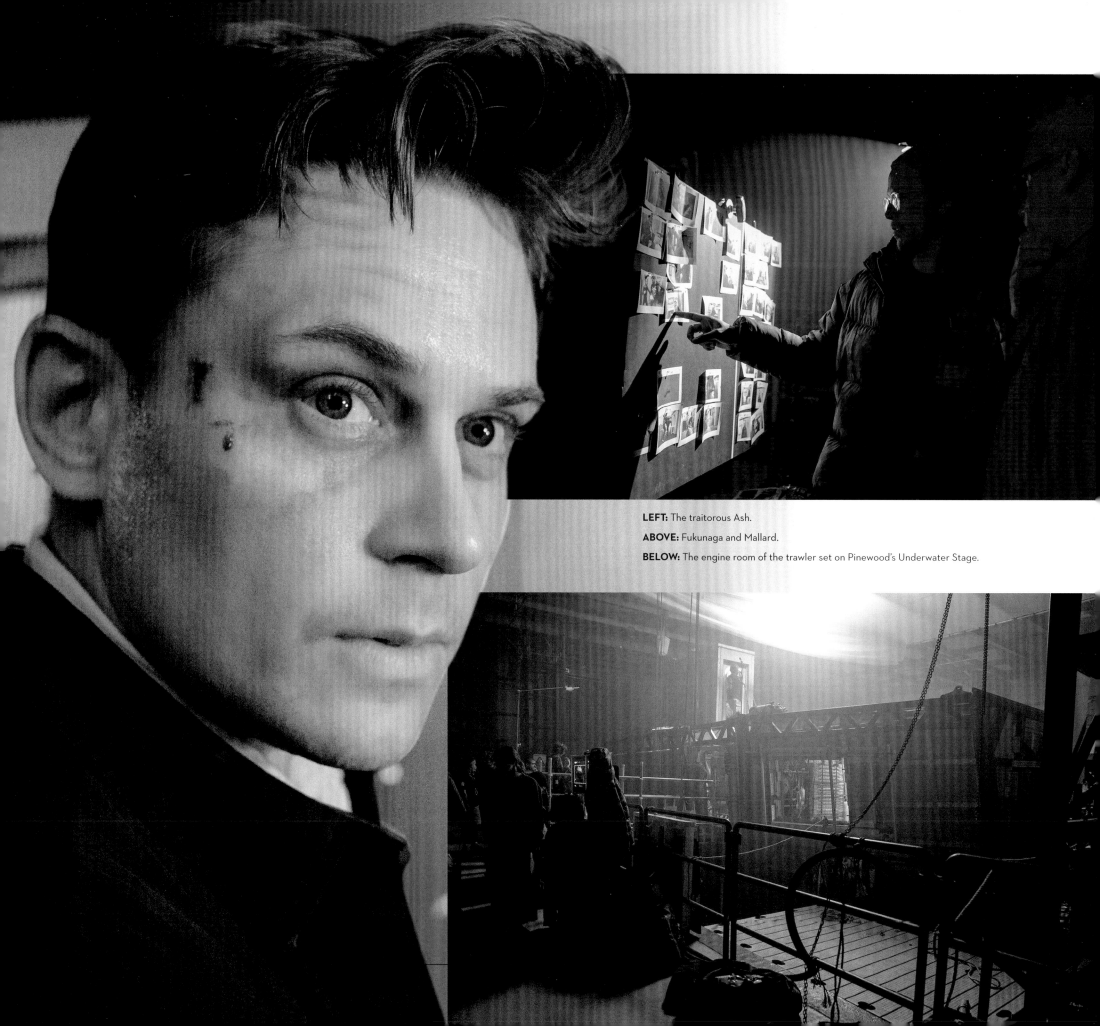

LEFT: The traitorous Ash.

ABOVE: Fukunaga and Mallard.

BELOW: The engine room of the trawler set on Pinewood's Underwater Stage.

Corbould, who also built the sinking Venetian house for the climax of *Casino Royale*. "It was more interesting at 90 degrees, with the engine sticking out sideways."

"Chris is an absolute genius, and the things he's built for Bond over the years are mind-blowing, but this particular rig was a standout," insists stunt coordinator Lee Morrison, who, together with Corbould and Craig, blocked out the scene on video, in the dry first, choreographing the trawler sinking with the action inside the engine room, before submerging the set and determining how long the actors would need to hold their breath. "Daniel wanted to get a feel for it himself, the way he wanted it to sink," says Corbould. "Then Cary came down and we got his input. There was debate around how quickly it should fill up, how many bubbles, does it roll sooner, does it roll later. It was combining a lot of ideas to get what everyone was happy with." Once everyone was satisfied, the rig's movements were programmed into a computer, which meant they could be replicated over and over again at the press of a button.

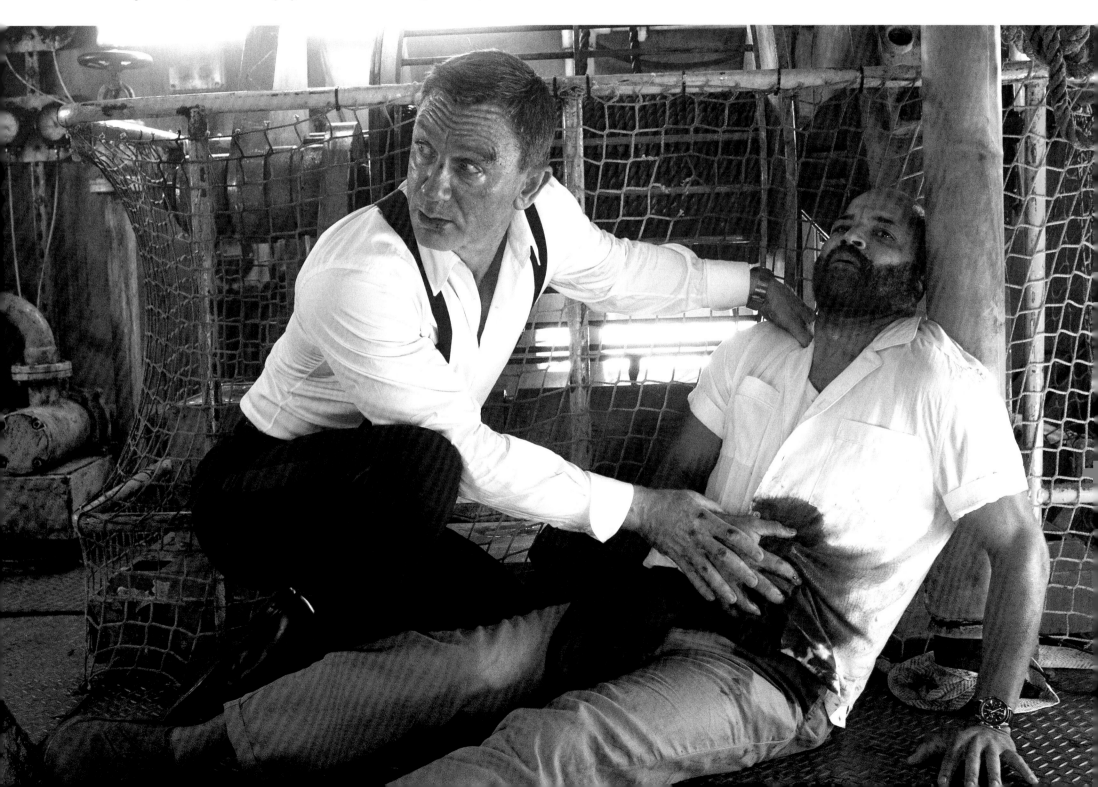

BELOW: Bond and a gravely injured Felix are trapped in the engine room.

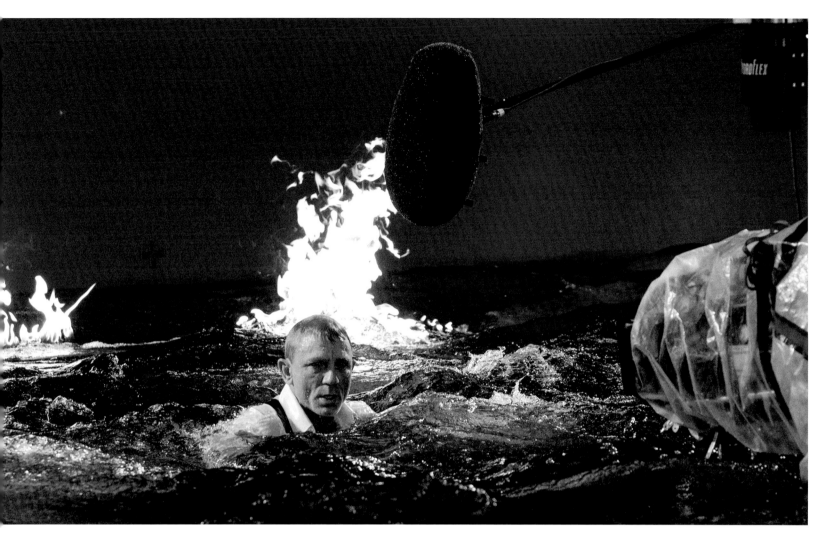

ABOVE & RIGHT: Craig shooting on the Underwater Stage.

Once Bond and Felix are dumped inside the engine room, Sandgren abandoned the red lighting for dingy fluorescents. "All the lights on boats are usually twelve volts and a twelve volt DC works underwater, even if it's drenched. But we felt it would be quite dramatic, as they get submerged and the panic emerges, that some of the fluorescents die, some start flickering, to create more chaos for Bond in that underwater sequence."

When it came to shoot, Craig rehearsed first in the dry, before the set was flooded and he and Morrison ran through it again, this time with goggles and a regulator, "to find his comfort zone," Morrison explains. "Then we roll camera and he takes it to another level."

The sequence climaxes with Craig swimming nearly six metres underwater, through the sinking ship to the bow, where he takes air in from the last remaining air pocket, before going back under and eventually escaping through a hatch to the surface, which is aflame with burning oil. A fire effect that was done practically on U Stage. "It's an amazingly powerful scene," notes Morrison. "Very moving, very claustrophobic and very uncomfortable. Not only for Daniel, but for everybody watching. Finishing the water work on U Stage, which we've used so many times over the years, was a real moment for Daniel."

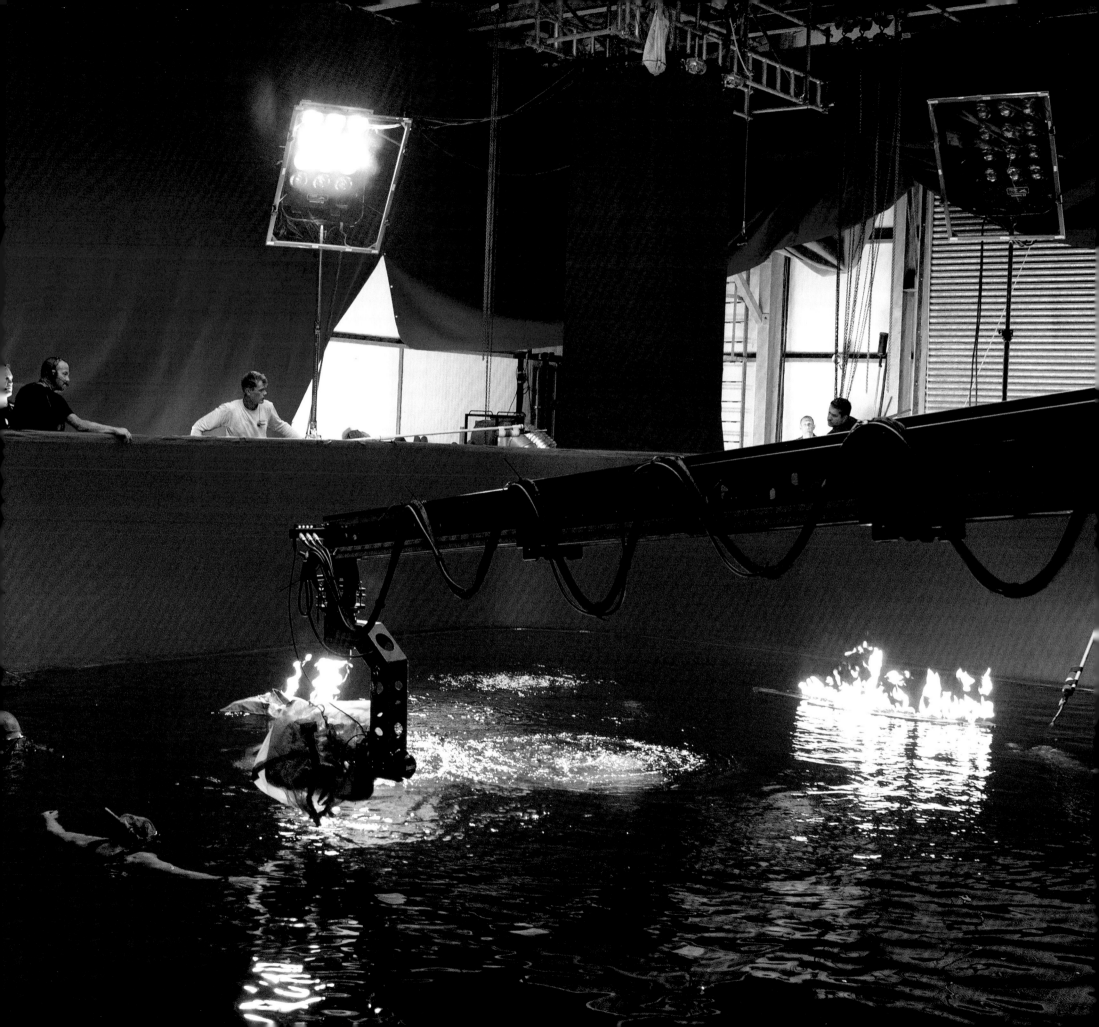

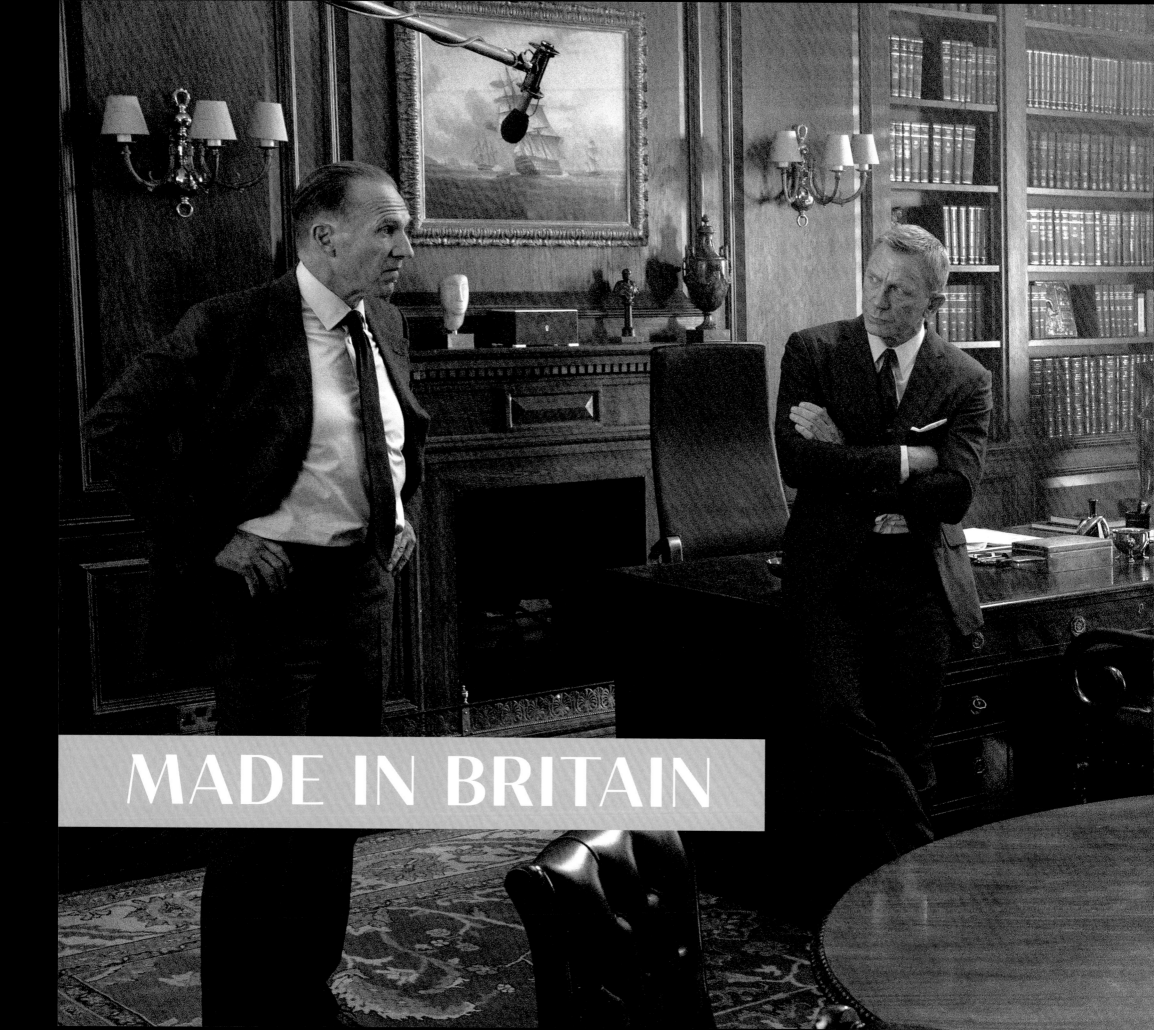

MADE IN BRITAIN

MADE IN BRITAIN

As sure as death and taxes, a Bond movie will involve a trip to M's wood-panelled office. Therefore, the MI6 headquarters set, which also includes Moneypenny's office, is kept in storage between films, waiting to be dusted down and given a new lick of paint and, perhaps, a technological overhaul.

"We rebuilt MI6 pretty much as it was from *Spectre*, but tweaked it for the action," says Sandra Phillips, who oversaw the revamped set, which included a new corridor, stairwell and lift area. "We also gave it more colour. This time we put in more greys and tonally heavy colours. It's such a classic set."

Not that that stopped production designer Mark Tildesley from making a few telling alterations. "We changed the colour of the leather on M's door," he reveals. "It's gone from red to a deep brown, because the red leather was a bit gaudy, and very sixties, and didn't quite fit our aesthetic. The furniture's also a slightly different colour leather to match the door. Everything else is pretty much the same. Behind M's desk is a ship painting that has been there forever. These are icons."

Tildesley also introduced a video screen, hidden behind a Japanese print, while set decorator Véronique Melery added several pieces of art, most notably a recreation of a 1944 painting by Paul Nash called *Battle of Germany* that hangs in the Imperial War Museum. "I wanted to break a little with the classical British interior by including this type of painting, which is less known and less obvious, and shows a more mature and interesting side to M," explains Melery.

PREVIOUS SPREAD: M (Ralph Fiennes), Bond, Nomi, Q (Ben Whishaw), Moneypenny (Naomie Harris) and Tanner (Rory Kinnear) in M's office.

RIGHT: M in his office.

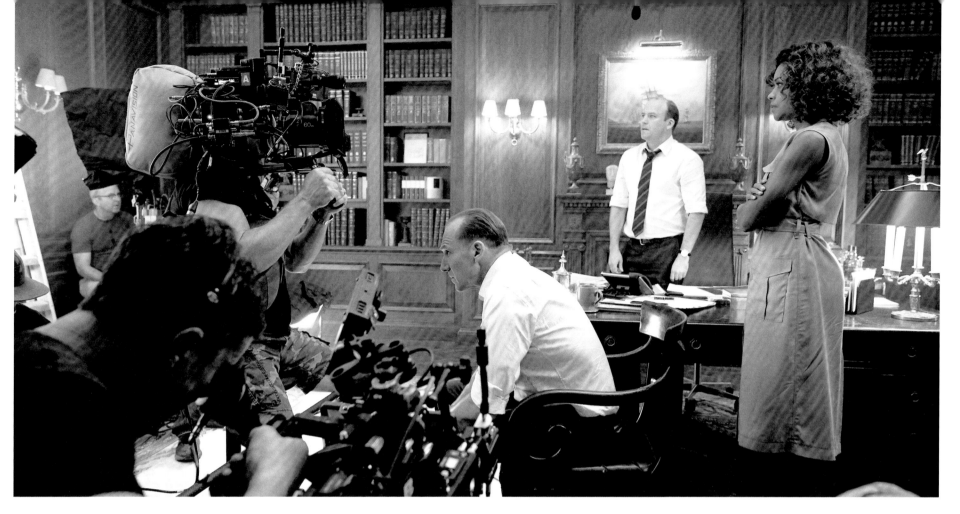

ABOVE: Fiennes, Kinnear and Harris shooting in M's office.
BELOW: Moneypenny at the iconic door of M's office.

All the changes were discussed with Fiennes before being implemented. "Ralph was happy when he came in. We made it slightly busier than before. On top of the Nash, there are three pieces of sculpture that add a sensitivity to his character, because, in this, he's not as controlled as he was. He also had an old mask, the mask being a red-line we have throughout. There are masks from different eras and places all around the movie."

Elsewhere in MI6, the art department created a corridor that featured portraits of the last three Ms prior to Fiennes – played by Bernard Lee, Robert Brown and Dame Judi Dench – much like Downing Street's wall of former Prime Ministers. "Judi Dench has been such an important M, I felt she *had* to exist, in a way, in the movie," says Melery, who was inspired by a painting of Lee she saw in the James Bond archive and subsequently commissioned a sixties-style portrait of Brown by Sally Dray. Desmond Mac Mahon painted the one of Dench. "It was a nice touch having Judi looking down, kind of disapproving," notes Phillips.

Another nice touch was the painted backdrop that lined the

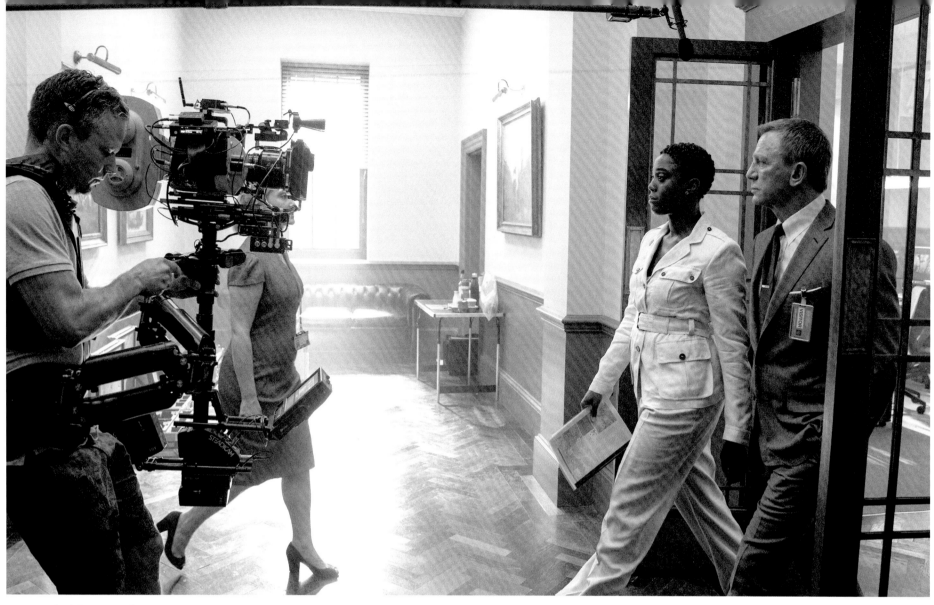

ABOVE: Behind the scenes of Nomi escorting Bond, as a visitor to MI6 headquarters, to M's office.

BELOW: Set decorator Véronique Melery and supervising art director Chris Lowe on the MI6 headquarters set.

BELOW: Storyboard artist Steven Forrest-Smith, Witt, first assistant director: second unit Dominic Fysh, Fukunaga, director's assistant India Flint and senior visual effects coordinator Lisa Wakeley on the MI6 headquarters set, with the portrait of Judi Dench's M in the background.

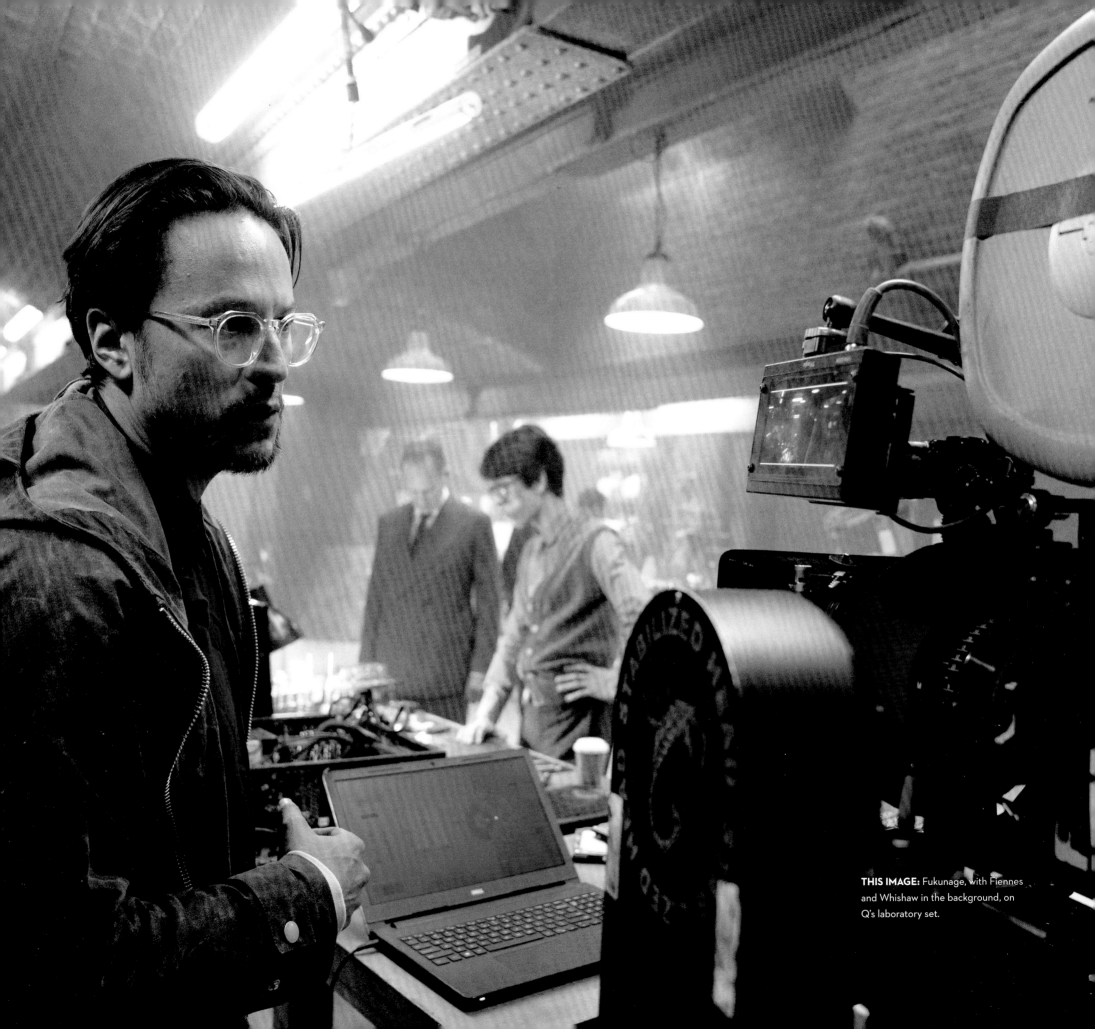

THIS IMAGE: Fukunage, with Fiennes and Whishaw in the background, on Q's laboratory set.

set, a wonderfully detailed diorama of King Charles Street in London that took two artists five weeks to complete. On *Skyfall* and *Spectre*, the art department had almost exclusively used large-scale photographic backdrops, but given the choice, Phillips prefers the more traditional approach: "There are amazing skills and amazing people involved and you want to keep using them. The nice thing about a painted backdrop is you can change things, but once a printed backing is up, that's it. We didn't use any printed backings on this film. It was all painted backdrops or LEDs – two ends of the technology spectrum."

> " We have a plethora of Aston Martins in this film, including the new Valhalla, which makes a little appearance in Q's lab."
>
> *Barbara Broccoli, producer*

LEFT: Whishaw behind the scenes on Q's laboratory set.

RIGHT: Detail of Q's laboratory set.

BELOW: M in the wind tunnel in Q's laboratory, with the Aston Martin Valhalla in the background.

"Nomi is one of the few female agents in the '00' program and the only black woman, which she absolutely uses to her advantage," reveals Lashana Lynch, who plays her. "In such a male-dominated environment, she seamlessly holds her own. She's quite the perfectionist and very modern in her approach. Highly skilled, borderline cocky and very ballsy, with a sharp tongue and a sharp mind. But she's also elegant and sarcastic. She has great instincts and does what needs to be done."

What she wanted was landing Bond's hallowed number. "No one wanted 007, because it was held in such high esteem," explains Barbara Broccoli, "but she fought for it, and she got it. But going into the third act of the film, Bond needs to have his licence to kill restored, and out of sheer humanity and kindness she asks he be reinstated with the original number, because the mission they're going on is life or death."

"Nomi tried to play down taking on the number, because she didn't want anyone to compare her to Bond," continues the London-born Lynch, hitherto best known for her role as fighter pilot Maria Rambeau in *Captain Marvel*. "She isn't replicating anything Bond has done. She's starting it completely anew, almost as if it's a brand-new number."

Self-assured, tech savvy and "stealth-like," Nomi represents the next generation of MI6 agent, despite sharing much in common with her illustrious predecessor.

"Both have a very deep hunger and zeal for taking down any force that is messing with the equilibrium of their world and both think they're the very best. Bond does it in a boisterous, sarcastic and classic way," Lynch says, "[while] Nomi has the newer mind, the updated training and she has the compassion, which she uses wisely. She's also a teacher's pet. She likes to have a pat on the back from M when she gets something right. And if she doesn't, she will make sure everybody knows that the ideas came from her."

When Nomi and Bond meet in Jamaica, she warns him not to interfere in her mission to find Valdo, only to have Bond turn the tables on her, proving his time in the sun hasn't dulled any of his abilities. For Lynch, filming in Jamaica was "a golden point for me. I'm British Jamaican, my family's Jamaican. So it felt incredible to be working there, on my family's birth land, shooting something so British with a Jamaican crew. It was a special moment for me and my culture."

Given the role required a lot of action, Lynch was put through her paces immediately following her screen test with Craig. "I went straight downstairs to the stunt team and we did five different set ups, all highly intense. It absolutely blew my mind," she recalls.

"At the beginning I was slightly tentative, then, when I got into it, I was screaming my head off, ready to kill everybody. It showed me how fierce they wanted Nomi to be."

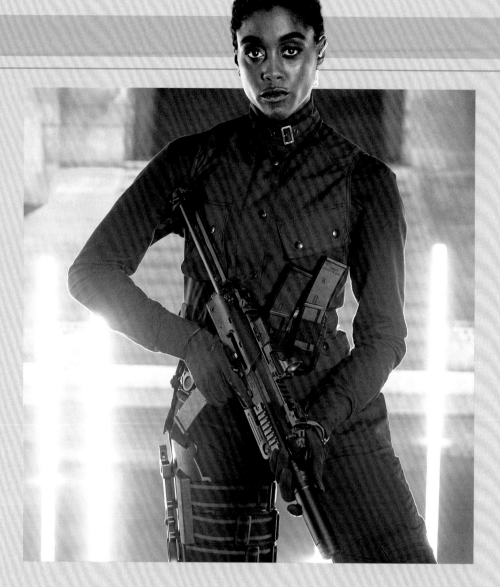

"Stunts review the actors to see what they're capable of, and Lashana physically was really impressive," says Fukunaga. "Watching her drop, spin, roll, jump again, she could do this stuff. It was really exciting to see her do it dynamically, and with a gracefulness and an effortlessness befitting of a 007."

The stunt team continued to school Lynch in hand-to-hand combat, firearms and knives. "Even if she's not going to use everything, it helps build the character," notes Olivier Schneider. "Because she's tall, I wanted to use all that power and energy. I knew right away, she has a natural force. You don't want to be punched by her."

"It really helped me create a Nomi that was, inside, invincible," she insists. "Someone who feels they *can't* be taken down, and they have all the strength in the world to take down ten men." Inevitably, such feelings of invincibility led to Lynch wanting to do all her own stunts. "I was constantly having a go at the stunt department, because they wouldn't let me do the daring stuff. I was always, 'Get me higher in the sky. Let me run further. Can I jump off this ledge?' And they were

always, 'No, no, no, it's too dangerous.'"

"I loved having Lashana around," says Fukunaga, "because she always had a smile, or she'd dance or sing, and she'd always make me laugh. Lashana always came to set with so much energy, and sometimes when things are stressful and hard, to have people around who just bring that kind of energy is really important to the overall experience of making a film."

"Nomi was an interesting one to get into, because she's a field agent," says costume designer Suttirat Anne Larlarb, who felt it was important she not be "just another sharp-dressed man in a suit, but a woman who has her own agency and style points. Because she's a field agent, she would have a level of sophistication that you would expect from Bond. James Bond gets to dress the way he does, so what would be the Nomi version of that? We wanted her to be a very stylish female agent icon."

Sometimes that meant long trousers and a roll-neck sweater, other times a suit. Whatever the outfit, Nomi was always ready for action. "We knew we had to obey certain rules," Larlarb reveals. "James Bond might be at a bar, something happens and he can just insert himself in that situation. Nomi, similarly, has to be able to do that, as a '00'. At any point, she could be called into service. So I wanted to make sure we didn't do anything that felt like it could get in the way of that. Skirts and heels didn't really make sense, but we didn't want her to feel mannish and be in the same kind of clothes as Bond. She does have some suitings, but they're decidedly her own. We didn't want it to be androgynous. We wanted it to feel distinctly female, but we also wanted it to feel action-ready. That was the overarching rule."

Which translated as no unnecessary ruffles, jewellery or accessories. "You don't want to see a female action hero doing their darnedest to disarm some heavily armed person and you're being distracted by a frilly bow moving around," continues Larlarb. "We wanted to make sure everything had a level of operability. We had something like twenty-five fittings with her, lasting from one hour to four hours. That's a lot of time to spend with someone and understand what looks good on them, talking about what the character needed to be, why this earring made sense over that earring or why that [outfit] was right for one environment, because she could blend in, but not when she really wants to stand out, the way Bond stands out."

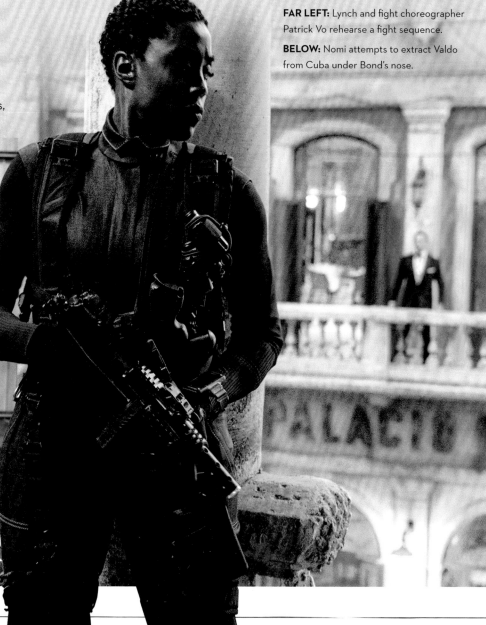

OPPOSITE: Lynch on the Poison Island set.

FAR LEFT: Lynch and fight choreographer Patrick Vo rehearse a fight sequence.

BELOW: Nomi attempts to extract Valdo from Cuba under Bond's nose.

ASTON MARTIN V8

In addition to an appearance by the iconic DB5, *No Time To Die* also sees the reappearance of the Aston Martin V8 that Timothy Dalton's Bond drove in *The Living Daylights* (1987).

"That was Daniel's idea," says Barbara Broccoli. "He loves that car, and we brought it back. It's beautiful, really beautiful. We have a plethora of Aston Martins in this film, including the new Valhalla, which makes a little appearance in Q's lab."

"They've become a real collector's item," says Craig of the V8. "I knew that and said, 'We should get it in,' because, obviously, there's a lot of Aston Martin fans out there who would love to see it. I think it's a very beautiful car, it's of an era, and we haven't seen it in a while. It's not even an Easter egg, it's for the fans."

"I wanted to bring back the V8, as well," agrees Fukunaga, "because they're just works of art. I like the fact they're basically crafted in clay and hammered on wood and no single one is exactly the same as any other. There's a sort of wabi-sabi aspect to it."

"It's James Bond's personal car, so it's not got any gadgets. They've probably been decommissioned," jokes special effects and action vehicle supervisor Chris Corbould, whose department was again responsible. "It's a great looking car, a lovely sounding car. Funnily enough, I did *The Living Daylights* and had four of those under my control. I have fond memories of driving it around on an ice lake in Austria."

The production employed three five-speed Aston Martin V8s; two hero and one pod car, all of which were rebuilt by the Stratton Motor Company to the exact specifications of the one seen in *The Living Daylights*. "They've been absolutely faultless," says Ashley Hollebone, who looked after the cars on set. "We've had one headlight bulb go, but that's all we've had to do with them. They've been brilliant to drive, really reliable."

RIGHT: Bond retrieves his V8 Vantage from his lockup in London.

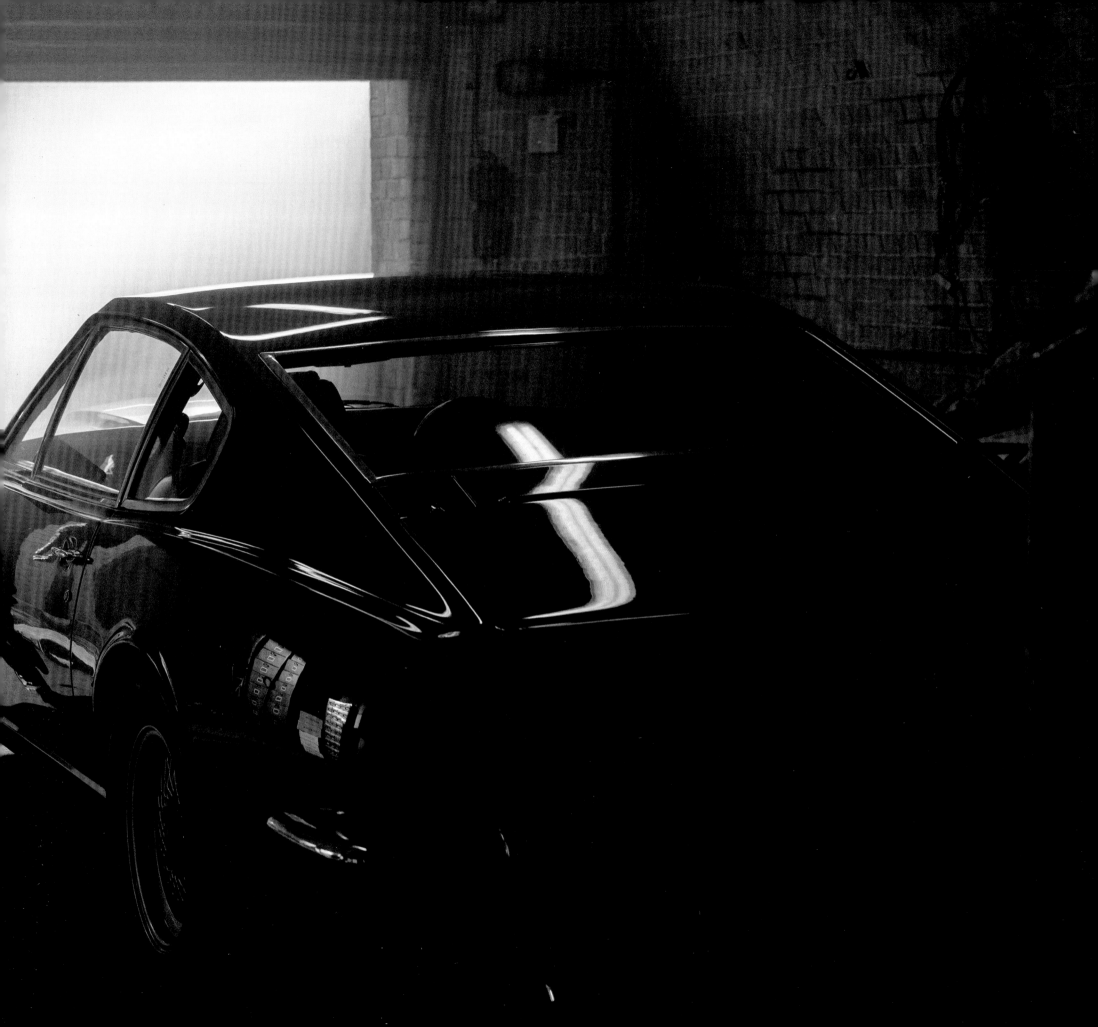

Q'S HOME

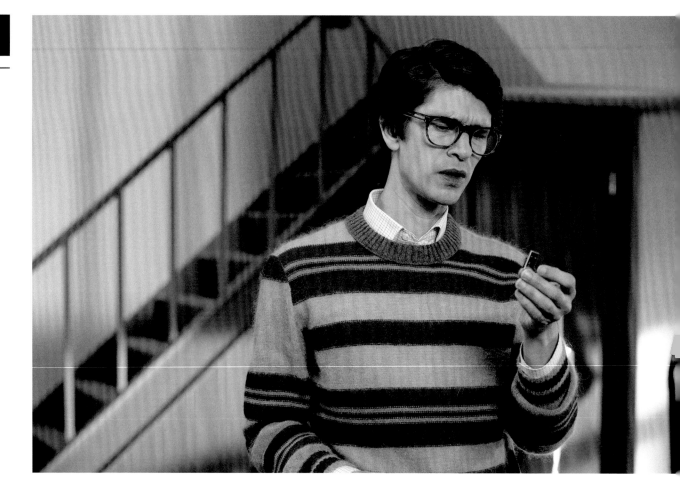

"After meeting M, Moneypenny asks Bond if they can go to dinner. He says, 'fine,' and they end up going to Q's house. We see Q's domestic situation for the first time, with his hairless cats, and he's preparing for a friend coming for dinner. It is great to see Moneypenny, Bond and Q back together. It's the usual banter and humour we've come to expect from these characters. Q reluctantly helps out Bond. He knows it's not something sanctioned by M and MI6, but he senses something is wrong. Q gets into the database that Bond gives him and begins to see issues that affect the plot. It takes us on to the next phase of the film," explains Wilson.

Designing a home for MI6's resident genius required thinking outside the box. "Q's an interesting character. He was quite difficult to nail down, because there's not much written about him, so you have to fill in the gaps," reveals art director Sandra Phillips. "We've never seen his home life and you don't imagine he does much else except create." In the end, Phillips gave Q a "lovely two up-two down," based on a Victorian terrace in Roupell Street, a conservation area near Waterloo train station. "A very Q neighbourhood, really great bakery around the corner," says Fukunaga. "We felt Q would have one of those folding bikes to go to work on."

While the real Roupell Street exterior was used for the scene where Bond and Moneypenny turn up unannounced, interrupting his dinner preparations, the interior of Q's home was a set, built on the Richard Attenborough Stage, which featured an open-plan ground floor with interconnected living space, kitchen-diner and garden. "We had lots of Georgian influences, but tried to use a lot of dark blues and reds," continues Phillips. "It was a rich mixture of textures and colours, so it felt very lived-in. Lots of dark wood and low, moody lighting."

When it came to furnishings, it was important that every item reflected Q's personality. "He's very dapper, very smartly put together, so obviously cares about things," notes Phillips. "His home is well looked after, even if it's slightly chaotic.

TOP RIGHT: Q examines the memory stick Bond gives him.

RIGHT: Q's homemade electronic music device.

OPPOSITE: Moneypenny in Q's home.

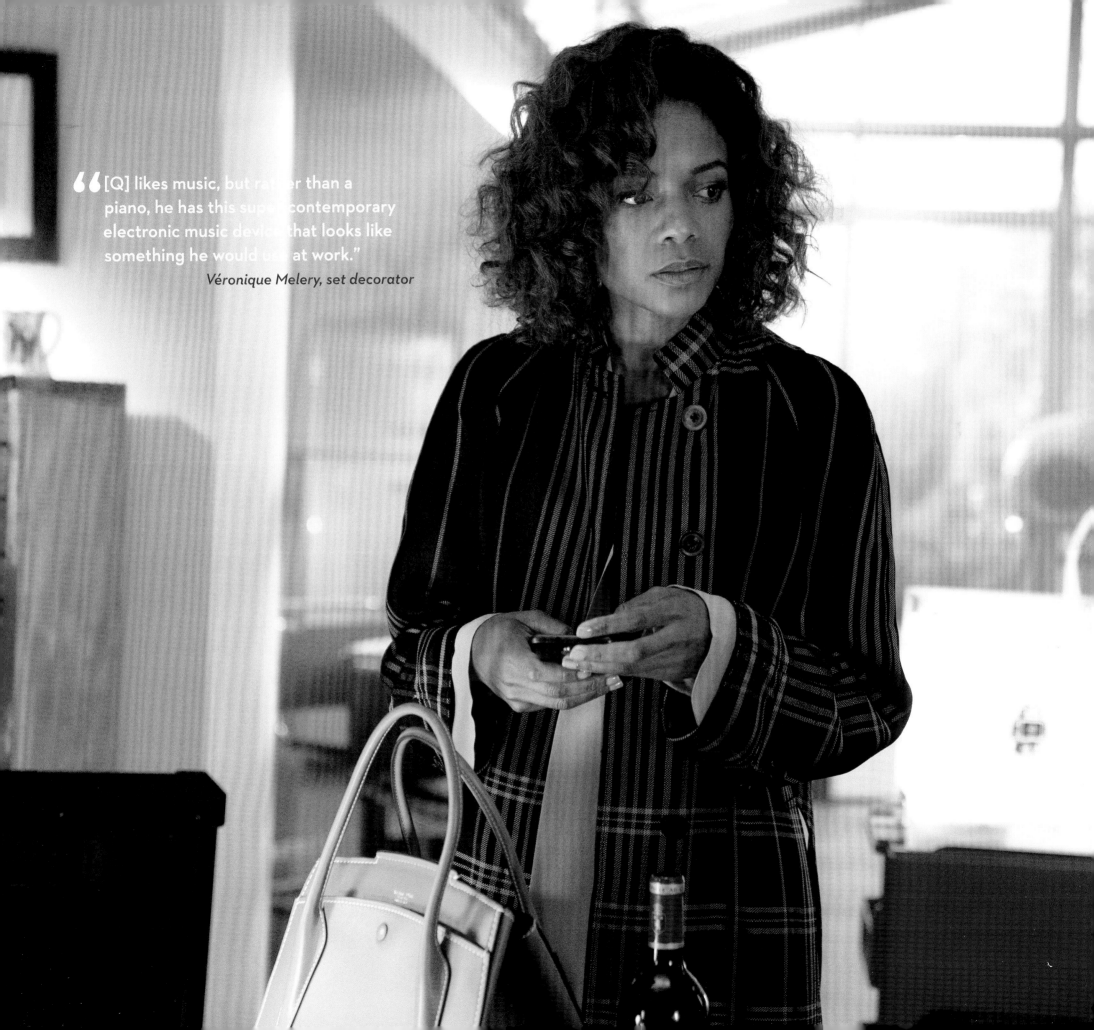

"[Q] likes music, but rather than a piano, he has this super contemporary electronic music device that looks like something he would use at work."

Véronique Melery, set decorator

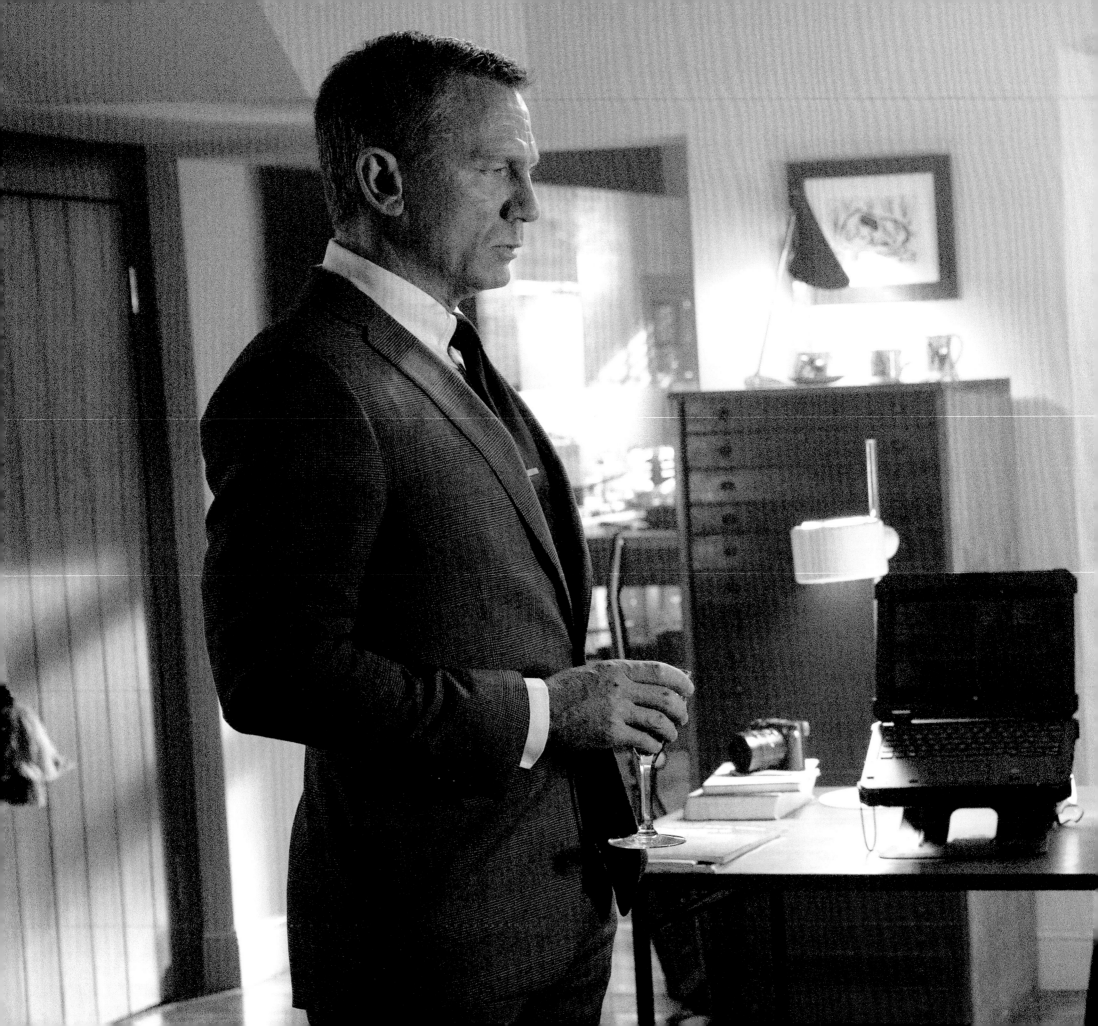

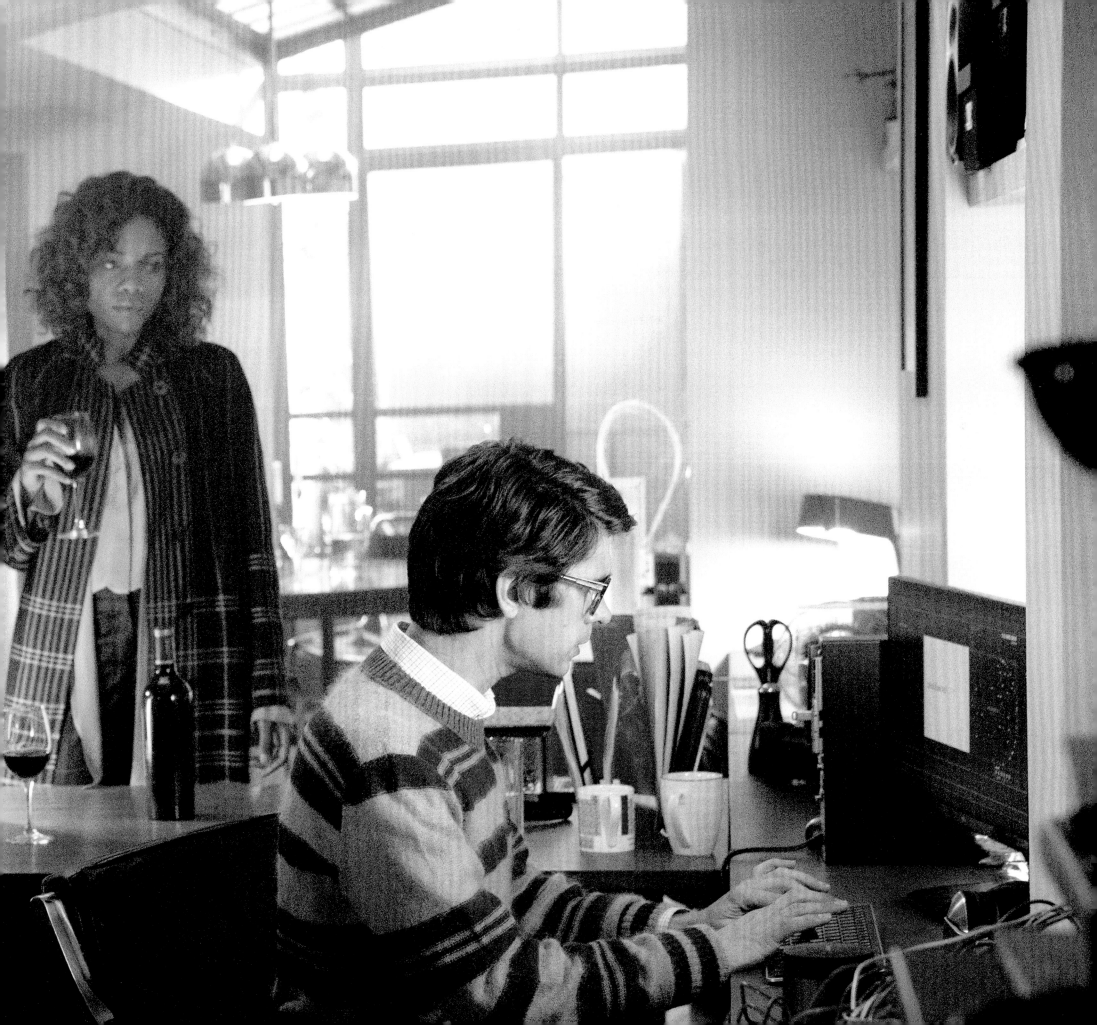

He hasn't tidied things away, he's just added to them. So you've got piles of books, gadgets he's made, things he's soldered together. He has old computers piled up, with the latest one in front."

"He is a genius. But is he the sort of genius who would bring work home, or is he someone who is having a bit of a life?" says set decorator Véronique Melery. "He likes music, but rather than a piano, he has this super-contemporary electronic music device that looks like something he would use at work."

It was actually a modular synthesizer built by associate producer Gregg Wilson that production designer Mark Tildesley had seen him use on a flight to Canada while scouting for the Danny Boyle incarnation and remembered months later when it came time to decorate Q's home. "Gregg is very like Q," says Tildesley. "He's a super-bright scientist working in the arts."

Additionally, Melery furnished Q with a small 3D printer, a well-appointed kitchen and "a reasonable collection of fine art," the idea for which sprang from *Skyfall*, where Q met Bond at the National Gallery in London. "So we thought, maybe Q has a liking for art," explains Melery. "But we tried to give him paintings and art that are not entirely traditional – outsider art. He's slightly different and this kind of art reflects his personality more."

Since, in *Spectre*, Q mentioned he had cats, they also gave him a pair of hairless Egyptian sphynx. "We had the cats in for weeks and weeks, wandering the set, having their food in there, trying it out. They were really well behaved," recalls Tildesley. "It was quite a stylish place. [Ben Whishaw] was super happy with it."

Not everyone was so enamoured. "I was very jealous, because we've seen inside Moneypenny's home, which isn't anywhere near as glamourous and well-designed," jokes Naomie Harris. "Q clearly has better taste."

MADELEINE'S OFFICE

The first time we meet Safin in *No Time To Die*, his identity is shrouded behind a Japanese Noh mask. It's only years later, when Safin visits Madeleine at her office, posing as a patient, that she discovers he's the man who killed her mother but spared her life as a young girl in Norway. It's a chain of events that Safin uses to his advantage.

"He comes back into her life when she is working as a therapist and he approaches her as a patient. Safin suddenly reveals himself to Madeleine and asks her to do him a favour," says Wilson.

ABOVE: Detail of Madeleine's office set.

BELOW: Rami Malek, Seydoux and Fukunaga between shooting on Madeleine's office set.

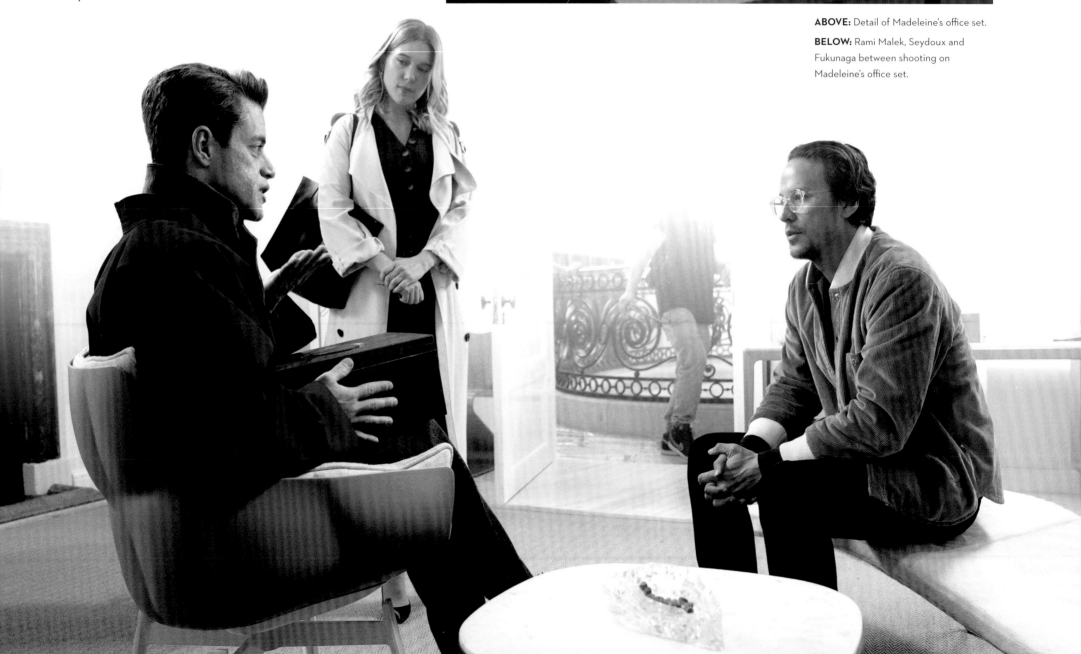

As originally written, the pre-credit scene in Norway featured Safin and a henchman. "Then, to simplify it, I just made it Safin and he didn't die in the first barrage of bullets," reveals Fukunaga. "If he didn't die, maybe he saved her life and therefore she's indebted to him. Which meant I could play that trope of a woman with a past, similar to Vesper Lynd, which might cause her to betray Bond, but is actually a red herring. To give their story some stakes, some history."

"He's controlling her in a way, because he manipulates her and she can't escape him," says Léa Seydoux of Safin. "I think what the film says about her is that she's predetermined, she will fall in love with a killer, and at the end it's tragic. Her destiny is quite sad."

Initially, both men wore masks. Safin's was "almost like a *Hellraiser* mask, with spikes all over it," says Fukunaga. "It was an eighteenth-century hunting mask and was very, very cool," says costume designer Suttirat Anne Larlarb. "Because Safin's mask was originally so heavily textured, I felt his henchman's, for hierarchy's sake, should be nothing like that, so we started developing cleaner-looking masks." Larlarb remembered seeing a Japanese Noh mask in a museum and showed an image to Fukunaga, who gave it the go-ahead. Fukunaga decided the scene would play better if Safin was on his own, ditched the spiked mask and had Malek wear the Noh mask instead, along with the "all-white nod-to-Roger Moore snow suit" from *The Spy Who Loved Me*, which Larlarb had designed for the henchman to wear. "In terms of retaining the anonymity of the character until later in the story, it was the right choice," says Fukunaga.

"It was a circuitous way of getting there," reflects Larlarb, "but it ended up being exactly the right decision and quite startling. With many Noh masks, it's the lighting that gives it expression. If you light it from above and are looking at it from below, it can look aggressive and angry. They have a changeability that's built in. Also, for an actor like Rami, who does so much with his eyes and facial expressions, having to perform behind that kind of mask adds a whole other level of potential menace."

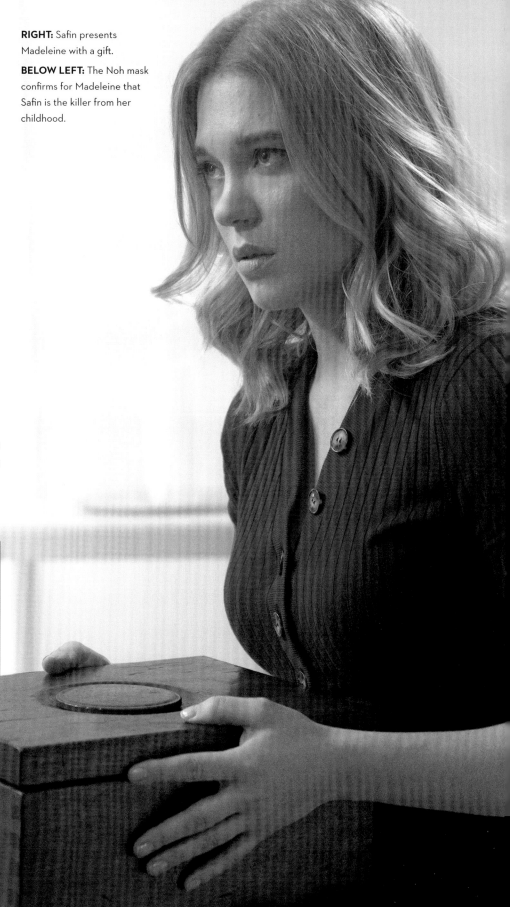

RIGHT: Safin presents Madeleine with a gift.

BELOW LEFT: The Noh mask confirms for Madeleine that Safin is the killer from her childhood.

AN OLD FOE

AN OLD FOE

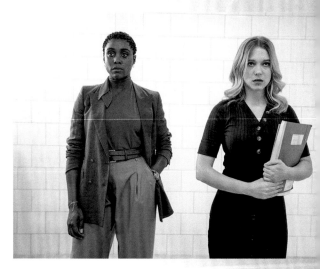

Ernst Stavro Blofeld (Christoph Waltz) has spent the last five years at Her Majesty's pleasure, locked in a cell at London's Belmarsh prison, following his capture in *Spectre*. Given Blofeld's stature as a criminal mastermind, Fukunaga wanted something extra special when it came to his incarceration. "We were discussing ways of containing the most dangerous human being in the world, talking about entrapment and zoos and dangerous animals," recalls Mark Tildesley. Among the photographic references the art department pulled together were images of a confinement cage used to separate and transport American prisoners. "Mark showed Cary pictures of a high-security prison, with all these murderers in a group therapy meeting, sitting in their cages," says Linus Sandgren. "It was crazy, and horrifying, and everyone was very affected by those images."

"Those cages were very small and very confined," continues Tildesley. "How dangerous were these men that they had to be

inside these things? One guy looked like a caged gorilla. He had his hands cuffed on the outside of this mesh cage. It was very shocking and sad."

It was *exactly* what Fukunaga was after. Although, to make Blofeld's appearance even more unsettling, Tildesley suggested they suspend his cage from the ceiling and have it move along on a motorised track. "It was pretty shocking, like a piece of meat being moved around a factory. It was very potent and very strong, and a bit bonkers." Fukunaga liked this idea, adding that Blofeld should be ferried into the interrogation room, sliding down a corridor, so we see him pressing upon Madeleine, unnervingly invading her personal space.

Waltz loved it. "We had to build a replica so Christoph could try it out, because it's really restrictive for an actor to be inside a tiny cage," explains Tildesley, "and he said, 'This is absolutely fantastic.'"

Blofeld is first seen manoeuvring into shot at the far end

PREVIOUS SPREAD: Ernst Stavro Blofeld (Christoph Waltz) in his cell at Belmarsh.

ABOVE LEFT: A 3D digital model of the prison set layout by Phillips.

ABOVE MIDDLE TOP: Blofeld's cage on the prison set.

ABOVE MIDDLE BOTTOM: Waltz and Fukunaga in the interrogation room section of the set.

ABOVE TOP: Sandgren and Wilson.

ABOVE: Nomi and a nervous Madeleine.

RIGHT: Bond and Madeleine.

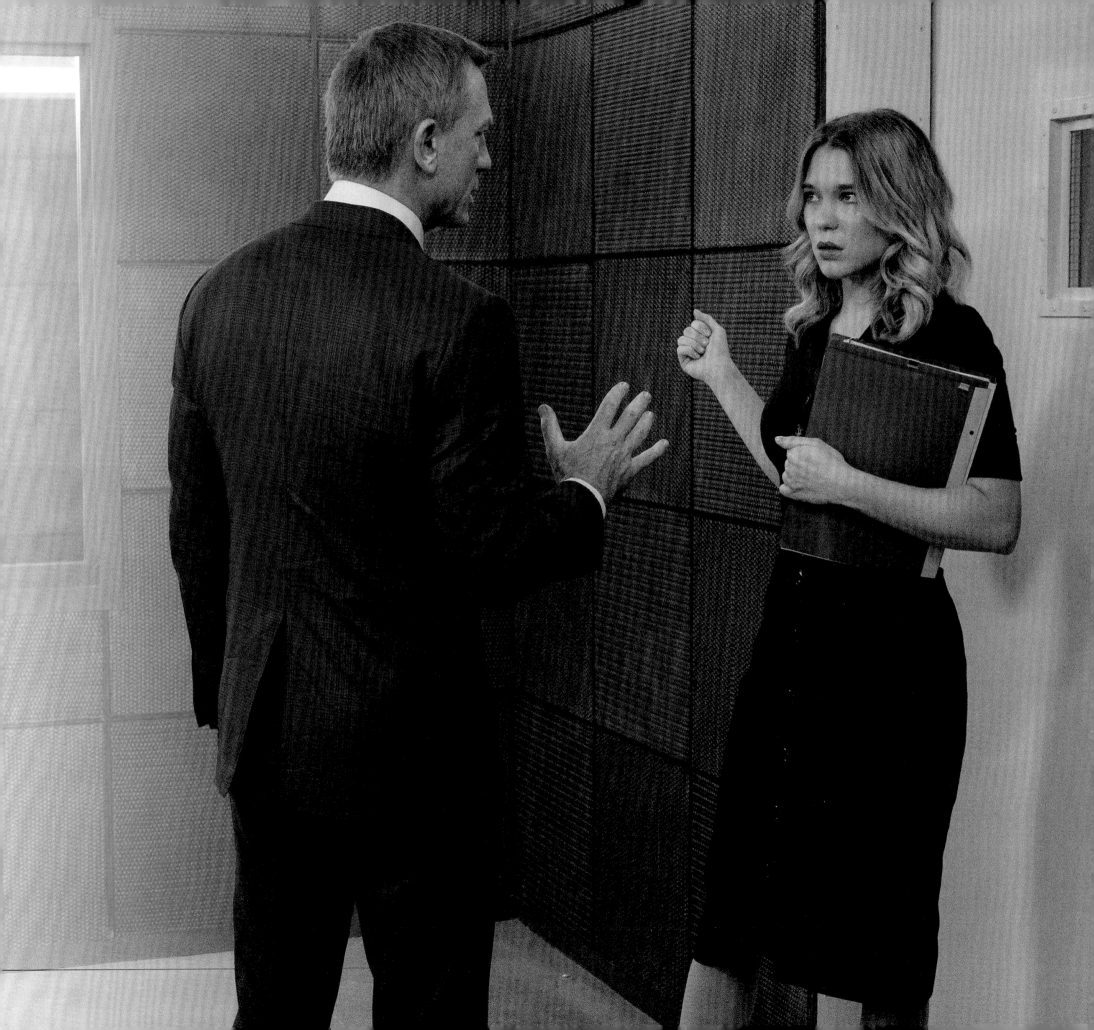

of a forty-foot-long corridor, wreathed in darkness, before his cage passes through a series of bright spotlights as it slowly approaches Bond. "I thought it would be really interesting if we lit him strongly, and he goes in and out of this spooky, menacing lighting, rather than soft, realistic lights, and when he lands on Bond, he still has this really hard light on his head and sort of glows," says Sandgren. "So all the light in the room is emitted from his box."

"It's very sinister, very theatrical, and very odd," says Sandra Phillips, who oversaw the Belmarsh set, which also included several plain, seemingly endless, low-ceiling corridors along which Bond and Madeleine walk, as well as the bathroom in which the latter daubes herself with Heracles-laced perfume.

Blofeld remains inside his cage throughout his interaction with Bond, the pair finally talking in the interrogation room. "Daniel had a lot of ideas for the first two monologues of that scene," says Fukunaga. "I think there were some things Bond wanted to say to Blofeld that didn't quite come out in the last film. Phoebe and I went through it and edited it, but the bones of it are what Daniel wanted."

Phillips positioned a pair of two-way mirrors on opposing walls to allow Fukunaga and Sandgren to frame Bond and Blofeld so they were reflected into infinity. "Having mirrors on two sides made it a little more visually interesting," says Sandgren. "Cary loved the idea of seeing endless versions of Bond, so we worked a lot to find angles so we could see him disappear into the depths."

"Again, it was all about light," adds Phillips. "We even padded the walls. It was nice to do something so unusual. You're not trying to base it in reality, you're trying to stylise it and make it look interesting, but also not draw your eye too much. It's finding that balance. It should be part of the scene, but not overtake it."

" Having mirrors on two sides made it a little more visually interesting. Cary loved the idea of seeing endless versions of Bond, so we worked a lot to find angles so we could see him disappear into the depths."

Linus Sandgren, director of photography

RIGHT: Bond confronts Blofeld in the interrogation room.

FAMILY MATTERS

FAMILY MATTERS

Upon learning from Blofeld that Madeleine didn't betray him in Italy, Bond tracks her down to her childhood home in Norway. There he finds not only his former lover, but also her five-year-old daughter Mathilde (Lisa-Dorah Sonnet) who has the same striking blue eyes as him. Madeleine insists Mathilde isn't his but Bond has his suspicions. Madeleine finally opens up about Safin, telling Bond that her father was responsible for the death of his family, and that Safin killed her mother in retaliation when she was young, but spared her life.

Fearful for their safety, Bond bundles the pair into Madeleine's old Land Cruiser and sets off. But Safin's men, including Ash, are soon on their trail. "He's reunited with Madeleine, he meets the daughter, and they're in danger, so they have to escape into the countryside," says Fukunaga. "Then it becomes, 'How can we do something that doesn't feel like just another car chase?' Because of the child, Bond's never been in this position before, so how will this change it?" "He's vulnerable now, because there is more at stake than just his life," adds Wilson.

PREVIOUS SPREAD: Safin's men, in two Range Rover Sport SVRs, pursue Bond in Norway.

BELOW: Madeleine and Mathilde (Lisa-Dorah Sonnet) at home.

RIGHT: Shooting Bond driving Madeleine and Mathilde away from Safin's pursuit.

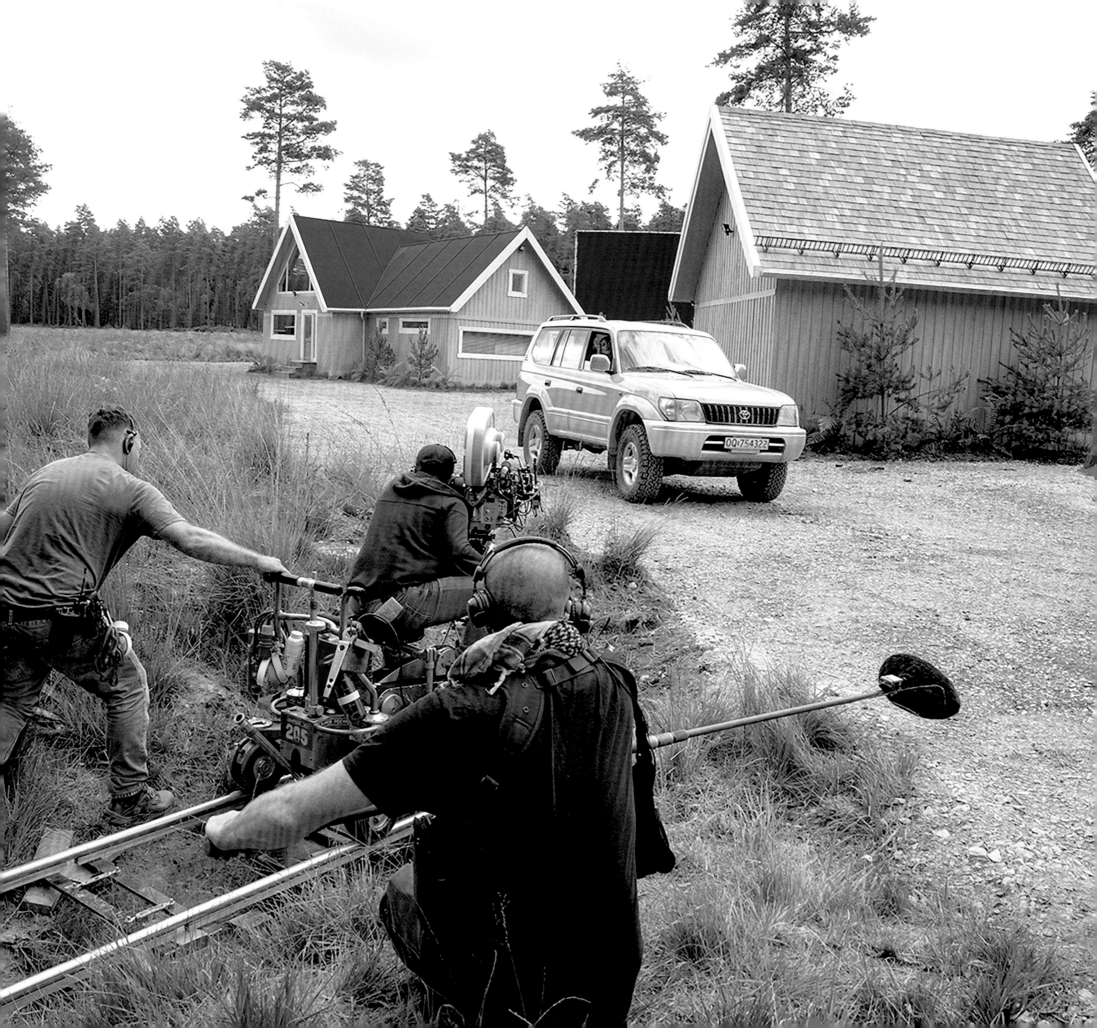

Designed by Morrison in conjunction with Fukunaga, Witt, Schneider, Corbould and Craig, the chase was filmed by both main and second unit in Norway, the Ardverikie Estate in Scotland, Windsor Great Park and Salisbury Plain. "The major difference between this and any other car chase in a Bond film is the cargo on board," reveals Morrison. "As with Matera, it's another intense, intimate chase, because of Madeleine and Mathilde."

The chase begins on the breathtaking Atlantic Road in Norway, as two Range Rover SVRs blast past the Land Cruiser in the opposite direction, before they quickly turn around and begin following them. "That's when Bond and Madeleine share a look," says Morrison, "and the chase is on, forcing Bond to turn off-road, because he knows he's going to be outrun."

From then on, the chase is all off-road, with Scotland standing in for rural Norway, as Bond is pursued "through a very open environment, using riverbeds and mountains. The idea was to have him on the run and totally outnumbered. The only thing he can do is to keep going forward," says Morrison, whose team flattened the ground with heavy machinery prior to filming. "We used a lot of natural features, because I wanted to keep it as wide and as natural as possible, and use the terrain, which is extremely challenging, but it paid off. Hopefully it's going to be something special because of what's going on *inside* the car."

As the two SVRs come alongside, Bond forces them off the road using "pure aggression," says Morrison. "We think they're okay, but as they turn into the woods, they can see, in the distance,

BELOW: Bond, Madeleine and Mathilde.

RIGHT: Fukunaga, Morrison and Craig preparing to shoot a section of the car chase sequence.

FAR RIGHT: A sketch showing the route of a section of the car chase sequence.

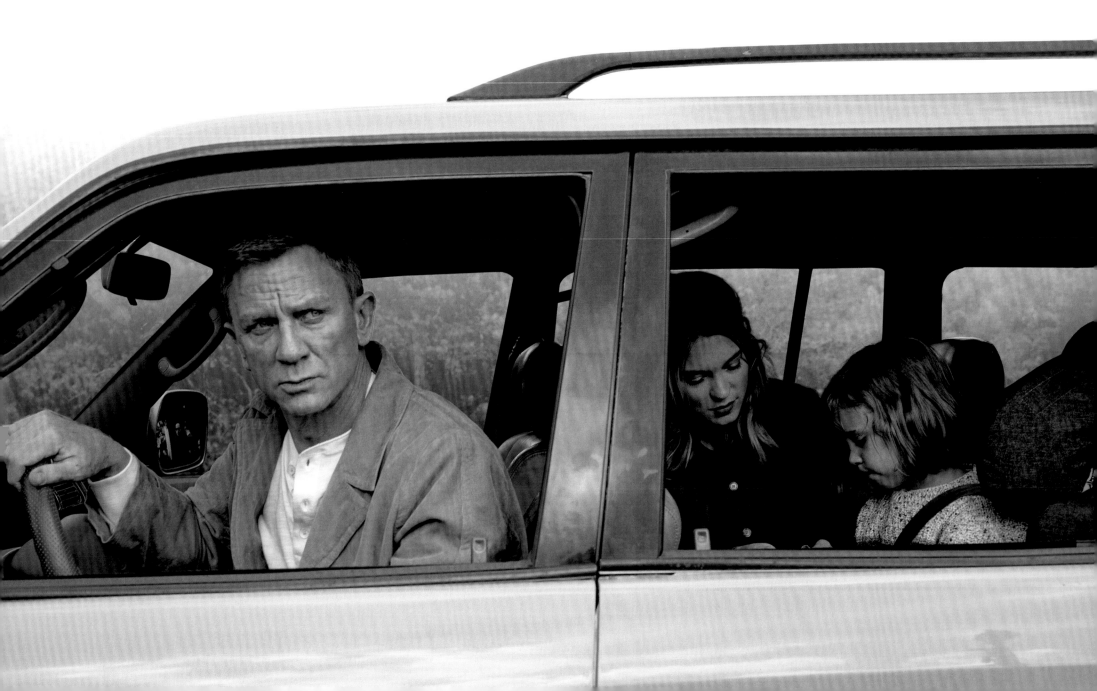

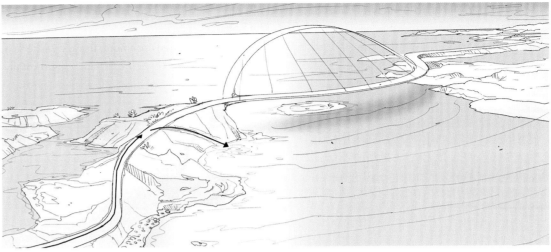

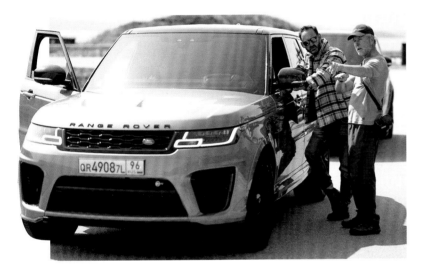

ABOVE: Morrison and Witt with one of the Range Rover Sport SVRs on location.

RIGHT: Craig shooting in the Land Cruiser mounted on a hydraulic rig at Pinewood used for close-ups.

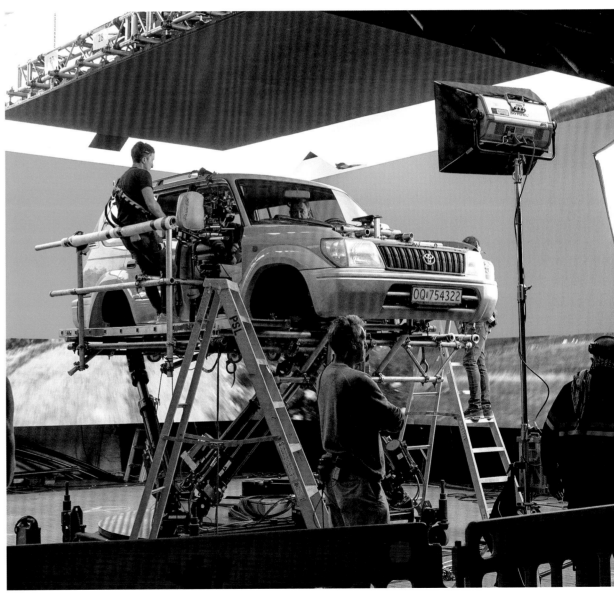

>> The idea was to have [Bond] on the run and totally outnumbered. The only thing he can do is to keep going forward... Hopefully it's going to be something special because of what's going on *inside* the car."

Lee Morrison, stunt coordinator

dust trails of another assault coming down from high ground."

Referred to as the "cavalry charge" in the script, this second wave involves three Land Rover Defenders, three motorcycle outriders and Safin in a helicopter. Despite the odds, Bond continues to outfox the bad guys. "Again, it's Bond doing whatever it takes, going through rivers, driving into the woods," says Morrison. "Vehicles are blocking the road, so he turns left, drops down a huge drop, then uses the river, driving at high speeds, going over hugely rough ground, with the car airborne and basically unstoppable." Once again, the stunt team utilised a pod-driven vehicle to put Craig at the wheel and in the middle of the action. "A couple of times, even the pod car was airborne, three, four, five feet in the air, for twenty feet over a couple of sections, with Daniel and Léa in."

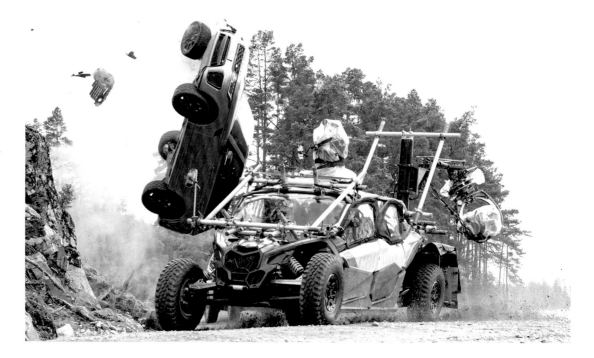

"Daniel did a lot of the driving," adds Witt, who spent three weeks in Scotland shooting with second unit. "Actors want to do as much as they can. Sometimes they're limited, because of the insurance, not because they don't want to do it, because they're having fun, and there is less dialgue with second unit and you can see that. We had cameras on helicopters, camera cars and dollies. The use of drones helped us fly low and closer to the action as you don't have to worry about the wash you get from a big helicopter. A drone can go low, it can go high, and we could go closer to the action, because you don't have the wash you get from a big helicopter."

For close-ups of Bond, Madeleine and Mathilde, Fukunaga filmed Craig, Seydoux and Lisa-Dorah on stage at Pinewood, inside a Land Cruiser mounted on top of a hydraulic rig that was programmed to simulate all the bumps, bangs, drops and sudden movement of the car on location in Norway and Scotland, with exterior footage projected onto an LED backing that surrounded the stage-bound car on two sides. "Because it's very difficult for the actors to concentrate at forty-to-fifty miles an hour with three cars banging along the side of them and making contact," explains Morrison.

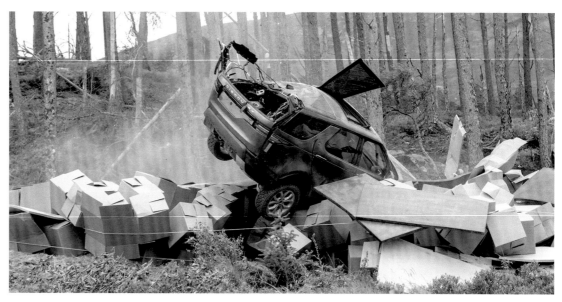

RIGHT: Shooting the car chase on location in Scotland, featuring three Land Rover Defenders, including cameras mounted on a camera car and a drone.

NEXT SPREAD, LEFT: Bond turns hunter.

NEXT SPREAD, RIGHT: Malek and Fukunaga on location.

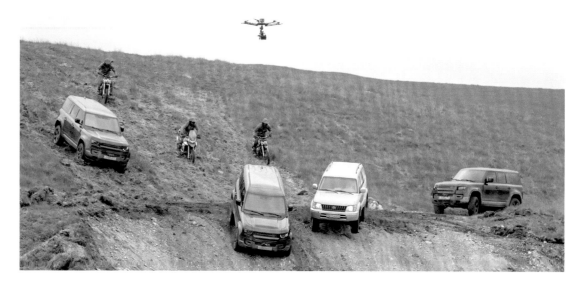

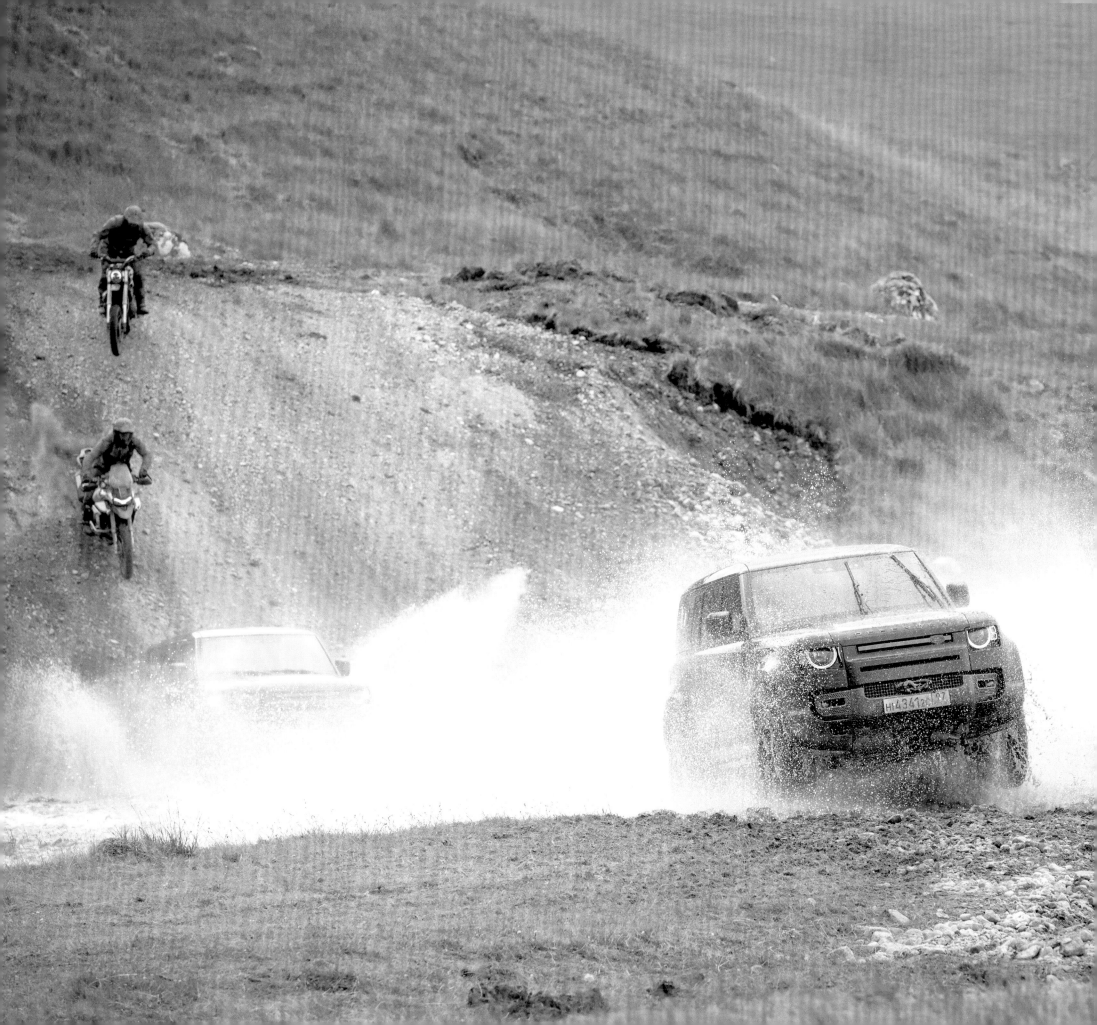

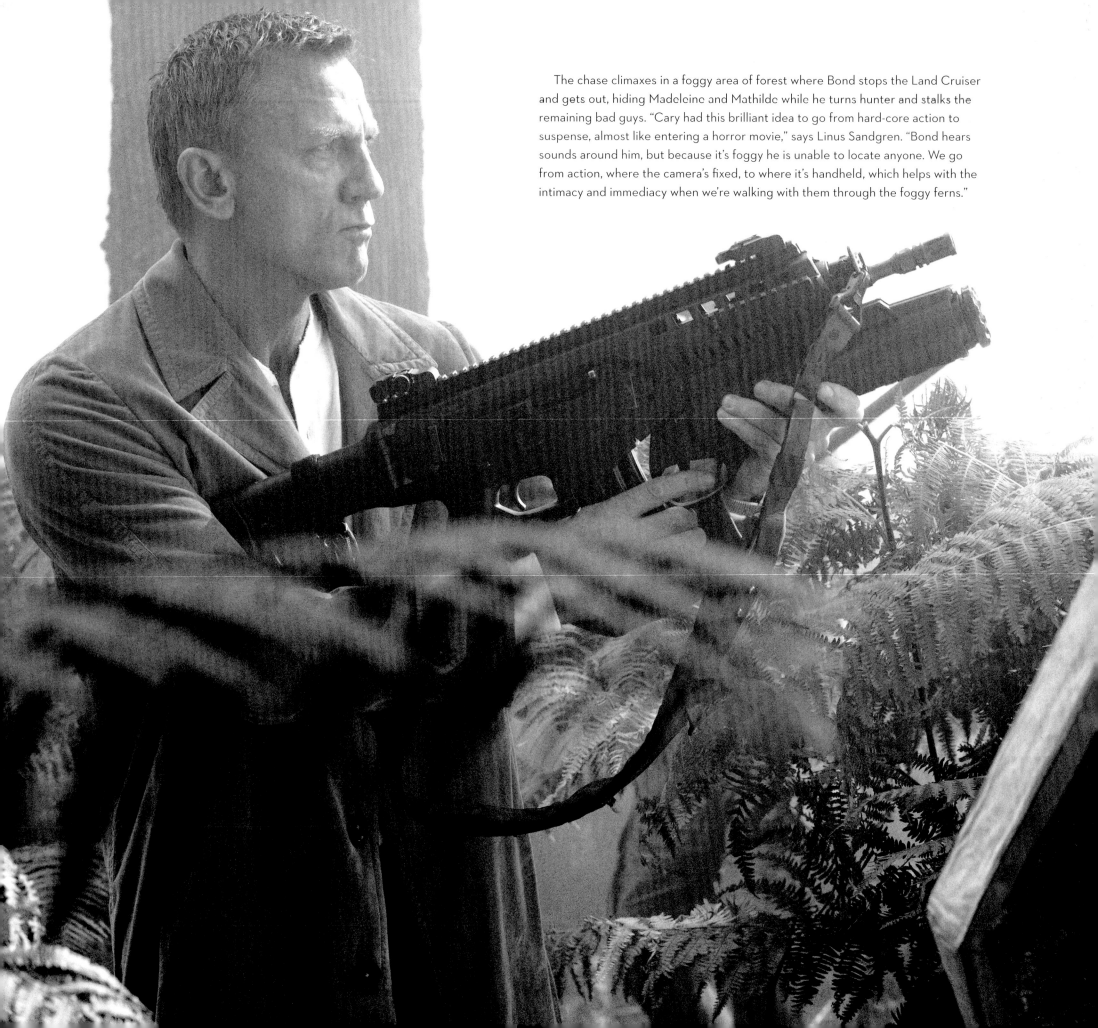

The chase climaxes in a foggy area of forest where Bond stops the Land Cruiser and gets out, hiding Madeleine and Mathilde while he turns hunter and stalks the remaining bad guys. "Cary had this brilliant idea to go from hard-core action to suspense, almost like entering a horror movie," says Linus Sandgren. "Bond hears sounds around him, but because it's foggy he is unable to locate anyone. We go from action, where the camera's fixed, to where it's handheld, which helps with the intimacy and immediacy when we're walking with them through the foggy ferns."

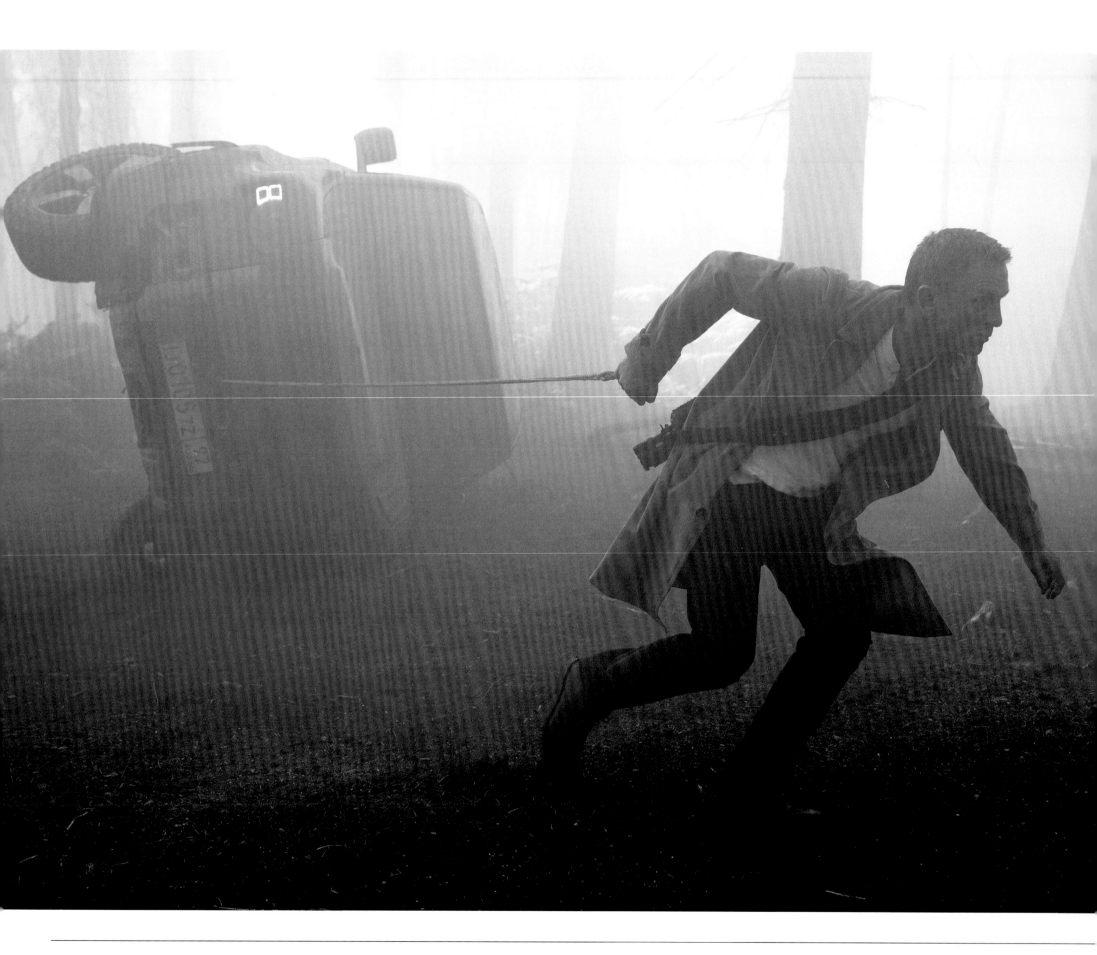

During this final section of the chase, filmed in Windsor Great Park, Bond lures the Defender with Ash inside to hit a tree trunk at full speed, causing it to flip end-over-end. It comes to rest teetering on its side, the off-roader held in place by what the storyboard suggested was a stick, and an injured Ash crawls out of a window to drop underneath. Corbould didn't buy it. "A two-ton vehicle held up by a twig! It seemed cheesy, so I said, 'How about if there's something a bit more substantial, like a tree trunk, which Bond shoots out?'" However, Bond had used all his bullets up, so Craig suggested the twig

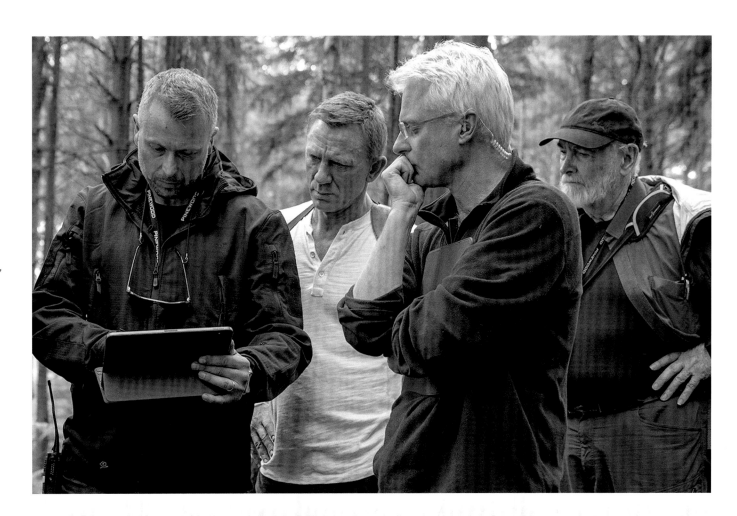

LEFT: Bond sets a trap.

RIGHT: Supervising stunt coordinator Olivier Schneider, Craig, visual effects supervisor Charlie Noble and Wilson on location.

BELOW: Mallard, Noble, Sandgren and Fukunaga watch Magnussen shooting a scene.

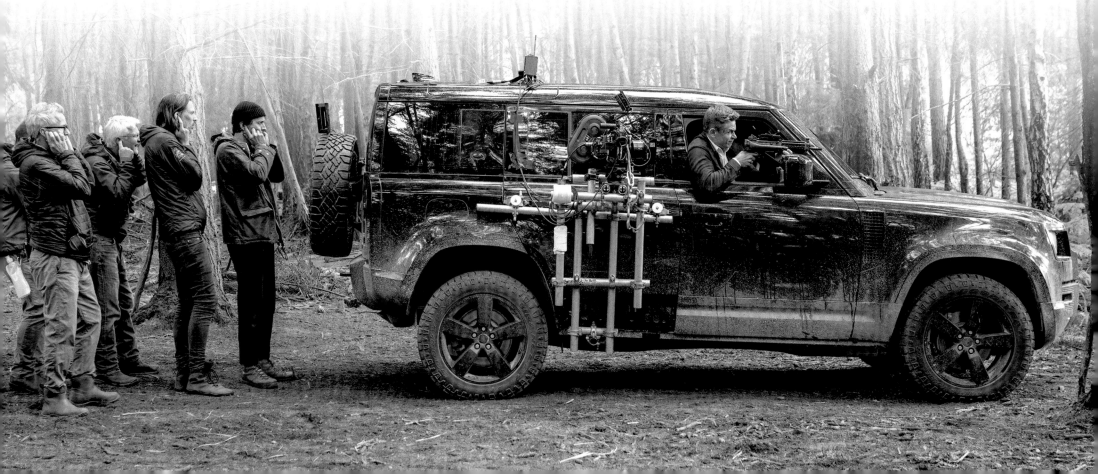

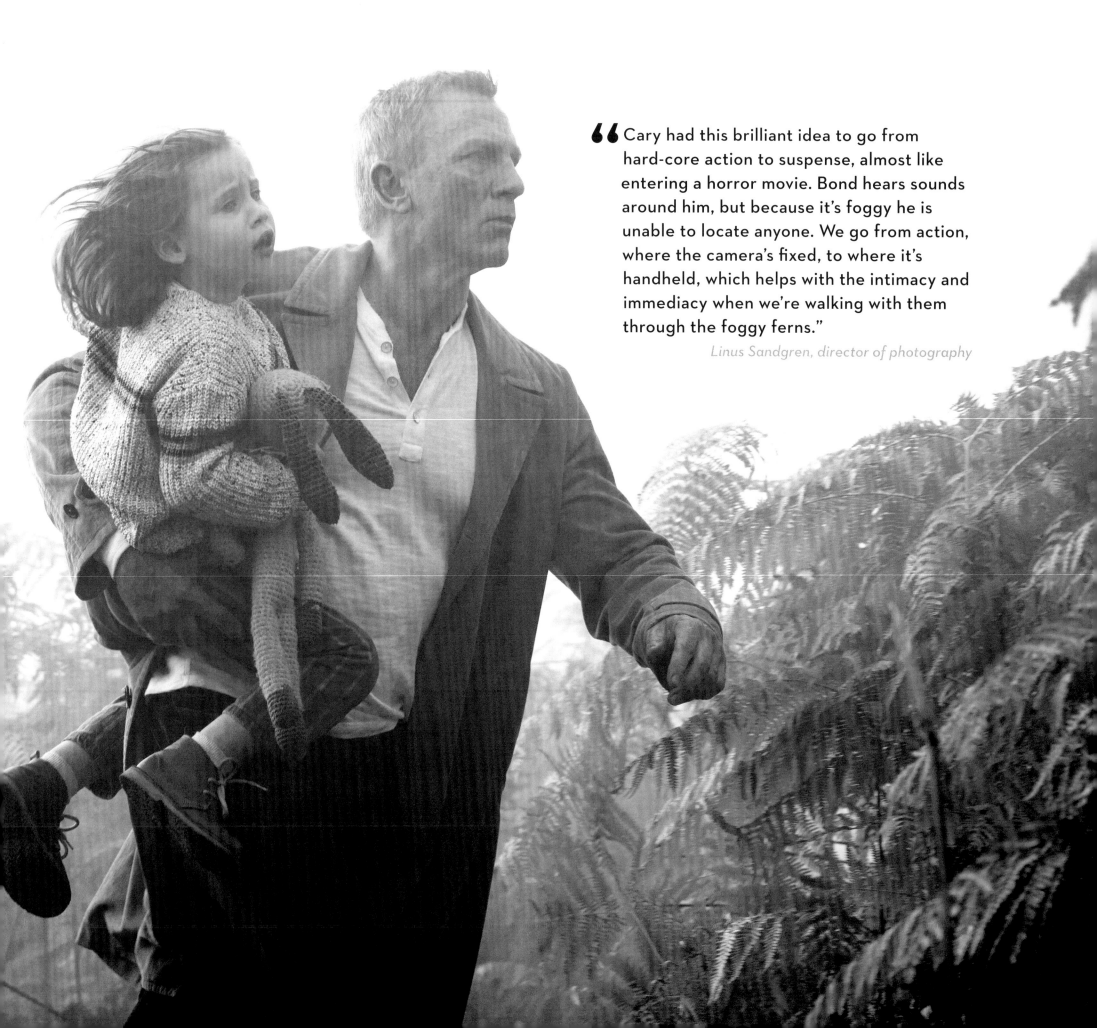

> " Cary had this brilliant idea to go from hard-core action to suspense, almost like entering a horror movie. Bond hears sounds around him, but because it's foggy he is unable to locate anyone. We go from action, where the camera's fixed, to where it's handheld, which helps with the intimacy and immediacy when we're walking with them through the foggy ferns."

Linus Sandgren, director of photography

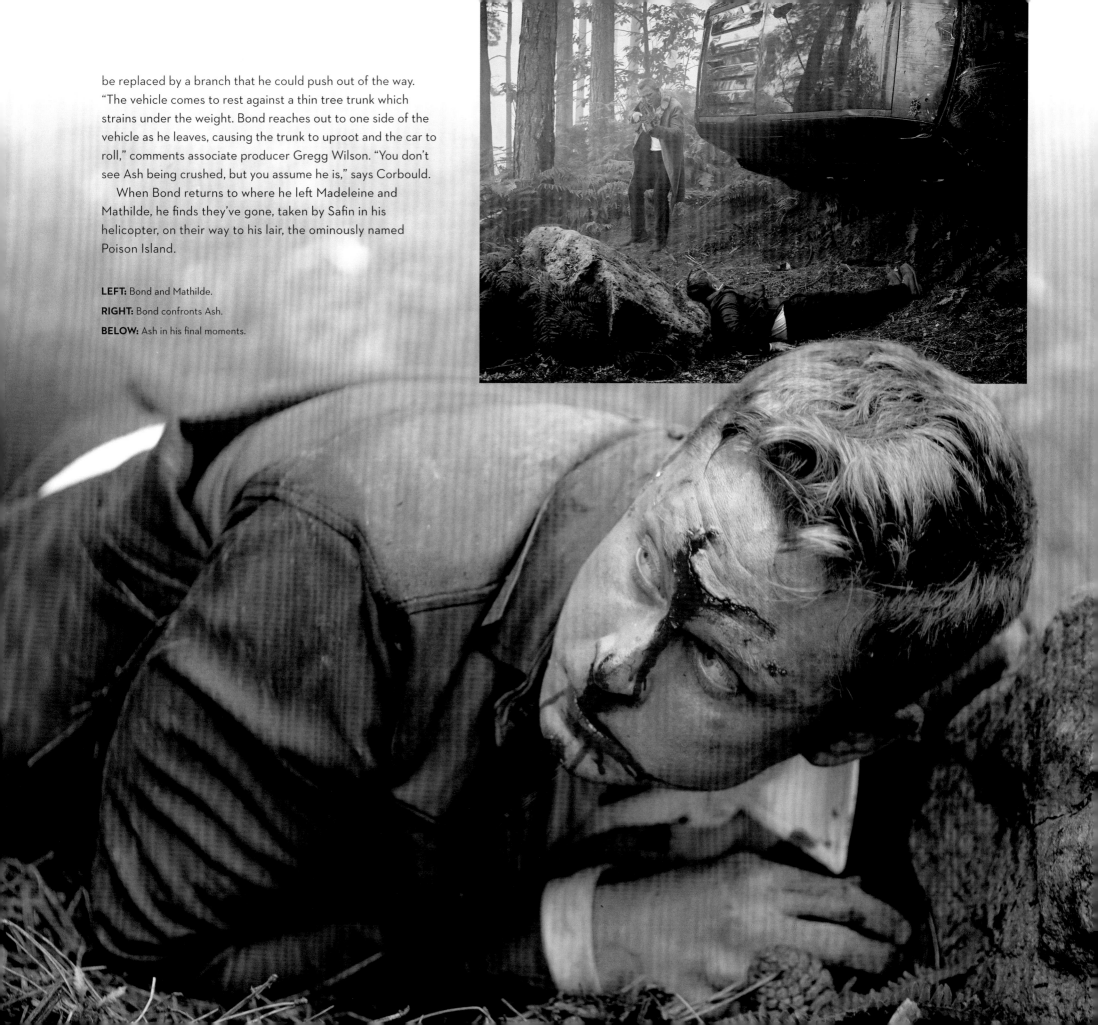

be replaced by a branch that he could push out of the way. "The vehicle comes to rest against a thin tree trunk which strains under the weight. Bond reaches out to one side of the vehicle as he leaves, causing the trunk to uproot and the car to roll," comments associate producer Gregg Wilson. "You don't see Ash being crushed, but you assume he is," says Corbould.

When Bond returns to where he left Madeleine and Mathilde, he finds they've gone, taken by Safin in his helicopter, on their way to his lair, the ominously named Poison Island.

LEFT: Bond and Mathilde.

RIGHT: Bond confronts Ash.

BELOW: Ash in his final moments.

STEALTH WEAPON

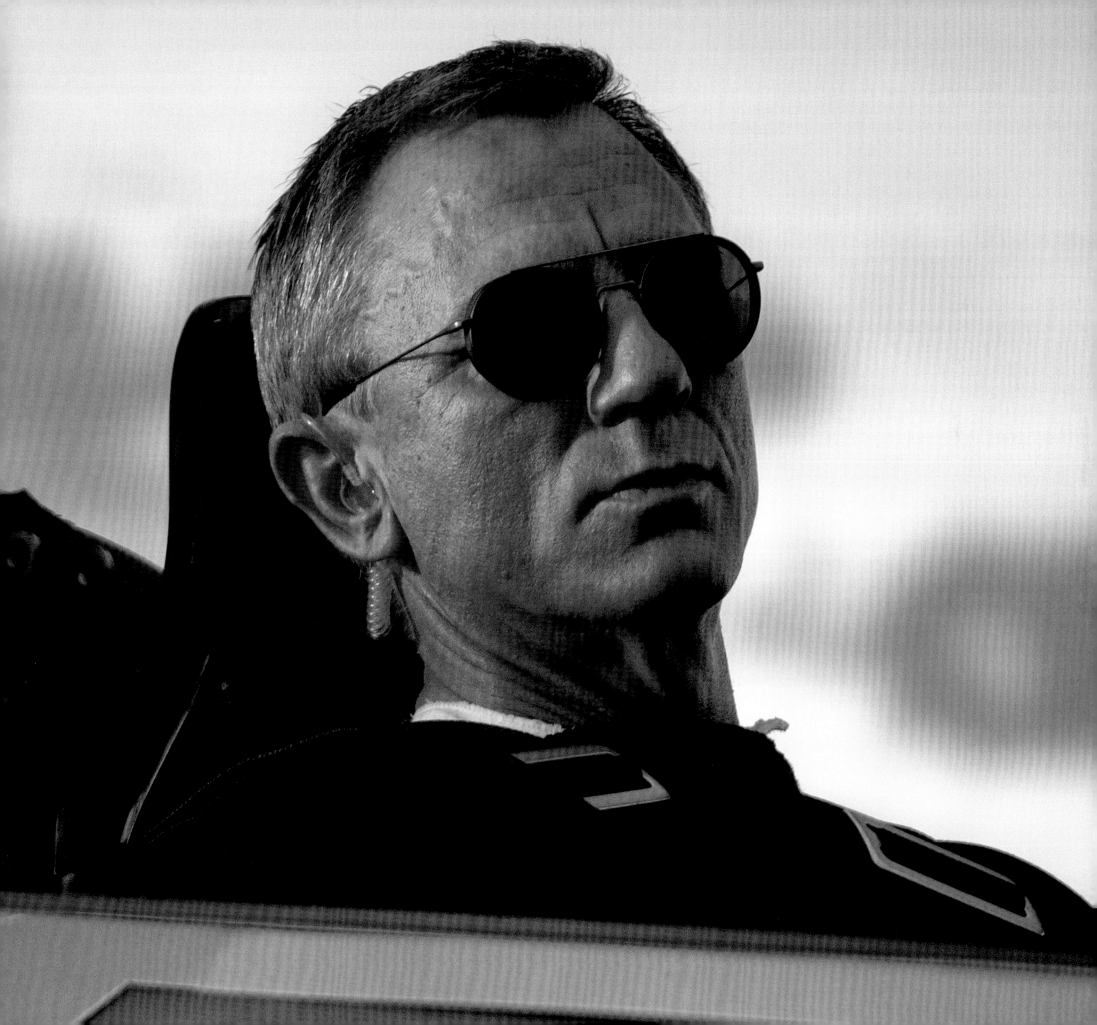

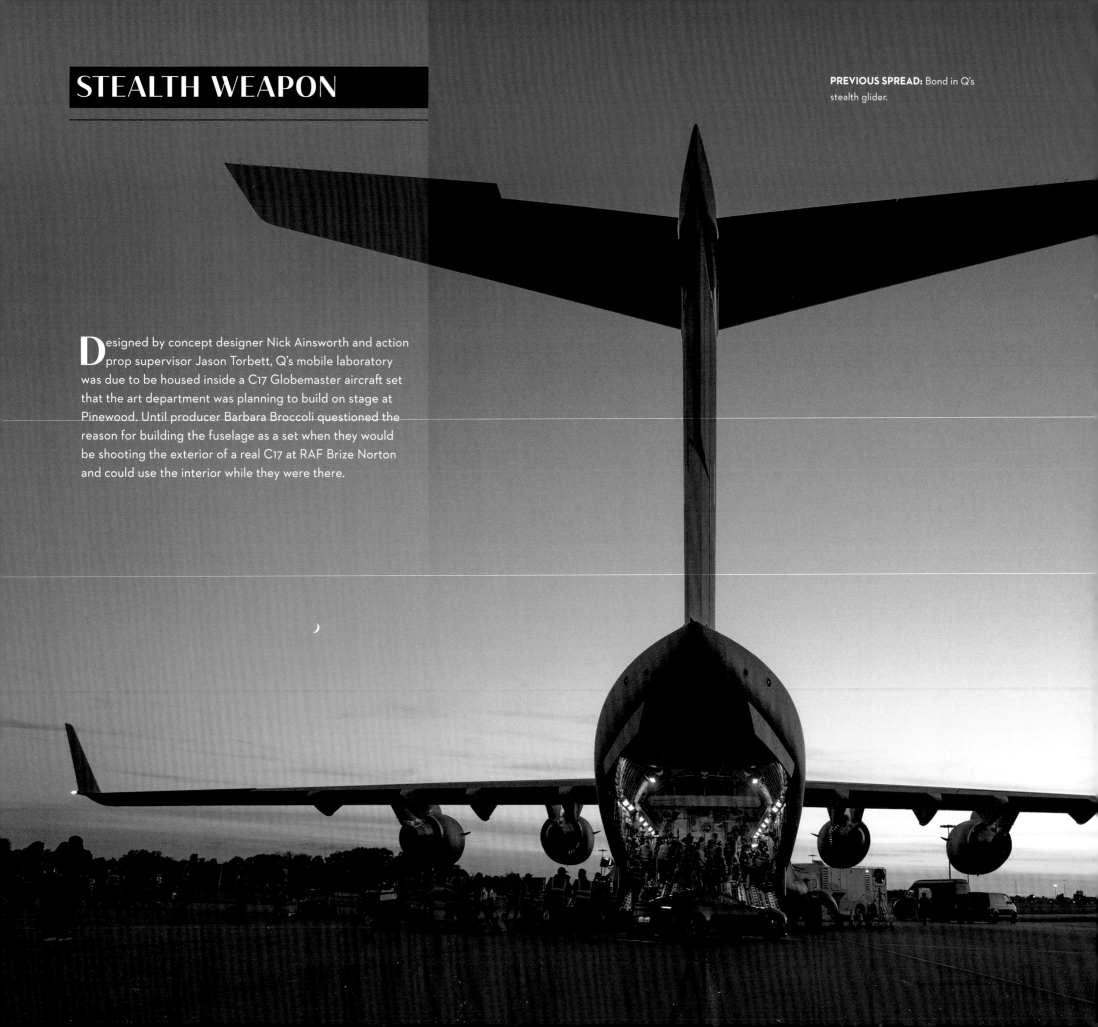

STEALTH WEAPON

PREVIOUS SPREAD: Bond in Q's stealth glider.

Designed by concept designer Nick Ainsworth and action prop supervisor Jason Torbett, Q's mobile laboratory was due to be housed inside a C17 Globemaster aircraft set that the art department was planning to build on stage at Pinewood. Until producer Barbara Broccoli questioned the reason for building the fuselage as a set when they would be shooting the exterior of a real C17 at RAF Brize Norton and could use the interior while they were there.

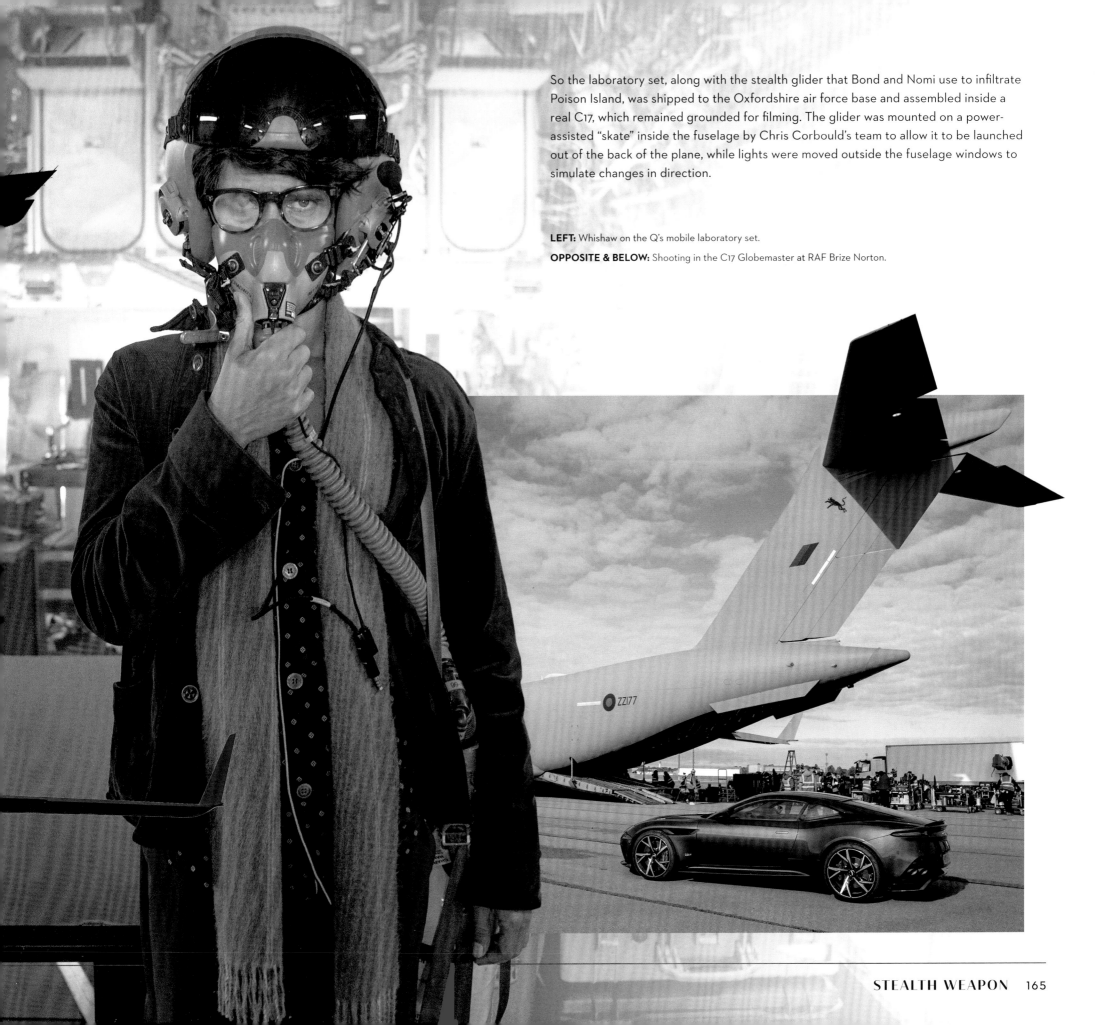

So the laboratory set, along with the stealth glider that Bond and Nomi use to infiltrate Poison Island, was shipped to the Oxfordshire air force base and assembled inside a real C17, which remained grounded for filming. The glider was mounted on a power-assisted "skate" inside the fuselage by Chris Corbould's team to allow it to be launched out of the back of the plane, while lights were moved outside the fuselage windows to simulate changes in direction.

LEFT: Whishaw on the Q's mobile laboratory set.
OPPOSITE & BELOW: Shooting in the C17 Globemaster at RAF Brize Norton.

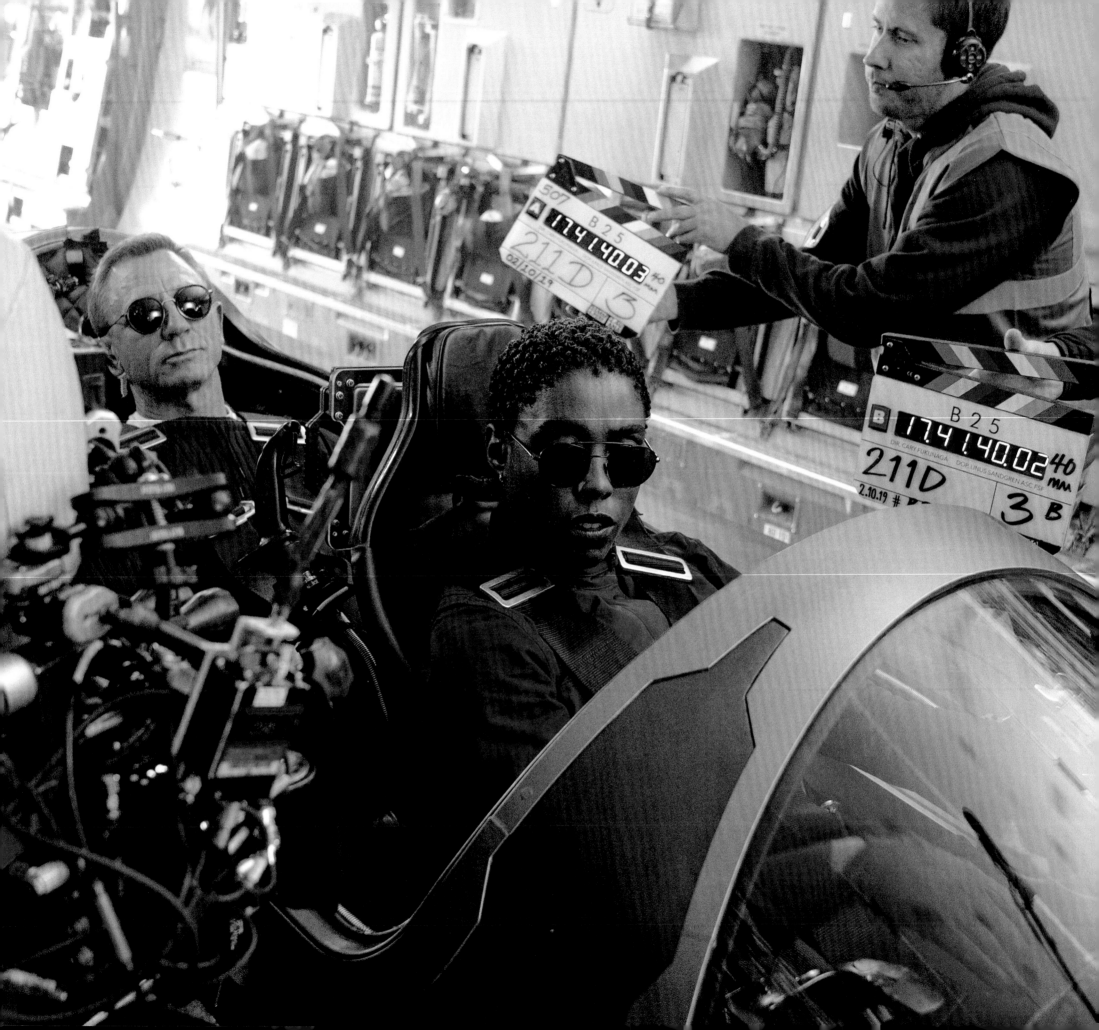

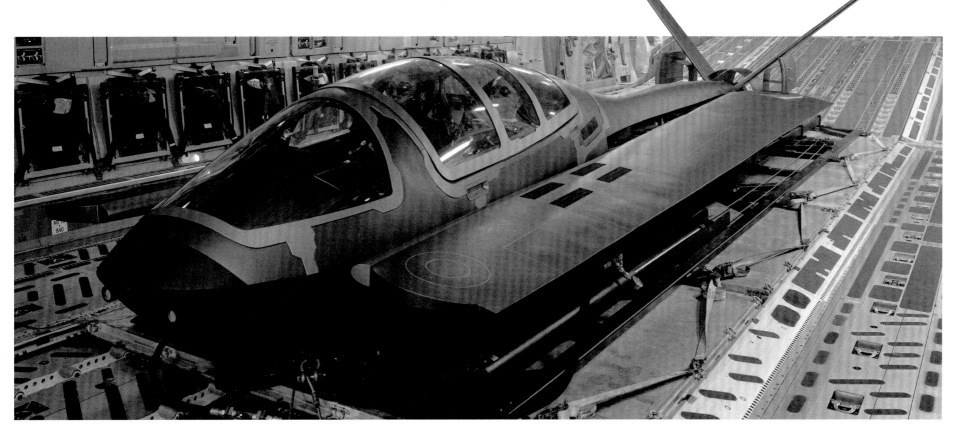

OPPOSITE: Craig and Lynch shooting preparations for the stealth glider launch.

ABOVE: Nomi and Bond prepare to launch the glider.

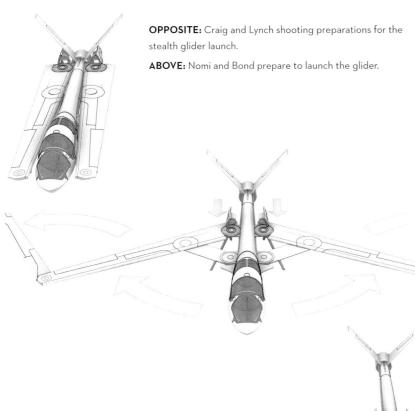

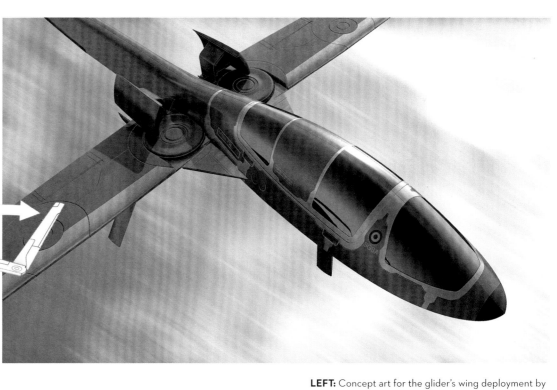

LEFT: Concept art for the glider's wing deployment by Mark Harris.

ABOVE: Glider concept art by Tim Browning.

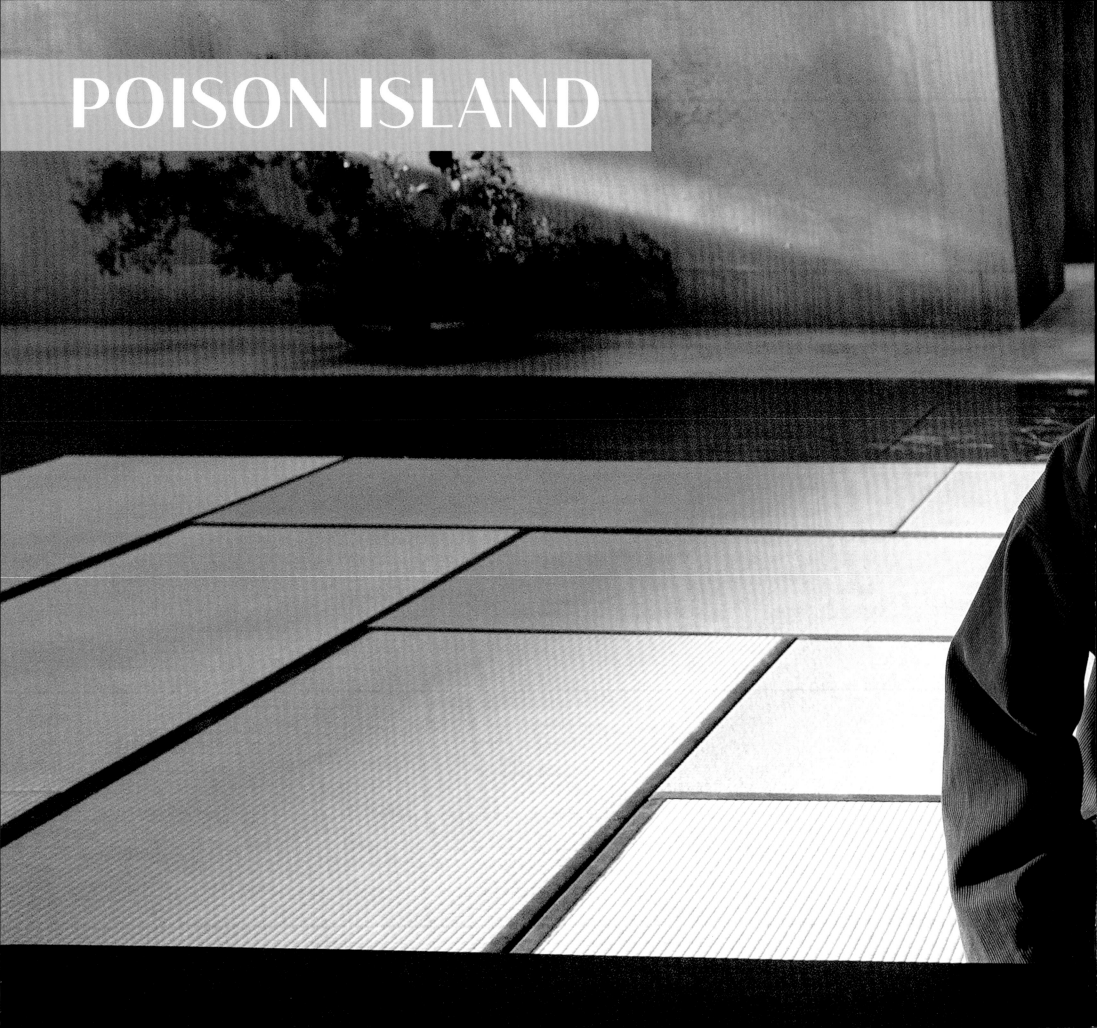

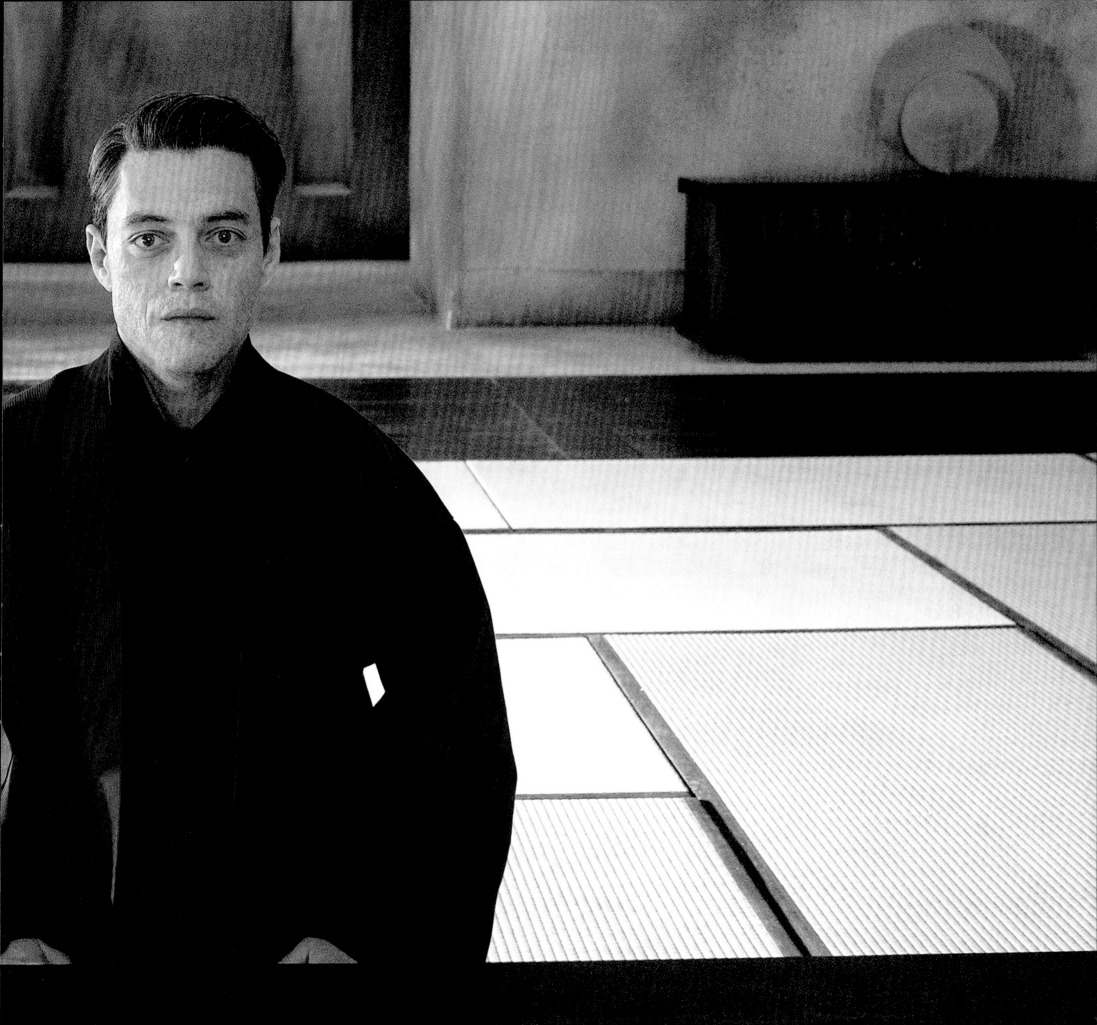

POISON ISLAND

When the time came to design Safin's island lair, Mark Tildesley took a leaf out of the sketchbook of legendary production designer Ken Adam, who set the benchmark for what a Bond film should look like with his jaw-dropping sets for *Dr. No* (1962), *Goldfinger* (1964), *Thunderball* (1965), *You Only Live Twice* (1967), *Diamonds Are Forever* (1971), *The Spy Who Loved Me* (1977) and *Moonraker* (1979). "It's the twenty-fifth film, so we've been trying to reflect on all the Bond movies in some way, harking back," explains Tildesley, who dug out Adam's original drawings, housed in the James Bond Archive, for inspiration. "Quite often we've opened Ken Adam's drawings up and stood in front of them to try to analyse what it is about them, what it is about Bond. What I like about Ken Adam is his boldness. He basically used a big felt-tip pen, nothing delicate, and made very strong, bold statements. Designs that were not hampered by realism, but which had a bit of drama and theatre to them."

PREVIOUS SPREAD: Safin in the "games room".

Not to mention scale. Ken Adam created sets of such magnitude that Pinewood's cavernous 007 Stage – for many years the largest purpose-built soundstage in the world – was originally constructed to house the submarine pen he created for *The Spy Who Loved Me*. It was Adam's sets for Bond's 1967 Japanese-set adventure *You Only Live Twice*, most notably Blofeld's monumental volcano-based lair, that were of particular inspiration for Tildesley when brainstorming Poison Island. "We wanted to find a language that felt appropriate for the end of a Bond film," reflects art director Neal Callow.

"As is characteristic of Mark, he exceeded all my expectations," says Malek. "You walk into Poison Island, Safin's lair, and you are immediately transported. It harks back to Ken Adam's legendary sets, but the scale and spectacle brings a modernity to it that is truly unique and beyond what most of us are used to seeing. It is truly a feast for the eyes. Oftentimes you read something in a script and you only hope it can live up to some aspects of how you've imagined it. You never think it's going to be comparable to your mind's eye, but seeing this for the first time, it exceeded what my imagination was able to conjure up, and that is rare."

"I didn't want it to be a dense jungle island. I wanted to do something that felt more prickly and bare. Once we were getting into *You Only Live Twice* as an influence, one of the places in Japan I really love in terms of the creative awakening that's happening there is Naoshima," reveals Fukunaga. "It's an island dedicated to art, run by the Benesse Foundation, which sounds very Bond-esque. There are several museums designed by Tadao Ando, whose brutalist concrete work and use of light and space were a huge influence in creating Poison Island."

"He makes these extraordinary minimalist pieces. Very simple bold shapes, which, in a way, are a modern form of Ken Adam," concurs Tildesley, who co-opted both Adam's and Ando's big chunky concrete aesthetic, bold minimalist architectural approach, fondness for vaulted ceilings and graphic high-contrast lighting to help create mood and atmosphere for Safin's hideout. "The trick was to try and keep it as simple as possible."

Before Tildesley began, however, Fukunaga and the art department worked up a thorough backstory and architectural timeline for Poison Island – so named because of the poisonous plants that flourish in its nutrient-enriched volcanic waters. "We tried to find a mythology for the place that went back to World War II, this disputed land between Japan and Russia, and what that might look like," says Fukunaga.

OPPOSITE TOP: Bond on Poison Island.

OPPOSITE BOTTOM: A cutaway of the Poison Island layout by Neal Callow.

LEFT: Bond hiding in the shadows.

Poison Island was originally a Japanese radar sounding station in the thirties, before being taken over by the Russians during World War II, who transformed it into a working missile base. After perestroika, the island was bought by the Safins, a Russian pharmaceutical family and SPECTRE's poisoners, who moved in, sealed the silo doors and turned the abandoned military complex into a home and factory. Until Blofeld had them killed. Now, having reclaimed the island from SPECTRE, Safin is set on continuing his father's legacy.

It is where Safin takes Madeleine and Mathilde hostage, and where Craig's Bond, alongside Nomi, must battle the bad guys one last time.

Bond and Nomi arrive on Poison Island in a twenty-four-feet long two-seater glider that was designed by senior art director Mark Harris and concept artist Tim Browning, and which transforms into a stealth submarine as it hits the water. Its wings fold in, cormorant-style, as it dives below the surface like a dart, before surfacing in one of the island's abandoned submarine pens.

One of a dozen or so built by the Russians during their occupation, this particular pen has partially collapsed due to seismic activity on the island, becoming dislodged from its foundations, "and sank, somewhat, into the water, shaking the pen in two different orientations, which is convenient for us, as set designers, because it makes the space look so much more interesting," notes Callow. "Again, we included some very bold geometric shapes to allow for interesting lighting conditions and make it feel like a Bond film, as well as get some scale in there. Mark's idea was to have daylight coming in through a slot, so we could light the set in an ambient way."

To simulate the glider's arrival in the pen, special effects supervisor Chris Corbould mounted it on a track just beneath the waterline, which allowed it to rise up, like a scissor lift, as it comes to a halt. "We did it in two parts," explains Corbould. "We shot it on the surface, pulling to a halt under the broken bridge, with Daniel and Lashana getting out. Then, with second unit, we shot it rising up with a big gust of bubbles to make it look like the ballast tanks were doing their bit."

From the submarine pen, Bond and Nomi make their way up through a series of dark cylindrical-shaped corridors, lit either from above via circular grated ceiling holes, or from the side by louvred slots, allowing the pair "to disappear into places that really had no nooks and crannies," says Fukunaga. "We wanted Bond and Nomi to be hiding in shadow, almost in plain sight," explains Callow. "Then they step out into the light and do what they do. We found some nice reference of black-and-white film noir-style lighting and designed the sets to recreate those conditions."

ABOVE: Concept art of the corridors by Cobb.
OPPOSITE TOP: Concept art of the corridors and tunnels by Zhang.

BELOW: Lynch on the Poison Island set.

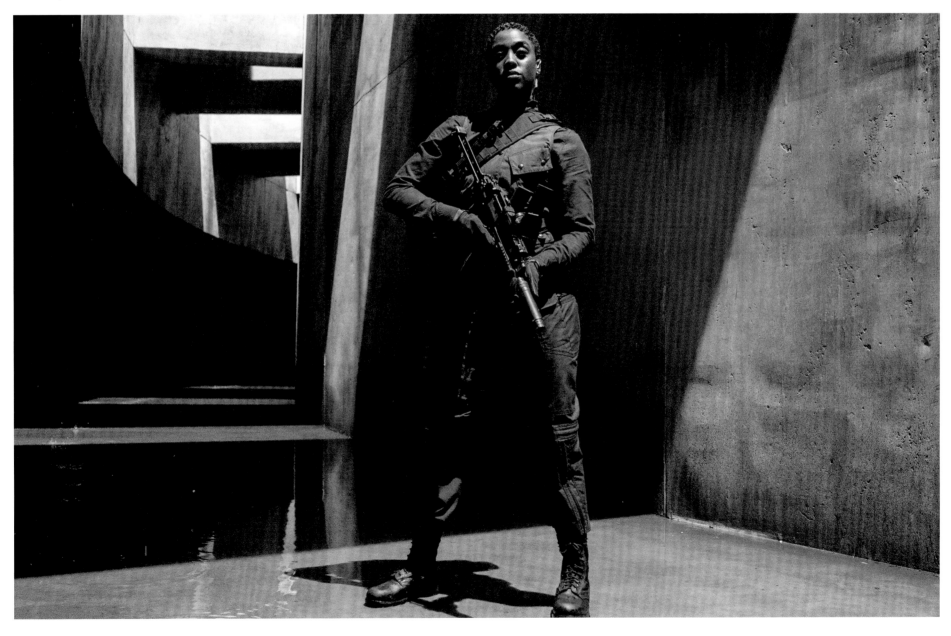

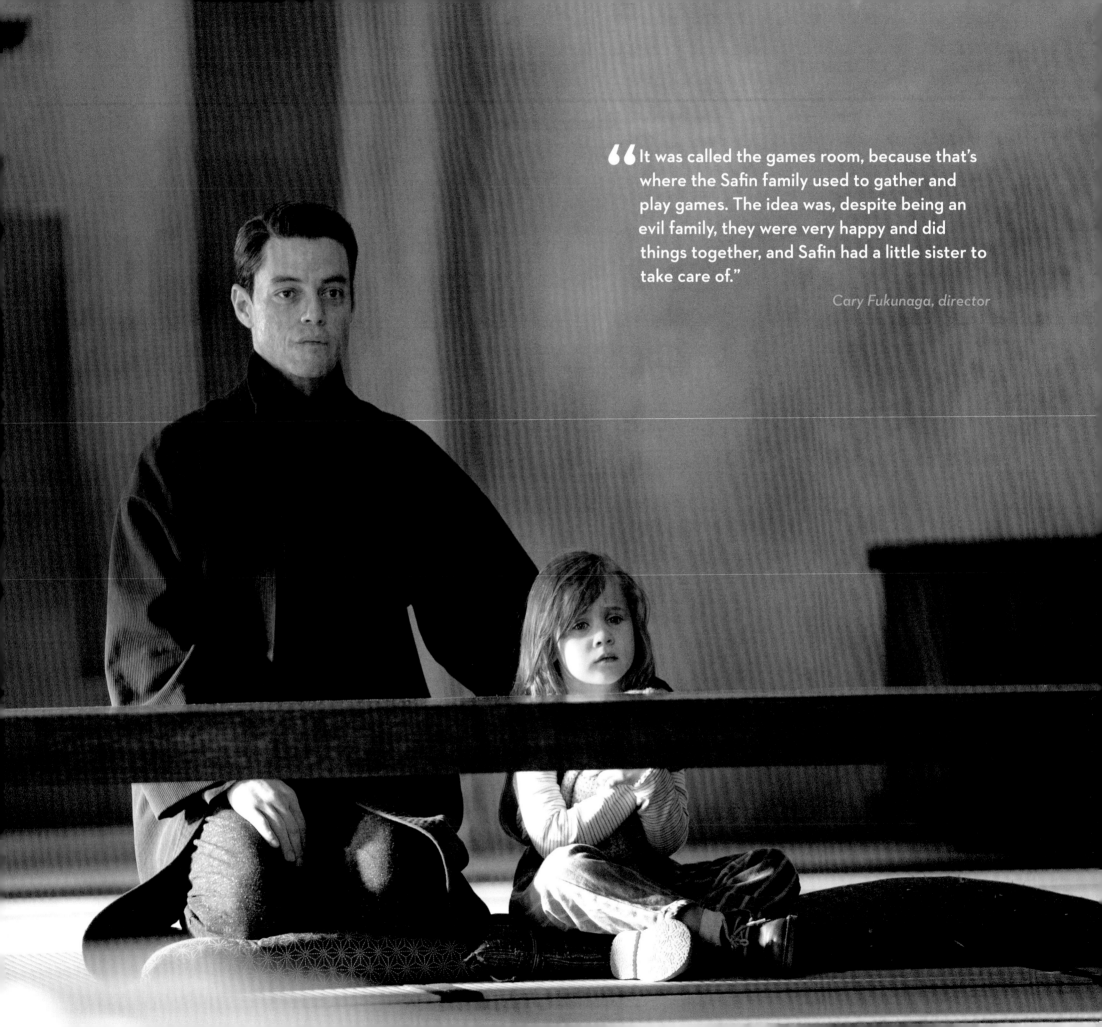

> "It was called the games room, because that's where the Safin family used to gather and play games. The idea was, despite being an evil family, they were very happy and did things together, and Safin had a little sister to take care of."

Cary Fukunaga, director

Built outside on the north lot, beyond the Cuba set, these defensive ring corridors were, perhaps, the most directly influenced by Ken Adam. "The idea was to show you can keep architecture quite pure, but light it in a very striking way to accentuate those moments," says art director Andrew Bennett. "Here, lighting is fifty percent of the design. Ken Adam always tried to create a sense of height and a real strong light source, and that's what we tried to nod to."

"With these sets it was all about the lighting and simple shapes," adds art director Sandra Phillips. "Linus was very involved with the look of the third act and sculpting with light. So we had open shapes, open voids, lots of concrete shuttering and open slits with light coming in."

"Our mood boards for the concrete tunnels were inspired by a museum Cary had visited that had shafts of light coming down through the ceiling and along the walls," says Sandgren. "When Daniel saw the boards, he thought it was the perfect opportunity to hide in the shadows then jump into the light. We loved that. Then I thought, *What if we move the lights, so they pulse through the corridors, because of machinery above the set that we don't see but hear, which forces him to be constantly on the move, hunting down the shadows to avoid the light?* So we programmed all the lights, tried it, and it looked great. Then, on the day, Arwel Evans, our standby art director, came up to me and said, 'Wouldn't it be beautiful if the light moved and you saw Bond's blue eyes pop in the light?' We all loved that. So now Bond stands in the shadows, there's a reflection from one of the puddles and you see his eyes in this movement of light. It's a lovely example of what you can achieve when you collaborate openly with ideas."

"In the original third act, it was the place in which Bond and Safin finally meet," says Fukunaga of Safin's office. "It was called the games room, because that's where the Safin family used to gather and play games. The idea was, despite being an evil family, they were very happy and did things together, and Safin had a

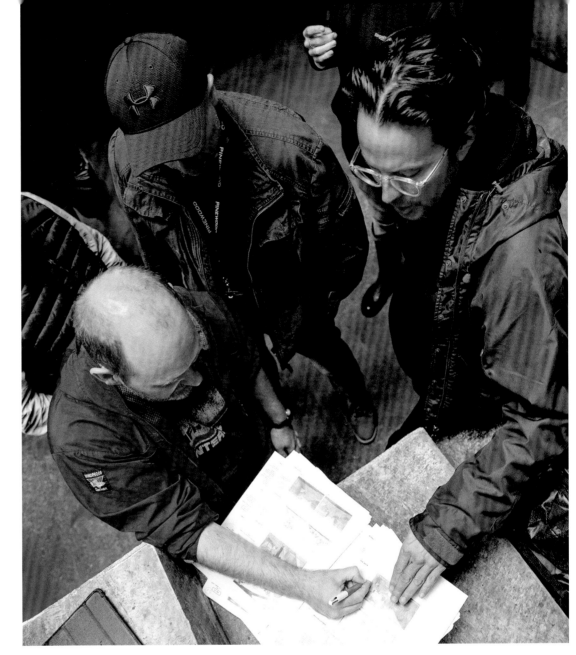

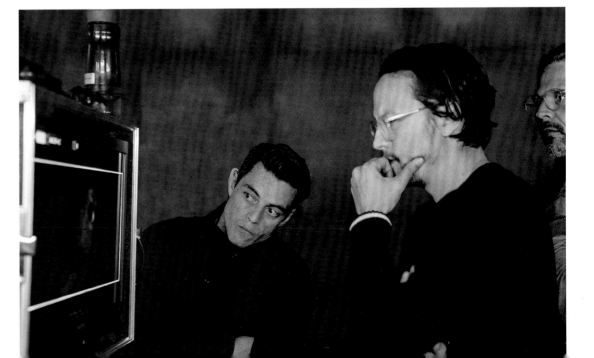

LEFT: Safin and Mathilde in the games room.

TOP RIGHT: Forrest-Smith and Fukunaga refer to storyboards.

RIGHT: Malek, Fukunaga and Sandgren watch playback of a scene.

little sister to take care of."

The pyramid-shaped space followed the island's concrete vernacular, but had an almost ecclesiastical feel, thanks to its lofty ceiling. "It's a cross between a living room and Safin's personal office and was a slightly more formal interior than a lot of the other spaces there," explains Callow. "It was one of the rooms that, during the original Safin family occupation, was tidied up and had windows cut into it. Linus was keen to get daylight coming in through a slot in the ceiling, which led Mark to coming up with a big chunk of concrete, out of shot, that let light in round the sides. Plus, it had views out either side."

Another area renovated during the Safin family occupation was the living quarters. "It's where Safin hangs out," says Callow. "The concrete has been cleaned, he's got tables and chairs, he's got art on the walls, he's got interesting bad-guy sculptures and fish tanks." In charge of dressing the space was Véronique Melery.

"It was really difficult but extremely interesting to try to imagine what Safin would have," she recalls. "Being of Russian descent, but having spent a part of his youth on this Japanese island, we tried to mix up all of those influences to create a very unexpected kind of place with traditional Chinese urns and bright Russian icons, along with one of Monet's Water Lilies painting series that Safin's parents bought years ago and was still there."

The massive "Monet" was the work of Rohan Harris, who also painted the murals on the Cuba set. "It's based on a real Monet and was almost full-size," says Melery. "The original's eleven metres long and ours was eight, because we didn't quite have the space." Initially, Melery was reluctant to give Safin such a famous painting, feeling such a valuable work might not be appropriate outside of a museum. "Then I discovered there are some Water Lilies [paintings] in private collections, so it's not impossible Safin's father, with his enormous wealth, could have

BELOW: Concept art of the zen garden by Lottie Geliot.

RIGHT: Malek shooting a scene on the Poison Island set.

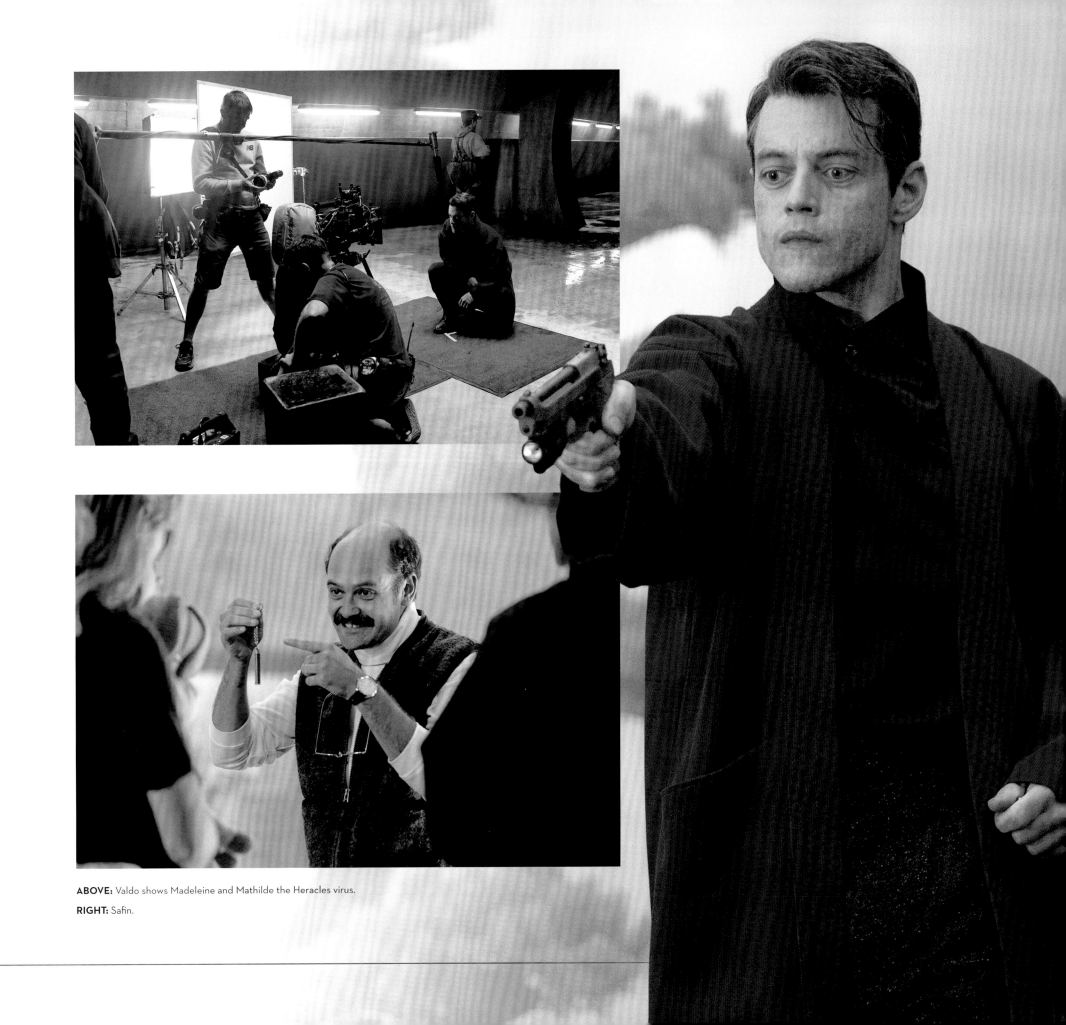

ABOVE: Valdo shows Madeleine and Mathilde the Heracles virus.

RIGHT: Safin.

bought it." Moreover, it was one of Monet's later Water Lilies, from when he was suffering with cataracts and shied away from the fresh, bright colours of his earlier work, instead using more blurry browns and reds, painted with a much heavier texture – an aesthetic choice that fitted perfectly with the dank, dark underground world of Poison Island. "The painting looks almost like an organic substance. Cary was very enthusiastic when I showed him the reference."

The centrepiece of Poison Island is a magnificent Japanese zen garden, housed inside the base of one of the conical-shaped missile silos. "It's very much like a volcano, only inverted," says Tildesley, who was paying direct homage to Blofeld's volcano lair in *You Only Live Twice*.

Built on Pinewood's Richard Attenborough Stage, the "exterior" garden measured 150 feet at its widest, and contained a variety of poisonous plants, fungi and fauna, a raked cement-coloured gravel floor, shiny black walkways, an inky black pond and a series of rock piles, "which look very simple until you realise there's a whole language behind what they represent," says Tildesley. "Some represent mountains, some represent shorelines. They're replicating parts of nature in a very condensed and simple way. Cary's like a black belt on the subject."

"The garden was Safin Senior's pride and joy," says Callow. "Safin's family used this place as a showcase to their clients and friends, and now with Safin having reclaimed it from SPECTRE, he's brought the garden back to tip-top condition." When Madeleine and Mathilde arrive on Poison Island, an eager-to-impress Safin shows them around. "It was supposed to be a slightly terrifying moment for Mathilde, being introduced to these deadly poisons while Safin watched," says Tildesley.

At the centre of the zen garden is a black pond that sits directly on top of the sealed blast doors that lead to the decommissioned

BELOW: Craig and Malek shooting a fight sequence on the zen garden set.

RIGHT: Craig shooting on the zen garden set.

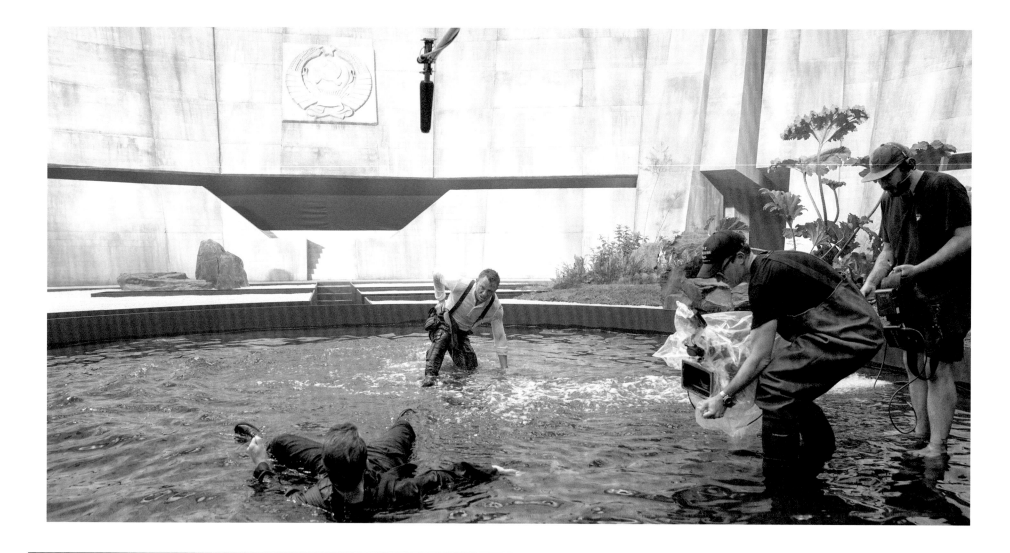

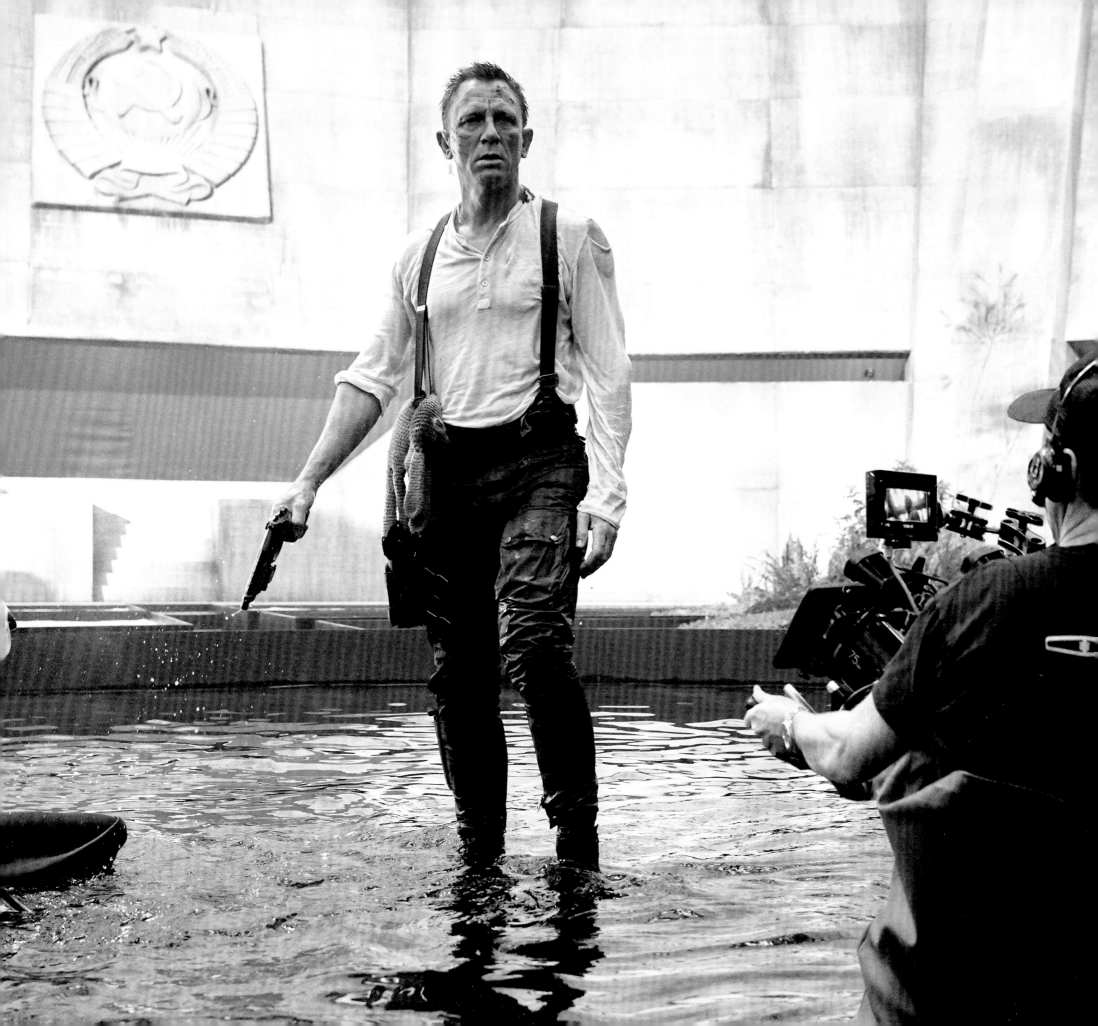

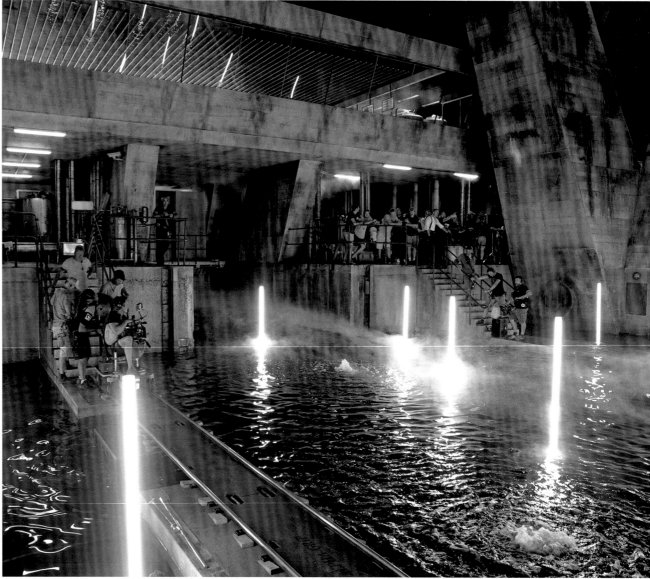

silo below. "It looked black, because the sides of the pond were black," explains Callow.

The outline of the walkways was inspired by an Edward Burtynsky photograph of Lake Lefroy in Western Australia. "Michael Wilson owns a couple of his photographs, and just by chance we used an image he shot of poison in a lake," says Tildesley.

Sandgren chose to shoot the zen garden in soft light, giving Safin and his poisonous pride and joy a romantic feel. "The first thing you'd normally think of for that type of environment is to go really cold and grey, but I thought maybe it would be nice to give it a warm sunset glow, like you're in Provence," he explains. "Safin's a disturbed personality, but he thinks he's a

romantic. He has a romantic view of what he's doing, which fits with the way he talks to Madeleine, when he's showing off his beautiful poisonous flowers. He loves being on that island, in that concrete bunker, so whenever he's there, metaphorically it fits that we are in sunset. The actual light source in many of these scenes on the island was a 200,000-watt SoftSun that was manufactured for us on *First Man*, to be used as a sun on the moon set. It is the most powerful lamp existing. "

"Safin is a romantic," concurs Fukunaga. "In his head, he's Madeleine's saviour."

While the zen garden is Poison Island's ornamental showpiece, the heart of Safin's nefarious operation is a massive bacteria farm,

ABOVE LEFT: Early concept art of the bacteria farm by Cobb.

ABOVE: Craig preparing to shoot on the bacteria farm set.

RIGHT: The bacteria farm.

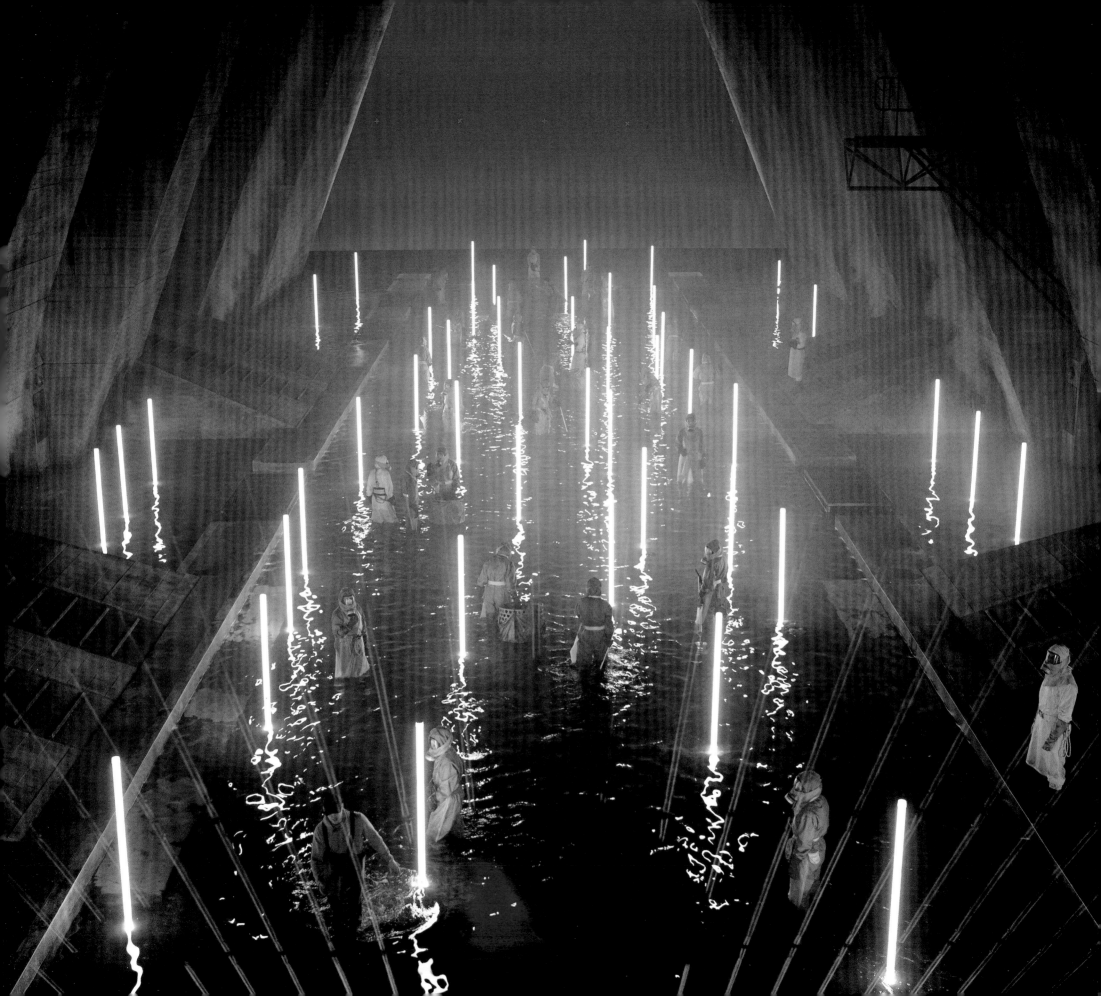

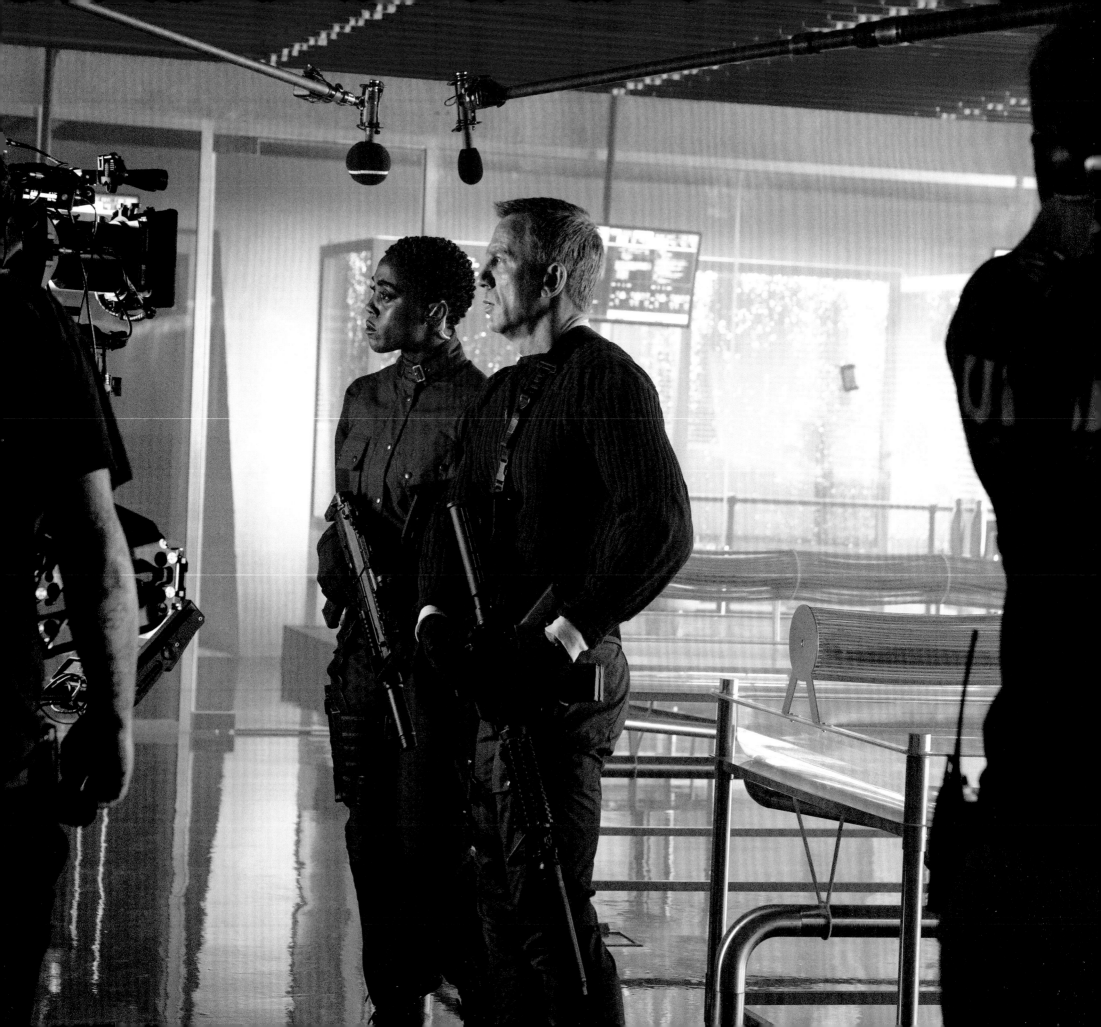

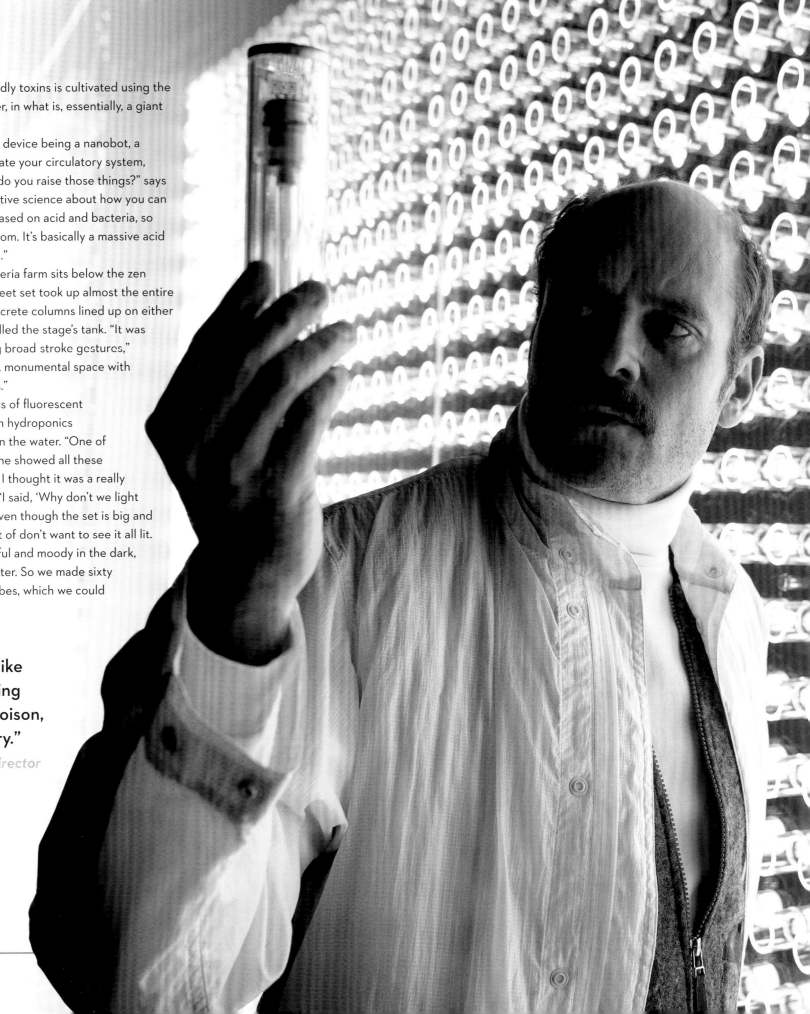

where the raw material for his deadly toxins is cultivated using the island's nutrient-rich volcanic water, in what is, essentially, a giant petri dish.

"Once we settled on Safin's evil device being a nanobot, a miniature squid that could eviscerate your circulatory system, then [the question] became, how do you raise those things?" says Fukunaga. "There's all this speculative science about how you can make nanobots, and some of it's based on acid and bacteria, so that's where the pool idea came from. It's basically a massive acid bath that the nanobots are built in."

In geographical terms, the bacteria farm sits below the zen garden. In reality, the 350 by 180 feet set took up almost the entire 007 Stage, with cathedral-like concrete columns lined up on either side of a pool of dark water that filled the stage's tank. "It was all about light and shadow and big broad stroke gestures," says Bennett. "It was a very grand, monumental space with Bond-esque gantries going across."

Illuminating the set were dozens of fluorescent light sticks, similar to those used in hydroponics farms, forming a reflective forest in the water. "One of the concept designs Mark had done showed all these lightsaber things in the water and I thought it was a really beautiful idea," recalls Sandgren. "I said, 'Why don't we light the set with nothing but those?' Even though the set is big and you kind of want to see it, you sort of don't want to see it all lit. We found it much more suspenseful and moody in the dark, with just light coming from the water. So we made sixty waterproof battery-driven LED tubes, which we could control with iPads".

> ❝ Each one of the vials is like a loaded bullet, containing both the nanobot and poison, and put in the rack to dry."
>
> *Andrew Bennett, art director*

LEFT: Lynch and Craig shooting on Valdo's laboratory set.

RIGHT: Valdo with one of the vials of the Heracles virus.

Working in the water are dozens of people wearing pink hazmat suits. "Again, that was a reference to the volcano set in *You Only Live Twice*, where there were all these people in various coloured jumpsuits, which I've always associated with Bond," says Tildesley. "So we riffed on that."

As big as the bacteria farm set was in reality, onscreen it will appear three times longer, thanks to visual effects. "We wanted it to feel like this industrial space, but slightly unfamiliar. It needed to feel *large*," says Callow. "Part of the concept is that before Bond and Nomi arrive on the island, they think Safin doesn't have the capability to deliver this weaponised DNA on a global scale. When they get to the bacteria farm, they realise, 'Wow, this is gigantic.' That's what wakes everyone up and says, 'We've got to do something to stop this.'"

For Valdo's island laboratory, Tildesley was after a "scintillating image that would remain with people," but which would also function as a visual representation of the scale of Safin's diabolical plan. He found both in architect Thomas Heatherwick's Seed Cathedral, a 'sculpture structure' created for the UK pavilion at Expo 2010. "From the outside, it looked like a giant sixties fibre-optic lamp. It was a set of Perspex rods and on the end of each one was a seed. Light travelled down each rod and when you went inside it was almost like a sea of stars. We loved that idea."

Using Heatherwick's installation as inspiration, Tildesley designed a high-tech laboratory at the far end of 007 Stage that overlooked the bacteria farm set and was connected to it via the stage's existing concrete ramp, which they incorporated into the design. "It's what we call a freebie," says Bennett. The actual laboratory was dominated by a backlit wall that was, in essence, a giant wine rack containing between six and seven thousand Perspex vials filled with Safin's DNA-coded poisons, farmed from the grungy waters below. "Again, we had to evoke scale, to show Safin's plans for these poisonous vials. Each one of the vials is like a loaded bullet, containing both the nanobot and poison, and put in the rack to dry."

"Once the racks are loaded, you can slide them across, bring out an empty one and make more," reveals Callow. "Not only was it a beautiful art installation-like piece of set design, it [visually] told you the story of the bad guy's scheme, how many vials there were,

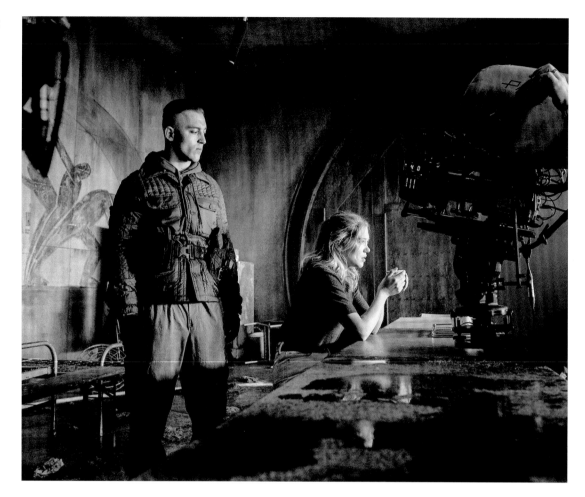

TOP RIGHT: Benssalah and Seydoux shooting on the barracks set.

RIGHT: Benssalah, Fukunaga, Seydoux and Sandgren between shooting.

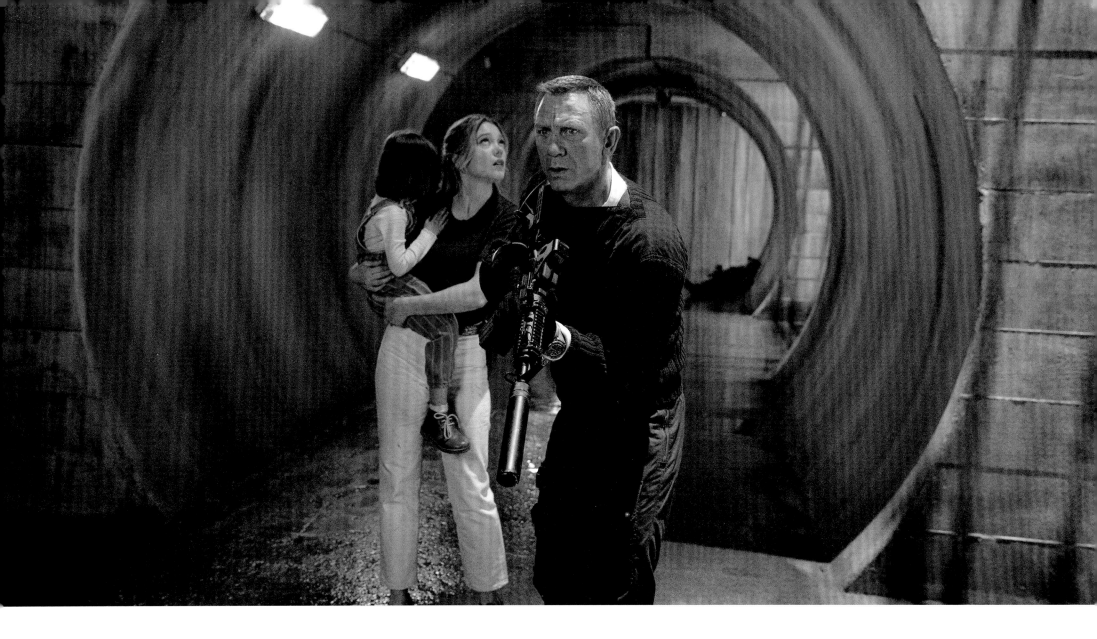

ABOVE: Bond atttempts to lead Mathilde and Madeleine to safety through the Poison Island tunnels.

and what kind of cataclysmic event they could cause."

As Nomi, Madeleine and Mathilde head to the sub pen and a boat off Poison Island, Bond works his way to the control room to open the giant blast doors that safeguard Safin's operation from outside attack, thereby allowing the Royal Navy's missiles to penetrate and destroy the base. Standing between him and his destination are Primo and a phalanx of bad guys.

Since it was to be Craig's final piece of action as Bond, Fukunaga wanted something exceptional to round off the actor's tenure as the world's greatest secret agent. So, with supervising stunt coordinator Olivier Schneider, they choreographed an almost three-minute-long sequence that would feature Bond, machine gun in hand, climbing a stairwell, taking out baddies with bullets and grenades, crashing back down the stairs and wrestling

with Primo, before finally making it to the control room.

Dubbed the "brutal stairs," the sequence was designed to be filmed as one single, uninterrupted take – referred to as a "oner" – similar to Bond's introduction at the start of Spectre, which follows him from a busy Mexico City street, into his hotel, up in a lift, and through his room, before heading outside onto the balcony and walking along a rooftop.

"Cary is keen on doing long takes, and I told him the stairs would be the moment to do a oner," says Schneider. "It should be very special, and the way to make it special is to stay with Daniel all the time and play up all the confusion and disorientation, because it's very dark, there's smoke, you hear gunfire, but you don't know where the bad guys are, so you get surprised all the time. Cary was very keen on that. As was Daniel."

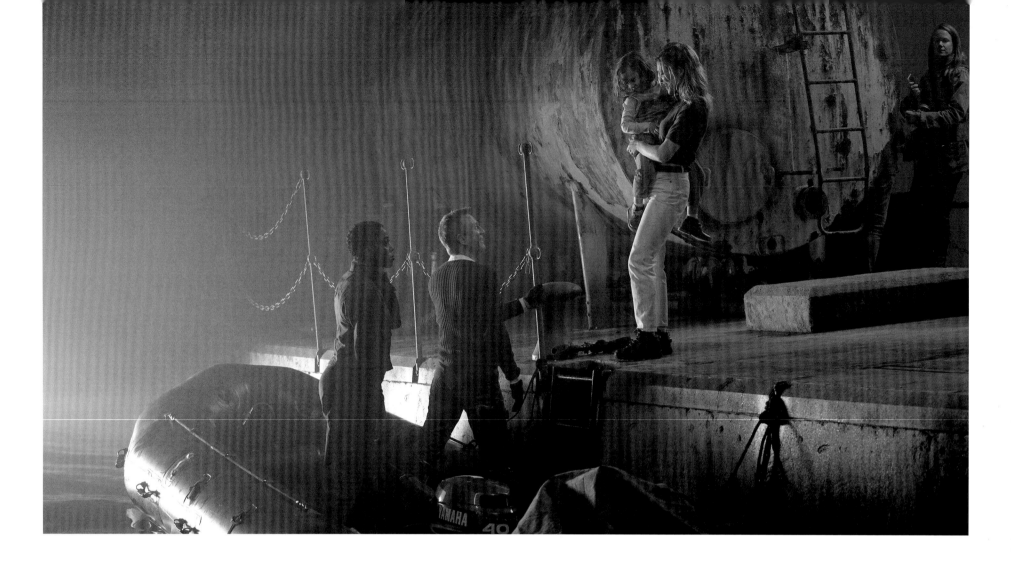

Fukunaga's fourth episode of *True Detective* featured an extraordinary six-minute tracking shot, and he had written several oners into the *No Time To Die* script, although the brutal stairs was the only one filmed. "I would do ten oners in a film if I could," Fukunaga admits. "I would have done Cuba as a oner. If you're making a film that's coming from the experience of the character, there's nothing that puts you more in the 'present tense' than a oner. I think what makes this James Bond film different to the others is it's more of a *personal experience*. It's Bond's perspective versus a God's-eye perspective, and when you're in Bond's perspective, oners put you right there with him. They increase the tension and the thrill of the moment. I like being with characters for that long. In cinema, we're always looking for that aesthetic experience."

"The less you cut the more immersive it is," concurs Sandgren, who, like Fukunaga, favours longer takes wherever possible. "It's really beautiful to stay in shots and follow someone, or be with them without cutting, because it feels like you're there. A oner has to be a singular point of view, and this was the perfect moment in

the movie for that."

While the brutal stairs will appear to be one continuous take, in reality it was four shots digitally stitched together. "It works, because the stitches are done the smart way," says Fukunaga, who opted to shoot handheld to double down on Bond's confusion and anxiety throughout the scene. "We chose very deliberately when to go handheld in the movie, because we didn't want it to be all handheld," says Sandgren. "We would shoot handheld when it was *emotionally* motivated, even in dialogue scenes. Sometimes Bond is in control and we're smoothly flying along with him. At the end of the movie, in this sequence, he's not in control anymore, so the handheld felt motivated when we're following him up the stairs. It was very intense."

Directed by Q, via comms, to Poison Island's Soviet-era control room, Bond struggles to unlock the blast shields that have been sealed shut for decades. "It's analogue and physical, cogs and dials, with a counterweight system that opens the silo doors, so we looked at big industrial plants, places like Chernobyl and Battersea Power Station," says Tildesley. "We also looked at Apollo launches,

ABOVE: Lynch, Craig, Sonnet and Seydoux prepare to shoot a scene on the submarine pen set.

RIGHT: Craig and Benssalah shooting the fight on the "brutal stairs".

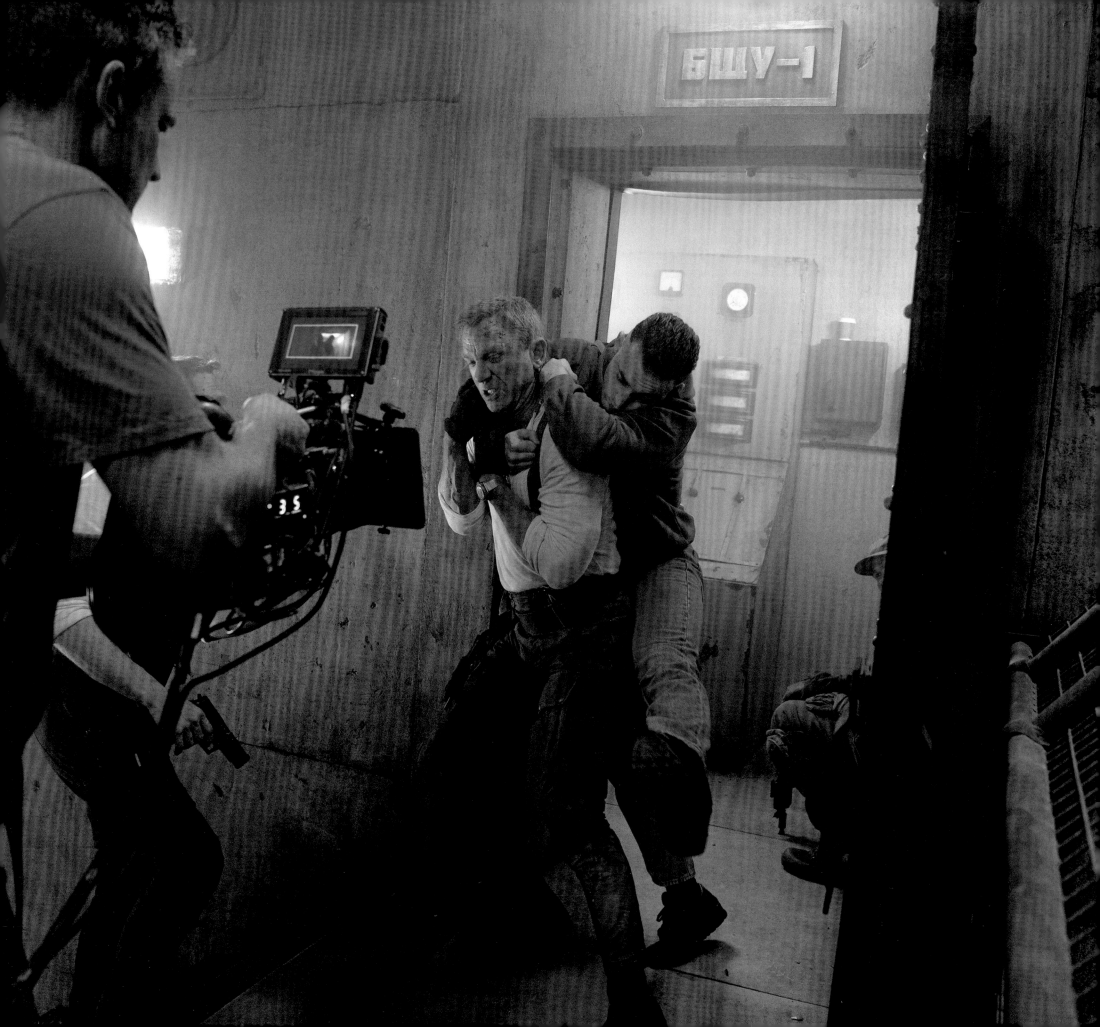

where the equipment was chunky and old-school and there's a sea of screens and dials. The idea was to evoke that period as well as show the history of the island."

"The control room, which looks down on the zen garden, was probably the busiest room in terms of dressing," says Phillips. "It's the heart of the mechanics of the island, so while everywhere else was much sparser, this had lots of props: fuse boxes, pipework, ropes and switches, plus the counterweights that operate the doors. There was a lot going on."

Giving the critical counterweights heft and making them move was the responsibility of special effects. "We draw what we'd like things to look like, then discuss it with them," says Phillips of the collaboration between the two departments. "They're always trying to make things as strong and as safe as they have to be, and we always try to make things look as good as they can be, so it's a balance. Ultimately, it has to look good *and* be safe, so there's always a compromise."

> **"I think what makes this James Bond film different to the others is it's more of a *personal experience*. It's Bond's perspective versus a God's-eye perspective."**
>
> *Cary Fukunaga,* director

THIS PAGE: Bond in the control room.
OPPOSITE: Safin

SAFIN

"There's a long string of fabulous, super-talented Bond villains, and it's very hard to follow in the footsteps of the Javier Bardems and Christoph Waltzs and Mads Mikkelsens," says Cary Fukunaga. "Who can do that in this day and age, and go toe-to-toe with Daniel?" The answer was American actor Rami Malek, who won widespread acclaim for his starring role in TV's *Mr. Robot* and picked up an Oscar® for his portrayal of Queen frontman Freddie Mercury in *Bohemian Rhapsody*.

"I've always appreciated Rami's work, and the diversity of his work, and I'd never really seen him play a villain," continues Fukunaga. "We knew each other socially and kind of joked about it, and at one point I was like, *Why not?* We weren't sure the timing would work, but I started forming this character around him. I liked the idea of this fragile, behind-the-curtains kind of villain, not the frontman."

"I spent a significant amount of time speaking with Cary, and together we started throwing out ideas," reveals Malek. "We had very specific attributes that we wanted to incorporate into the character and while I wouldn't say he gave me carte blanche, we were very collaborative throughout the entire process. We wanted the character to feel timeless. We talked about [his] accent, and wanted it to feel as if it came from, perhaps, centuries ago."

"Safin's a villain who has no qualms about using any device to manipulate people, and that's what makes him particularly frightening. He seems to have no limit to the ends to which he'll go to achieve what he wants. So when Bond and he finally have a confrontation, it's highly charged and highly emotional," notes Wilson.

"When we started to build the character of Safin, we wanted him to be different to the characters we've had before," says producer Barbara Broccoli. "We wanted him to be younger. We wanted him to be very tortured in a way and, through his own life experience, be very damaged. Through his damage he sees the world a different way, and he sees how to solve the world's problems through this prism of

having being scarred, literally and figuratively, by the SPECTRE organisation and wanting to make up for his family's massacre."

When Safin arrives at Madeleine's Norwegian home at the start of *No Time To Die*, he fully expects to kill everyone present. Why he spares young Madeleine's life, pulling her from the frozen waters of a lake, is a mystery to both her and him. Because he saves Madeleine's life, he feels a sense of ownership and companionship towards her that becomes the tethering of their dynamic in this movie. "He makes what the audience might deem a very unpredictable choice to save Madeleine in that moment," says Malek. "He cannot fight his instinct to save her, so justifies it with the idea that one day she will have to repay her debt to him. He becomes obsessed with this idea."

"He's a man without any empathy," says Broccoli. "He seems to have this fascination with Madeleine, because she puzzles him. He doesn't quite know why he spared her life. I guess he figures it must be love, because he doesn't know what love is. But he goes back to claim his chit, and in doing so becomes obsessed with her." It's an obsession that not only puts Madeleine in Safin's crosshairs, but Bond and Mathilde, too. "The whole idea that he is the person haunting the person that Bond loves is very Fleming-like," says Broccoli. "Fleming always talked about characters having a dirty secret, and this is Madeleine's dirty secret that she's terrified of, having this man re-enter her life. Of course, it comes at a time when she's covering up another secret, which is the big Bond bombshell, and she doesn't want to put that person in jeopardy."

While less flamboyant a Bond villain than, say, Waltz's Blofeld or Bardem's Silva, Malek's unnerving Safin proves to be more of a threat, not only killing Blofeld and wiping out SPECTRE, but planning to unleash retribution on the world via his and Valdo's DNA-targeted virus. "Cary and I discussed at length what could make this villain especially frightening and realised

that the plausibility of his actions would be our key centre-point," Malek recalls.

"When you're working on a character like this, you have to find a way in to understand why they're doing what they're doing. From his point of view, Safin might consider himself to be as heroic as James Bond himself," concludes Malek. "No one ever thinks they're the villain. They're fighting to protect or restore something they truly believe in. Nothing that Safin is has happened by accident. I never want anyone to think he's a victim of circumstance, because we know the trauma he experienced in his youth. Everything that makes him evil is a choice. It wasn't a sequence of events, it was choice after choice that got him here."

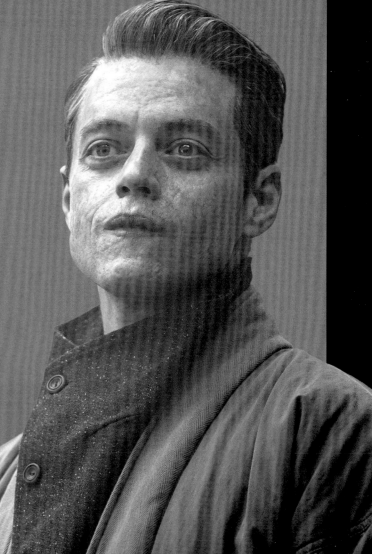

EPILOGUE

With the missiles flying, Bond says his goodbyes to Madeleine from the control room roof.

"The first time Bond sees Madeleine, she's in bright light and then at the end of the film, Bond sees her disappear into this bright sunset light," says Linus Sandgren. "She's the love of his life, and having her enter and exit in the sunset light like an angel, we thought that was a nice bookend to her character's story."

"It's sins of the father, sins of the mother," says Cary Fukunaga. "The movie starts off with a mother and daughter, and ends with a mother and daughter. I've always enjoyed symmetry in narratives, if only for the aesthetic balance of it. In many ways the story starts off with Madeleine's perspective and ends with Madeleine's perspective, and that's a big departure for Bond. But I think, especially if we're going to say goodbye to a character, it's the right way to say goodbye, from the inside, rather than from God's perspective. It's a very satisfying film. I think it will feel, first of all, like a *film*, not like a tentpole or a ticket-bait spectacle. It feels like a real story. One that, for this iteration of Bond, had to be told."

"Bond has always been someone who didn't know from one day to the next whether he was going to die, so he was very hedonistic and trying to live life to the fullest," concludes Barbara Broccoli. "I think his realisation over the course of these [Daniel Craig] films is life is precious and the lives of others are precious, not just on the big scale of saving the planet and the people on it, but also through allowing himself to become attached to individuals. He's always been terrified of that, because he never wants to be in a situation where his existence could put [his loved ones] in jeopardy or he would have to compromise himself for the people he loves. So it felt like that was the fitting conclusion to the Daniel Craig arc, that we would have to put him in the worst, the most unthinkable situation he could ever possibly be put in, which is facing a threat to the people he loves and him having to make the choice whether he saves the world or saves those individuals. I think it's a fitting conclusion to his extraordinary run as this character."

RIGHT: Bond with Madeleine and Mathilde in the submarine pen.

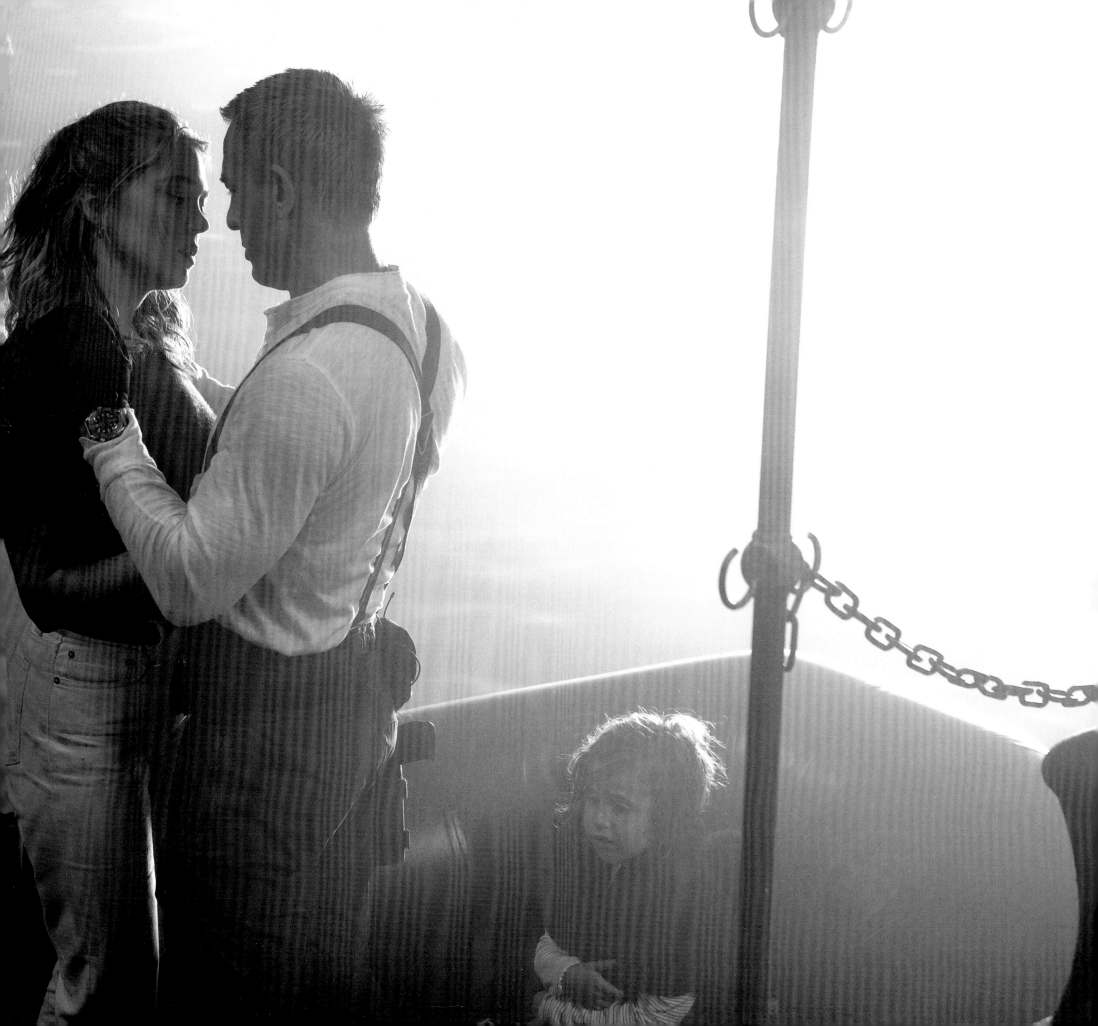

ACKNOWLEDGEMENTS

AUTHOR ACKNOWLEDGEMENTS

I am indebted to the cast and crew of *No Time To Die* for welcoming me onto their sets, into their offices, the occasional trailer, hotel room and Aston Martin DB5 interior, and putting up with my numerous questions, or simply allowing me to hang out and watch. Thank you one and all, but especially to Daniel Craig, Cary Joji Fukunaga, Michael G. Wilson, Barbara Broccoli, Gregg Wilson, Léa Seydoux, Ana de Armas, Lashana Lynch, Naomie Harris, Rami Malek, Dali Benssalah, Linus Sandgren, Mark Tildesley, Chris Corbould, Suttirat Anne Larlarb, Olivier Schneider, Lee Morrison, Alexander Witt, Véronique Melery, Chris Lowe, Andrew Bennett, Neal Callow, Dean Clegg, Mark Harris, Sandra Phillips, Oliver Rayner, Neil Layton, Ben Strong and Ashley Hollebone.

I would very much like to thank Stephanie Wenborn for entrusting me with this book. I am also hugely grateful to the behind-the-scenes team of Rosie Moutrie, Claudia Kalindjian, Debi Berry, Sean Hill, Zara Beyaz, Liam Dunne, Nicola Dove, India Flint and Freddie House who, in ways large and small, helped make this book happen. Thank you.

To my unflappable editor Jo Boylett and the other folk at Titan Books – Laura Price, Simon Ward and this book's designer Tim Scrivens – thank you for your unflagging enthusiasm, fortitude and hard work to wrestle this into print.

And finally, to my lovely wife Laura, son Milo and my mum, for their endless patience, support, understanding and love. Without whom...

TITAN BOOKS would like to thank the cast and crew of *No Time To Die* who contributed their valuable time and material to this book. Thanks also to the team at EON Productions for making this book possible and for their time and dedication to bringing it to fruition. Thanks to Metro Goldwyn Mayer Studios.

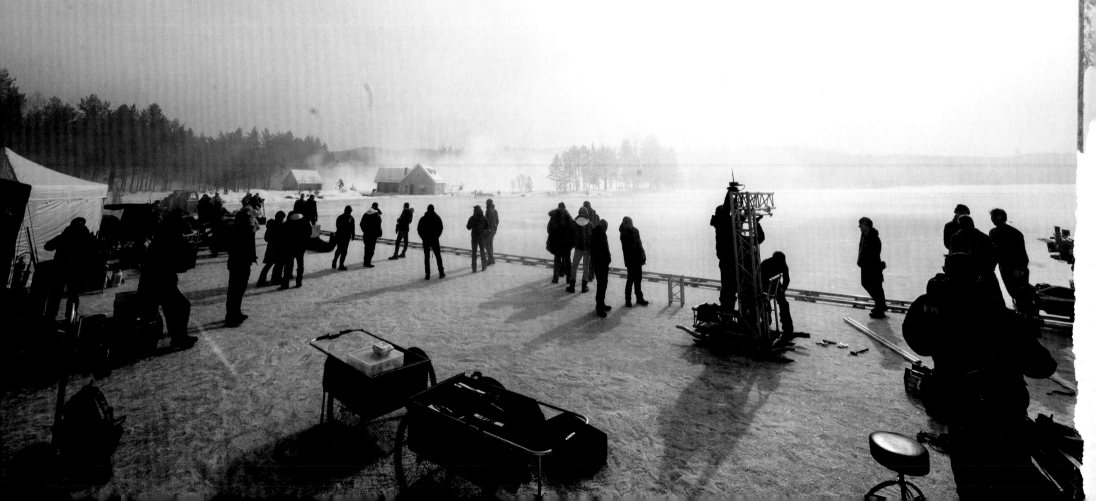

BELOW: Shooting the flashback to Madeleine's childhood on location in Norway.